DATE DUE

Before the Suffragettes

Before the Suffragettes

Women's Emancipation in the 1890s

David Rubinstein

Senior Lecturer in Social History
University of Hull

St. Martin's Press
New York

First published in the United States of America in 1986

Printed in Great Britian

ISBN 0-312-07160-4

Library of Congress Cataloging-in-Publication Data

Rubinstein, David.
 Before the suffragettes.

 Bibliography: p.
 Includes index.
 1. Women — England — Social conditions. 2. Women —
Employment — England — History — 19th century. 3. Women
in politics — England — History — 19th century. I. Title.
HQ1599.E5R83 1986 305.4'0942 86-3793
ISBN 0-312-07160-4

Contents

Illustrations

Preface

It is difficult to isolate a period of modern history which cannot justifiably be called an age of transition. In the 1890s, however, history appears to have been given an extra push, and it was often women who did the pushing. The aim of the present book is to discuss the novel and controversial developments in the period in which women played the principal part. Inevitably the focus is on the women of the middle and upper social classes. Large groups of women such as domestic servants and working-class housewives, in whose lives the 1890s made little change, have been ignored. I have also, with some reluctance, ignored women participants in the socialist movement, on the grounds that their numbers were small and their lives considered, in part at least, under a variety of other headings.

The introduction attempts to justify the choice of the 1890s as a subject of research. Here it should be noted that the content of the book does not cling rigidly to its designated dates. Where relevant, both earlier and later years are drawn on; the censuses of 1891 and 1901 are used as frames for the portraits presented, but it would be pointless to attempt to make them a straitjacket. In researching and writing I have thought of the 1890s as beginning in 1891 and ending in 1900, in the fashion of the period. A leading article in *The Times* of 1 January 1901 declared portentously: 'The twentieth century has dawned upon us; and as we float past this great landmark on the shores of time feelings of awe and wonder naturally creep over us.' I have followed this practice, while reserving my own awe and wonder for the courage and resolution of the women discussed in the following pages.

The process of research and writing has resulted in many debts which I am glad to have the opportunity to acknowledge. The first is to my former colleagues in the English Department of the University of Tours, where I was visiting professor in 1983-4 and wrote the first complete draft of the book. Their interest and support and the opportunity to publish a version of chapter 2 in *G.R.A.A.T.*, the departmental journal

vii

edited by Pierre Gault, was of enormous assistance. (It is republished in revised form with his permission.) Upon my return to Britain, Graham Johnson, David Martin and Michael Turner, colleagues and friends, meticulously read and commented on the entire draft, helping me to avoid verbal infelicities, remove errors and rephrase ambiguities, as well as clarify and expand obscure passages. The published version owes a great deal to the time and attention which they unselfishly took from their own work to apply to mine. Too many students to name have corrected misapprehensions and suggested previously unconsidered lines of research or sources. Joyce Bellamy and Gail Malmgreen have provided the same service at a high level of professional expertise, and have shown a continuing and heartening interest in the work from start to finish. John Saville and Nicholas Tucker have generously given advice and support to this as to other projects over many years. Anna Davin gave much appreciated encouragement at a crucial early stage.

I am also grateful to many librarians and archivists for their unstinting assistance. I should mention in particular Margaret Gaskell, librarian of Girton College, Susan Reynolds, tutor and archivist of Lady Margaret Hall, and Angela Raspin, archivist of the British Library of Political and Economic Science, all of whom willingly provided much greater assistance than any scholar has a right to expect. The same is true of David Doughan and Rita Pankhurst, indispensable friends and allies at the Fawcett Library of anyone studying women's history. The staff of the library at the University of Hull were of the greatest assistance, above all the photographic and inter-library loan staff. Local history and other librarians all over the country helped to identify particular members of my cast of characters and resolve queries.

June Norman of the National Council of Women, and staff of the Liberal Party generously allowed me to invade busy offices in search of rare records; my thanks to them all. Without two generous grants from the Nuffield Foundation I could hardly have hoped to undertake the book. The Foundation's support during a period of over six years is gratefully acknowledged. So too is the expert assistance of Pat Wilkinson, who prepared the final typescript from a jumbled combination of heavily amended typing and semi-legible, hand-written additions.

Others who have assisted with particular points are acknow-

ledged where appropriate in the notes, but I must reserve my warmest thanks to Ann Holt, without whose encouragement and interest the book would never have been completed. Like others who share a roof with an historian she has been subjected to far more information about a restricted historical subject and period than she would have wished. For her willingness to put up with the tedium involved and her unfailing support I am immensely and permanently grateful.

David Rubinstein
Hull, June 1985

Introduction

Why a book on women in the 1890s? It is obvious enough that history does not fall into neat divisions by date, but it is also obvious that without arbitrary divisions historical movements are difficult to isolate and analyse.

Certain subjects lend themselves more readily to intensive examination than others. The history of English women in the 1890s is one such subject. The suffragette decade before the outbreak of war in 1914, an equally short period, is often treated as if it were unrelated to movements of opinion which preceded it, or at least as an exaggeratedly sharp break with the past. Part of the explanation may be that the history of women in the 1890s has been tacitly but widely regarded as the province of the literary historian. The tendency probably began with the researches and reminiscences of such contemporaries as Holbrook Jackson and Richard Le Gallienne, and has been strengthened by the searching examination of modern scholars, especially Penny Boumelha, Gail Cunningham, Elaine Showalter and Patricia Stubbs, who have recreated a forgotten literary movement with notable success. It is time that the period was viewed in a wider perspective.

The demands of 'advanced' women of the educated classes achieved some successes in the 1890s in terms both of employment and the franchise, the targets of women's organisations for a generation. By the 1890s the employment of middle-class women had increased, less because of the demands of feminists or the products of new educational institutions than in response to the needs of business, the professions and government for docile, well-educated and cheap labour. Women also entered new occupations such as the sanitary and factory inspectorate and strengthened their position in professions to which they had previously gained admission, such as medicine. Allied with developments in employment came the acknowledgement that the government itself could profit from the assistance and advice of women. The first women Royal Commissioners took their places in 1894 and several women were appointed to member-

ship of other, less glamorous government committees. The Board of Education appointed three women to its Consultative Committee upon its creation at the end of the decade. Such innovation was not echoed in the learned societies of the private sector, which generally resisted demands to admit women. The British Medical Association, however, accepted women members from 1892.

The campaign for the parliamentary vote secured no more than propaganda victories in the period, including a favourable second reading vote in the House of Commons in 1897. But at local level women made important gains. Women rate-payers, almost exclusively widows or single women, voted in local elections, and in 1897 women were probably about 15 per cent of the total local government electorate. Women had served as school board members and poor law guardians since the 1870s, and a reduction in property qualifications followed by new legislation in 1894 greatly increased the number of women guardians and created new opportunities as urban and rural district and parish councillors. Against these gains and others, including membership of county and county borough education committees, must be set the loss of representation on the lower echelon of London local government when the metropolitan boroughs were created in 1899.

Economic and political advance was less significant than the new spirit revealed by the emancipation movement of the 1890s. The 'revolt of the daughters' and the 'new woman' were short-lived phenomena of the mid-1890s. They were press sensations, but behind sensation lay demands by educated and independent-minded women for types of emancipation more far-reaching than the immediate impact of the parliamentary vote could be. Daughters sought to travel unchaperoned, visit the theatre and music hall, read what they wished and take part in sport and games, notably cycling. Adventurous spirits smoked their cigarettes, cycled in divided skirts or 'rational dress' and defied the suffocation of Mrs Grundy's embrace. The legal right of a wife to leave her husband's roof was finally established at the start of the decade, and a few years later another controversy helped to determine that cohabitation by the unmarried young of opposite sexes was a sane, if not socially acceptable, procedure. It was not the case that the emancipation of middle- and upper-class women advanced irrevocably

in the 1890s; rather, the first stage was taken in an enduring campaign.

The campaign was aided by the remarkable literary flowering of the period, in which women's rights and wrongs were freely discussed. The writers who achieved an enduring reputation in this context were generally men: George Meredith, Thomas Hardy, George Moore, George Gissing, Bernard Shaw, and pre-eminently Henrik Ibsen. But to the list must be added many women, prominent during the 1890s but later ignored even by specialists until the modern interest in women's work and achievements inspired careful examination of this early feminist school. Though explicit descriptions of sexual passion were taboo, such themes as women's sexual drive and venereal disease were treated with a frankness especially shocking because the writers were women. However, these writers were generally less concerned with sexual questions than with the problems of educated women struggling with a man-made world, in which emancipation meant overcoming the domination of fathers, brothers and husbands. The heroines of this 'new woman' fiction generally came to grief, but they represented and inspired advanced women's aspirations as no previous school of writers had wished, or dared to do.

The struggle for the parliamentary vote for women also entered a new phase in the 1890s despite lack of success in the House of Commons. Andrew Rosen and Leslie Parker Hume have suggested that the women's suffrage movement of the period was too moderate and cautious to achieve its goal, too much part of the political and social establishment of its day to resort to the unorthodox weapons which alone could bring women's suffrage into the realm of practical politics. I do not share the view that the militants of the Women's Social and Political Union did their cause more harm than good, but I feel that both Rosen and Hume, whose chief interests lie in a later period, have too lightly dismissed the suffragists of the 1890s. It was in this decade that women first took an important role in party political activity, through the agency of political organisations established in the 1880s. A petition in favour of votes for women secured over a quarter of a million women's signatures by 1896; meetings to support the same end filled the largest halls and crowded into overflow gatherings. Most significant, women intent on securing the vote drew a lesson from parliamentary

frivolity and cynicism; some of them concluded that old forms of political protest would have to be superseded by more militant action. In these respects, and also in terms of a stronger organisational structure, the 1890s marked the start of a new era.

The education of girls and women of all social classes had begun to develop and expand in the 1870s. High schools emerged new or reformed from the work of the Endowed Schools Commissioners and the Girls' Public Day School Company. The first women's colleges at Cambridge and Oxford opened their doors. For girls of the working classes board schools in which education was available – and soon compulsory – for both sexes marked a new departure, although there was no doubt that in both working-class elementary and middle-class secondary schools girls were expected and encouraged to learn a woman's role conforming to the conventions of the period. By the 1890s improved education had begun to bear fruit in respect of the daughters of the upper social classes. The increasing number of women professional workers was a sign of the times; the often alarmingly well-read 'new woman', who refused to accept the place laid down for her by others, was another. The experience of the working-class girl, however, was another matter.

Elementary schooling to the age of ten, the compulsory school-leaving age until 1893, or even to fourteen, the age enforced by many school boards under by-laws, did little to overcome social and economic reality. The 1890s saw no departure from the steady working-class underemployment of past decades, although in the second half of the period there was something of a trade revival. Exploited by their husbands, by their employers, by society at large, most working-class women were in no position to rebel against social injustice.

There is, of course, a case for maintaining that the bond of social class was a more obvious and closer one than the bond of sex. The match girl suffering from necrosis of the jaw, the sweated seamstress, the exploited domestic servant would have taken little joy or encouragement from knowing that women of the upper-middle class were finding a measure of emancipation in the new woman fiction or competing with the best of the men in the Cambridge mathematical tripos. It will be argued in the following pages that women of all classes were subject to similar forms of exploitation, but the actual context of

exploitation was heavily dependent upon one's position in the social scale.

Even among working-class women, however, there were signs of change. The Women's Co-operative Guild, founded in 1883, had over 14,000 members early in the new century. Revealingly, over half were in the north-western section, where numbers of women trade unionists, concentrated in the Lancashire cotton industry, were far greater than elsewhere in the country. Both co-operators and trade unionists drew their membership from the relatively prosperous and stable sections of the working class. It was in the same part of England and among the same type of women that working-class support for women's suffrage was manifested at the end of the century.

The historian's chief interest in the working-class woman of the period, however, lies less in changing or improving conditions than in contemporary discussion and controversy, and in the new sources of information which became available in the decade. It is much easier to ascertain women's working conditions and attitudes in the 1890s than in earlier years. The Royal Commission on Labour, which began its work in 1891, heard the testimony of a few courageous working women prior to appointing four 'lady assistant commissioners' to gather information about women's work at source. The reports of these commissioners were the fullest and most authoritative that had yet been made on the subject. The Board of Trade, whose Labour Department was established in 1893, began two years later to enumerate female trade unionists. Its correspondent on female employment, Clara Collet, produced several reports during the decade which contributed to much improved knowledge of women's work. In 1901 the census figures included for the first time a category of employed married and widowed women separate from other workers, although it was not until 1911 that wives and widows were themselves identified separately.

There was much voluntary as well as official activity on behalf of working-class women in the period. The Women's Trades Union League reorganised itself in the early 1890s, adopted a new perspective and bolder policies and employed several working-class women as organisers in factory districts. Its enlarged and reinvigorated quarterly journal and its annual report showed that the organisers' work was unceasing, despite

frequent discouragement. The Women's Industrial Council, founded in 1894, also provided useful information about working conditions in its painstaking and authoritative surveys and acted as a focal point for demands for legal change.

The decade was also characterised by a sustained debate about improving the conditions of working women, whether by self help, including trade-union action, or by legal protection. The debate was already old by this time, but the participants in the 1890s were more numerous, their arguments more fully worked out and the publicity they secured more extensive than in the past. A debate which involved such protagonists as Millicent Garrett Fawcett and Beatrice Webb was sure of being conducted on a high and compelling level.

The pages of newspapers and literary journals confirm the topicality of the 'woman question'. Most of them opposed the attempts of the new woman to shift the balance of power between the sexes towards women. Demands for emancipation, however, received almost universal attention, and coverage extended also to less titillating subjects like education and employment. As the nineteenth century drew to a close claims were heard that it had been 'the woman's century'. There was a stronger case for arguing that the 1890s had been 'the woman's decade'. The claims of the educated woman and the plight of the working-class woman received an unprecedented hearing in the male-dominated press and in official circles, even though the ice-floe of convention, opposition and apathy hardly began to crack. Publicity arose from and reinforced an unprecedented self-confidence on the part of increasing numbers of women. The period, fascinating and important in itself, formed an essential background to a new, stronger and better organised movement which, by concentrating its attention on the single issue of votes for women, increased the effectiveness or at least the prominence of the women's cause in the new century.

The book is divided into four sections. The first examines the ways in which women were regarded by themselves and by men, and the attempts made by some women to break free of what by the 1890s were already well-established pseudo-scientific stereotypes. Women in law, women in fiction and stereotypes about relations between the sexes are also considered, in order to establish the framework of received opinion

about the role of women and the ways in which it began to change. The second section is devoted to questions of employment, including the features shared by working women of all social classes, and the ways in which and reasons why almost all of them were exploited in various ways. The attitude of male workers towards their female co-workers is also discussed, and its compound of prejudice and reason examined. In this section the controversy over protective legislation confined to one sex, and the problems and progress of women's trade unions are also considered. Next comes the political role and aspirations of women, including not only efforts to persuade Parliament to pass women's suffrage bills but also women's political activity in electoral and organisational work, and the first stirrings of a working-class women's suffrage movement. The problems and achievements of women in local government, a complicated topic too often ignored, are considered in a separate chapter. The final section is devoted to ways in which women developed new ways of thinking and new ambitions, often indirectly, through their participation in higher education, sport and other forms of leisure, including the remarkable London women's club movement of the period. Finally, an afterword briefly assesses the significance of the 1890s in the history of English women in the light of the information provided in the body of the book.

I. IMAGES OF WOMEN

1

Stereotypes: prejudice confirmed

The attempts of women in the 1890s to secure greater equality with men confronted the crushing weight of age-old prejudice, strongly supported by the use made of biology, anthropology and other sciences which flourished in the period; biology in particular, in the words of a contemporary, 'threatens to invade and annex every province of thought'.[1] The authority of Charles Darwin, powerfully bolstered by Herbert Spencer who was still alive and writing, gave a spurious authenticity to the assertion that the subordination of women was scientifically ordained.

Prejudice masquerading as science was no longer unchallenged by the end of the century. The biometrician Karl Pearson for example insisted that available evidence failed to prove the theory of greater variability among males, thus attempting to destroy what he termed 'a pseudo-scientific superstition' commonly used to support belief in the inferiority of women. His assistant Alice Lee struck a blow for her sex by demonstrating in an article published in 1901 that skull capacity and by correlation brain weight were unrelated to intellectual ability, and hence that the brains of men and women could not usefully be compared simply by analysing their weight, another popular contemporary pseudo-science.[2]

Views of the type combated by Pearson, Lee and others, however, retained their hold over lay and much scientific opinion. The belief that women were less capable of rational and original thought than men was too firmly rooted in a male-dominated society to submit to easy destruction not only in the 1890s but long afterwards. Whether the issue was education, politics, employment or other aspects of the struggle for equality, the assertion that the inferiority of women stemmed from ineradicable physiological causes was widely accepted and used to justify their continued legal and social handicaps.[3]

Even before the work of Pearson and Lee was published prejudice had begun to be couched in more sophisticated terms than in past decades. Harry Campbell, a specialist on diseases

3

of the nervous system, claimed in a book published in 1891 that women adapted themselves to new situations more readily than men, and that as a result of changes in society women were likely to evolve in new ways in 'subsequent ages'. He dismissed the argument that woman's smaller brain implied intellectual inferiority with the observation that it was related to the dimensions of her body; the dog, for example, was much more intelligent than the whale despite its smaller brain. Nonetheless, he asserted that women were weak-willed, dependent and emotional: 'Women, like children, are timid and easily frightened.' Men were apt to resent or defy misfortune; women accepted it passively. It was true that women performed as well or better than men in examinations, but this was the result not of equal intellectual capacity but of women's earlier intellectual maturity and their ability to think rapidly, store facts and reproduce them without original thought. (This view was probably received wisdom among male educationists; the economist Alfred Marshall wrote a few years later that 'examinations test receptivity and diligence in prescribed lines: and these are the strong points of women.')[4] Men's intellectual superiority was relatively slight below the level of genius, but in that category it was absolute. It was not a question of opportunity, for had an embryo woman Shakespeare or Beethoven existed, 'the world would have heard of her in spite of unfavouring external circumstances'.[5]

Campbell referred, not wholly uncritically, to one of the most influential books in the field published during the period. This was *The Evolution of Sex*, by Patrick Geddes and J. Arthur Thomson. First published in 1889 the book was republished in 1901, unchanged in its essentials. The authors wrote that men were 'katabolic', or active, energetic and variable; women were 'anabolic', or passive, sluggish and stable. Although they asserted, like other writers, that neither male nor female was the higher form of life, they insisted that physical and mental differences were innate. They could be exaggerated or reduced, but not abolished without new forms of evolution: 'What was decided among the prehistoric Protozoa cannot be annulled by Act of Parliament.'[6]

Havelock Ellis's *Man and Woman* (1894) was also highly influential, probably more so than Geddes and Thomson among the public at large. Ellis, a pioneer sexologist and prolific

4

writer on a variety of subjects, was as Jeffrey Weeks has pointed out something of a hero to many 'advanced' women,[7] but his writing demonstrates how limited was the development even of advanced thought in this decade. Ellis was a believer in eugenics and as his latest biographer comments he viewed motherhood as 'the chief fulfilling purpose for women on this earth'.[8] Like Campbell, Ellis attributed some of the differences between the sexes to environmental factors. But he was in no doubt that the most important differences were based in biology, which confirmed men's creative and women's supportive roles. He accepted and emphasised the conclusion of the American psychologist Joseph Jastrow that men were naturally abler in dealing with the remote and abstract, while women were more competent in practical and immediate matters. Women, Ellis claimed, were more emotional than men and less capable of artistic achievement. His central assertion was a remarkable statement: 'Nature has made women more like children in order that they may better understand and care for children'.[9]

The *Evolution of Sex* and *Man and Woman* were widely noticed, but they contained little that was new, and under the guise of enlightened thought sustained many of the common stereotypes of the day. Philosophers and historians like Frederic Harrison and Leslie Stephen, medical writers like James Crichton-Browne and S.A.K. Strahan, and intemperate publicists like the barrister W. S. Lilly and the journalist J. F. Nisbet put forward similar ideas more briefly but often with less pretence at scientific dispassion. Congenial foreign writers like Max Nordau, Cesare Lombroso and Guglielmo Ferrero were also recruited by the adherents of the prevailing orthodoxy.[10] Lilly and Nisbet claimed that women were governed by emotion rather than reason and that they were deficient in understanding such abstractions as truth and justice. As a result they were prone to view corruption indulgently in those whom they loved (i.e., men). Such views pandered directly to male prejudice: as one critic remarked, 'nothing gives the male of the lower middle-classes keener joy than to hear women cheapened and decried.' Authors of this school also insisted, as male writers had long done, that chastity was a natural female virtue, a doubtlessly reassuring conclusion to male readers.[11]

Unlike the forgotten Lilly and Nisbet, Harrison and Stephen were two of the outstanding intellects of their day, though there

is little indication of originality in their writings on women. Harrison was one of the best-known exponents of the 'domestic angel' school of thought.[12] His eulogies of women who lived and worked at home for the benefit of others claimed support from 'the positive fact of biological and psychological science'. Its proof, however, was not subject to rational discussion: 'People must feel it: we must appeal to common language, the ideals of mankind, to eternal poetry.'[13] Stephen based his belief in the justice of female subordination on physiological facts, which seemed 'to suggest a difference implied in the whole organisation and affecting every mental and physical characteristic'. But his real concern was social. John Stuart Mill in his claims for women's rights, Stephen stressed, had attacked 'the most fundamental condition of the existing social order'.[14]

Strahan's claim that woman was as inferior to man in intellectual as in physical strength[15] was common among medical men, the most prominent of whom in this connection was Sir James Crichton-Browne, a leading figure in medical psychology and mental disease. In a widely reported 'oration' delivered to the Medical Society of London on 2 May 1892 Crichton-Browne asserted that the blood supply towards various portions of the brain was responsible for the fact that men were better equipped than women in the volition, cognition and ideo-motor processes. Women were naturally disposed to the sensory functions. This supported in medical language the stereotype that men were suited to analytical thought and decision-taking, women to feeling and emotion. Crichton-Browne claimed that women's brains were probably even lighter compared to men's than had previously been supposed, an argument which militated against intellectual work for women. Growing girls in particular should not overwork their brains as some girls in the new high schools and colleges were apt to do. He had met a party of college girls waiting for a train: '[M]any of them had a stooping gait and withered appearance, shrunk shanks, and spectacles on nose.' The beauty of English girls and the health of the next generation were more important than a knowledge of logarithms. It was more valuable to be able to boil a potato than to read Lucretius.[16]

The writings of these authors represented the dominant sentiment of the age, reaffirming the deeply held belief in male superiority and reinforcing the view that women were above all

wives and mothers, at the expense of other creative functions. The youthful Ernest Newman, later a celebrated music critic, submitted this point of view to scathing criticism in an article published in 1895:

> [M]en have started out with the theory of the natural inferiority of woman, have assumed — like Rousseau, because it suited them to do so — that her 'true' sphere was the home and her 'true' function maternity, and then persuaded themselves that they had biological reasons for keeping her out of the universities and for denying her a vote.[17]

But contemporary beliefs did more than rationalise the assumptions of the dominant male. Like all enduring opinion the doctrine of male superiority succeeded in finding acceptance among influential members of the subordinate group as well as amongst most of the advantaged. Mary, Lady Jeune, was one of the most interesting participants in the debates of the 1890s. Firmly Conservative, she was by no means wholly unsympathetic to feminist aspirations. She was, however, adamant that political and social activity came second to the responsibilities of the wife and mother, and that in political as in other work women's role should be a strictly subordinate one. They should canvass but not speak from the platform. Nor should they 'encroach on ground fitted only for stronger wills and rougher natures'. Woman's position was clear: 'She is, and always must be, physically and intellectually inferior to the man; but in many qualities she is infinitely his superior; and his tacit acknowledgement of that superiority, in the chivalry, devotion, and respect of men, is all she should ask.'[18]

Lady Jeune was a thoughtful writer whose work sheds a good deal of light on her sex and age. She was not, however, one of the intellectual or cultural leaders of her generation of women. It is significant that some of the most talented and determined women still accepted, as Elizabeth Barrett had done in a letter to Robert Browning in 1845, that women's minds were naturally inferior to and dependent on men's.[19]

Ethel Smyth fought valiantly to be accepted as a composer, and in later years took a prominent role in the suffragette movement. Yet she had also to struggle against both self-doubt and disbelief in the capacity of her sex. She wrote to her friend Harry Brewster in 1894: 'You know all my natural temptations

lie in the direction of wasting time; and there a woman is at a disadvantage from her birth up. She has not the instinct of application, and I ascribe more female failure to this than to lack of talent.'[20] Beatrice Webb told her diary in the same year that it was better for a woman to be a mother than to enter any other occupation, exalting the 'holiness of motherhood' in terms which should be set against the fact that she had decided to remain childless. Physical factors including menstruation, she wrote, encouraged women to devote themselves to looking after children and contrasted sharply with men's 'unremitting activity and physical restlessness'. Writing near the start of one of the most productive intellectual careers of her generation,[21] she insisted that she spent much of her day idly moping, because as a woman she could 'only work my tiny intellect for two or three hours at the most'. Woman's intellect was less productive than man's, 'the ideas thin and wire-drawn'. Training alone would not enable her to acquire 'that fulness of intellectual life which distinguishes the really able man'.[22]

Treatises on sexual characteristics in this period were generally the work of men. One of the few women who contributed to the discussion of the subject was Frances Swiney, a general's wife whose *The Awakening of Women* (1899) began a career of writing and speaking in support of women's emancipation. She acknowledged that women had enjoyed access to higher education for a relatively short period. When trained they were often as capable of intellectual achievement as men. They had much to offer the community as public servants. Yet she accepted Crichton-Browne's view of men's superior intellectual powers and asserted that it was unlikely that many women would ever equal men's intellectual level. Women's superiority was moral. It lay in purity, freedom from sensuality and unselfishness. Men, not women, were raised by marriage. Woman was 'the higher evolution', and on her rested 'the moral future of the race'.[23] This kind of claim did little to challenge the domestic angel school, who were content to acknowledge that women were morally superior provided that they remained at home.[24]

The women's movement of the 1890s concentrated on the particular rather than the general. Women who demanded the vote, opportunities in education and employment, and freedom from the restrictions of convention paid little attention to the

Stereotypes: prejudice confirmed

solemn warnings of Geddes and Thomson or Crichton-Browne even if, like Ethel Smyth and Beatrice Webb, they shared the assumptions which their creative work helped to undermine. But the one-sided nature of the pseudo-scientific publications of the period can have done little to encourage doubtful women or discourage bigoted men. Given the consequent uphill nature of the struggle the women's movement of the period stands out as a particularly impressive and heartening development.

Notes

1. Robert Mackintosh, *From Comte to Benjamin Kidd: the Appeal to Biology or Evolution for Human Guidance* (Macmillan, London, 1899), p. 2.
2. Karl Pearson, 'Variation in man and woman', ch. 8 of *The Chances of Death*, vol. I (Edward Arnold, London, 1897), pp. 256-377; Alice Lee, assisted by Karl Pearson, 'Data for the problem of evolution in man. — VI. A first study of the correlation of the human skull', *Philosophical Transactions of the Royal Society of London*, series A, 196 (1901), pp. 225-64, esp. pp. 258-9; Rosaleen Love, '"Alice in Eugenics-Land"; feminism and eugenics in the scientific careers of Alice Lee and Ethel Elderton', *Annals of Science*, 36 (1979), pp. 145-58. An enlightening view of 'craniology' is provided by Elizabeth Fee, 'Nineteenth-century craniology: the study of the female skull', *Bulletin of the History of Medicine*, 53 (1979), esp. pp. 428-32. For Pearson see Bernard J. Norton, 'Karl Pearson and statistics', *Social Studies of Science*, 8 (1978), pp. 3-34 and Donald A. MacKenzie, *Statistics in Britain 1865-1930* (Edinburgh University Press, Edinburgh, 1981), esp. ch. 4.
3. This complex and important subject has been examined by a number of writers, including Flavia Alaya, 'Victorian science and the "genius" of woman', *Journal of the History of Ideas*, 38 (1977), pp. 261-80; Jill Conway, 'Stereotypes of femininity in a theory of sexual evolution', in Martha Vicinus (ed.), *Suffer and Be Still* (Indiana University Press, Bloomington and London, 1972), ch. 8; Lorna Duffin, 'Prisoners of progress: women and evolution', in Sara Delamont and Lorna Duffin (eds), *The Nineteenth-Century Woman* (Croom Helm, London, 1978), ch. 3 (I am grateful to David Croom for a gift of this book when most needed); Brian Easlea, *Science and Sexual Oppression* (Weidenfeld & Nicolson, London, 1981), pp. 138-57; Susan Sleeth Mosedale, 'Science corrupted: Victorian biologists consider "The Woman Question"', *Journal of the History of Biology*, 11 (1978), pp. 1-55; Janet Sayers, *Biological Politics* (Tavistock, London, 1982), chs. 3, 6. Jane Lewis provides an excellent summary of the subject in her *Women in England 1870-1950* (Wheatsheaf, Brighton, 1984), pp. 81-5, 98-100.
4. Alfred Marshall, 'To the Members of the Senate', flysheet addressed to

9

members of the Cambridge University Senate, Emily Davies Papers, Girton College Library, ED XVI/94, 3 February 1896, p. 6. *See below*, p. 202.

5. Harry Campbell, *Differences in the Nervous Organisation of Man and Woman* (H. K. Lewis, London, 1891), esp. pp. 52-6, 162-4, 171-5.

6. Patrick Geddes and J. Arthur Thomson, *The Evolution of Sex* (Walter Scott, London [1889]), pp. 267-71.

7. In Sheila Rowbotham and Jeffrey Weeks, *Socialism and the New Life* (Pluto Press, London, 1977), pp. 169-82. *See also* Viola Klein, *The Feminine Character* (Kegan Paul, Trench, Trubner, London, 1946), pp. 45-8.

8. Phyllis Grosskurth, *Havelock Ellis* (1980; Quartet Books, London, 1981), p. 153.

9. *ibid.;* Havelock Ellis, *Man and Woman* (Walter Scott, London, 1894), esp. pp. 168, 174, 186-92, 324-5, 394-5; Alaya, 'Victorian science', pp. 273-6.

10. Max Nordau's *Entartung*, two volumes (C. Duncker, Berlin, 1892-3) was translated from German in 1895 as *Degeneration* and was highly successful. His *Paradoxe* (B. E. Nachfolger, Leipzig [1885]), though published in the United States in 1886 was not published in England until 1896. It contained a number of passages like the following: 'Woman is not a personality but simply a type' (*Paradoxes* (Heinemann, London, 1896), p. 45). Lombroso and Ferrero's influential *La Donna Delinquente* (Roux, Turin, 1893) received an English translation as *The Female Offender* (T. Fisher Unwin, London) in 1895. *See* Penny Boumelha, *Thomas Hardy and Women* (Harvester Press, Brighton, 1982), pp. 17-18, 22, 69.

11. W. S. Lilly, *On Shibboleths* (Chapman & Hall, London, 1892), ch. VI; J. F. Nisbet, *The Human Machine* (Grant Richards, London, 1899), ch. VII; J. Peyton, 'The modern malignant. I. The malignant in journalism', *The Humanitarian*, 8 (1896), p. 441. Even Edward Carpenter, the able publicist of women's wrongs, accepted among other stereotypes that men were naturally polygamous, women naturally chaste (Edward Carpenter, *Marriage in Free Society* (Labour Press, Manchester, 1894), p. 30-1). *See* Eric Trudgill, *Madonnas and Magdalenes* (Heinemann, London, 1976), esp. ch. 4, part I.

12. A typical lecture by Harrison on 'Woman's true function' was reported in *The Times* on 7 September 1891.

13. Frederic Harrison, *On Society* (Macmillan, London, 1918), lecture II, 'Family life', first delivered 1893, esp. p. 43. *See also* Rodney Barker, *Political Ideas in Modern Britain* (Methuen, London, 1978), pp. 116-17.

14. Leslie Stephen, *The English Utilitarians, vol. III, John Stuart Mill* (Duckworth, London, 1900), pp. 284-5.

15. S. A. K. Strahan, 'The struggle of the sexes: its effect upon the race', *The Humanitarian*, 3 (1893), p. 350.

16. Sir James Crichton-Browne, 'Sex in education', *The Lancet*, 7 May 1892, pp. 1011-18. The report of the oration in *The Times* (4 May 1892) was amplified by a leading article which concluded that 'even "educationists" will be baffled in the struggle against nature'. *The Lancet* for its part asserted that sex equality in intellectual effort was 'not nature's manifest design' (7 May 1892, p. 1038).

17. Ernest Newman, 'Women and music', *Free Review*, 4 (1895), p. 49.

Stereotypes: prejudice confirmed

18. Mary Jeune, *Lesser Questions* (Remington, London, 1894), p.121; Mary Jeune, 'English women in political campaigns', *North American Review,* 161 (1895), p. 453. (*See below* p.163. n.75.) Books of advice for women commonly were inspired by similar sentiments. Fanny Douglas, for example, wrote in *The Gentlewoman's Book of Dress* (Henry & Co., London [1895]) that women had a latent tendency to acrimony and a natural inclination to triviality. The latter quality was to be overcome by developing the affections. She disparaged 'the political enthusiast' and 'the rabid supporter of the divided skirt' (p.121).

19. Joan Burstyn, *Victorian Education and the Ideal of Womanhood* (Croom Helm, London, 1980), p.71.

20. Ethel Smyth, *As Time Went On ...* (Longmans, London, 1936), p.326.

21. However, Deborah Epstein Nord, the author of the most thorough examination of *The Apprenticeship of Beatrice Webb* (Macmillan, Basingstoke and London, 1985), stresses the constraints on her intellectual and emotional development which resulted from her marriage; *see* pp.218-26.

22. Beatrice Webb's typescript diaries (British Library of Political and Economic Science), vol. 15; 25 and 28 July 1894, pp.1323-9; Norman and Jeanne MacKenzie (eds), *The Diary of Beatrice Webb, vol. 2, 1892-1905* (Virago, London, 1893), pp.52-3. *See* Barbara Caine, 'Beatrice Webb and the "Woman Question"', *History Workshop Journal,* 14 (1982), pp.23-43; Jane Lewis, 'Re-reading Beatrice Webb's diary', *History Workshop Journal,* 16 (1983), pp.143-6, and Jose Harris, *Beatrice Webb* (London School of Economics and Political Science, London, 1984), pp.9-17.

23. Frances Swiney, *The Awakening of Women* (2nd edn, William Reeves, London [1905]), pp.24, 71-9, 81, 86-8, 104-5. I have been unable to locate a copy of the first edition of this book (George Redway, London, 1899), but the second edition appears to be unchanged.

24. Swiney's point of view may have been general among women who contemplated their subjection against a background of evolutionary theory. The American writer Eliza Burt Gamble insisted that the female was the higher stage of development than the male, woman 'the very fountain whence spring the higher faculties' (Eliza Burt Gamble, *The Evolution of Woman: an Inquiry into the Dogma of her Inferiority to Man* (G. P. Putnam's Sons, New York, 1894), pp.v-vi, 78-9).

2

The revolt of the daughters and the new woman

Many writers in the 1890s sought to confirm the old stereotype of women as creatures controlled by their emotions and mentally inferior to men. The decade was also notable, however, for the growth of a new stereotype, the advanced woman who sought emancipation from traditional restraints.

Behind the new phenomenon lay a changing society, which involved a new role for many women of the wealthier social classes. More of them were able to benefit from the improved secondary education which had been established since the 1870s and a small but significant number was able to enjoy the intellectual stimulus and relative freedom of university life. Once their formal education was over many such women sought paid employment which made use of their education, and provided that they were willing to accept inferior salaries and conditions they often found themselves pushing at an open door. In the heady atmosphere of the 1890s more women may have chosen not to marry, but a 'surplus' of females which exceeded a million in England and Wales in 1901 and included a striking imbalance at normal marriage age were unable to do so whatever their preference.[1] Employment and emancipation from family restraint were accordingly important objectives to some, while greater freedom within marriage was the aim of others. The fiction of the period was partly a reflection of the changing age and partly a stimulus to innovation in relations between the sexes. So too was the development of the pneumatic-tyred safety bicycle, affectionately recalled in the memoirs of contemporaries.

These factors will be considered more fully in subsequent chapters. Here it is important to establish that they were the essential background to the revolting daughter and the 'new woman'.

In January 1894 Blanche Alethea Crackanthorpe, the wife of a barrister and the mother of a promising writer, published an article in the *Nineteenth Century* which quickly became a sensa-

tion. It was entitled 'The revolt of the daughters'. 'These are the days of strikes', Mrs Crackanthorpe began, with a reference to a wave of industrial turmoil which had recently reached a climax in a sporadically violent miners' strike. The daughters' demands were presented as modest. They centred on the right of the unmarried girl to be considered 'an individual as well as a daughter'. She should be able to make her own errors, travel freely, visit music halls — with her brother — and enjoy better education. Boys were ungrudgingly prepared for a variety of professional careers, while many girls were confined to the prospect of a single career, marriage. The daughter who asked for a fraction of the expenditure laid out on her brother, and who was refused on the ground that a woman should remain in the parental home until called from it by a husband, had real cause to protest her lot. The basis of Mrs Crackanthorpe's support for professional training for the revolting daughter was a significant indication either of her own conventionality or of that of the readers whom she sought to persuade. For it was the daughter compelled by the shortage of men to remain single on whose behalf she appealed: 'Marriage is the best profession for a woman; we all know and acknowledge it; but, for obvious reasons, all women cannot enter its strait and narrow gate.' She also took the opportunity to denounce the double standard of sexual morality, which dictated that a man with a murky 'past' was a satisfactory husband for a sexually ignorant girl of 'passionate ideals'.[2]

The 'hurricanes' and 'thunderbolts' which, Mrs Crackanthorpe wrote, followed the publication of her article,[3] indicated that she had launched public discussion of a subject on which many educated people had strong feelings of different kinds. The *Nineteenth Century* itself published a number of other articles on the same theme, and the series was the subject of wide comment and emulation. Ethel Harrison's contribution, in the form of a short story, suggested that despite her opposition to women's suffrage she had rather more sympathy for the aspirations of the young of her sex than had her husband Frederic. Her heroine told of friends whose parents had inhibited their efforts to paint, study history or (in the absence of an escort) attend economics classes. One mother had given her daughter a novel, but had carefully censored a section by the strategic use of a bonnet pin.[4]

Mrs Crackanthorpe's second article attacked the 'matrimonial hunt', the purpose of which was the capture of a husband in

a girl's own social class or a higher one. She pointed out that mothers had themselves helped to create the new ferment by engaging in a variety of forms of social and political work unknown to earlier generations. These included 'slumming' in the East End of London, membership of school boards or boards of poor law guardians, establishing clubs for working girls, taking part in organising women's trade unions and similar activities.[5]

The *Nineteenth Century* gave two of the daughters an opportunity to speak for themselves. The American-born Alys Pearsall Smith, soon to marry Bertrand Russell, insisted that a woman whose life was 'dwarfed and thwarted' injured not only herself and her family but also the community. The daughter wanted to 'belong to herself', she wrote repeatedly. Among the girls of her acquaintance almost all secretly wanted to study or work outside the family circle, yet all faced the prospect of parental opposition.[6] Lady Kathleen Cuffe, daughter of the Earl and Countess of Desart, claimed to 'speak in the name of the average more or less unemployed, tea-drinking, lawn-tennis playing, ball-going damsel' of the upper and upper-middle class. Many girls, she wrote, plunged into loveless marriages simply to escape the restrictions of the parental home. Lady Kathleen mentioned some common symbols of the revolt, such as the music hall and possession of a latchkey. But what she sought most ardently was the abolition of a chaperon in all normal circumstances. Young unmarried women of her class could not visit a friend two or three streets away, walk in the park, attend a tea party, play or concert or even church unaccompanied, although a young married sister could freely do all of these things. Social work was out of the question, for 'who has ever heard of anyone "slumming" under the protecting care of a chaperon?' She concluded wistfully: 'Perhaps we may even see the day when a chaperon will be as little known as a great auk or other creature of a past era.'[7]

The spread of the controversy to other prominent journals was the surest proof of its topicality. The *Fortnightly Review* called on Lady Jeune, who attempted to stem the tide. She asserted that girls generally possessed as much freedom as they required, that 'no civil war is being waged in English households' and that marriage was rightly much the most important aim of a woman's life. But even this cautious and conservative writer

14

admitted that girls had changed in the past forty years, that education and 'the spirit of the age' opposed 'vexatious restrictions' and that in all classes equality was 'the cry of the day'.[8] The *Westminster Review* gave space to a short rejoinder from another daughter, Gertrude Hemery, who announced that at the age of 18 she had her own latchkey and was never chaperoned. Purity, she commented, was the result of knowledge rather than ignorance, a belief she intended to put into practice if she became a mother, bringing up sons and daughters without differentiation on grounds of sex.[9] A similar view was taken in the *Contemporary Review* by Sarah Amos, a prominent suffragist and mother.[10]

By the time that Gertrude Hemery's article had been published in June 1894 the revolting daughter was giving way to the more enduring phenomenon represented by the 'new woman', a term often used rather loosely by modern writers. By early 1894 the demands of women seeking emancipation had reached such a pitch that it was fairly common to write in terms of a 'new' womanhood.[11] However, the creation of the 'new woman' as a heroine or bogey figure was almost certainly the result of an interchange between two prominent women in the pages of the *North American Review*, a journal to which many British writers contributed.

The first was Sarah Grand, the name adopted by Frances Elizabeth Bellenden Clarke (1854-1943). She struggled as a writer after leaving her insensitive husband David McFall in 1890, but with the publication of *The Heavenly Twins* in 1893 she achieved a literary sensation and sudden fame. Her condemnation of marriages of convenience and the double standard, and her discussion of the consequences of venereal disease shocked some of the reading public but won widespread approval. Following the publication of the book she was lionised, interviewed and regarded as a principal feminist[12] authority on relations between the sexes.[13]

The second author was 'Ouida', the pen name of Louise Ramé (1839-1908). She was a romantic novelist of an older generation, whose best-known book, *Under Two Flags*, had been published in 1867. She now made her home in Italy and her living by writing articles on a variety of topics, frequently expressing virulent opposition to the emancipation of her own sex. In terms of stereotype she belonged to the Lilly - Nisbet

school of misogynists. Women, she wrote, were a 'drag on the wheel of the higher aspirations' of men. All of them possessed a 'sleeping potentiality for crime, a curious possibility of fiendish evil'.[14]

Sarah Grand asserted in an article published in March 1894, entitled 'The New Aspect of the Woman Question', that men understood traditional women, particularly the types which she incautiously termed 'the cow-woman' and 'the scum-woman'. But, she added, 'the new woman is a little above him'. This was the woman who would have to hold out her hand to man and to educate him out of moral infancy.[15]

Ouida seized with commendable journalistic alacrity upon the opportunity offered her. In 'The New Woman' (May 1894) she took up the term which Sarah Grand had perhaps used carelessly to create a new species. Like Mrs Crackanthorpe, Ouida coupled the rise of the women's movement with the rise of labour, insisting that both were 'unmitigated bores'. She continued: 'The Workingman and the Woman, the New Woman, be it remembered, meet us at every page of literature written in the English tongue; and each is convinced that on his own especial W hangs the future of the world.' She followed this remarkably prophetic sentence by denouncing the new woman's alleged lack of humour, and her preference for public life, sport and medical study to her proper vocation as wife and mother. The cow-woman, she alleged, was the new woman's term of abuse for maternity; instead of tilling her own field she occupied herself in coveting her neighbour's.[16]

As soon as the May number of the *North American Review* reached Britain (the British Library's copy is dated 11 May 1894) the new woman became a stock phrase at the tip of every journalistic pen. In September 1894 it figured as the title of a highly successful play by Sydney Grundy. *The Times* augustly disregarded the phenomenon, but it made its first appearance in the *Daily Telegraph* on 12 May, in the *Daily Chronicle* on the 14th and the *Pall Mall Gazette* on the 16th. Once *Punch* took hold of the novelty on 26 May it refused to release its grip; as late as 10 January 1900 it asked whether the new woman was alive or dead.

The new woman was by no means the first stereotype created by opponents of feminism as a sensation and a caricature. The redoubtable Eliza Lynn Linton (1822-98), an inveterate opponent of the emancipated woman, had attacked the 'Girl of the

16

Period' in 1868 and the 'Shrieking Sisterhood' in 1871 in articles in the *Saturday Review*.[17] Neither phrase had been forgotten; the shrieking sisterhood was carefully disowned by such women's champions of the 1890s as Sarah Grand, and Emilia Dilke of the Women's Trades Union League.[18] In 1891-2 Mrs Lynn Linton created another stereotype in a series of articles in the *Nineteenth Century*. The 'Wild Woman' opposed marriage, clamoured for political rights and sought 'absolute personal independence coupled with supreme power over men'.[19] But the impact of the new woman was greater than that of her predecessors, partly because her rebellion against the subjugation of women to men and to custom was more specific and more widespread than in the past, partly because the power of the press had increased by the 1890s. The new woman, although grossly exaggerated and caricatured by her enemies, corresponded to a recognisable and potentially dangerous class of advanced women.

Ridicule was the weapon of first recourse; anti-feminists disguised their apprehensions by professing to find humour in the spectacle of women challenging the existing pattern of relations between the sexes. A period in which women outnumbered men was thought an appropriate one to characterise the new woman as mannish, dowdy, flighty, incompetent and insistent. *Punch*'s first comment was typical:

> There is a New Woman, and what do you think?
> She lives upon nothing but Foolscap and Ink!
> But, though Foolscap and Ink form the whole of her diet,
> This nagging New Woman can never be quiet![20]

It would be easy to cite multiple instances of ridicule of this kind. The new woman was represented not only as a grossly exaggerated version of the stereotypes of women of the age, but also as a threat to the male monopoly of the professions, as this stanza from 'A Song of the Twentieth Century' makes clear:

> Aunt Polly's a marvel of knowledge,
> With any amount of degrees,
> She's Master or head of some college —
> I forget whether Corpus of Caius —
> Aunt Nell is the eminent counsel
> Who pleads at the criminal bar,
> And I feed the canary with groundsel
> For I'm learning to be a Papa.[21]

17

(It is useful to remember that women could not obtain degrees at Oxford until 1920 and at Cambridge on equal terms with men until 1948. Previously all-male Oxbridge colleges began to admit women undergraduates in 1972, but none of them has yet had a woman head.)[22]

Ridicule was so widely used as to suggest that there was real fear among conventional people of the new forms of emancipation being demanded by many women. As the journalist Hulda Friederichs asked: 'Is there in all this world a creature that has been slandered like her? Slandered, ridiculed, calumniated, scorned, mocked, caricatured, and abused, till you can hurl no more insulting epithet at any girl or woman than to call her a New Woman.'[23] Those to whom ridicule was inappropriate could pontificate like the country clergyman Owen Jenkins, who in an 1895 sermon called upon the weight of biblical authority to sustain his attack. Women should rule at home and in the sick chamber and not attempt to imitate men: 'Imitations are generally bad and clumsy.' The virtuous woman of the Proverb had a price far above rubies: 'What a difference between Solomon's and the new woman!'[24]

The new woman was largely the creation of the press, but the type was easily recognised in the fiction and the social life of the period. Novels written by and about her flooded the market (and will be discussed in the next chapter). Her demands were not primarily the parliamentary vote or new opportunities for employment; these were easy to parry or divert into harmless channels. But social and sexual revolt was another matter, directly challenging established institutions of male supremacy. Many real husbands must have felt, like one in a short story of 1896, that their wives had suddenly 'advanced to the middle of the twentieth century!'[25]

New women thought for themselves. As Dora Montefiore, one of the few recognisably socialist feminists of the period explained in a poem, women had for centuries blindly followed wherever their lords and masters had led. Now they considered social problems independently and acted freely.[26] Women refused to accept previous images of themselves as weak and incapable of physical exertion. This was true above all of cycling, but participation in sport also included hockey and golf and other forms of recreation, as the Reverend Mr Jenkins noted disapprovingly.[27] Some courageous women, especially

cyclists adopted 'rational dress', a kind of knickerbocker outfit which was a commonsensical alternative to long, trailing skirts, but which could only be worn in defiance of social orthodoxy and at the risk of violence.

Increasing numbers of women took up smoking, a curious but potent symbol of emancipation.[28] By the turn of the century women smokers were no longer novel, though the habit continued to outrage the conventional. An amusing manifestation was reported by a male correspondent to the *Daily Telegraph*. His railway carriage had been invaded in Halifax by four young women, one of whom produced a 'smoking' label which she fixed to a window. His protests were met by the retort that the smoke would be good for him.[29]

The requirement of the wedding service that brides should promise to obey their husbands was widely questioned. The feminist *Woman's Signal* attacked the requirement that a bride should 'yield blind, unreasoning obedience and subjection', and some clergymen seem to have been willing to modify their services to omit the objectionable phrase.[30] The *Young Woman* staged a correspondence entitled 'Should Brides Promise to Obey?', and though it disappointingly refrained from publishing an analysis of the replies, the fact that hundreds were received proved that the subject was a controversial one.[31] Another clergyman reported that some brides, unwilling to say 'obey', promised to 'go gay', words which might well alarm a husband nearly a century later.[32]

Objection was voiced to a woman's marital status being made public property. The journalist Ella Day urged that the term 'Miss' should be reserved for the young, while older women should be known as 'Mrs', whether or not they were married:

> [W]hy should a woman be, as it were, branded on the forehead? Why should her luggage, when she travels, proclaim her domestic condition to every railway porter? Why should the announcement of her name at a public dinner or a reception indicate to every ear that she is somebody's property, or is still available for somebody else?[33]

Although differentiation of title by age rather than marital status was common practice in continental countries it was not until the age of 'Ms' that the 'domestic condition' of English women could become a private matter.

19

One of the principal targets of the new woman had been born in the eighteenth century. She could never, however, have been such a bogey figure as in the 1890s. This was 'Mrs Grundy', the prudish spectre of Thomas Morton's play *Speed the Plough* (1798), who remained the living emblem of straitlaced orthodoxy and convention. *Woman*, for example, asked its readers in 1894 to suggest 'woman's greatest grievance'. Nineteen per cent of the abundant crop of replies complained of the 'numerical preponderance of women'; the second most common grievance, expressed by 15 per cent of respondents, cited Mrs Grundy and 'social laws'.[34]

Although frequently represented as dowdy and mannish, most new women were careful to reject the image; they were encouraged to do so by Sarah Grand, the most easily identifiable new woman. Nor did they generally identify themselves with the tiny 'free love' coterie, which was an easy object of horror or condemnation. Despite the failure of her own marriage Sarah Grand repeatedly asserted that 'marriage is the most sacred institution in the world, and it is better not to interfere with it'.[35] As she pointed out, the crime of the new woman was not frivolity but seriousness. The society woman who neglected her home and family was rarely criticised.[36] The challenge of the new woman could not be dismissed as a silly preoccupation with latchkeys, *risqué* literature and attendance at the music hall.

The new woman's striving for emancipation had little chance of triumphing over the resistance of conventional and respectable opinion in her time. By the end of the decade her name was seldom invoked. But she had had a great impact, both on her own sex and on men. Not only sympathisers like Edward Carpenter[37] but also critics took her seriously. One such was Hugh Stutfield, who insisted that she was more than the creation of the comic papers: 'The New Woman is simply the woman of to-day striving to shake off old shackles, and the immense mass of "revolting" literature cannot have grown out of nothing, or continue to flourish upon mere curiosity.'[38] This is a suitable epitaph for an unorganised, leaderless movement which briefly seemed to be on the point of turning Victorian society upside down.

Notes

1. The major share of the imbalance, not susceptible to exact calculation, was the disproportionately high level of male emigration. *See* Census of England and Wales 1901, *General Report* (P.P. 1904, CVIII, Cd. 2174), pp. 17-18; N. H. Carrier and J. R. Jeffery, *External Migration: a Study of the Available Statistics 1815-1950* (HMSO, London, 1953), pp. 47, 102, 105 and *passim*. There is a useful table in Jane Lewis, *Women in England 1870-1950* (Wheatsheaf, Brighton, 1984), p. 3.
2. B. A. Crackanthorpe, 'The revolt of the daughters', *Nineteenth Century*, 35 (1894), pp. 23-31.
3. B. A. Crackanthorpe, 'A last word on the revolt', *ibid.*, 35 (1894), p. 424.
4. E. B. Harrison, 'Mothers and daughters', *ibid.*, 35 (1894), p. 317. *See* Frederic Harrison, *Memoir and Essays of Ethelbertha Harrison* (Pitman, Bath, 1917), pp. 19-22, 30-1, and Eric Trudgill, *Madonnas and Magdalens* (Heinemann, London, 1976), p. 273.
5. B. A. Crackanthorpe, 'A last word', pp. 425-7. *See below*, p. 40.
6. Alys Pearsall Smith, 'A reply from the daughters', *Nineteenth Century*, 35 (1894), pp. 443-50. Helen Taylor had asserted in 1872 that woman 'claims the right to belong to herself' (Patricia Hollis (ed.), *Women in Public: the Women's Movement 1850-1900* (Allen & Unwin, London, 1979), p. 294).
7. Kathleen Cuffe, 'A reply from the daughters', *Nineteenth Century*, 35 (1894), pp. 437-42.
8. Ma(r)y Jeune, 'The revolt of the daughters', *Fortnightly Review* 55 n.s. (1894), pp. 267-76.
9. Gertrude Hemery, 'The revolt of the daughters. An answer — by one of them', *Westminster Review*, 141 (1894), pp. 679-81.
10. Sarah M. Amos, 'The evolution of the daughters', *Contemporary Review*, 65 (1894), pp. 515-20.
11. The poet and novelist Robert Buchanan, for example, made three references to the 'New Womanhood' in a letter in the *Daily Chronicle* on 15 January 1894.
12. 'Feminism' and 'feminist' were new words in the period and seldom used. I have attempted to restrict their use to cases of comprehensive challenge to the domination of contemporary society by men.
13. The first published biography of Sarah Grand, Gillian Kersley's *Darling Madame* (Virago, London), appeared in 1983.
14. Ouida, *Views and Opinions* (Methuen, London, 1895), pp. 319, 324. None of the biographies of Ouida discusses her role in the 'new woman' controversy.
15. Sarah Grand, 'The new aspect of the woman question', *North American Review*, 158 (1894), pp. 271-3. When an interviewer later suggested that she had invented the new woman, Sarah Grand replied: 'I did, in an article of mine which appeared in the *North American Review*, 1894' (*Lady's World*, June 1900, p. 883). *See* Kersley, *Darling Madame*, pp. 76, 105.
16. Ouida, 'The new woman', *North America Review*, 158 (1894), pp. 610-19.

Images of women

An article in the comic paper *Judy* for 18 April 1894 discusses the new woman (p. 186). I have found no other which predates Ouida's.

17. [Eliza Lynn Linton], 'The girl of the period', *Saturday Review*, 14 March 1868, pp. 339-40; 'Modern man-haters', *Saturday Review*, 29 April 1871, pp. 528-9.
18. Sarah Grand, 'The new aspect of the woman question', p. 270; Lady Dilke, preface to A. Amy Bulley and Margaret Whitley, *Women's Work* (Methuen, London, 1894), p. vi.
19. Eliza Lynn Linton, 'The wild women as social insurgents', *Nineteenth Century*, 30 (October 1891), p. 596. Her other articles appeared in July 1891 and March 1892.
20. *Punch*, 26 May 1894, p. 252. *Punch* was so pleased with this verse, or so short of copy, that it repeated it little changed on 21 September 1895, p. 136.
21. *ibid.*, 14 July 1894, p. 22.
22. Josephine Kamm, *Rapiers and Battleaxes* (Allen & Unwin, London, 1966), p. 194; information kindly supplied by Universities of Cambridge and Oxford, February 1985.
23. Hulda Friederichs, 'The "old" woman and the "new"', *Young Woman*, 3 (1895), p. 202.
24. *Hull News*, 28 December 1895. Jenkins was at the time curate of North Cave, near Hull. I owe this reference to Joyce Bellamy and Peter Stubley.
25. Walter Parke, 'How Mrs. Newman became a new woman', *Atalanta*, 9 (1896), p. 259.
26. Dora B. Montefiore, 'The New Woman', *'Singings Through the Dark': Poems* (Sampson Low, London, 1898), p. 62.
27. *Hull News*, 28 December 1895.
28. *See* E. B. Harrison, 'Smoke', *Nineteenth Century*, 36 (1894), pp. 389-96. The *Lady's Realm* published an instructive symposium entitled 'Should ladies smoke?' in February 1900 (7, pp. 513-18). Meresia Nevill, a well-known Primrose Leaguer who was one of the all-women group of contributors, claimed that it was 'the exception to find people shocked at a lady smoking' (p. 517).
29. *Daily Telegraph*, 1 May 1894.
30. *Woman's Signal*, 6 February 1896, p. 88; J. Frome Wilkinson, 'The Moloch of modern marriage', *The Humanitarian*, 7 (1895), pp. 296-7.
31. *Young Woman*, 6 (1898), pp. 253-4. *See also* Mary Billington (ed.), *Marriage* (F. W. Sears, London [1900]), pp. 42-3, and M. V. Hughes, *A London Home in the 1890s* (1937; Oxford University Press, Oxford, 1983), p. 138. For Billington, a *Daily Telegraph* journalist and author, see Lord Burnham, *Peterborough Court, the Story of the Daily Telegraph* (Cassell, London, 1955), p. 122.
32. E. J. Hardy, *Love, Courtship and Marriage* (Chatto & Windus, London, 1902), p. 91. Hardy was the author of *How to be Happy though Married* (T. Fisher Unwin, London, (1895). *Punch's* version was 'love cherries and whey' (13 October 1894, p. 179).
33. Ella Day, 'Letters to the harassed', *Young Woman*, 5 (1897), p. 313. The same point was made by 'E.I.C.' in an article entitled 'Miss or Mrs.?', *Westminster Review*, 145 (1896), pp. 454-5.
34. *Woman*, 7 March 1894, p. 3.

22

35. Sarah Grand, 'The morals of manner and appearance', *The Humanitarian*, 3 (1893), pp. 87-93; Sarah Grand, interviewed by Sarah A. Tooley in *ibid.*, 8 (1896), pp. 166-7; Sarah Grand, *The Modern Man and Maid* (H. Marshall, London, 1898), p. 66; Sarah Grand, *The Human Quest* (Heinemann, London, 1900), p. 13. The quotation is from the Tooley interview, p. 167.

36. *ibid.*, p. 165.

37. Carpenter's sentiments are strikingly expressed in his pamphlets on *Marriage, Sex-Love* and *Woman, and her Place in a Free Society* (Labour Press, Manchester, 1894), reprinted in his *Love's Coming of Age* (Labour Press, Manchester, 1896).

38. Hugh E. M. Stutfield, 'The psychology of feminism', *Blackwood's Edinburgh Magazine*, 161 (1897), p. 115.

3

Literary images

At no time in the history of English women's struggle for emancipation can fiction have played such an important part as in the 1890s. The new woman, more immediately recognisable in literature than in real life, symbolised the women's movement in the decade in a way that the suffrage campaign was to do in the new century. The literature of the 1890s was of course built on the foundations laid in an earlier period. From the 1860s writers like Mary Braddon, Rhoda Broughton and Ouida created lively heroines, conscious of their personalities and grievances, but ultimately conforming to the conventions of their day.[1]

In the 1880s and '90s George Meredith, George Moore, George Gissing and in particular Thomas Hardy helped to create a new type of heroine, aware of her own sexuality and her wrongs in a male-dominated society. Grant Allen, a lesser figure, was also prominent in the 1890s, though whether his enthusiasm for 'free love' can be regarded as a contribution to the feminist cause is open to doubt.[2] Such men were influenced, as Elaine Showalter observes tartly, by 'their own fantasies of sexual freedom',[3] but they were also concerned to create real women and to expose the flaws of their society. The same comment can be made of Henrik Ibsen, whose plays triumphantly surmounted the barriers of nationality and language, and British playwrights like Arthur Wing Pinero, Henry Arthur Jones and George Bernard Shaw.[4]

With the exception of Allen these men retain their place in English literature. Their works are read and performed, largely because of the new image of women which took life from their pens. However, the 1890s was also a period in which a number of women writers, dealing as feminists with the social and sexual rights of women, secured a prominence which at times developed into sensation. Moreover, as Martha Vicinus points out, their writing predated much of the work of their male contemporaries;[5] in consequence they helped to wrench English fiction into new channels.

The fiction of the 1890s was the more remarkable in that

overtly feminist novels had been almost unknown before the beginning of the decade. Olive Schreiner's well-received and influential *Story of an African Farm* (1883)[6] stood almost alone until the end of the 1880s, and it is significant that the author was not English. In the conditions of the society and publishing world of late-Victorian London another decade had to pass before the feminist novel became prominent. With the publication in 1893 of *The Heavenly Twins* by Sarah Grand and *Keynotes* by George Egerton (as Mary Chavelita Dunne called herself)[7] a new era was launched. The publisher of *The Heavenly Twins* claimed sales of 35,000 in a little over a year, while *Keynotes* was in its seventh edition in 1896[8] and gave its name to an adventurous and highly successful series of novels and stories.[9]

For a time the female authors of the 'sex novel' swept all before them. In February 1894 a *Daily Chronicle* review commented that 'every third novel published is avowedly a statement of one or other aspect of the "Social Question", the "Sex Question", or the "Woman Question".' Another review concluded that 'the bulk of novels published nowadays' was concerned with 'the relations of sex'.[10] The next year the critic Edmund Gosse testily condemned 'The decay of literary taste' in an article written for a mainly American audience: 'Things have come to a pretty pass when the combined prestige of the best poets, historians, critics and philosophers of the country does not weigh in the balance against a single novel by the New Woman.'[11] George du Maurier illustrated a common theme in a *Punch* cartoon in 1896 in which an eminent publisher admits to a 'fair novelist' that he refuses to allow his wife and daughters to read her books. Told by the novelist that her latest book, which he has just purchased, contains nothing unsuitable for the eyes of a girl of fifteen the publisher is horrified.[12]

Yet the new woman fiction was in decline by 1896 or so, and its authors have had to be rescued from obscurity by modern feminist scholars and Virago reprints.[13] Various reasons for the decline have been given. Samuel Hynes, discussing dramatic innovations in the 1890s and Grant Allen's *The Woman Who Did*, points out that 1895 was the year of the trial of Oscar Wilde, an event which may have inhibited public discussion of sexual morality.[14] Elaine Showalter concludes that feminist novelists had 'but one story to tell, and exhausted themselves in its narration'. It was a story of women's wrongs at the hands of

men, particularly of 'physical oppression and sexual exploit-
ation'.[15] Gail Cunningham, whose conclusion is similar, asserts
that as women became freer in fact the case for the propaganda
novel appeared less urgent.[16] Patricia Stubbs writes that
women had dominated fiction throughout the Victorian period
but that at the end of the century men were 'quite accidentally'
in the ascendant. With the exception of Olive Schreiner and
George Egerton women were not gifted enough as writers to
change the course of the English novel.[17]

One can certainly agree that the ability to create character
and to compel the sympathetic attention of the reader was much
more characteristic of the work of Thomas Hardy or George
Gissing than of the fiction of most feminist women novelists of the
1890s. (This disparity of writing ability, however, was by no
means universal; the reader may well wonder what process keeps
some fiction alive while 'burying' so much else.) It is also clear
that after 1900 the women's movement was channelled into the
suffrage question and that the kinds of issues which women
writers raised in the 1890s were not again important social
questions in England for many years. Neither the inequality of
husband and wife nor women's social and economic aspirations
enjoyed the kind of prominence which might have ensured that
the fiction of the 1890s remained a living entity.

The modern scholars to whom reference has been made have
performed an invaluable service in reviving interest in the work
of such leading feminist writers as Sarah Grand, George
Egerton, Mona Caird and Ménie Muriel Dowie. It should be
pointed out, however, that there were many more feminists
among women writers, some of whom still await modern dis-
cussion. Their common theme was the attempt of women to
secure control of their own lives, and the barriers which social
convention and male domination posed to their freedom.

Despite the enthusiasm of feminist novelists for their cause
their readers must have been made of strong stuff if they felt
inclined to follow the steps of the characters about whom they
read. As Gail Cunningham points out, new woman novels
contained a heavy dose of 'nervous disorder, disease and
death'. To be emancipated was to bring upon oneself 'a
relentless catalogue of catastrophe . . . Many of the New Woman
novelists seem positively to wallow in gloom.'[18] There were
probably two reasons for this state of mind. The first was

personal experience. Those writers about whose lives we are informed suffered at the hands of weak or tyrannical fathers and husbands and they wrote of their own experiences.[19] Second, if fiction was to seem realistic to its readers feminist heroines could not be allowed to triumph; their gropings for emancipation had to collapse before the social and sexual realities of their day.

One typical novel of the school is Isabella O. Ford's *On the Threshold*, published in 1895. Isabella Ford, though not an outstanding writer, was one of the most interesting women of the period. An unmarried member of a wealthy Leeds Quaker family, she was active in trade union work and in the Independent Labour Party, and later as a supporter of the suffragette movement; Sylvia Pankhurst recalled her in sympathetic and affectionate terms.[20]

On the Threshold discusses the lives of Lucretia Bampfylde and her friend Kitty Manners, who go to London as students of art and music: 'It was before the days of ladies' chambers and cheap flats, so, because our means were limited, painfully limited, we had settled into three small, dark rooms in a street in Bloomsbury.' The first problem had been to overcome the opposition of their parents, particularly their fathers: '[O]f course men always think women's studies and lives generally, are mere fads.' The two young women join a society of advanced young people, where a male member summons up all the old stereotypes: 'Woman is a spiritual being, and ought to be treated as such ... Women must be the inspirers of the world ... and men must be the workers.'

One of their friends is a Miss Burton, a thirty-year-old school teacher who lives in poverty in a single room and speaks for many of the real and fictional new women of the period:

> I hate, how I hate men! Think of my life and the life of hundreds and hundreds of women like me! We cannot get paid, we cannot walk home at night from our work in peace, we cannot, if we have a father such as mine was, live our own lives or even think our own thoughts; we can do nothing but sit and smile and endure, all because of men!

Much of the novel discusses attitudes to marriage. Kitty returns home to help to nurse her sick father, to find that neither she nor her mother loves him. She writes to Lucretia that they should not marry, for fear of coming to regard their husbands

27

merely 'as useful pieces of furniture ... or as errand boys'. But after further vicissitudes Kitty decides to marry a young writer. She is to continue her art career and have her own studio. Lucretia remains single, intending to pursue her music studies at home and abroad: '[T]he idea of marriage does not attract or interest me very much; women's lives are so cut up when they marry. And, after all, is it worth it?'[21]

The themes of the feminist novels of the 1890s certainly suggests that it was not, though women who did not marry seldom provided a model whom many readers would wish to emulate. Isabella Ford treated her principal characters relatively kindly, but other writers of the school were less gentle. Ella Hepworth Dixon's *The Story of a Modern Woman* was a widely noticed novel, as the author, the daughter of a prominent man of letters and herself a successful journalist, recalled with some satisfaction many years later.[22] Her heroine was Mary Erle, a scientist's daughter born too late not to need a serious education but too early to have been given it. Her first lover goes to Australia and gradually stops writing to her. Mary finds herself in a similar position to Isabella Ford's Miss Burton, understanding

> for the first time the helplessness, the intolerable burden which society has laid on her sex. All things must be endured with a polite smile. Had she been a boy, she was aware that she might have made an effort to break the maddening silence; have stifled her sorrow with dissipation, with travel or hard work.[23]

Mary undergoes many problems, first as a student of art and then as a budding journalist. Her second lover, a superficial man about town named Vincent Hemming, asks her to marry him. She thinks of the loss of control of her life and happiness which would result: 'His hands, which held her two wrists as they stood there gazing at each other, felt like links of iron.' However, Hemming soon decides that his ambitions would be better realised by marrying a manufacturer's daughter, only to weary of her after a few years. He returns to Mary and asks her to go away with him. She refuses, repeating her earlier declaration: 'All we modern women mean to help each other now.' This, as Dixon told the journalist W.T. Stead, was 'a plea for a kind of moral and social trades-unionism among women', and it was the theme not only of her book but of much of the feminist fiction of the period.[24]

One of the most interesting and best written books of this school of writers was Netta Syrett's *Nobody's Fault* (1896). Netta Syrett, who was to enjoy a long career as a writer, was herself originally a teacher like her heroine, Bridget Ruan. Her early career aptly illustrated the life of the advanced young woman of the 1890s, though few enjoyed her opportunities. She shared a flat in London with her four sisters and made her first literary contacts with the assistance of Grant Allen, a relative by marriage. It was not Allen, however, but her teaching career which brought her into contact with Aubrey Beardsley's sister Mabel and thus with the group of writers and artists around the *Yellow Book*. An early profile commented that she was 'by no means of the ordinary depressing type of blue-stocking, but has a merry laugh, a contempt for Ibsen, and a busy bicycle'[25] It was natural that the first novel of an author moving in such advanced circles should be published in John Lane's *Keynotes* series.[26]

Bridget is a publican's daughter, whose education at a local high school carries her out of her parents' world ('it's nobody's fault — that's the worst of it') to a position in a London high school. She finds the loneliness and poverty of her life unendurable and seeks excitement and romance. A slightly older woman colleague preaches the virtues of work 'for making one forget all that sort of thing', but Bridget asks: 'Because I'm a teacher, am I to cease to be a woman?' She observes to a writer, Larry Carey, whom she meets after lunching at a teashop,[27] that 'it takes such a lot of struggling and fighting before we reach the point at which men — or most of them — begin.' Only birth, social position and money could overcome these problems.

Five years later Carey returns from abroad to find that Bridget has married a wealthy writer, 'one of those men who can't endure women to have brains'. Her attempts at writing have collapsed against the wall of her husband's hostility and ridicule. She returns to her mother, who counsels her not to be 'too hard on men They're all alike Suppose everyone was to leave their husbands just because they didn't love them.' This is just what Carey urges her to do and Bridget, seeing her one chance of happiness, prepares to do so. Asked about children she replies that they would be 'born into a world which is slowly freeing itself from the chains of prejudice, and of hateful, perverted morality'. But her father dies shortly before the end of the book and for her mother's sake she decides against living in sin with Carey.[28]

Penny Boumelha points out that Hadria, Mona Caird's heroine in the better-known novel *The Daughters of Danaus* (1894), also decides for her mother's sake against leaving her husband for her lover. Boumelha notes the role of what Netta Syrett called 'the tie of blood' in binding daughters to their families and hence convention.[29] The impact of this 'tie' was so strong that, as Carey bitterly told Bridget, women appeared to delight in self-sacrifice. Apart from the difficulty mentioned earlier, that novels intended to be realistic could not permit their feminist heroines to emerge triumphant from their trials, such endings reflected their authors' realisation that they lived in an age when expectations were aroused which could not be fulfilled. There was no easy answer to Carey's question: 'How will the world go on if we are to be cramped, hindered, fettered, for ever?'[30] Whatever women did, Hadria concluded, they ended in much the same plight: 'It doesn't answer to rebel against the recognised condition of things, and it doesn't answer to submit. Only generally one *must*, as in my case.'[31] In these circumstances, as Boumelha comments, happy endings were usually restricted to works of fantasy or prophecy.[32]

On the Threshold, The Story of a Modern Woman and *Nobody's Fault* may stand as typical products of the feminist writers of the age, and as such they do much to throw light on the aspirations of advanced women. A number of other important novels are discussed in detail by the scholars cited in this section, and a few more deserve brief notice. One such is *Mona Maclean, Medical Student* (1892), the work of Dr Margaret Todd writing under the pseudonym Graham Travers. The heroine after many tribulations marries another doctor with whom her practice and her marriage are shared on equal terms.[33] Written before the main wave of feminist fiction of the period the book's message was moderately but clearly stated. It apparently drew on the early life of Emily Flemming, who married her doctor tutor and practised for many years, also bearing four children.[34] It was praised for its realistic assessment of its subject by Sophia Jex-Blake, the pioneer woman doctor whose biography Margaret Todd wrote many years later.[35]

Among the other subjects treated by feminist writers of the period were a woman's right to her own money in the pursuit of emancipation (*The Comedy of Cecilia*, a cleverly conceived story by Caroline Fothergill, 1895), a man's cowardice when his

prospective wife loses her money and a woman's courage in bearing and raising an illegitimate child ('Coals of fire', from *In Homespun*, a book of Kentish stories by Edith Nesbit, 1896), the struggles of employed middle-class women enduring the privations of a 'home for working gentlewomen' and expected to undertake 'a woman's work as well as a man's' (*The Making of a Prig*, by Evelyn Sharp, 1897),[36] a woman's need and right to sexual fulfilment (*Seaweed, a Cornish Idyll*, by Edith Ellis, 1898) and free love and its problems (*The Image Breakers*, by Gertrude Dix, 1900). None of these books is great fiction, though Phyllis Grosskurth's judgment of *Seaweed* is exaggeratedly harsh and *In Homespun* retains the charm and freshness characteristic of Edith Nesbit's writing.[37] But all of them contain much to interest readers who wish to understand women's aspirations and deprivations in the period.

George Egerton's books of short stories have been fully treated by previous scholars and the two most important, *Keynotes* (1893) and *Discords* (1894) have recently been republished.[38] Her impressive *Rosa Amorosa* (1901) also deserves attention. At the turn of the century she wrote a series of love letters to a young Norwegian, identified only as 'Ole' in the study of her life and letters by her kinsman Terence de Vere White.[39] *Rosa Amorosa*, presumably modified in publication, is the result. The letters portray a woman aware of her body and determined to preserve her intellectual and sexual freedom to a degree that might discomfort many modern men. The book needs to be read as a whole, but the following passages suggests its flavour:

> [T]he essence of perfect love for our peculiar natures must be freedom Neither you nor I believe in any legal tie as binding — it is a concession to public opinion, no more I have no wish to be your rival in your life's work, but equally I would resent interference with mine. Whilst I respect your opinions, your prejudices, I expect equal tolerance on your part for those I have One [of her past lovers] wanted to pop me into a gilt-wired cage Another felt I could regenerate him, make a new man of him, imagined he paid me a compliment by offering to allow me to darn the heels of his moral socks Never demand of me as a right when I am your wife, what you would have to sue for were you my lover or I your mistress....[40]

31

It is the argument of this book that the aspirations of advanced
women in the 1890s helped to change the climate of intellectual
opinion and were a significant strand in the developments which
led to a militant women's suffrage movement early in the new
century. Such a contention defies convincing proof, but it is fair
to point out that the new woman fiction, itself part of a remark-
able development of English literature and the arts in the
1890s,[41] had at least temporary repercussions on writers who
would have repudiated identification with the new womanhood.

Such an influence can be seen in *Marcella* (1894), a tremen-
dously successful[42] triple-decker novel by Mary Augusta Ward.
Mrs Ward was in many respects a conventional upper-middle
class woman, known to her public under her husband's name
and prominent also for her prolonged opposition to women's
suffrage.[43] The heroine repents of her flirtation with socialism
and marries a landowner whose sympathies with the working
class entail no conflict with his Conservatism. Moreover, the
book in full of such passages as: 'Womanlike, her mood instantly
shaped itself to his.' Nonetheless, it is more ambiguous in its
message than is suggested by grouping it as part of a 'conserva-
tive reaction'.[44] Before her marriage Marcella leads an actively
and dangerously independent life which might have held more
appeal to readers than the author intended. Moreover, her
marriage is clearly going to be unconventional. When she first
accepts the landowner Aldous Raeburn she announces: 'I shall
never be a meek, dependent wife. A woman, to my mind, is
bound to cherish her own individuality sacredly, married or not
married.' Aldous promises: 'You shall be free.' By the eve of the
marriage, two volumes and eight hundred pages later, Marcella
is a much chastened woman. But Mrs Ward, herself an active
social worker, makes clear that she will continue to attempt to
improve social conditions in ways likely to lead to an eventful life
and conflict with Aldous's 'critical temper' and 'larger brain'.[45]

Marcella was condemned in the conservative *Quarterly Review*
by the Rev. W.F. Barry for its decadent 'French combination of
action and sentiment', and its author assigned to the 'new group
of female novelists' which included George Egerton and Sarah
Grand.[46] One imagines that such a verdict surprised Mrs Ward
as much as it does the modern reader, but it suggests that the
book was at the least not wholly conventional. Its influence on
young, leisured women was considerable. Many years later

Lady Sybil Lubbock wrote of Mrs Ward's influence on the young women of what she called the 'Marcella period' in the 1890s as 'widespread and almost irresistible'. Under her influence the young Sybil Cuffe was actively drawn into social work. Such work might well do no more than confirm existing prejudices, and there was little meeting of minds between Lady Sybil and the young London working girls with whom she came in contact,[47] but it might also lead to new ideas about the structure of society and the role of women. In context *Marcella* can as plausibly be assigned to the emancipation movement as to the opposition.

Feminist writers of our own day point out that the women novelists of the 1890s modified the existing feminine ideal rather than superseding or abolishing it. Elaine Showalter, for example, comments that the novelists exalted womanhood and claimed that feminine influence would purify public life.[48] Penny Boumelha stresses the importance of the biological, physiological and mystical, especially in the work of George Egerton.[49] It is easy to find examples of these attitudes, from 'the noble attitude of women wherever injustice was rife, the weak oppressed, and the wronged remained unrighted'[50] to 'the untamed primitive savage temperament that lurks in the mildest, best woman'.[51] Such images of women, given different motivation, could easily descend into Ouida's 'sleeping potentiality for crime' or Grant Allen's vision of women as man-worshipping, marriage-renouncing breeding machines.[52]

Women writers of the 1890s reacted, like all writers, to the problems and attitudes of their time. Before artificial methods of birth control became generally available women were not in a position to mount a fundamental challenge to sexual propriety.[53] Unmarried mothers were likely to face the severest forms of hardship and deprivation, and few middle-class women could hope to live in comfort from their own earnings.[54] To have mounted such a challenge would have been to harm their own cause, which was better served by a sustained attack on the double standard of sexual morality. Their view of the female condition was radical in its time, and if many of the novelists accepted the notion of sexual stereotypes, their stereotypes were designed to advance understanding of feminine psychology[55] and thus women's emancipation, in contrast to most of the men who dealt with the subject. The feminists of the 1890s con-

tributed little of permanent value to the development of English fiction, but the courage and forcefulness with which they opened new aspects of the case for women's emancipation amply deserve the recognition which they have begun belatedly to receive.

Notes

1. Elaine Showalter, *A Literature of Their Own* (1977; Virago, London, 1978), ch. 6; Patricia Stubbs, *Women and Fiction; Feminism and the Novel 1880-1920* (1979; Methuen, London, 1981), ch. 2.
2. Allen's *The Woman Who Did* (John Lane, London, 1895) caused a sensation in its day, but it certainly does not seem feminist to the modern reader. Millicent Garrett Fawcett delivered a convincing attack on the book and on Allen — 'not a friend but an enemy' — in the *Contemporary Review,* 67 (1895), p. 630. A salient passage of the article is reprinted in Showalter, *A Literature,* p. 185n.
3. *ibid.,* p. 184.
4. Samuel Hynes provides a useful summary of the work of these writers and related topics in *The Edwardian Turn of Mind* (Princeton University Press, Princeton, 1968), ch. 6.
5. Martha Vicinus, introduction to reprint of George Egerton's *Keynotes* and *Discords* (Virago, London, 1983), p. viiin.
6. Ruth First and Ann Scott, *Olive Schreiner* (Deutsch, London, 1980), discuss the book's reception on pp. 119-24. Writing a long review of 'the novel of the modern woman' in July 1894 W. T. Stead called Olive Schreiner 'the founder and high priestess of the school' ('The novel of the modern woman', *Review of Reviews,* 10 (1894), p. 64).
7. The daring nature of *Keynotes* presumably explains its author's adoption of a pseudonym (her husband's first two names), a disguise soon exposed by the press. For some general comments on women writers' use of male pseudonyms see Showalter, *A Literature,* pp. 57-9.
8. *The Heavenly Twins* was published in February 1893. Heinemann advertised the book as in its nineteenth thousand opposite the title page of Emma Brooke's *A Superfluous Woman* (British Library copy date-stamped 10 January 1894) and in its thirty-fifth thousand opposite the title page of Ella Hepworth Dixon's *The Story of A Modern Woman* (British Library copy date-stamped 11 May 1894). (Heinemann's sales figures are not available before the 1920s.) The *Daily Chronicle* for 25 May 1894 commented that the book had sold about 100,000 copies in a pirated American edition: 'Here the sale has as nearly as possible been half that.' Despite the claim by William Heinemann's biographer that Sarah Grand earned £1,200 in royalties within a few weeks of publication (Frederic Whyte, *William Heinemann* (Cape, London, 1928), p. 104), Gail Cunningham appears

therefore to be mistaken in citing sales of 20,000 copies in the first days of publication ('The "New Woman Fiction" of the 1890's', *Victorian Studies*, 17 (1973), p. 179n.) and over 40,000 within a few weeks (*The New Woman and the Victorian Novel* (Macmillan, London, 1978), p. 57). The seventh edition of *Keynotes* was advertised by its publisher, John Lane, in the endpapers of Marie Clothilde Balfour's *Maris Stella* (1896). By contrast, *The Woman Who Did* (published by Lane well over a year after *Keynotes*) was then in its twenty-second edition.

9. *See* Wendell V. Harris, 'John Lane's Keynotes series and the fiction of the 1890's', *PMLA*, 83 (1968), pp. 1407-13. There is a brief, vivid reminiscence of George Egerton and the *Keynotes* series in J. Lewis May, *John Lane and the Nineties* (John Lane, London, 1936), pp. 128-30.
10. Both reviews appeared in the *Daily Chronicle* for 6 February 1894.
11. Edmund Gosse, 'The decay of literary taste', *North American Review*, 161 (1895), p. 116.
12. *Punch*, 25 January 1896, p. 42.
13. But see Harold Williams, *Modern English Writers* (1918; Sidgwick & Jackson, London, 1925), part 4, ch. 4; and Amy Cruse, *After the Victorians* (Allen & Unwin, London, 1938), ch. 9.
14. Hynes, *Edwardian Turn of Mind*, pp. 184-5.
15. Showalter, *A Literature*, pp. 193, 215.
16. Abigail Ruth Cunningham, 'The emergence of the new woman in English fiction, 1870-1914' (unpublished D. Phil. thesis, University of Oxford, 1974), pp. 291-3, 295, 297.
17. Stubbs, *Women and Fiction*, p. 120.
18. Cunningham, *The New Woman*, p. 49.
19. I am thinking of Sarah Grand (for whom see Gillian Kersley, *Darling Madame*, Virago, London, 1983) and George Egerton (see Terence de Vere White (ed.), *A Leaf from the Yellow Book*, Richards Press, London, 1958).
20. E. Sylvia Pankhurst, *The Suffragette Movement* (Longmans, London, 1931), pp. 177-8, 203.
21. Isabella O. Ford, *On the Threshold* (Arnold, London, 1895); quotations from pp. 9-10, 15, 30, 60, 139, 201.
22. Ella Hepworth Dixon, *'As I Knew Them': Sketches of People I Have Met on the Way* (Hutchinson, London [1930]) p. 136. Dixon edited *The English-woman* in the mid-1890s.
23. In another passage, as Linda Dowling notes ('The decadent and the new woman in the 1890's', *Nineteenth Century Fiction*, 33 (1979), p. 440), Dixon comments that 'the very fabric of society was based on that acquiescent feminine smile' (p. 172; full reference in note 24).
24. Ella Hepworth Dixon, *The Story of a Modern Woman* (Heinemann, London, 1894); quotations from pp. 31, 59, 213-14, 255; Dixon to Stead, 'The novel of the modern woman', p. 71. *See also* Penny Boumelha, *Thomas Hardy and Women* (Harvester, Brighton, 1982), pp. 63-4.
25. Arthur Waugh in *The Critic*, 2 January 1897, quoted in Katherine Lyon Mix, *A Study in Yellow: the Yellow Book and its Contributors* (University of Kansas Press, Lawrence; Constable, London, 1960), p. 237.
26. For Netta Syrett see *ibid.*, pp. 236-8; her autobiography *The Sheltering Tree*

(Bles, London, 1939), and another early profile in *Atalanta* by J.E. Hodder Williams (10, 1897, pp. 473-4).

27. The first A.B.C. teashop was opened in 1884; J. Lyons followed in 1894 (W. Hamish Fraser, *The Coming of the Mass Market, 1850-1914* (Macmillan, London and Basingstoke, 1981), p. 213). The teashop served as a haven for young women seeking independence (Roger Fulford, *Votes for Women* (Faber, London, 1957), p. 118) and at times as a suffragist rendezvous. Elizabeth Wolstenholme Elmy, a leading suffragist over a long period, proposed a London meeting to her friend Harriett McIlquham in an 1897 letter, adding: 'We could then get tea together at the Aerated Bread shop and talk over our plans' (B.L. Add. Mss., 47,451, f. 52, 12 January 1897).

28 Netta Syrett, *Nobody's Fault* (John Lane, London, 1896); quotations from pp. 68, 108, 109, 134, 176, 182-3, 226-7.

29. Boumelha, *Thomas Hardy*, pp. 79-80. Boumelha also discusses Caird's *The Wing of Azrael* (1889), a precursor of the new woman fiction (pp. 80-1).

30. Syrett, *Nobody's Fault*, pp. 247, 249.

31. Mona Caird, *The Daughters of Danaus* (Bliss, Sands & Foster, London, 1894), p. 376.

32. Boumelha, *Thomas Hardy*, p. 81.

33. Graham Travers (Margaret G. Todd), *Mona Maclean, Medical Student* (three volumes, Blackwood, Edinburgh and London, 1892), vol. 3, pp. 277, 284-5.

34. So I assume from the account given in Hilda Martindale, *Some Victorian Portraits and Others* (Allen & Unwin, London, 1948), pp. 65-6.

35. Sophia Jex-Blake, 'Medical women in fiction', *Nineteenth Century*, 33 (1893), pp. 268-72.

36. For Evelyn Sharp, writer, suffragette and socialist, see Mix, *A Study in Yellow*, pp. 238-40; Stephen Gwynn, *Experiences of a Literary Man* (Thornton Butterworth, London, 1926), pp. 137-8; the autobiography of the journalist H. W. Nevinson, whom she later married, *More Changes More Chances* (Nisbet, London, 1925), pp. 331-3; and her own autobiography, *Unfinished Adventure* (John Lane, London, 1933). Cecil Sharp the folk-song collector was her brother.

37. Phyllis Grosskurth, *Havelock Ellis* (1980; Quartet Books, London, 1981), pp. 180-1. Edith Ellis was the wife of Havelock Ellis. For *In Homespun* see Doris Langley Moore, *E. Nesbit* (1933; Rich & Cowan, London, 1936), pp. 140-1.

38. By Virago with an introduction by Martha Vicinus, 1983.

39. White, *A Leaf from the Yellow Book*, pp. 57, 59.

40. George Egerton, *Rosa Amorosa* (Grant Richards, London, 1901); quotations from pp. 53, 72, 98, 178, 183. There is an interesting reference to this book in Williams, *Modern English Writers*, p. 451.

41. This development is brilliantly evoked in Holbrook Jackson, *The Eighteen Nineties* (Grant Richards, London, 1913).

42. Mary Augusta Ward, *A Writer's Recollections* (Collins, London, 1918), pp. 301-2.

43. *See* Janet Penrose Trevelyan, *The Life of Mrs. Humphry Ward* (Constable,

London, 1923) and Enid Huws Jones, *Mrs. Humphry Ward* (Heinemann, London, 1973).

44. As Patricia Stubbs does, *Women and Fiction*, p. 136.
45. Mary Augusta Ward, *Marcella* (three volumes, Smith, Elder, London, 1894); quotations from vol. 1, p. 221; vol. 2, p. 87; vol. 3, p. 367. Some of the book's themes were further developed in the author's *Sir George Tressady* (1896).
46. [W. F. Barry], 'The strike of a sex', *Quarterly Review*, 179 (1894), pp. 307-8. *See* Dowling, 'The decadent', p. 441.
47. Sybil Lubbock, *The Child in the Crystal* (Cape, London, 1939), pp. 252-4. As Amy Cruse points out (*After the Victorians*, p. 96), H. G. Wells wrote a reference to 'the Marcella crop' of young women engaged in 'politico-philanthropic activities' into *The New Machiavelli* (John Lane, London, 1911), p. 207.
48. Showalter, *A Literature*, pp. 184-93.
49. Boumelha, *Thomas Hardy*, pp. 85-93.
50. Sarah Grand, *The Beth Book* (1897; Virago, London, 1980), p. 493 (*see also* p. 414).
51. George Egerton, *Keynotes* (Elkin Mathews and John Lane, London, 1893), p. 22.
52. For Ouida *see* p. 16 above; for Grant Allen, *The Woman Who Did*, *passim*, and Millicent Garrett Fawcett's review (note 2 above).
53. *See* p. 47 below.
54. See Showalter, *A Literature*, p. 191, and Stubbs, *Women and Fiction*, p. 126.
55. Cunningham, 'The emergence of the new woman', pp. 242-3.

4

Love and marriage

Discussion of the problems of marriage was not new in the 1890s, but the subject was debated more publicly and candidly in this decade than ever before. In the course of the debates the reality behind the respectable Victorian facade was revealed and the case was vigorously urged for reforms which would make marriage an equal partnership.

Shortly before the beginning of the decade the novelist and feminist Mona Caird published the first of several articles on marriage which were later collected in a book. She wrote in outspoken terms, pointing out that marriage should be based on love and freedom, not on calculation and dependence. Few women had a clear alternative, and as a result they were trapped into unsuitable, mercenary marriages. The 'victims' of a conventional marriage, she wrote in the initial article,

> are expected to go about perpetually together, as if they were a pair of carriage-horses; to be for ever holding claims over one another, exacting or making useless sacrifices, and generally getting in one another's way, with a diligence and self-forget-fulness which would be admirable were it not so supremely ridiculous. The man who marries finds that his liberty has gone, and the woman exchanges one set of restrictions for another.[1]

A trenchant passage recognised the economic foundations of free marriage and urged that wives should enjoy their own incomes, in terms which anticipated the American feminist Charlotte Perkins Gilman:

> The idea of a perfectly free marriage would imply the possibility of any form of contract being entered into between the two persons, the State and society standing aside, and recognising the entirely private character of the transaction. The economic-al independence of woman is the first condition of free marriage. She ought not to be tempted to marry, or to remain married, for the sake of bread and butter.[2]

38

The *Daily Telegraph* now took a hand. Enjoying London's (and, it claimed, the world's) largest circulation, it liked to ask its readers to exercise their own pens during the summer slack season, 'coming in with the grouse and going out with the pheasant', as the paper's biographer remarked. The subject of Mona Caird's article proved to be an unprecedented success. Before the correspondence, headlined 'Is Marriage a Failure?', closed at the end of September 1888 the paper had received some 27,000 letters. None, a commentator observed, came from the aristocracy, and only one or two were from working-class readers.[3] (In contrast, a fascinating *Telegraph* correspondence a decade later, asking 'Should Wives Work?', seems to have attracted over 2,000 letters.)[4] George and Weedon Grossmith took the opportunity to write a reference to the correspondence into their Pooter chronicle;[5] the subject was evidently topical and controversial.

Mona Caird pointed out in a subsequent article that marriage as it then existed was based on the economic and social dependence of the wife and on her submissively bearing large numbers of children.[6] But as she wrote the position was already changing. Women's inferiority was being challenged and the average number of children born to lasting marriages fell by about a third between the late 1860s and the 1890s.[7] It is not surprising under these circumstances that marriage as an institution was subject to analysis and criticism.

Novelists of both sexes held marriage responsible for waste and unhappiness, to the point that a conservative writer like Margaret Oliphant could attack the exponents of what she termed 'the Anti-Marriage League' in an article published in 1896.[8] But it needed more than an ageing novelist of waning reputation to stem the tide of criticism. Thomas Hardy's frank exploration of change and growth after marriage in *Jude the Obscure* (1896), a principal focus of Mrs Oliphant's attack, found an echo in too many hearts to be denied.

Marriage ritual within the alliance of title and plutocracy calling itself London society also had its enemies, though the 'season' continued unabated until war broke out in 1914. Leonore Davidoff has skilfully dissected the institution and rescued from oblivion the memoirs of many of its participants,[9] and Beatrice Webb has left an excellent insider's analysis of the feverishly serious round of pleasure-hunting by day and night

which constituted the marriage market. Behind the sham the business of getting rid of daughters to the most suitable bidders went on, she wrote, 'sometimes with genteel surreptitiousness, sometimes with cynical effrontery'.[10]

'The revolt of the daughters' was partly a revolt against the London marriage market. Blanche Crackanthorpe, who made the first contribution to public discussion of the subject, urged in a subsequent article: 'Let the frantic pursuit of so-called pleasure — that ugly cloak for the still uglier matrimonial hunt — be abandoned as the unclean thing Let early marriages on modest incomes become the rule and not the exception.'[11] The *Lady's Realm* conducted a discussion of the subject in 1897 which was published as a book the following year. Marie Corelli, the popular romantic novelist, was the only one of the four contributing authors to insist that the claims of love must be paramount and exclusive. She denounced the exchange of rank and title for American 'dollar-pottage', and the allegedly common sacrifice of a 'Christian virgin' to an unsavoury Jew.[12] Other authors were more hard-headed. Susan, Countess of Malmesbury, who made a number of contributions to discussions of women's role in the period, stressed that girls were 'allowed freedom undreamt of twenty years ago', as a result of which they needed protection against rash, unsuitable marriages. It was rare, she warned, for marriage across social class lines to be successful. Lady Jeune insisted that girls were more and more independent, and unwilling to marry a man they did not love. Nor did their mothers wish them to do so.[13]

She also claimed, as did other writers, that the young of both sexes among the more prosperous classes were disinclined to marry.[14] Reluctance on the part of women found a measure of support among commentators of their own sex. Roy Devereux, a woman author who contributed to the *Saturday Review* as 'A Woman of the Day', asserted that the 'modern maid' no longer believed that any husband was better than none; she received her own proposals of marriage and was frequently inclined to reject them.[15] This independence of spirit was also welcomed by Annie S. Swan, a popular novelist and journalist. In her *Courtship and Marriage* (1893) she wrote that marriage, while still the best life for women, was no longer the only one, for 'no open-eyed person will deny that a single, independent, and self-respecting life is far preferable to the miserable, starved, in-

adequate wifehood to which many women are bound'. The woman who trained her daughter for no other career than marriage was 'a mistaken, despicable creature'.[16]

Such comments sprang from new attitudes on the part of women towards themselves and towards marriage, although the surplus of women of marriageable age in the population must have been an important indirect factor. The apparent indifference to marriage among women of the educated classes was ascribed by one writer to a changing society, the influence of Ibsen and other writers, the bicycle, improved education and the defeat of Mrs Grundy. Young men too looked for wives among educated, capable women, rather than for 'engaging zoological specimens'. This was the optimistic view of Ella Hepworth Dixon, who provided a useful summary of the freedoms of the fortunate few:

> If young and pleasing women are permitted by public opinion to go to college, to live alone, to travel, to have a profession, to belong to a club, to give parties, to read and discuss whatsoever seems good to them, and to go to theatres without masculine escort, they have most of the privileges — and others thrown in — for which the girl of twenty or thirty years ago was ready to barter herself to the first suitor who offered himself and the shelter of his name.

A minor reason, she added, for the reluctance of some professional women to marry was unwillingness to interrupt their careers for maternity.[17]

Women writers urged that wives should have money of their own to spend as they chose. Annie Swan, for example, proposed that except in the case of working-class families with low incomes, the wife should have 'a few odd shillings ... for her very own'.[18] Beatrice Harraden, whose *Ships that Pass in the Night* (1893) had created a stir and placed her among the ranks of new woman novelists, said in an interview in 1900 that all married women should have an allowance in payment for their work as wives and mothers. It was degrading for a woman to have to ask her husband for money to buy clothes, presents or travel. 'However small it may be, every married woman should have a definite sum to call her own.'[19]

Money 'for her very own' emerged as a principal reason for wives to work outside the home in the remarkable *Daily*

Telegraph correspondence on the subject in 1898. Some wives were content with a fixed sum from their husbands, but others preferred money which they had earned themselves. An Oxford correspondent wrote that both a wife's self-respect and her pocket benefited from paid employment. Other writers commented that it was 'miserable' and 'humiliating' to have to ask one's husband for spending money.

This attitude was part of a wider shift in the perception of marriage. It was well brought out in the 206 letters published in the *Telegraph*, many of which put the case for the employed wife. Marriage, it was said, would be happier and stronger if both partners had experience of the world outside the home. They should take equal part in bringing up their children and other household duties not performed by servants. Death, desertion or other factors might compel a wife to earn her or her family's living, and she should have training and experience to enable her to do so. Above all, a wife was a human being with abilities and interests which deserved expression: 'Why, when God has given to a woman a great talent should she not use it to the best of her ability, just because she is married?'

Most of the letters were written from addresses in greater London, where opportunities for employment and the desire for emancipation were often further advanced than elsewhere. Even so, they were a tribute to the fact that among a section of the middle class new attitudes had begun to emerge. The *Daily Telegraph*, which made no secret of its opposition to the trend, amended its tone in response to the opinions and the evidence which it had called forth. Especially among women, the paper concluded, 'our old English notions of wifehood, its obligations and ideals, have undergone a silent but complete revolution'.[20]

The 'revolution' was a journalistic mirage. As Carol Dyhouse has stressed with a wealth of examples,[21] there was still a widespread conviction in all social classes that a young woman's proper vocation was marriage to a dominant husband. But there were at least the first signs of change.

Some contemporaries felt with Lady Violet Beauchamp that marriage was 'on its trial'. In her view a wife's economic contribution to her family must help to destroy belief in masculine 'intellectual superiority'.[22] A working wife might also have the financial resources and the self-confidence to break free from an unhappy marriage. Divorce, however, was uncommon,

although its incidence was increasing. Public opinion was more liberal than in the first decades after the passage of the first Matrimonial Causes (divorce) Act in 1857, but to women of the upper and middle classes, to whom divorce was effectively limited on grounds of cost, the prospect of a broken marriage still conjured up a spectre of personal and financial disaster. There were under 650 divorce petitions a year in the 1890s, and as late as 1914 only 1,104. Forty-two per cent of the petitions were brought by wives between 1894 and 1898.[23]

Easier divorce was not a clearly feminist issue during the period. Many women believed that it was more in the interests of philandering husbands than of unhappy wives.[24] Millicent Fawcett looked to mutual fidelity and to equality in marriage to secure women's right,[25] and Susan, Countess of Malmesbury, asked: 'How can there be a day's peace or freedom from care and jealousy when any man or woman can with propriety offer to marry your wife or your husband under your eyes, when warning can be given to you as if you were a servant?'[26]

It was not until early in the new century that there was an organised and persistent demand to reform the marriage laws.[27] Easier divorce, however, was an obvious remedy for the unhappy marriages of which so much was made in the fiction and the tracts of the 1890s, and it was supported by many emancipated women. There was a particularly strong case for ending one of the most blatant aspects of the inequality of the sexes in the period (an aspect which endured until 1923), the fact that divorce was obtained more easily by a husband than by a wife. This was a reflection of the fact that adultery was regarded, perhaps especially in the exclusively male ranks of parliamentarians and the legal profession, as less reprehensible when committed by a man than by a woman, who had accordingly to find additional grounds for divorce. The anomalous status of the English law was emphasised by the fact that in Scotland adultery or desertion by either husband or wife constituted grounds for divorce.

Perhaps surprisingly one advocate of easier divorce was Eliza Lynn Linton, well known as the virulent opponent of the new woman. Mrs Lynn Linton, who had long been separated from her husband, believed that the man should be the dominant partner in marriage, but that the existing marriage laws were 'both imperfect and unjust'. She not only wanted to allow

divorce for persistent drunkenness, madness, felony and desertion, but suggested that it be permitted if both partners or even one wanted to end a marriage.[28] Roy Devereux criticised both the marriage laws and the state of marriage itself, though she insisted that it was the 'best protection' for most women and dismissed Mona Caird and her 'inconsiderable faction' of alleged 'abolitionists'. On the other hand she claimed that the kind of woman who was prepared to accept the role of 'mere breeding machine' was now exceptional, and she denounced 'the meaningless production of children' in terms which Caird herself must have approved. She attacked the constant proximity of husband and wife in the English family as destructive of romance and love, urged equal access to divorce for both sexes and the additional grounds of felony, lunacy and habitual drunkenness.[29]

Under the dedicated leadership of Elizabeth Wolstenholme Elmy the Women's Emancipation Union put forward equality in marriage as one of its principal demands during its short lifetime (1892-9). The Union was unsuccessful in finding an MP to undertake the thankless task of introducing an annual bill to equalise recourse to divorce, but it published a series of pamphlets and circulars on the subject, took part in the preparation and presentation of two petitions urging reform of the divorce law, and repeatedly denounced 'the shameful and immoral inequality as between husband and wife of the English law of divorce' and the effective restriction of its availability to the wealthy.[30]

Questions of marriage and divorce received periodic, reasoned discussion in the pages of *The Humanitarian*. This neglected monthly was edited in London by Victoria Woodhull Martin, a 'singular being'[31] who in her youth had been a celebrated advocate of free love and a presidential candidate, as Victoria Woodhull, in her native United States.[32] There was nothing sensational about *The Humanitarian*, but it consistently gave space to feminist causes (and also to stirpiculture, or selective breeding).[33] An editorial note in July 1897 mentioned cases in which men had been unable to divorce wives guilty of slander, pregnancy before marriage by another man and incarceration in a mental asylum. It continued: 'and all around us every day we see women bound to men who are impure and diseased without a hope of freedom or redress. These things

should not be. Marriage law reform is the crying need of the age.'[34]

Advocacy of freer divorce may have been inhibited by fear of association with advocacy of free love, which was generally defined as an enduring but not necessarily lifelong sexual relationship unsanctioned by church or state. The more liberal atmosphere of the 1890s encouraged public support for sexual freedom not manifest in the days of a discussion group like the Men and Women's Club in London in the mid-1880s; Olive Schreiner and Karl Pearson had been prominent members.[35] It would, however, be wrong to attach great importance to free love in a study of women in the 1890s. Acknowledged supporters were few, though free unions in emancipated sections of the middle class and among the urban poor were of course not new. In addition, it was by no means clear to contemporaries that either the practice or the public support of free love were steps towards the emancipation of women.

The boldest advocates of free love were found in the ranks of the Legitimation League, a body whose inaugural meeting was held in Leeds in June 1893 and which had originally been dedicated to demanding equal rights for children whether born in or out of wedlock.[36] Oswald Dawson, the founder and first moving spirit, was a member of a wealthy Leeds Quaker family, whose common-law wife Gladys Heywood formally took his name in 1893. At the time the couple, who were described as living together in perfect propriety, had one child. They suffered hostility and ostracism in Leeds[37] and the League, after a period of inactivity, moved in 1897 to what was hoped to be more fertile ground in London. At the same time its objectives were amended to include the words: 'To educate public opinion in the direction of freedom in sexual relationships'.[38] A number of meetings of the League were held, but the women who attended were reported on one occasion to be reluctant to speak.[39] One who was not was the lively Edith Vance, who was also a member of the National Secular Society and whose subsequent appointment as assistant secretary of the Rational Dress League must have contributed to concern that the latter body was 'getting mixed up with the cult for the abolition of marriage'.[40] At a meeting of the Legitimation League in February 1896 Vance called attention to the fact that men and women were bound to view free love from different perspectives:

> I did not know until I had a talk with Mrs. Dawson afterwards, what a very great deal she has to endure. It is very easy — perhaps it is fun to you gentlemen — to be twitted about your connection with the Legitimation League. You can bear it with fortitude, and perhaps rather like it than otherwise, and if the conversation gets too bad, you can knock the man down, or threaten to do so, but Mrs. Dawson is not in a position to thus deal with her slanderers, men or women, and in most cases the women are the worst.[41]

Several other couples connected with the League lived openly as stable, unmarried partners. However, one such couple, Emma Wardlaw Best and Arthur Wastall, emigrated to the Seychelles when their cohabitation was formally announced, a fact which suggests that family or social pressures in England might have been too great to bear.[42]

The Legitimation League received more prominence under Dawson's successor as honorary secretary, George Bedborough (born Higgs). He began a League journal in June 1897 entitled *The Adult* which survived for less than two years. It was initially printed by a dubious firm calling itself the University Press, which in 1897 published Havelock Ellis's *Sexual Inversion*, the first volume of his *Studies in the Psychology of Sex*. In May 1898 the police arrested Bedborough and seized a number of publications in his possession. He was prosecuted and tried at the Old Bailey the following October for publishing and selling obscene libels including the Ellis book, certain articles in *The Adult* and a pamphlet by Oswald Dawson. The outcome of the trial was confused and unsatisfactory, but *The Adult*, which had passed into the hands of another editor, ceased publication in March 1899 by which time the Legitimation League had faded away.[43] Whether the police action prevented 'the growth of a Frankenstein monster wrecking the marriage laws of our country, and perhaps carrying off the general respect for all law' as claimed by Detective-Inspector John Sweeney of Scotland Yard[44] is, however, open to doubt.

The demise of the League was soon followed by that of the *University Magazine,* another University Press publication which, together with its predecessor the *Free Review* and the earlier *Modern Review* argued a consistent case for free love in the 1890s. However, some contributors put the view that in existing society 'the woman paid'. She lacked independent social status, assured

economic position and the certainty of avoiding pregnancy, for while contraceptive devices controlled by women were advertised and used,[45] most single women were not in a position to enjoy ready access to them. The woman who rejected the marriage tie thus stood to suffer trebly, as a poverty-stricken social outcast and unmarried mother.[46] At best the position of such a woman was unenviable. As a woman correspondent pointed out in *The Adult* itself; 'To my mind "free love" offers no honourable or happy solution to the woman ... a woman who accepts a free union has now the choice of remaining childless, or of accepting the final responsibility of the children she bears. Is this a solution?'[47]

A modified form of free love was proposed in a pamphlet by Edith Ellis published in about 1893. Her objects were to remove commercialism from the sexual relationship and to work towards 'the absolute economic and social independence of woman', who under existing conditions was 'the greatest slave and parasite in the community'. She stressed the lamentable ignorance of most brides of the sexual part of marriage and advocated what she called 'noviciate' marriages as a means of replacing prostitution and secret liaisons with a truer monogamy. A year-long 'noviciate', while not necessarily involving 'actual cohabitation' and excluding illegitimate children, was a means of preventing unhappy marriage, a procedure preferable to easy divorce.[48]

It could hardly have been expected that free love would prove to be a popular means of expressing dissatisfaction with the existing state of marriage and the role of women within it. Dawson said when the League was founded: 'We don't expect to be popular in this generation',[49] and his expectation was justified. He did hope to move public opinion, but the weight of convention and the agencies of the law were too strong for his little band. In society as then constituted the priorities of those whose goal was the emancipation of women inevitably lay in other directions.

Notes

1. Mona Caird, *The Morality of Marriage* (George Redway, London, 1897), pp. 104, 106; reprinted in revised form from Mona Caird, 'Marriage', *Westminster Review*, 130 (1888), pp. 196-8. The *Westminster Review* contained many articles on marriage and divorce during the 1890s.

2. Mona Caird, 'Marriage', p. 198; see *The Morality of Marriage*, p. 109.

3. Lord Burnham *Peterborough Court, the Story of the Daily Telegraph* (Cassell, London, 1955), pp. 146-7; Harry Quilter (ed.), *Is Marriage a Failure?* (Swan Sonnenschein, London [1888]), pp. 2-3, 6.

4. *Daily Telegraph*, 3 September 1898. *See below*, p. 42.

5. *Punch*, 17 November 1888, p. 233; George and Weedon Grossmith, *The Diary of a Nobody* ([1892]; Dent, London, 1940), p. 116.

6. Mona Caird, 'The morality of marriage', *Fortnightly Review*, 47 n.s., (1890), p. 314; *The Morality of Marriage*, p. 138.

7. Angus McLaren, *Birth Control in Nineteenth-Century England* (Croom Helm, London, 1978), p. 11.

8. M. O. W. Oliphant, 'The anti-marriage league', *Blackwood's Edinburgh Magazine*, 159 (1896), pp. 135-49.

9. Leonore Davidoff, *The Best Circles* (Croom Helm, London, 1973), esp. pp. 49-53.

10. Beatrice Webb, *My Apprenticeship* (Longmans, London, 1926), pp. 45-9.

11. B. A. Crackanthorpe, 'A last word on the revolt', *Nineteenth Century*, 35 (1894), pp. 427, 428.

12. Marie Corelli, Mary Jeune, Flora Annie Steel, Susan, Countess of Malmesbury, *The Modern Marriage Market* (Hutchinson, London, 1898), pp. 30-1.

13. *ibid.*, pp. 80, 81, 160, 161, 165.

14. *ibid.*, p. 82. *See also* Mary Jeune, *Lesser Questions* (Remington, London, 1894), p. 46.

15. Roy Devereux, *The Ascent of Woman* (John Lane, London, 1896), p. 37; reprinted from the *Saturday Review*, 1 June 1895, p. 721.

16. Annie S. Swan, *Courtship and Marriage* (Hutchinson, London, 1893), pp. 126-7. *See also* R. Q. Gray, 'Religion, culture and social class in late nineteenth and early twentieth century Edinburgh', in Geoffrey Crossick (ed.), *The Lower Middle Class in Britain 1870-1914* (Croom Helm, London, 1977), pp. 147-8.

17. Ella Hepworth Dixon, 'Why women are ceasing to marry', *The Humanitarian*, 14 (1899), p. 394.

18. Swan, *Courtship and Marriage*, p. 37.

19. *The Humanitarian*, 17 (1900), p. 175 (Beatrice Harraden interviewed by Sarah A. Tooley).

20. The correspondence appeared in the *Daily Telegraph* between 15 August and 2 September 1898. The quoted letter was from 'A wife who works', Mile End, London, 18 August. The paper's first leader appeared on 15 August; its second thoughts on 3 September. The final leader rightly commented: 'Such a correspondence as that to which we have throughout

the last three weeks opened our columns should provide the social historian of the future with material of no little value.'

21. Carol Dyhouse, *Girls Growing Up in Late Victorian and Edwardian England* (Routledge & Kegan Paul, London, 1981), *passim*.

22. Lady Violet Beauchamp, 'The woman's century', *The Humanitarian*, 15 (1899), p. 272. Lady Violet Beauchamp was divorced by Sir Reginald Proctor-Beauchamp in 1901 and married Hugh Watt in 1906.

23. O. R. McGregor, *Divorce in England* (Heinemann, London, 1957), pp. 36, 40; Griselda Rowntree and Norman H. Carrier, 'The resort to divorce in England and Wales, 1858-1957', *Population Studies*, 11 (1958), p. 201.

24. For example Elizabeth Rachel Chapman, *Marriage Questions in Modern Fiction* (John Lane, London, 1897), p. 163 and *passim*; Mrs H. D. Web, 'Marriage and free love', *Free Review*, 4 (1895), p. 548:

 Without regulations founded on the principle of permanent and life-long unions, the woman in a large number of cases would be deserted at the moment she became unattractive to her husband, and after she had spent her beauty and her youth in the bearing and bringing up of his children.

 Sarah Grand took a similar line in a review of Chapman's book: 'Marriage questions in fiction', *Fortnightly Review*, 63 n.s. (1898), p. 389.

25. Millicent Garrett Fawcett, 'The woman who did', *Contemporary Review*, 67 (1895), p. 631.

26. Susan, Countess of Malmesbury, 'The future of marriage', *Fortnightly Review*, 51 n.s. (1892), p. 280.

27. McGregor, *Divorce in England*, pp. 24-6; Samuel Hynes, *The Edwardian Turn of Mind* (Princeton University Press, Princeton, 1968), pp. 186-97; Royal Commission on Divorce and Matrimonial Causes, *Report* (P.P. 1912-13 XVIII, Cd. 6478), pp. 95-6; *Evidence*, vol. I (Cd. 6479), qs. 5147-59.

28. Eliza Lynn Linton, 'The judicial shock to marriage', *Nineteenth Century*, 29 (1891), pp. 697-700; also Eliza Lynn Linton, 'The philosophy of marriage', in Quilter (ed.), *Is Marriage a Failure?*, pp. 199-200.

29. Devereux, *The Ascent of Woman*, pp. 35, 39-42, 47; reprinted from the *Saturday Review*, 1 and 8 June 1895, pp. 721, 753. *See also* J.A. and Olive Banks, *Feminism and Family Planning in Victorian England* (Liverpool University Press, Liverpool, 1964), p. 101.

30. Women's Emancipation Union; *Report* of inaugural meeting, October 1892, pp. 2, 7-8; *Report* presented to final meeting held 1 July 1899, pp. 2-3, 48-9.

31. Marie Belloc Lowndes, *Where Love and Friendship Dwelt* (Macmillan, London, 1943), p. 186.

32. For Victoria Woodhull Martin see Emanie Sachs, '*The Terrible Siren*' (Harper Bros., New York, 1928), Johanna Johnston, *Mrs Satan* (Macmillan, London, 1967) and Marion Meade, *Free Woman* (Knopf, New York, 1976). None of these books is enlightening about Woodhull Martin's years in England or about *The Humanitarian*.

33. H. G. Wells wrote, in words which applied to the journal as a whole, that 'popular preachers, popular bishops, and popular anthropologists vied with titled ladies of liberal outlook' in advocating the cause of stirpiculture

(*Mankind in the Making* (Chapman & Hall, London, 1903), p. 38).

34. *The Humanitarian,* 11 (1897), pp. 65-6; also 7 (1895), pp. 226-7.

35. Ruth First and Ann Scott, *Olive Schreiner* (Deutsch, London, 1980), pp. 145-58; Phyllis Grosskurth, *Havelock Ellis* (1980; Quartet Books, London, 1981), pp. 95-100; E. S. Pearson, *Karl Pearson* (Cambridge University Press, Cambridge, 1938), p. 18.

36. *The Rights of Natural Children: Verbatim Report of the Inaugural Proceedings of the Legitimation League* (W. Reeves, London and Geo. Cornwell, Leeds, 1893), reverse contents page, pp. 5, 43.

37. *ibid.,* pp. 6, 10-14, 63; Oswald Dawson (ed.), *The Bar Sinister and Licit Love: the First Biennial Proceedings of the Legitimation League* (W. Reeves, London and Geo. Cornwell, Leeds, 1895), pp. 62, 189-99.

38. *The Adult,* 1 (1898), pp. 98-9, 101-2, 106-7, 119. The League had enjoyed a brief period of frenetic public activity during the Lanchester affair in 1895. *See below* pp. 58-62.

39. Oswald Dawson, *The Outcome of Legitimation* (Legitimation League, London [1898]), pp. 1, 15.

40. Concern was expressed by Lady Harberton, the leader of the Rational Dress League, in a letter to S. S. Buckman (copy in Buckman Papers, Hull University Library; DX 113/2, 7 October 1898, f. 2B). For the League *see* ch. 12 below.

41. Dawson (ed.), *The Bar Sinister,* pp. 228-9.

42. *The Adult,* 1 (1898), pp. 147-8.

43. Reports of this affair may be found in Grosskurth, *Havelock Ellis,* ch. 13; Hynes, *Edwardian Turn of Mind,* pp. 263-6; John Sweeney, *At Scotland Yard* (Grant Richards, London, 1904), ch. 8; Arthur Calder-Marshall, *Lewd, Blasphemous and Obscene* (Hutchinson, London, 1972), ch. 5; *The Adult,* 2 (1898), esp. pp. 157-62, 189-91, 272-4, 339-41; *The Times,* 1 November 1898.

44. Sweeney, *At Scotland Yard,* p. 189.

45. McLaren, *Birth Control,* pp. 94-5, 132-3, 222-7; Patricia Branca, *Silent Sisterhood* (Croom Helm, London, 1975), pp. 130-8. *See also* Barbara Strachey, *Remarkable Relations* (Gollancz, London, 1980), pp. 103, 151.

46. *See* e.g., note 24 above and *Free Review* 7 (1896), p. 95.

47. Mary Reed, 'The question of children', *The Adult,* 2 (1898), p. 204.

48. Edith Ellis, *A Noviciate for Marriage* (published by the author, ? Haslemere, Surrey, ?1894), pp. 4-7, 11-17. For the author's own unconventional marriage see Grosskurth, *Havelock Ellis,* chs. 9 and 10.

49. *The Rights of Natural Children,* p. 14.

5

Women's legal image: the Jackson case and the Lanchester affair

The legal rights of Englishwomen in the 1890s were character-ised by the kinds of anomalies which could be expected in a male-dominated society in which small groups of women, often isolated from each other, had concentrated on piecemeal re-forms.[1] To say this is not to denigrate the triumphs of the women and their male supporters who had struggled against ridicule and hostility to reform the law of property and repeal the laws which enforced inspection and treatment of women suspected of being prostitutes carrying venereal disease in certain ports and garrison towns. After 1882 English wives, in Elie Halévy's words, 'enjoyed a freedom unknown in any other country'[2] to own and control their own property. The common law assump-tion that husband and wife were one person and that the husband was that person had lost much of its validity in the field of property. By 1886 working-class women were free from compulsory inspection and treatment under the terms of the Contagious Diseases Acts of the 1860s.[3] Despite the remaining inequalities of the law of property[4] and recurrent demands to reinstitute the Contagious Diseases Acts women campaigners had achieved successes of considerable magnitude

Both campaigns, however, worked with the grain of legal reform which characterised the mid-Victorian years, and both attracted the support of the Liberal nonconformist groups who were also moving spirits behind other socio-legal reforms of the age.[5] Moreover, the Married Women's Property Acts were conceived in the interests of wider legal reform and the pro-tection of property as well as in the interests of women; they affected relatively few women and the protection they offered was often more nominal than real.[6] Had it been possible to treat venereal disease effectively by the medical methods then emp-loyed, or had the support of working-class men not been secured,[7] the struggle over the Contagious Diseases Acts would

probably have been a much longer and even more arduous affair.

Women had gained little by the start of the 1890s in terms of destroying the legal essentials of male superiority, and their progress during the decade was limited. Their access to divorce was unequal, though their need to escape the domination of a tyrannical spouse was undoubtedly greater than men's. They could vote and sit as members of various local government bodies, but on conditions which ensured that women members would not exceed a small minority. Moreover, local government lacked the glamour and prestige of membership of the House of Commons, which women's suffrage groups at this time did not generally demand. There was no legal key which could turn the locks preventing access to degrees at the ancient English universities, admission to the legal and other professions, and membership of the many learned and professional societies which excluded women (the British Association and the British Medical Association, however, were among the bodies which began to admit women in the 1890s). Despite the claims that the nineteenth century had been the 'woman's century' and the tributes paid by legal men to the improved position of married women,[8] the legal inferiority of married women remained largely intact. Moreover, as Elizabeth Wolstenholme Elmy pointed out, the actions of judges and other officials 'par[ed] down the rights and liberties of women in almost every direction'.[9]

A wife's legal rights were greater in the 1890s than previously. She enjoyed not only control of her own property in most circumstances but a measure of protection against her husband's physical brutality. Since 1878 she had been entitled to a separation order and to the payment of maintenance in cases of aggravated assault, and since 1886 to maintenance if she was deserted by her husband. These measures were strengthened and consolidated in 1895.[10] On the other hand if she had property of her own she was responsible for the maintenance of her husband, as he was for her, and children and grandchildren also became a joint responsibility.[11] In general her legal gains did little to alter her position of inferiority to her husband, so that she could in consequence be unfavourably compared to the domestic servant or the unmarried working-class woman.[12] Although the obstacles posed by the law were probably less

severe than the psychological, economic, social and political barriers to equality, the subordination of women was a seamless web; the different aspects of oppression influenced and re-inforced each other.

A wife was in a somewhat stronger position in the 1890s with respect to her children as a result of the passage of the Guardian-ship of Infants Act in 1886. The act, however, has rightly been called a half measure,[13] and advocates of women's rights insisted with some justice that under its terms a married woman's children were not her own.[14] The heart of the act was left to interpretation by the courts, but while the mother's wishes were legally admissible for the first time and she was given the right of joint or sole guardianship of her infant children after her husband's death, their religion, education and upbringing were still to be determined by him. The case of religion presented a special difficulty, since courts would not normally permit a mother to bring up her children in a religion different from that of her dead husband, even if husband and wife had agreed such a course before their marriage.[15]

This being the case, Dora Montefiore had a relatively gentle introduction to the unequal rights of mothers and fathers, bruising though the experience naturally was to her. Born Dora Fuller in 1851, she married George Barrow Montefiore in Australia in 1879, where she had two children. Upon her husband's death in 1889 she found herself a widow in what was then the British colony of New South Wales, and remained there until 1892. As she wrote in her autobiography, it was not until after her husband's death that she understood the status of the contemporary widow. She visited a lawyer, who told her that as her husband had left no instructions about the guardian-ship of their children they would remain under her care. Restraining her anger she replied that her husband would never have thought of appointing anyone to act in her stead: '"As there is a difference in your religions," he continued grimly, "he might very well have left someone of his own religion as their guardian."' The lawyer went on to tell her that in law a married woman had no rights over her children. It was that incident, she wrote, which began her conversion to feminism.[16] It should be noted that the 1886 act had not been adopted in Australia at this time,[17] but it would have done little to protect a mother in the situation of Dora Montefiore. One can only guess at the number

of English women in the 1890s and later who were bullied or persuaded out of the nebulous rights conceded them under the act by an all-male legal profession.

The legal position of a wife *vis-à-vis* her husband at the start of the decade was illustrated vividly in the so-called Clitheroe case, *R. v. Jackson,* in 1891. The case, which has often received brief attention in histories of women, should be seen in its context as demonstrating not only the legal rights of wives, but also the vehemence of public reaction when an attempt was made to exercise them.

On 5 November 1887 Emily Emma Maude Hall and Edmund Haughton Jackson were married in Blackburn. Mrs Jackson, a woman of independent means aged over 40, married without the knowledge of her two sisters, who evidently concluded that the motive for the marriage was financial. Their suspicions were strengthened by the fact that Jackson left his wife in their care in Clitheroe and set off almost at once for London. On 10 November he sailed for New Zealand to establish himself in business. Either because of family pressure or because of his lack of success Mrs Jackson decided not to join him. Jackson returned to England in July 1888 to find that his wife now refused to leave the home of one of her sisters to live with him. A decree for restitution of conjugal rights obtained on 30 July 1889 failed of its object and Jackson now resorted to physical force. On 8 March 1891 he and two accomplices abducted Mrs Jackson as she was leaving church despite her violent struggles and the attempts of her sister to aid her. She was taken by her husband to his uncle's house in Blackburn, eleven miles away, and kept there against her will while legal proceedings were initiated.[18]

The Jackson case came at an appropriate time to clarify marriage law. Cochrane's case in 1840 had established that a husband could restrain his wife by confining her in the conjugal home. Justice Coleridge had declared in that case: 'There can be no doubt of the general dominion which the law of England attributes to the husband over the wife.' The judgment was weakened but not reversed by the Leggatt case of 1852, in which the Court of Queen's Bench refused to direct a wife to return to her husband's home. The law had not been tested by further cases and Richard Henn Collins, Jackson's QC who became a high court judge shortly after the case, argued plausibly that

54

each case had to be judged on its merits.[19] The position was not basically altered by the institution of a legal procedure for obtaining divorce in 1857, or by the introduction of legal separation and maintenance in 1878. It was not for over thirty years after Leggatt that a real measure of freedom for the unhappy spouse, usually the wife, was secured by the passage of the Matrimonial Causes Act of 1884. Under its terms a decree for restitution of conjugal rights could not be enforced by arrest and imprisonment of the spouse. Instead, non-compliance was to be dealt with by periodic payments, a property settlement, a separation order or, in aggravated cases, by divorce. Thus at the time of the Jackson case the law seemed to stand in favour of a wife who sought freedom, but this assumption had not been confirmed in the courts. It could be and was argued by Collins that if the court's right of attachment had been removed the husband's had not been. He also claimed that Mrs Jackson had not been imprisoned but rather confined in her husband's house, of which she had full run.[20]

The Jackson case came before the Queen's Bench on 16 March 1891. There the judges found against Mrs Jackson. Sir Lewis Cave felt that she had been wrong to refuse to live with her husband after the grant of a restitution order and deplored the 'very mistaken conduct' of her sisters. Jackson had acted within his rights. Sir Francis Jeune, husband of Mary Jeune the writer, charitable worker and hostess concurred, saying that 'where the relations are those between husband and wife, there may be a detention which is not illegal'.[21]

The case then went to the Court of Appeal where, after seeing Mrs Jackson, the three judges delivered a unanimous verdict which vindicated and freed her. The emphatic character of their judgment is a significant feature of the case. Lord Halsbury, Lord Chancellor in the Conservative government of the day, declared that a husband could not forcibly imprison his wife and that he was reluctant to believe that such a right had ever existed. In a notable display of the intransigent adherence to conviction for which he was to become celebrated[22] he compared the Jackson case with slavery, a once-accepted institution now universally condemned: 'In the same way, such quaint and absurd dicta as are to be found in the books as to the right of a husband over his wife in the matter of personal chastisement are not, I think, now capable of being cited as

authorities in a court of justice in this or any civilised country.'
He went on to brush aside the notion that a husband retained a
power to imprison his wife denied to the courts by the 1884 act:
'I am of opinion that no such right exists or ever did exist.' His
two fellow judges were as emphatic as Halsbury in their judg-
ments, though their language lacked something of his exuber-
ance. Lord Esher, Master of the Rolls, asserted that Collins's
claim that Mrs Jackson was confined rather than imprisoned
was 'a refinement too great for my intellect'. Sir Edward Fry
said that the result of Cochrane's and Leggatt's cases had been
to leave the law in doubt, but that since the 1884 act it was in
doubt no longer.[23]

The aftermath of the case was also significant. On one level it
was a victory for married, and indeed for all women, and was
hailed as such. The *Law Times* called it 'the charter of the
personal liberty of married women', and the *Englishwoman's
Review* expressed its pleasure that a husband was no longer a law
unto himself in relation to his wife. Nearly fifty years later Sylvia
Pankhurst recalled the case as a significant event of her child-
hood.[24] But on another level it was less obvious that women had
gained a great victory. Legal opinion was divided, and there
were questions in Parliament, where Lord Winchilsea said that
certain magistrates were now refusing to make separation or
other orders to protect married women and Lord Esher claimed
that the case had been 'more misunderstood than any judgment
I recollect'.[25]

Press opinion was also divided, and vocal popular opinion
sided with Jackson as *The Times* predicted in the immediate
aftermath of the case: 'The decision, we fear, will not be very
popular at Blackburn, where somewhat primitive ideas prevail
as to the rights of man and the duties of woman.' This smug
metropolitan prediction was amply justified by the subsequent
behaviour of the rude northerners. A week after the hearing Mrs
Jackson returned to Clitheroe with her sister and brother-in-
law. Her train made a special stop at Gisburn so that the
remainder of the journey could be undertaken in the privacy of
a carriage. However, her return had been anticipated, and two
miles from Clitheroe her carriage was mobbed. The journey was
completed, but a large crowd gathered outside the house in
Clitheroe and police protection was required. The paper's
report continued:

Groans, hisses, and yells were given for Mrs. Jackson, and cheers, with the singing of 'He's a jolly good fellow', for her husband. The midnight scene was an extremely stormy and threatening one, the police being hard pressed to prevent violence. The crowd continued outside nearly the whole of the night.

Rioting subsequently took place in Clitheroe, the houses of Mrs Jackson's sisters being stoned and her effigy being prepared but not burnt. As the *Manchester Guardian* observed: 'Mrs. Jackson's return was far more exciting than her abduction.'[26] The bishop and the town clerk of Blackburn and other prominent local men lent their names to an appeal for funds for Mr Jackson to take his case to the House of Lords, though in the event there was no further legal action. However, the appeal, together with the rioting at Clitheroe tended to 'confirm the belief', the *Blackburn Times* observed, 'that *everybody* in this district, from the highest to the lowest, is inclined to cast the blame on Mrs. Jackson and her abettors, rather than on the husband'.[27]

The popular reaction was doubtless enhanced by the opportunity offered for a night's revelry, at a time when popular disturbances were still a living tradition. But not all sensational events caused riots, and the rioters did not pick their side at random. It is interesting to speculate whether the Clitheroe riot was a late example of the 'rough music' meted out to those who transgressed the sexual norms of society.[28] The *Englishwoman's Review* pointed out that the decision had been popularly treated 'as if it amounted to a general setting loose of all ties of marriage', and correspondents in the press suggested that infringement of the rights of the dominant husband would result in the destruction of marriage and the ruin of society.[29]

Mrs Lynn Linton commented dramatically and predictably: 'Marriage, as hitherto understood in England, was suddenly abolished one fine morning last month! ... a deep shock of surprise and indignation is thrilling through the country.'[30] But Mrs Lynn Linton, like *The Times*, took the view that it was not possible simply to condemn the verdict, since as seen above she supported a wide extension of the grounds of divorce, while the paper acknowledged that the principle decided in the case was 'in harmony with modern feeling and modern legislation'. The Jacksons, however, remained married and Jackson remained responsible for his wife's debts. Was conservative opinion ready

to accept the logic of the case by extending the grounds of divorce?[31] The paper implied that it was not, and the government lost little time in confirming that the law of divorce was not to be altered.[32]

The impact of the Jackson case was thus ambiguous. Although it gave wives legal freedom of movement it also demonstrated the strength of opposition to equality within marriage and to judicial interference with the supposed rights of husbands. The *Manchester Guardian,* which hailed the bringing into line of the law with 'the modern conception of a just and decent relation between husband and wife', warned that its own sentiment might not be the majority view.[33] Like other women's victories in the period the case demonstrated how far the movement had still to travel.

'Not since the famous case of Mrs. Jackson, whose husband abducted her and carried her to his house by force, has there been so extraordinary a story as that of Miss Lanchester.'[34] Edith Lanchester was born in July 1871, the daughter of an architect and surveyor. She was educated at home and privately, at the Birkbeck Institution in scientific subjects, and at the Maria Grey College to prepare for teaching. She obtained a post, but her socialist convictions provoked conflict and she left the school. Having learned typing and shorthand she became a clerk in the City of London office of the Cardiff (New South Wales) Gold Mining Company. By 1893 she had left her parental home in Kingston and was lodging in Battersea with a working-class family named Gray. Mary Gray, like Edith Lanchester, was a member of the Marxist body the Social Democratic Federation. Lanchester stood as socialist candidate for the London School Board in the 1894 election, polling a low but respectable vote. As a convinced advocate of women's rights she challenged the ban on participation by women in the Battersea Parliament, a well-known local assembly. One recollection was that she had told the parliament, amidst uproar: 'I came here to fight for the rights of women. You men want educating.' She was also remembered, apparently by another socialist, as having 'a whole hive of bees in her bonnet. She wore her hair short, and walked with her hands in her jacket pockets.'[35]

None of the foregoing is especially remarkable, though social-

ist feminists of Edith Lanchester's strength of character were highly uncommon. What made her story a sensation was her family's violent opposition to her plan to live as an unmarried woman with her lover, James Sullivan, who was of working-class origin. Since the affair followed by some months the publication of Grant Allen's best-selling novel *The Woman Who Did*, whose plot bore a superficial resemblance to the Lanchester story, public interest was bound to be heightened. Fellow socialists, including Mrs Gray and Sullivan, attempted without success to persuade Lanchester to marry. Moreover, she was wholly uninfluenced by *The Woman Who Did*, which she had not read; she told journalists that she had advocated freedom from the marriage tie for some years before its publication. In view of the strength of her parents' opposition she and Sullivan agreed to emigrate within the next year to Australia.[36]

Lanchester's life with Sullivan was to have begun on 26 October 1895, despite the continued strong opposition of her family. On 25 October her father, Henry Jones Lanchester, and two of her brothers called at her lodgings after Mr Gray, a builder, had left for work. They were accompanied by Dr George Fielding Blandford, a leading mental specialist, who had been informed, he told the *British Medical Journal*, 'that she intended to go at once and live in illicit intercourse with a man in a station of life much below her own'. (One can speculate about the degree of opposition to the union had the man been of a higher social class and not borne an Irish name.) The doctor talked to Lanchester for half an hour. She told him that she would not marry Sullivan under any circumstances, that marriage was immoral and that if she married she would lose her independence. Blandford continued: 'I pointed out that if she had children and was deserted she would have very little independence, but she only replied that he would not desert her. She could, she said, earn her own livelihood if he did.' Her own version ran: 'The medical man, in the presence of two of my brothers, asked me if I would consent to marry Mr. Sullivan. I replied that I certainly would not, for I objected on principle to becoming the chattel of any man.'[37]

Dr Blandford pondered on the fact that there had been insanity in her family, and that she had, he was informed, 'always been eccentric, and had lately taken up with Socialists of the most advanced order'. Observing (with some justification)

59

'Dear, dear, I can do nothing with her', he signed a medical certificate to commit Lanchester to an asylum.[38] She was forcibly dragged from the Gray home into a carriage, one of whose windows she broke, and then to a private asylum in Roehampton. This was in accordance with the wishes of Henry Jones Lanchester, who had waited in an adjoining room while the examination was conducted.[39] He subsequently wrote to *The Times*: 'My opinion, and that of the family, is that the girl is, for the time being, not of sound mind, and that the effects of overstudy have predisposed her naturally impressionable temperament to be abnormally acted on by her self-imposed surroundings.' Dr Blandford explained that had she contemplated suicide he would unhesitatingly have certified her, and that this type of 'social suicide' equally justified certification.[40]

The high-handed action of family and doctor led to a furious reaction, led by the socialist comrades of the embattled pair. Oswald Dawson and the Legitimation League were also actively engaged in the struggle, the self-professed extreme individualist Dawson happily championing the cause of the socialist Lanchester.[41] Sullivan appeared before the South-Western Metropolitan Police Court on the night of the abduction, where the magistrate told him that the court was powerless to assist him and that he would have to apply to the high court.[42] Shortly afterwards John Burns, MP for Battersea and a former member of the Social Democratic Federation intervened, and after four days in the asylum Edith Lanchester was released by an order of two Commissioners in Lunacy. The Commissioners pronounced her 'very foolish' but 'perfectly sane'.[43]

Public reaction to the affair was mixed. The *Daily Telegraph* called Lanchester 'this wretched girl' and castigated her in offensive terms. The *Standard* thought that the Lanchester family should be 'commended rather than blamed'.[44] Other adverse opinion was based on practical rather than moral grounds. A correspondent wrote to *The Star* to say that if the Lanchester-Sullivan relationship ended the ultimate support of any children, beyond a few shillings a week from their father, would fall on their Lanchester grandfather. Another correspondent asked what right Edith Lanchester had to inflict the disadvantages of bastardy on her children, while a third declared that if Sullivan tired of the relationship Lanchester

would have had to choose between the workhouse, starvation or prostitution.[45]

Much published comment, however, expressed the view that however mistaken Edith Lanchester might have been in refusing to marry she should be left to conduct her life free from legal sanctions. She had been certified insane, it was noted, for daring to act on opinions at variance with accepted morality; Dr Blandford had himself warned in his standard work on *Insanity and its Treatment* (1st edn 1871, 4th edn 1892) that the opinions of fathers were sometimes untrustworthy, that unusual views about religion or politics were not madness and that the medical practitioner must be concerned with irrationality rather than immorality.[46] A correspondent in *The Star* pointed out that if an opponent of marriage could be 'so easily put away', perhaps an opponent of meat-eating like George Bernard Shaw or an opponent of Toryism might also be at risk. The SDF weekly *Justice* commented that if everyone who opposed or infringed the marriage laws were judged insane, 'a very large part of the community' would be in danger of incarceration. Both the medical weeklies, the *British Medical Journal* and *The Lancet*, expressed their concern that a breach of social convention had been treated as insanity.[47]

The point was not lost that the offender was an adult woman. The *Saturday Review* said that the case had demonstrated in outrageous fashion the extent of women's inequality, and demanded the reform of the lunacy laws. Herbert Burrows, a well-known socialist active in the case, commented (in the words of *The Star*): 'The question is not whether she was right or wrong in her opinions; it is whether a woman of 24 has the right calmly and deliberately to form an opinion and act upon it just as a man is allowed to do without question.' The paper was itself of the same opinion: 'Now are we, or are we not, a logical people? If so, what is sauce for a girl is sauce for a man.' Lanchester, it argued, should have had the protection of habeas corpus against her captors.[48]

Her release was greeted jubilantly. 'Shoals' of congratulatory letters arrived at the Gray home. A wide range of opinion, however, extending from *Justice* (though not a number of its correspondents) to the feminist *Woman's Signal* thought that the couple would have been wise to marry, given the conventions of existing society.[49] The affair did not recede from public

prominence before the Marquess of Queensberry, another notorious offender against convention, had written to Sullivan supporting Edith Lanchester's stand against marriage but advising that the couple should go through a legal ceremony which they could later repudiate: 'It is not fair to the woman to place her in such a position, to say nothing of the children of such marriage [sic].' He offered Lanchester £100 as a wedding present, a sum which must have equalled about two-thirds of the couple's joint annual income. Even Oswald Dawson cheekily advised them to accept Queensberry's offer as an advertisement for the Legitimation League.[50]

Released from the public eye the couple lived modestly in South London, Sullivan working as a commercial clerk. They had two children and neither married nor emigrated. One of the children, Elsa, became a well-known actress and wife of the actor Charles Laughton. There was no reconciliation with the elder Lanchesters, and Edith Lanchester paid a considerable price, at least financially, for her fidelity to priciple.[51]

There was a significant difference between the Jackson case and the Lanchester affair. The former enunciated an important new legal principle, while the latter moved some way towards ensuring that the existing law should not in practice be used more stringently against women than against men. But the two cases also had marked similarities. In both a woman refused to accept existing legal and social conventions with respect to marriage, despite the forcible attempts of men to preserve their claimed rights. Both vindicated women and marked definitive settlements of points of principle. Both also showed that, despite the presence of vocal support, women had to be courageous almost to the point of martyrdom if they were to exercise the same rights as men in law and in social usage. Only a woman of rare courage or obstinacy was likely to make the attempt.

The Jackson and Lanchester cases were sensational demonstrations of the boundaries of women's rights in the 1890s. An increasingly enlightened public opinion accepted that in many respects the rights of the two sexes should be equal. But the violent opposition of the ignorant and prejudiced, and the timorous warnings of the conventional and the prudent were never far below the surface. Their counsels of despair and

inertia found much support among the respectable; emancipated women and their supporters were still too few to secure unequivocal triumphs.

Notes

1. An historical account of women's legal rights is needed to supplement Erna Reiss's admirable but dated *Rights and Duties of Englishwomen* (Sherratt & Hughes, Manchester, 1934). The third edition of W. P. Eversley, *The Law of the Domestic Relations* (Stevens & Haynes, London, 1906), part I, esp. ch. IX, provides a comprehensive and relatively readable account of the legal position of married women at the beginning of the twentieth century. *See also* A. B. W. Chapman and M. W. Chapman, *The Status of Women under the English Law* (Routledge, London, 1909), section III.

2. Elie Halévy, *A History of the English People: Epilogue vol. II* (1932; English translation: Benn, London, 1934), p. 488.

3. For the Married Women's Property Acts of 1870 and 1882, see Lee Holcombe, 'Victorian wives and property: reform of the married women's property law, 1857-1882', in Martha Vicinus (ed.), *A Widening Sphere* (1977; Methuen, London, 1980), ch. 1, and Lee Holcombe, *Wives and Property* (Martin Robertson, Oxford, 1983), chs. 7-9. For the repeal of the Contagious Diseases Acts see Judith Walkowitz, *Prostitution and Victorian Society* (Cambridge University Press, Cambridge, 1980).

4. For which see Reiss, *Rights and Duties,* pp. 137-43; Holcombe, *Wives and Property,* pp. 222-8; Jane Lewis, *Women in England 1870-1950* (Wheatsheaf, Brighton, 1984), pp. 78, 122.

5. *See* Holcombe, 'Victorian wives and property', pp. 22-7; Holcombe, *Wives and Property,* pp. 195-7, 206-7; Walkowitz, *Prostitution and Victorian Society,* pp. 99-104. A married woman's rights to control her property was further strengthened by acts passed in 1884 and 1893.

6. Holcombe, *Wives and Property,* pp. 8-13, 33-5, 65, 152, 206-7: R. J. Morris, 'The Married Women's Property Act of 1870', Social History Society *Newsletter,* 5 (1), (1980), pp. 4-5; also R. J. Morris, 'Men, women and property' (unpublished paper). *See* Carol Smart, *The Ties That Bind* (Routledge & Kegan Paul, London, 1984), ch. 2.

7. Walkowitz, *Prostitution and Victorian Society,* pp. 50-3, 102, 170. Mercury, the principal cure for syphilis in the nineteenth century, was a remedy of doubtful efficacy.

8. Writing in *A Century of Law Reform* (Macmillan, London, 1901), W. Blake Odgers commented: 'Now a wife is in a position of almost complete equality with her husband' (p. 20). The verdict of Montague Lush was: 'It is not that there has been an alteration, but a revolution in the law' (*ibid.,*

p. 342). The feminist *Humanitarian,* however, thought that the term 'the Woman's Century' would probably be more applicable to the twentieth century than to the nineteenth (18 (1901), p. 61).

9. 'Ignota' (Elizabeth Wolstenholme Elmy), 'Judicial sex bias', *Westminster Review,* 149 (1898), pp. 147-60, 279-88. The quotation is from p. 149.

10. Reiss, *Rights and Duties,* pp. 67-9; O. R. McGregor, *Divorce in England* (Heinemann, London, 1957), p. 23 & n.; O. R. McGregor, Louis Blom-Cooper, Colin Gibson, *Separated Spouses* (Duckworth, London, 1970), pp. 15-16, 60.

11. Holcombe, 'Victorian wives and property', p. 25; Holcombe, *Wives and Property',* p. 203.

12. M. E. Browne, 'Marriage and divorce', *The Humanitarian,* 10 (1897), pp. 29, 31, 99-100.

13. Reiss, *Rights and Duties,* p. 100.

14. Browne, 'Marriage and divorce', p. 99; Christabel Pankhurst, *The Great Scourge and How to End It* (E. Pankhurst, London, 1913), pp. 96-7.

15. Reiss, *Rights and Duties,* pp. 98-100.

16. Dora B. Montefiore, *From a Victorian to a Modern* (Archer, London, 1927), pp. 30-1.

17. P. E. Joske, 'Family Law', in G. W. Paton (ed.), *The Commonwealth of Australia: the Development of its Laws and Constitution* (Stevens & Sons, London, 1952), p. 155. An act resembling the British act of 1886 had been passed in the colony of Victoria in 1883 (Charles H. Pearson, *The Present Position of Women in Victoria* (Women's Emancipation Union, Congleton, 1893), p. 1).

18. *The Times,* 10 and 17 March 1891; 1 Q.B. (1891) 672-4; *Law Times Reports,* 64 n.s. (25 July 1891), pp. 679-81.

19. Reiss, *Rights and Duties,* pp. 45-8; 1 Q.B. (1891) 674; *Law Times Reports,* 64 n.s. (25 July 1891), p. 682.

20. Reiss, *Rights and Duties,* pp. 48-9; 1 Q.B. (1891) 675-7; *Law Times Reports,* 64 n.s. (25 July 1891), pp. 681-2.

21. *ibid.,* pp. 679-80.

22. Lord Halsbury was to lead the 'diehards' in the House of Lords against the Parliament Bill of 1911; he was then aged nearly eighty-eight. For an account of his life and character see Alice Wilson Fox, *The Earl of Halsbury Lord High Chancellor* (Chapman & Hall, London, 1929); the Jackson case is discussed on pp. 136-9. A shorter, more analytic account is provided by R. F. V. Heuston, *Lives of the Lord Chancellors 1885-1940* (Clarendon Press, Oxford, 1964), esp. pp. 68-75.

23. *Law Times Reports,* 64 n.s. (25 July 1891), pp. 682-5; 1 Q.B. (1891) 678-86; *The Times Law Reports,* 7 (1890-1), pp. 386-8.

24. *Law Times,* 28 March 1891, p. 386; *Englishwoman's Review,* 22 (1891), p. 107; Sylvia Pankhurst in Margot Asquith (ed.), *Myself When Young* (Muller, London, 1938) p. 267.

25. *Parl. Deb.,* 3rd ser., 352 (16 April 1891), cols 641-2.

26. *The Times,* 20, 28, 30 March 1891; *Manchester Guardian,* 28, 30 March 1891: *Clitheroe Times,* 3 April 1891.

27. *Blackburn Times,* 4 April 1891; *Clitheroe Times,* 3 April 1891.

28. E. P. Thompson, '"Rough music": le charivari anglais', *Annales*, 27 (1972), pp. 285-312. Graham Johnson suggested this point to me.
29. *Englishwoman's Review*, 22 (1891), p. 107; Charles M. Beaumont, *Marriage and Money* (Elizabeth Wolstenhome Elmy, Congleton [1891], p. 1 (reprinted from *Red Tape*, April 1891).
30. Eliza Lynn Linton, 'The judicial shock to marriage', *Nineteenth Century*, 29 (1891), p. 691.
31. *The Times*, 20 March 1891.
32. *Parl. Deb.*, 3rd ser., 352 (20 April 1891), col. 921.
33. *Manchester Guardian*, 20 March 1891; also Matilda M. Blake, 'The lady and the law', *Westminster Review*, 137 (1892), p. 367; Mabel Sharman Crawford, 'Maltreatment of wives', *ibid.*, 139 (1893), p. 297.
34. *Woman's Signal*, 31 October 1895, p. 280.
35. *The Times*, 24 November 1894; *The Star*, 26 and 28 October 1895; Oswald Dawson (ed.), *The Bar Sinister and Licit Love: the First Biennial Proceedings of the Legitimation League* (W. Reeves and Geo. Cornwell, London and Leeds, 1895), pp. 272, 281, 293-4; Joseph Edwards (ed.), *The Labour Annual: 1896* (Clarion, London (etc.) [1895]), p. 60.
36. *The Star*, 26, 28, 30 October 1895.
37. *Daily Telegraph*, 30 October 1895; *The Star*, 26 October, 1 November 1895; *British Medical Journal*, 2 November 1895, p. 1127; Dawson (ed.), *The Bar Sinister*, p. 297.
38. Under s. 11 of the Lunacy Act, 1890, a medical certificate signed by a single doctor validated for a period of seven days an urgency order signed by a relative. In this case a certificate was signed by a second doctor three days later (*British Medical Journal*, 2 November 1895, pp. 1127-8).
39. *Daily Telegraph*, 30 October 1895; *The Star*, 30 October, 1 November 1895; *British Medical Journal*, 2 November 1895, p. 1127.
40. *ibid.*; *The Times*, 31 October 1895.
41. Dawson (ed.), *The Bar Sinister*, p. 262; Edwards (ed.), *Labour Annual: 1896*, pp. 59-60.
42. *Daily Telegraph*, 28 October 1895; *The Times*, 28 October 1895.
43. *The Star*, 30 October 1895; *The Times*, 30 October 1895; William Kent, *John Burns: Labour's Lost Leader* (Williams & Norgate, London, 1950), pp. 73-5.
44. *Daily Telegraph*, 31 October 1895; *The Standard*, 30 October 1895.
45. *The Star*, 30 October, 1 November 1895.
46. George Fielding Blandford, *Insanity and its Treatment* (1871; 4th edn, Oliver & Boyd, Edinburgh, 1892), pp. 485, 489; Dawson (ed.), *The Bar Sinister*, p. 287.
47. *The Star*, 29 October 1895; *Justice*, 2 November 1895, p. 1; *British Medical Journal*, 2 November 1895, pp. 1114-15; *The Lancet*, 9 November 1895, pp. 1175-6.
48. *Saturday Review*, 2 November 1895, pp. 569-70; *The Star*, 29 October 1895. Burrows supported the abolition of legal marriage, advocating not 'free lust' but 'free monogamy' (*Fabian News*, July 1895, p. 18).
49. *Justice*, 2, 9, 16 November 1895; *Woman's Signal*, 31 October 1895, p. 280, 7 November 1895, pp. 296-7; *The Star*, 31 October 1895.
50. *The Star*, 30, 31 October 1895; Dawson (ed.), *The Bar Sinister*, pp. 269-70.

51. Elsa Lanchester, *Charles Laughton and I* (Faber, London, 1938), pp. 26-7, 33; Elsa Lanchester to author, 1 June 1980. The baby Elsa, born on 28 October 1902, was registered as Elsa Sullivan. She was married on 10 February 1929 as 'Elsa Sullivan professionally known as Elsa Lanchester'.

II. WOMEN AND EMPLOYMENT

6

Salaried ladies

By the late nineteenth century the employment of women in urban, industrial occupations was a well established feature of the nation's economic life. In contrast to France and the United States[1] the proportion of employed women varied little between 1871 and 1911. Rather over 25 per cent of the female population engaged in paid employment and women composed about 30 per cent of the workforce, though both figures declined slightly towards the end of the period.[2] It was not employment as such, but its changing distribution which was the most remarkable feature of the 1890s.

One approaches census returns in the period with caution. Categories were subject to constant reclassification, and the figures themselves are of doubtful trustworthiness, as the census compilers were the first to admit.[3] Nonetheless, in broad terms one may regard the categories and in particular the trends as suggestive.

Throughout the sixty-year period from 1851 women's employment fell predominantly into three sectors of the economy; domestic and related services, textiles, and the clothing industry. The proportions employed in these occupations fell steadily as others were developed and opened to women, but as late as 1911, 70.6 per cent of employed British women still worked in these fields.[4] Figures drawn from the censuses of England and Wales in 1891 and 1901 show that nine out of ten employed women in 1891 and seven out of eight in 1901 worked in only five broad categories, no other in either year employing as many as 100,000 women (table 1).

The proportion of occupied females over the age of ten declined from 34.4 per cent to 31.6 per cent in these years, a decline explained by the census compilers in 1901 partly in terms of an exceptional method of classifying domestic servants in 1891. In 1911 the proportion rose to 32.5.[5] There may, however, have been a slight decrease in the overall proportion of employed women after 1891, though crude numbers continued to rise as population increased.

Women and employment

Table 1: Women's occupations in England and Wales, 1891 and 1901

| | 1891 | | 1901 | |
	Number	Percentage	Number	Percentage
Domestic offices or services	1,715,236	43.5	1,690,686	40.5
Dress	685,814	17.4	711,786	17.1
Textile fabrics	659,542	16.7	663,222	15.8
Food, tobacco, drink and lodging	259,051	6.6	299,518	7.2
Professional occupations	242,703	6.1	294,642	7.1
Total in these occupations	3,562,346	90.3	3,659,854	87.7
Total occupied	3,945,580	100.0	4,171,751	100.0

Source: *Seventeenth Abstract of Labour Statistics of the United Kingdom* (P.P. 1914-16, LXI, Cd. 7733), pp. 304-7.

Contemporaries were impressed by the growth of the number of women employed in middle-class occupations. A.L. Bowley later analysed this growth, drawing a broad distinction between manual and non-manual employment and classifying all clerks, professional and some ancillary workers, farmers and most shop assistants as middle class:

Table 2: Employment in middle-class and working-class occupations, 1881-1911

| Occupation by | Percentage of employed workers | | | | Percentage increase | |
| Social class | 1881 | | 1911 | | 1881-1911 | |
	Men	Women	Men	Women	Men	Women
Middle-class	21.5	12.6	25.0	23.7	72	168
Working-class	78.5	87.4	75.0	76.3	41	24

Source: A.L. Bowley, *Wages and Income in the United Kingdom since 1860* (Cambridge University Press, Cambridge, 1937), pp.127-9.[6]

The changing pattern of employment was analysed in a report made to the Board of Trade in 1894 by Clara Collet, its correspondent on female employment and as such a product of

the developments which she was one of the first to study. A London University graduate and a former schoolmistress who had been employed by Charles Booth (1888-92) and by the Royal Commission on Labour (1892-3) to report on the employment of working-class women,[7] Clara Collet was an authoritative figure in her field and a good example of the educated woman of the period. She pointed out that the wives and daughters of low-paid wage-earners had always been obliged to form part of the family labour force. This situation was now beginning to change:

> As men's earning power increases, it becomes possible for the family to be supported by the husband's earnings, and the greater comfort thus obtained in the home creates a general feeling that the wife at least should abandon bread-winning.

In the middle class, on the other hand, increased production and the advent of machinery had increased fathers' incomes and reduced the need for daughters to work in the home:

> In the middle class, therefore, a high standard of comfort, a smaller field for domestic usefulness, a diminished probability of marriage, apprehension with regard to the future, have all combined to encourage the entrance into the labour market of middle-class girls.[8]

If supply was increasing, so too was demand. The expansion of commercial and financial occupations in which the typewriter and shorthand were now common, the growth of the civil service, the establishment and expansion of nursing as a profession and the improvement of both elementary and secondary schools in the later nineteenth century gave unprecedented opportunities to women from middle-class homes, especially to the products of the reformed education system.[9] Striking innovation and remarkable progress were obvious features of women's salaried employment in the 1890s. It was easy to overlook the basis of exploitation on which they rested.

The first woman sanitary inspector was appointed as a 'workroom inspector' in Nottingham in 1892, the first two women factory inspectors in 1893, and a number of women obtained positions as inspectors and organisers in education and other fields. In 1892 four women were appointed 'lady assistant commissioners' by the Royal Commission on Labour; they included both Clara Collet and May Abraham, who was shortly

to become one of the first women factory inspectors. Three women were appointed to full membership of the Royal Commission on Secondary Education in 1894 and other women became members of committees of enquiry appointed by government departments. Women students entered the Swanley Horticultural College from 1891, and a number of former students found prestigious employment, including positions at Kew Gardens. More women found posts in libraries, and women journalists, a much discussed group, made an unprecedented impact. As for women clerks, they seemed to be, as Georgiana Hill wrote in 1896, 'everywhere', apart from certain government departments. They were found in the post office, in insurance and railway companies, in large businesses and in many different societies.[10] Their employment was stimulated by the growing availability and popularity of the typewriter, a machine which as Lee Holcombe notes was, with little logic other than the routine nature of the work and the lack of opportunity for promotion associated with its use, identified with women from its inception.[11]

A remarkable snapshot was taken early in the new century by an Englishman who styled himself 'an Old Oriental'. He had left England for the East in 1874, and apart from a visit of a few months in 1888 remained abroad until the beginning of 1904. Even allowing for defects in his vision and for the natural shock to such a Rip Van Winkle after his long absence, it is difficult not to be impressed by his description of 'the woman at work':

> So far as I remember in days gone by the only lines of employment open to girls or women were: teaching, assisting in a shop, dress-making, or bar-keeping. In these days there is hardly an occupation, or even a profession, into which a girl may not aspire to enter. Type-writing provides a living for many thousands, perhaps hundreds of thousands. There are women newspaper reporters almost as numerous as men. Accountants and book-keepers crowd the trains morning and evening, going to and from their work, while many branches of postal, telegraph and telephone work are entirely managed by women, as also are photographic studios. Sixteen years ago the A.B.C. refreshment rooms were in their infancy. Now they are counted by the hundred, each with a staff of from ten to fifteen girls. Hardly a district but has its lady doctor, and some of these have risen to great eminence. Girls of every rank think no more of

riding a bicycle through the busy thoroughfares of London, than than they do of going into an A.B.C. shop for a cup of tea. Go back to 1875, and try to think, if you can, what would have been said of a woman riding a bicycle down Piccadilly on a June afternoon.[12]

Most of the writer's comments were accurate, and most of the changes had taken place since his short stay in England in 1888. But to educated women in the 1890s attempting to establish themselves in professional careers life seemed less rosy. A more balanced account of their experiences emerges in their memoirs. Janet Courtney, for example, was as Janet Hogarth a student at Lady Margaret Hall, Oxford, from 1885 to 1888. After a spell as a teacher she took a post as a clerk with the Royal Commission on Labour, living with her sister in one of the first residential chambers catering for professional women. She enjoyed the work and the company of the unusually talented group of women with whom she shared an office, but she pointed out that their qualifications and their command of foreign languages would have brought them much higher salaries had they been men, a point tacitly acknowledged by the clerk of the Commission, Geoffrey Drage, in the course of a glowing tribute to his women workers in 1894.[13] She recalled an occasion late one August when she had lunched on a penny bun on a public seat in St James's Park, too poor to hire a chair. But with her family in the country, her acceptable lodgings and her regular salary due two days later she was more fortunate than many others. From the Labour Commission she went on to become first superintendent of women clerks at the Bank of England; she recalled their work as characterised by soul-destroying boredom and low salaries.[14]

Janet Courtney emphasised that many problems of middle-class women workers remained unchanged when she wrote her autobiography over thirty years later. Indeed, some aspects remain depressingly familiar after a century. Margaret Fletcher, who was born in 1862 and studied art in the 1880s, recalled a sobering visit to John Ruskin, who advised women artists to choose between art and love. She continued: 'When a man artist marries, he acquires a housekeeper, a model, a brush-washer, and perhaps a publicity agent. When a woman artist marries, with rare exceptions she perishes as an artist, gradually and perhaps painlessly.' Laura Knight and Annie Swynnerton,

who alone among women of the period eventually become Royal Academicians, married artists and remained childless. Margaret Fletcher's own artistic career suffered from the family responsibilities which gradually blighted the hopes of all her women fellow students.[15]

Some women workers surrendered their careers upon marriage with little sign of regret. As Carol Dyhouse points out, the educationist Molly Thomas, author (as M. V. Hughes) of an entrancing autobiography, gave up an excellent job when she married in 1897, apparently without a pang.[16] Edith Read (later Read Mumford) was more ambiguous in describing the end of her career. She was in the process of applying for a position as a university extension lecturer (and facing the strong opposition of the economist Alfred Marshall to the appointment of a woman) when she withdrew her application upon her marriage in 1895. Her husband, a Manchester doctor, opposed her tentative plan for an independent career, and in consequence she gave it up, a decision which she claimed involved her in 'no denial'. She wrote of herself in revealing terms: 'To continue with the lecturing she had planned would have been a lonely task for her, for labour questions were not in her husband's line.'[17]

Grace Chisholm had outstanding mathematical talent. She capped a brilliant student career in England with the first German doctorate awarded to a woman, a distinction achieved in 1895. She married William Henry Young in 1896, despite her inclination to remain single in the interests of her career. The couple had a uniquely successful mathematical partnership, though Young had achieved little before his marriage. Their research was undertaken in common, but most of the resulting publications bore W. H. Young's name. Early in their married life he wrote to his wife:

> The fact is that our papers ought to be published under our joint names, but if this were done neither of us get the benefit of it. No. Mine the laurels now and the knowledge. Yours the knowledge only At present you can't undertake a public career. You have your children. I can and do.[18]

Grace Chisholm Young achieved professional recognition, but while marriage handicapped her professionally, her husband benefited greatly.[19]

Finding an acceptable home and travelling to work posed much more acute problems for women workers than for men, to whom questions of class, money and gender were not omnipresent. Five hundred salaried women workers living in London who replied to a Women's Industrial Council survey published in 1900 paid an average annual rent of £28. 4s., 21.9 per cent of their average salaries of £128. 19s.[20] They told of the loneliness and depression of life in lodgings,[21] a point stressed by the author Gilbert Parker in a paper to the International Congress of Women in 1899. Parker presented a picture of a garret room whose occupant sat 'on her trunk with her feet under the washstand, or on the side of the bed, [as] she eats her leathery chop and her cold potato, and drinks the glass of stale water'.[22] Loneliness was accentuated if a woman's working colleagues were unsuitable companions for her leisure hours.[23]

Alice Zimmern pointed out that educated men could if need arose live in a workman's lodging-house but that ladies required respectable accommodation providing privacy and the appurtenances of a home, which might involve considerable expense.[24] Evelyn March-Phillipps, who like Zimmern was a journalist and writer, pointed out that in cases in which the home consisted of a single room cheap amusement must be sought in the streets. This could lead to undesirable results: 'I knew a handsome, high-spirited girl, who was receiving visits in her bed-sitting room from a man whose acquaintance she had made on the underground railway.' Girls as young as seventeen were 'thrown with little or no protection into the maëlstrom of London life'.[25] The result might be freedom and self-realisation, but it might also be a catastrophic pregnancy.

A popular solution to these difficulties, strongly supported by Gilbert Parker, was the provision of ladies' residential chambers. Accommodation of this type existed in London from the early 1890s, but rents were high and tenants often subject to petty restrictions and inconveniences. One woman told the Women's Industrial Council that none of the chambers were 'such as a woman of real education, experience, spirit and independent character can long endure'.[26] For the young Molly Thomas, however, such accommodation seemed 'the promised land' after her boarding-house and flat life. The main regulation was that nails should not be driven into walls. Meals in the

common dining room were productive of conversation and friendship with interesting women, including artists, authors and political workers.[27]

Few young women were so fortunate. Evelyn Sharp left a sheltered country home in 1894 to move into a hostel in Bloomsbury with little money and much ignorance. Her brother had terrified her with warnings about solitary life in London but had offered her no practical advice. Sharp was able to surmount her initial difficulties through success as a writer,[28] but some difficulties could not be surmounted. The most important of these was the unwelcome attentions of men. Dorothy Peel, later a well-known writer, was dress editor of *Hearth and Home* in the mid-1890s, working at an office close to Fleet Street. She later recalled: 'Although I was quietly dressed, and I hope looked what I was, a respectable young woman, there was scarcely a day when I, while waiting for an omnibus, was not accosted.'[29] Elizabeth Robins, the American-born actress and novelist who spent much of her life prosecuting feminist causes in England, did not escape the common experience of women of the period. Her autobiography contains a graphic account of the problems of young professional women in London in the 1890s, subject to molestation in hotels and boarding houses, in the street and even in church. Properly brought up young women had been taught to please men, but lived in fear of the consequences of so doing: 'It is astonishing to me to look back and see how even I was infected.'[30]

Even in the 1890s women of the wealthier classes often had great difficulty in persuading their families that they should be allowed to work for a living. The Royal Commission on Secondary Education (the Bryce Commission), reporting in 1895, noted with approval that belief that a girl should be educated 'like a boy ... to earn a livelihood, or, at any rate, to be a more useful member of society', had become more general. But the comments of the commission's own staff were less encouraging. Reports from Devonshire, Norfolk, Warwickshire and Yorkshire agreed that parents undervalued the secondary education of their daughters because they did not anticipate that girls from affluent homes would ever need to seek employment. Even some headmistresses, Frances Kitchener wrote from Lancashire, 'seemed to think I was casting some slur on their school by suggesting that any "career" was possible for their pupils,

except that of fashionable and accomplished young ladies in good society'.[31]

This aspect too finds its place in memoirs. When Rose Squire decided at the age of thirty-two to find a job she was conscious of a break with the values of her girlhood. Her choice of the sanitary inspectorate in 1893 involved her in extensive explanations and apologies to relations and friends.[32] Shortly afterwards Mary Warre-Cornish (later MacCarthy) decided on the same career, but family derision and lack of tuition put an effective end to her ambition.[33] Louisa Jebb's desire for higher education presents a chilling glimpse of the late Victorian father. Himself a man of pronounced intellectual bent, Arthur Jebb opposed Louisa's desire for a university education. Higher education led to employment, and employment was reserved for unmarried women. In a letter to his wife in October 1891 Jebb wrote:

> I should say, if a girl were marked with small-pox and had good abilities, if she were short-sighted as to make spectacles a perpetual necessity and had great common sense, if she were to be obliged hereafter to gain her livelihood as a teacher at some sad seminary, then there might be something to be said for Cambridge.

But if this attitude was still common in the period, daughters were now increasingly prepared to insist on living their own lives. Louisa Jebb attended Cambridge and, after their father's death, her sister Eglantyne, the founder of the Save the Children Fund, studied at Oxford.[34]

Although the 1890s were characterised by increased opportunities for middle-class women seeking employment, few found work which offered generous salaries and congenial working conditions. Many took up teaching,[35] and in the lower ranks of the middle class many women entered the socially ambiguous occupation of shop assistant. In elementary schools, whose staffs also lacked the status of the acknowledged middle class, women earned an average salary of £80 per annum in 1895, while men earned about £122.[36] In the secondary schools the range of salaries was wider and the variety of schools more complex than at elementary level. Evidence presented to the Bryce Commission suggests that the average disparity between men's and women's salaries may have been rather less than in elementary schools. The Commission was told, however, of cases of women

teachers being paid as little as £35 to £40 per annum; some young mistresses were dismissed as soon as experience had qualified them to request higher salaries.[37]

Low salaries and an inadequate pension system (which was improved in 1898[38]) made marriage not only an attractive alternative to teaching but an anxiously sought remedy, though many women were able to combine marriage and teaching.[39] The conference of the National Union of Teachers, whose membership was concentrated in elementary schools, was told in 1892 and 1893 of young women who had manifested their willingness to marry 'the first young man who proposes' to escape a penniless old age or intolerable working conditions.[40] (The same view was expressed in other lower-middle-class occupations. Clara Collet reported to the Royal Commission on Labour in 1893 that there was a sharp contrast between factory girls, many of whom insisted on continuing to work after marriage, and shop assistants, for whom marriage was 'their one hope of release'. One girl had told her that she would '"marry anybody to get out of the drapery business"'.[41])

Women teachers were particularly severely hampered by the operation of the English class system. The rural teacher faced problems of social distinction, usually being classed as 'neither lady nor woman', in Flora Thompson's words. The result was a combination of overwork and loneliness.[42] Girls from secure middle-class backgrounds seldom taught in elementary schools, whose staffs were generally drawn from much lower sections of the social scale.[43] A sprinkling of them did so in the 1890s, but the growth of schools which catered for children of both sexes, especially higher grade elementary schools, presented a further problem. Women were rarely made heads of such schools, thus restricting the opportunities of the 'young women of gentle birth and real culture' whom Frances Kitchener told the Bryce Commission were being persuaded to enter the elementary schools. 'But is it likely', she asked, 'that these women will continue to press into the ranks when they can never, however successful they may be, attain to any higher position than assistants to men, who, excellent teachers as they may be, are not of the sort with whom they are accustomed to associate?'[44]

Clerical work also attracted women of varying social backgrounds. Most accounts agreed that the occupation included three distinct classes. The 'superior' secretary, educated at a

high school and possibly at a secretarial school of a type which became common in London and provincial cities in the 1890s, knew at least one foreign language and could share in the administration of an organisation. This grade was generally paid about £2 a week in London, but could reach as high as £300 a year in exceptional cases. Such women, when employed in business firms, usually worked in strict isolation from their male colleagues. An intermediate grade, working in typing offices or commercial houses, was expected to be sufficiently educated to be able to improve an employer's ungrammatical prose. The salaries of this group in London offices ranged between £1 a week and a rarely attained £3. The third grade was the much despised typist, the product of the elementary school, who earned between ten and an exceptional thirty shillings a week.[45]

All kinds of clerical work shared certain features. The occupation was regarded as genteel, and normal hours, which extended from 9.00 or 10.00 a.m. until about 6.00 p.m., were not excessive. On the other hand, overtime could be frequent and sometimes unpaid. Sanitary accommodation was another drawback. It was often inadequate and sometimes non-existent.[46]

The central government employed an increasing number of unmarried middle-class women, particularly in the Post Office, which had long encouraged the employment of women telegraphists with the specific intention of attracting workers of a higher social class and lower salary than its existing male staff.[47] Despite the resentment of male staff the numbers of women civil servants continued to rise. By 1894 over a quarter of the Post Office telegraph staff, and by the end of the century 45 per cent of telephonists and telegraphists, and 25 per cent of civil service clerks were women.[48]

Although women civil servants were paid considerably lower salaries than their male colleagues, positions were eagerly sought, as 'a very El Dorado' in the words of two sceptical women authors.[49] It was reported in 1900 that eight or nine women applied for every vacancy in the Post Office.[50] The Tweedmouth Committee, whose investigation of Post Office conditions was published in 1897, observed complacently (or naively, as Margaret MacDonald suggested)[51] 'a general absence of complaint' from women employees. This conclusion was belied by their few women witnesses, who left no doubt about their dissatisfaction with their low salaries, inadequate

holiday entitlement and poor promotion prospects. Rose Garthwaite, a first-class telegraphist who had worked in the Post Office for nearly twenty-four years, pointed out that a senior category of male telegraphists could earn up to £190 per annum and enjoy a month's holiday, while women with greater responsibilities received no more than 38 shillings a week and three weeks' holiday. Reminded that men enjoyed superior pay and opportunities of promotion in other departments besides telegraphy, she replied: 'Yes, but it is not fair, is it?'[52]

The apparently spectacular gains made by a relative handful of middle-class women in the labour market in the 1890s often involved expensive and arduous years of training, the sacrifice of marriage and, in some cases, of a normal private life. Medicine was a case in point. Women enjoyed improved (but still grossly unequal) access to training facilities compared to earlier decades, their exclusion from the British Medical Association was ended in 1892 and the number of women doctors continued to rise.[53] Few women, however, possessed the financial and human resources required for success in the profession. An 'eminent lady doctor' wrote in 1895 that a five-year medical training cost about £1,000 in fees and living expenses, and that it would be followed by a year or two of poorly paid employment.[54] Elizabeth Garrett Anderson, the most prominent medical woman of her day and dean of the London School of Medicine for Women, agreed with a questioner at an 1897 lecture that the 'young lady doctor' would do well to earn £100 to £150 in her first year of general practice and that she would intially need the financial support of her father.[55]

Dr Caroline Latimer must have discouraged many of her readers from training for general practice, for as Mary Paley Marshall pointed out in the *Economic Journal*, she left no doubt that the life was 'too great a strain for the average woman'. Latimer accepted unequivocally the stereotype that women were less well endowed than men with the physical and nervous energy required for a career in medicine. A thorough preparation was required, which included Latin, French, German, physics, chemistry and biology. Greek and botany she also considered useful. Once so prepared the aspiring student could begin her training for a life of 'hardship, fatigue, discouragement, and of incessant self-denial'. She would also suffer from indifference and professional jealousy, and worst of all, have 'to

endure cheerfully the almost complete isolation which must be her lot'.[56] It is not surprising that as a result of these obstacles, added to a gruelling training, initial lack of money and continued hostility to medical women, there were no more than 101 women out of 19,037 doctors in England and Wales in 1891. After ten years' further struggle their number rose to 212 of the 22,698 doctors in 1901.[57] Their male colleagues, while also facing a difficult and costly training, could count on greater social acceptance and in most cases the eventual support of a wife, but in 1901 only 21 per cent of women doctors in England and Wales were married or widowed.[58] Others presumably married subsequently, but many of them must have regarded marriage as an unwarranted infringement of their liberty, like the popular Mary Murdoch of Hull,[59] or as inevitably inconsistent with their chosen career.

The small band was naturally closely scrutinised, and as Brian Harrison points out, it is not surprising that their contribution to medical science was not great.[60] Their awareness of their exposed position was underlined in an affecting letter written by Elizabeth Garrett Anderson to her sister Millicent Fawcett in October 1890. Anderson had just completed a major operation for an overgrown spleen at the New Hospital for Women, of which she was senior physician. She pointed out that the operation had been undertaken infrequently and that the mortality rate had been high: 'So if mine recovers it will be quoted for a long time.... I tell you this for the *sake of the cause*.'[61]

Another employment demanding women of total dedication was the factory inspectorate, to which May Abraham and Mary Paterson were appointed in May 1893 at salaries of £200 per annum. They were followed a year later by two other women; by 1899 the female staff numbered seven.[62] All were based in London except Paterson, the inspector for Scotland. Unlike sanitary inspectors, women factory inspectors were appointed only after a long campaign. By the early 1890s demands to appoint women had become hardy annuals at the Trades Union Congress. It was not simply unreasoning conservatism which caused delay, for many men genuinely believed that the work was beyond the capacity of women. Two inspectors gave graphic accounts to the Royal Commission on Labour of the problems which stemmed from the primitive facilities and the harsh exploitation which still characterised English factories in

the 1890s. J. D. Prior, an inspector in the West Riding and formerly a trade union leader, claimed:

> A woman could not go about in our country districts in the dark nights, climb up winding staircases in intense darkness so as to pop into some room that is lighted up on the fifth floor before anybody knows you are there, or has any inkling of it A woman could not go in petticoats to the places I go into.

The work was as demanding as Prior and James Henderson, a superintending inspector, indicated.[63] Adelaide Anderson, the 'principal lady inspector' after May Abraham's marriage and resignation, wrote almost casually about visits after midnight.[64] Abraham and a colleague were threatened by an outraged workshop proprietor with a knife; on another occasion Abraham fell into a barrel of lime.[65] The ruses and disguises to which employers and their willing or unwilling workers resorted were numerous, and male inspectors had frequently been hoodwinked; the women's powers of ingenuity were thoroughly tested.[66] Endurance and tenacity were also required. Rose Squire, who moved from the sanitary to the factory inspectorate in 1896, travelled through wild and desolate parts of Ireland where lone women were rarely seen. Her appearances in court, like those of other women inspectors, occasioned great interest; as a colleague observed a generation later, the inspector herself was also on trial.[67] It is easy to imagine the feelings of the woman inspector, no matter how experienced, when told: 'You have Mr. So-and-So, K.C., against you, Miss!' Unlike Dorothy Peel and Elizabeth Robins, however, Rose Squire was never molested in her fifteen years inspecting factories all over England and Wales, though her work took her into slum districts and involved her in regular and prolonged periods of night work.[68]

The women inspectors faced other problems. They were chronically short of clerical assistance. Their male colleagues were often uncooperative and sometimes obstructed or even sabotaged their efforts. Deference to the feelings of the male inspectors led to the downgrading of the powers of the women and of the principal lady inspector, resulting in angry comment in the House of Commons and elsewhere. All of the women were peripatetic, 'itinerant inspectors wandering about the country' in the words of H. H. Asquith, until Lucy Deane, who had first been appointed to the inspectorate in 1894, was put in charge of

over 4,000 west London women's workplaces in 1900.[69] The result was that the women were denied the opportunities for promotion which they would have enjoyed had they been integrated into the service with the prospect of rising to a position of authority over men. They also lacked the stable base which would have enabled them to lead a normal home and social life.

Nevertheless they persevered. In 1899 the seven women travelled over 50,000 miles by a variety of forms of transport, and visited 3,627 factories and workshops in addition to 1,800 visits to homes, schools, local authorities and courts.[70] Whatever their success in the uphill struggle to improve the conditions of their exploited fellow women in industry (which Adelaide Anderson claimed ten years after their initial appointment had been considerable,)[71] they were an undoubted success in their capacity as pioneer professional women.

The circumstances of their upbringing, social position and employment inhibited middle-class women from taking effective action to improve their conditions of employment. White-collar trade unionism was at a very early stage of development, and as Sidney Webb pointed out in an influential article, women clerks and civil servants were willing to accept supposedly genteel employment which paid less than half men's salaries, the Prudential Assurance Company being a notable example. Here as in the Post Office most women workers were allegedly incapable of coping with any but routine work. (Even where women were 'found to possess the governing faculty', however, it was rarely acceptable to prevailing opinion for them to be appointed to positions superior to men, as the case of the factory inspectorate demonstrated.)[72] Moreover, women were absent through illness more often than men, a point to which Janet Hogarth also referred, implying that the menstrual cycle would always prevent women from working as steadily as men.[73]

Widespread charges of inefficiency directed against middle-class women workers had a kernel of truth which prejudice and conservatism gleefully exaggerated. Sir James Fergusson, the Postmaster-General, issued a circular in 1892 urging greater courtesy and improved attention to duty, a circular principally aimed at women staff. Amy Bulley and Margaret Whitley, well-informed and sympathetic writers, admitted that there had

been many complaints against women Post Office clerks and noted that a large telephone office had replaced women clerks by men, to the satisfaction of its customers.[74]

The widespread belief that women could live adequately on lower incomes than men and the fact that many women mistakenly expected employment to be a short-term prelude to marriage also discouraged women workers from seeking improved pay and conditions. Honnor Morten, the author of manuals for nurses and midwives and a member of the London School Board, characterised women civil servants as 'anaemic, nerveless-looking creatures', a description which in many cases was probably a close approximation to the truth. She pointed out that women were employed because they were cheaper than men and urged the case for equal pay of both sexes in revealing terms: 'Then fewer women would work, and those who did would be more efficient.'[75]

Clara Collet stressed the influence on middle-class parents of the unfounded assumption that their daughters would marry when young. They were thus disinclined to welcome the lengthy period of training required for success in a professional career. Fathers allowed their daughters to work for little more than pocket money from a mistaken sense of kindness of which employers were the beneficiaries.[76] Collet later noted in her diary a case in which a combination of eagerness for work, a penny-pinching employer and parental subsidy kept a salary at a low level. A friend working as a sanitary inspector in St Pancras had asked for an increase from her weekly thirty shillings to £2. She had been offered thirty-five shillings: 'She has since accepted it as she is too much interested in the work to be willing to refuse it on principle. It may be a stepping stone to a decent appointment later on. Of course she cannot live on it without assistance from her father.'[77] The tradition of voluntary work also had a harmful influence, as Eliza Orme, who had led the team of lady assistant commissioners employed by the Royal Commission on Labour reminded readers of the *Nineteenth Century*: 'The erroneous ideas still fogging the mind of so many ladies of independent means that work is only "genteel" if it is voluntary does immeasurable mischief in lowering the rate of women's wages.'[78] Comments of this kind suggest the development of new forms of exploitation rather than emancipation through employment.

84

The problems of middle-class women's work were well sum-marised in the career of the woman journalist. No occupation seemed so glamorous to women in the period and none was the subject of more frequent discussion in the press and in women's magazines. This was the age of Flora Shaw reporting from South Africa for *The Times*, of Emily Crawford representing the *Daily News* in Paris, of Marie Leighton writing stories for the *Daily Mail*, of the daily 'Wares of Autolycus' column in the *Pall Mall Gazette*, contributed by the poet and essayist Alice Meynell and other prominent women, and of popular columnists like Charlotte Humphry ('Madge' of *Truth*). The expansion in the number and social range of women's magazines, generally edited by men, and the increased attention paid to fashion, society and other 'women's topics' in the rest of the press led to the appointment of many women journalists in the 1890s, though there was little opportunity for them as full time workers outside London. The more successful could earn about £400 a year, Bulley and Whitley reported in 1894, but many earned no more than about £200.[79]

By 1893 there were enough women journalists for Joseph S. Wood, the editor of *The Gentlewoman*, to found the Society of Women Journalists. The society appears to have been in a flourishing state at the end of the century, with a council of twenty-five women members and a programme of debates, lectures and receptions attended by over 200 guests.[80] The flavour of the life and limitations of the woman journalist is caught in a description of Marie Belloc Lowndes, in 1894 a youthful but already experienced writer, by her friend Kath-arine Tynan, herself a busy journalist, poet and novelist:

> She was doing journalism, and she had a wonderful system of filing data on all manner of subjects. Her ingenuity about articles amazed me. I would come in to find her writing an article on 'Titled Mayoresses of the United Kingdom,' or 'The Layettes of the Royal Babies of Europe.'

Another anecdote dated from a later period, but retained the authentic touch of the 1890s despite the presence of the tele-phone, which was then rare:

> 'Hello!' 'Are you Mrs. Belloc Lowndes?' 'Yes, who are you?' '*Sketch*. Can you give us five hundred words on Godfrey and

Deane, married at St. Peter's, Cranley Gardens, to-day. By to-night's post?' 'Yes.'

The enterprising journalist then turned to Tynan and asked: 'Katie — do you know anyone called Godfrey or Deane?'[81]

Most women journalists were confined in this way to 'the feminine side' of their profession,[82] and Marie Belloc Lowndes herself recalled that her earnings 'fluctuated wildly' as the women's magazines for which she wrote 'articles of any and every kind appealing to the average housewife' rose and fell.[83] The women's enforced specialism did not preserve them from harsh criticism of their ability and attitude to their work. One of their most knowledgeable critics was E. A. Bennett, editor of *Woman* when he wrote *Journalism for Women* in 1898 and subsequently better known as the novelist Arnold Bennett. He accused the large majority of women journalists of inability to spell, punctuate or write grammatical English. They were also guilty of irresponsibility and unreliability. Many of them, he wrote, thought that apologising or offering to make up lost time on a subsequent occasion were adequate excuses for missing important stories. They were not unreliable because of 'sexual imperfection' but because they did not understand the requirements of a profession only recently opened to them. If the education of women were conducted on more exacting standards their faults as journalists would disappear.[84]

Women journalists themselves made similar criticisms. Alice Meynell, interviewed as president of the Society of Women Journalists in 1898, acknowledged that women did not take the same pride in their work as men.[85] An anonymous woman journalist writing in *The Humanitarian*, one of the few journals edited by women, commented that Bennett's book was cruel but well-meant, and helpful to women like herself. There were too many women journalists, most of whom did 'hard and ill-paid work'; very few were capable of writing a leading article about politics. Their lack of training and the demands of women readers limited their work to fashion and society topics.[86]

Early in the new century Frances Low, a prominent journalist, wrote that she knew of only two women reporters doing the same work as men on the staffs of important newspapers. About a dozen did serious literary work for papers. Despite the spread of education among women the standard of feminine journa-

lism, she asserted, had declined since the heyday of such writers as Harriet Martineau, Frances Power Cobbe and Eliza Lynn Linton, when women journalists were a picked breed. But 'to-day every semi-educated girl attracted by an easy mode of earning a small income, takes to journalism'.[87] Moreover, the particular kind of 'froth and fribble' condemned by the *Humanitarian* writer[88] was hardly known to earlier generations.

Low pointed out that papers could make a lucrative income from the manufacturers of products 'puffed' by their women journalists,[89] a situation which could easily lead to corruption. Ten years earlier the subject had had an airing in the correspondence columns of *The Times*. An initial letter from an anonymous woman journalist pointed out that ladies' journals paid their writers very poorly. As a result some journalists mentioned favourably those bonnets, coal-scuttles or soap whose manufacturers were prepared to reward them. 'The whole system upon which women's journalism is conducted is utterly dishonest; and it does not speak much for the intelligence of women readers that they are still unawakened.' Another letter mentioned that puffing products was a form of dishonesty not limited to the staffs of ladies' journals.[90] But it was easy in condemning such practices to imply that women journalists were particularly liable to be corrupted.[91] Given the high proportion of women who worked in areas which attracted advertising and the low salaries paid to most of them the temptation to resort to dishonest means was in some cases evidently irresistible.

Exploitation was the common lot of the late Victorian middle-class working woman. Eleanor Marx, whose burdens were heavy and whose earnings were precarious, expressed what must have been a common view in a letter to her sister Laura Lafargue in 1889: 'It's jolly hard though! I often think "I'd rather be a kitten and cry mew" than a woman trying to earn a living.'[92] The balance sheet was not, however, without its positive side. Even low pay and poor conditions might be preferable to the lifelong dependence of the unmarried daughter, sister or aunt in an age in which the numerical preponderance of women meant that many were unable to marry. Employment might also be a relatively rewarding escape from the loneliness and submissiveness which so many women en-

dured in marriage. In either case it was an alternative and an attraction to many more middle-class women in the 1890s than ever before.

Notes

1. The percentage of employed females in France rose from 23.7 in 1872 to 38.7 in 1911; in the United States from 9.7 in 1870 to 16.7 in 1910 (Erna Olafson Hellerstein, Leslie Parker Hume, Karen M. Offen (eds), *Victorian Women* (Harvester Press, Brighton, 1981), p. 273).
2. Calculated from B. R. Mitchell (with Phyllis Deane), *British Historical Statistics* (Cambridge University Press, London, 1962), pp. 6, 60.
3. 'A census, taken on the ordinary method, where the schedule is filled up by the householder himself or some member of his family, who, too commonly, neither cares for accuracy nor is capable of it, does not supply data which are suitable for minute classification, or admit of profitable examination in detail.'

(Census of England and Wales 1891, *General Report*, P.P. 1893-4, CVI, C. 7222, p. 35.) *See also* Evelyn Bridge, 'Women's employment: problems of research', *Bulletin of the Society for the Study of Labour History*, 26 (1973), pp. 5-7.
4. Calculated from Mitchell and Deane, *British Historical Statistics*, p. 60. In 1891 the percentage was 79.97 (*ibid.*, p. 60).
5. Census of England and Wales 1901, *General Report* (P.P. 1904, CVIII, Cd. 2174), pp. 76-7; *ibid.*, 1911, *General Report* (P.P. 1917-18, XXXV, Cd. 8491), p. 157; *Seventeenth Annual Abstract of Labour Statistics of the United Kingdom* (P.P. 1914-16, LXI, Cd. 7733), p. 306.
6. *See also* Lee Holcombe, *Victorian Ladies at Work* (David & Charles, Newton Abbot, 1973), p. 216.
7. She also contributed to Booth's study of London life and labour an article on the secondary education of London girls.
8. *Report by Miss Collet on the Statistics of Employment of Women and Girls* (P.P. 1894, LXXXI-II, C. 7564, pp. 7, 71). *See also* note 49 below.
9. For the economic background to these developments see William Ashworth, *An Economic History of England 1870-1939* (Methuen, London, 1960), part one.
10. Among the contemporary books which analysed women's professional employment are Margaret Bateson (ed.), *Professional Women Upon their Professions* (Cox, London, 1895); Helen Blackburn (ed.), *A Handbook for Women Engaged in Social and Political Work* (1881; Arrowsmith, Bristol, 1895); C. S. Bremner, *Education of Girls and Women in Great Britain* (Swan Sonnenschein, London, 1897); A. Amy Bulley and Margaret Whitley, *Women's Work* (Methuen, London, 1894); Louisa M. Hubbard, Emily Janes (ed.), *The Englishwoman's Year-Book and Directory* (Kirby; Black, London, annual); Leonora Wynford Philipps and others, *A Dictionary of Employments Open to Women* (Women's Institute, London, 1898); Countess of Warwick (ed.), *Progress in Women's Education in the British Empire*

(Longmans, London, 1898). Georgiana Hill's comment was made in her *Women in English Life*, vol. II (Bentley, London, 1896), p. 182.

11. Holcombe, *Victorian Ladies at Work*, pp. 142-8; Jane Lewis, *Women in England 1870-1950* (Wheatsheaf, Brighton, 1984), p. 196. Typists were not however, exclusively women, as the young J. B. Priestley discovered in an all-male Bradford office in 1910 (J. B. Priestley, *Margin Released* (1962; Reprint Society, London, 1963), pp. 15, 23).

12. An Old Oriental, 'The woman at work', *Englishwoman's Review*, 35 (1904), pp. 151-2.

13. *The Times*, 12 November 1894. Drage's official report was made in P.P. 1894, XXXV, C. 7421-I, pp. 24-7, and contains an interesting analysis of the qualifications of his women clerks.

14. Janet E. Courtney, *Recollected in Tranquillity* (Heinemann, London, 1926), chs. 9-11.

15. Margaret Fletcher, *O, Call Back Yesterday* (Basil Blackwell, Oxford, 1935), pp. 79-82, 92-3, 107-11.

16. Carol Dyhouse, *Girls Growing Up in Late Victorian and Edwardian England* (Routledge & Kegan Paul, London, 1981), p. 33. The same observation is made by Deborah Gorham, *The Victorian Girl and the Feminine Ideal* (Croom Helm, London, 1982), p. 172. Their source is M. V. Hughes, *A London Home in the 1890s* (1937; Oxford University Press, Oxford, 1983).

17. Edith E. Read Mumford, *Through Rose-Coloured Spectacles* (Edgar Backus, Leicester, 1952), pp. 62-9.

18. I. Grattan-Guinness, 'A mathematical union: William Henry and Grace Chisholm Young' *Annals of Science*, 29 (1972), pp. 105-86. The quotation is from p. 141.

19. Grattan-Guinness calls Young 'perhaps the finest late starter in the history of the subject' and gives his wife much of the credit for his success (*ibid.*, p. 141).

20. Emily Hobhouse, 'Women workers: how they live, how they wish to live', *Nineteenth Century*, 47 (1900), pp. 471-4. A college vice-principal pointed out that 'the good old rule' that rent should be a tenth of income was no longer practicable (*ibid.*, p. 473).

21. *ibid.*, p. 475.

22. Gilbert Parker, 'The housing of educated working women', in Countess of Aberdeen (ed.), *The International Congress of Women of 1899*, vol. I, *Report of Transactions* (T. Fisher Unwin, London, 1900), p. 261.

23. Hobhouse, 'Women workers', p. 475.

24. Alice Zimmern, 'Ladies' dwellings', *Contemporary Review*, 77 (1900), pp. 96-7.

25. Evelyn March-Phillipps, 'The working lady in London', *Fortnightly Review*, 52 n.s. (1892), p. 200.

26. Hobhouse, 'Women workers', p. 477.

27. Hughes, *A London Home*, pp. 27-30.

28. Evelyn Sharp, *Unfinished Adventure* (John Lane, London, 1933), pp. 52-5.

29. Dorothy Peel, *Life's Enchanted Cup* (John Lane, London, [1933]), ch. 9. The quotation is from pp. 105-6.

30. Elizabeth Robins, *Both Sides of the Curtain* (Heinemann, London, 1940), pp. 164-8.

31. Royal Commission on Secondary Education, P.P. 1895; XLIII, C. 7862, *Report of the Commissioners*, p. 75; XLVIII, C. 7862-V and C. 7862-VI, *Reports of the Assistant Commissioners*, including Ella S. Armitage (Devonshire), Henry and Eleanor Lee Warner (Norfolk), Dilys Glynne Jones (Warwickshire), Catherine Lucy Kennedy (West Riding of Yorkshire). The comment by Frances Kitchener is from C. 7862-V, p. 297.

32. Rose E. Squire, *Thirty Years in the Public Service* (Nisbet, London, 1927), pp. 17-18.

33. As Leonore Davidoff points out: *The Best Circles* (Croom Helm, London, 1973), p. 97.

34. Francesca Wilson, *Rebel Daughter of a Country House: the Life of Eglantyne Jebb* (George Allen & Unwin, London, 1967), pp. 26-7, 49, 54-6.

35. Notably in the case of university-educated women, half or more of whom became teachers. *See* p. 188 below. The point is examined by Joyce Senders Pedersen, 'The Reform of Women's Secondary and Higher Education in Nineteenth Century England: a Study in Elite Groups' (unpublished Ph.D. thesis, University of California, Berkeley, 1974), pp. 360-2, 571-5.

36. Asher Tropp, *The School Teachers* (Heinemann, London, 1957), p. 273.

37. P.P. 1895, XLVI, C. 7862-III, qs. 12,944-57, 13,010-11, 13,029, 13,064-71; pp. 530-1, 538-9. *See also* Holcombe, *Victorian Ladies at Work*, p. 56.

38. *ibid.*, p. 39.

39. See Frances Widdowson, *Going Up into the Next Class* (1980; Hutchinson, London, 1983), pp. 64-5.

40. *The Times*, 21 April 1892, 6 April 1893. The expectation or hope of marriage helps to explain the relative apathy of women teachers towards NUT membership and their gross underrepresentation on the union executive (Donna F. Thompson, *Professional Solidarity among the Teachers of England* (1927; Ams Press, New York, 1968), pp. 113-14; Tropp. *The School Teachers*, pp. 114n., 157 and n.; Pamela Horn, *Education in Rural England 1800-1914* (Gill & Macmillan, Dublin, 1978), p. 248).

41. Royal Commission on Labour, P.P. 1893-4, XXXVII-I, C. 6894 – XXIII, p. 89. *See also* note 46 below.

42. Flora Thompson, *Lark Rise to Candleford* (1939; Oxford University Press, London, 1965), p. 211. She was writing about the 1880s, but as she pointed out, the problem long endured. See *The Times*, 29 December 1894, for a letter and leading article on the subject; also Horn, *Education in Rural England*, pp. 157-61.

43. *See* Widdowson, *Going Up*, esp. section III (iv).

44. P.P. 1895, XLVIII, C. 7862-V, p. 309. Referring to this point the Commission itself urged that women with 'the necessary capacity, knowledge, and organising power' should be as eligible as men to be selected as principals of mixed secondary schools (P.P. 1895, XLIII, C. 7862, p. 160).

45. *Women's Employment*, 12 April 1900, pp. 1-4; *Women's Industrial News*, June 1898, pp. 45-9. A useful chart illustrating the conditions found in clerical work was published in *Women's Employment*, 6 July 1900 (unpaginated). George Gissing described a secretarial school in *The Odd Women* (Lawrence

& Bullen, London, 1893), esp. chs. 6, 10.

46. *Women's Employment*, 12 April 1900, pp. 1-4; *Women's Industrial News*, June 1898, pp. 45-9; Philipps *et al.*, *A Dictionary of Employments*, pp. 147-8. Clara Collet told Janet Hogarth that women clerks kept cheerful until they were thirty by looking forward to the time 'When I get married'. Until thirty-five it was 'If I get married', after which their lives were marked by 'dullness and deterioration' (Janet E. Courtney, *The Women of my Time* (Lovat Dickson, London, 1934), p. 127).

47. *See* Patricia Hollis (ed.), *Women in Public: The Women's Movement 1850-1900* (Allen & Unwin, London, 1979), p. 104.

48. *Return of Post Office Telegraphists*, P.P. 1894, LXX, H.C. 202, pp. 2-3; Gregory Anderson, *Victorian Clerks* (Manchester University Press, Manchester, 1976), p. 109. According to Lee Holcombe, 18.1 per cent of all civil servants in 1901 were women (*Victorian Ladies at Work*, p. 211).

49. Bulley and Whitley, *Women's Work*, p. 41. Clara Collet's prestigious and unprecedented appointment in 1893 to a high-ranking internal administrative position as one of three labour correspondents to the Board of Trade was a hesitant and grudging exception (Courtney, *Women*, pp. 125-6; Hilda Martindale, *Women Servants of the State 1870-1938* (Allen & Unwin, London, 1938), pp. 47-8). The initial proposal of the Board of Trade was to pay the 'lady correspondent' £200 a year, but following other economies it was decided that she should receive the £300 paid to her male colleagues (Public Record Office, Treasury Papers, T1/8743A/10410/93). See also *Labour Department (Progress of Work)*, P.P. 1893-4, LXXXII, H.C. 194, pp. 3, 5, 10.

50. *Women's Employment*, 1 March 1900, p. 1.

51. Margaret E. MacDonald, 'Labour legislation for women', *Report of the Seventieth Meeting of the British Association for the Advancement of Science held at Bradford in September 1900* (Murray, London, 1900), p. 850.

52. Interdepartmental Committee on Post Office Establishments, P.P. 1897, XLIV; *Report*, H.C. 121, p. 33; *Evidence*, H.C. 163, qs. 2949, 2951, 2953-4, 2961-84, 10,812-14, 10,824-6.

53. E. Moberly Bell,, *Storming the Citadel: the Rise of the Woman Doctor* (Constable, London, 1953), pp. 132, 136, 138.

54. Bateson (ed.), *Professional Women*, p. 29.

55. Elizabeth Garrett Anderson, 'Medical training of women in England', in Countess of Warwick (ed.), *Progress in Women's Education*, pp. 96-7.

56. Caroline W. Latimer, 'The medical profession', in *Ladies at Work* (introduction by Lady Jeune) (A. D. Innes, London, 1893), pp. 76-84; Mary P. Marshall, 'Ladies at work' (review), *Economic Journal*, 3 (1893), p 679.

57. Census of England and Wales, 1901, *General Report* (P.P. 1904, CVIII, Cd. 2174), p. 92.

58. *ibid.*, *Summary Tables* (P.P. 1903, LXXXIV, Cd. 1523), p. 187. *See also* Brian Harrison, 'Women's health and the women's movement in Britain: 1840-1940', in Charles Webster (ed.), *Biology, Medicine and Society 1840-1940* (Cambridge University Press, Cambridge, 1981), p. 52.

59. Hope Malleson, *A Woman Doctor: Mary Murdoch of Hull* (Sidgwick & Jackson, London, 1919), pp. 10-11, 65.

60. Harrison, 'Women's health', pp. 55-6.

61. Fawcett Library, Autograph Letter Collection, vol. 10, part B, Elizabeth Garrett Anderson to Millicent Garrett Fawcett, 22 October 1890. The patient appears to have recovered satisfactorily (Valerie Lenton, Executive Secretary of the Medical Women's Federation to author, 28 November 1984). Anderson was one of very few women surgeons at this time, but her daughter's biography indicates that she disliked surgical work and was not highly qualified to undertake it (Louisa Garrett Anderson, *Elizabeth Garrett Anderson* (Faber, London, 1939), pp. 243-5).

62. *Reports of the Chief Inspector of Factories and Workshops*: P.P. 1894, XXI, C.7368, p.340; 1895, XIX, C. 7745, p.233; 1900. XI, Cd. 223, p.238; 1901, X, Cd. 668, p.348.

63. P.P. 1892, XXXV, C. 6708-VI, qs. 6837, 9023.

64. P.P. 1900, XI, Cd. 223, p. 271. Abraham's struggle between the demands of a fashionable upper-middle-class marriage and her commitment to her work, which she finally resolved by resigning from the factory inspectorate, is a revealing illustration of the pressures on professional women. Her difficulties are discussed in Violet R. Markham, *May Tennant, a Portrait* (Falcon Press, London, 1949), p. 35 and in Gertrude Tuckwell, 'Reminiscences' (undated typescript in Tuckwell Collection, Trades Union Congress Library), p. 185.

65. Markham, *May Tennant*, pp. 25-7; Tuckwell, 'Reminiscences', p. 152.

66. *ibid.*, pp. 152-3, 169; Squire, *Thirty Years*, pp. 68-70; Royal Commission on Labour, P.P. 1892; XXXV, C. 6708-VI, q. 5454; XXXVI-II, C. 6795-VI, q. 15,269.

67. Harrison, 'Women's health', p. 56. Adelaide Anderson was dismayed to discover within a few weeks of taking up her appointment that she was required to prosecute an offender in court. She asked the appropriate district inspector to undertake the case, but he refused (Adelaide Anderson, *Women in the Factory* (Murray, London, 1922), pp. 201-2).

68. Squire, *Thirty Years*, chs. 5-7. The quotation is from p. 101.

69. Violet Markham pointed out in her typescript biographical account of Lucy Deane (Streatfeild) that the appointment of women was 'bitterly resented by many of the men officials and prophecies of woe were loud and voluble' (1951, p. 3; the script is retained in the TUC library). For criticisms of the development of the women's branch of the factory inspectorate see *Parl. Deb.*, 4th ser., 63 (29 July 1898), cols 450-522 (the comment by Asquith who, as Home Secretary, had appointed the first woman inspectors in 1893, is on col. 477) and May Tennant, 'The women's factory department', *Fortnightly Review*, 64 n.s. (1898), pp. 148-56. For Lucy Deane's West London appointment see P.P. 1900, XI, Cd. 223, pp. 238, 345.

70. *ibid.*, pp. 241-2. In 1895, before being overwhelmed by clerical and other administrative duties, a smaller staff of women inspectors visited 6,957 factories and workshops (P.P. 1900, XI, Cd. 27, p. 147).

71. P.P. 1903, XII, Cd. 1610, p. 144.

72. The Post Office, however, did employ some women in positions of authority over men. In 1895 over 200 male telegraphists in London worked under female supervision under a system introduced in 1890. This situation caused much dissatisfaction among the men, some of whom

were paid considerably higher salaries than their female superiors, and the 1897 report noted with pleasure that the incidence of such cases was 'greatly reduced' (P.P. 1897, XLIV, H.C. 121, p. 14; H.C. 163, qs. 2419, 2574-9).

73. Sidney Webb, 'The alleged differences in the wages paid to men and women for similar work', *Economic Journal*, 1 (1891), pp. 650-3; Janet Hogarth, 'The education of women for business', in Countess of Warwick (ed.), *Progress in Women's Education*, p. 192.

74. *The Times*, 22 April 1892; Bulley and Whitley, *Women's Work*, pp. 46-7.

75. Honnor Morten, *Questions for Women (and Men)* (Black, London, 1899), pp. 48-9. For a recollection of Morten see Thomas Gautrey, '*Lux Mihi Laus': School Board Memories* (Link House, London [1937]), p. 79.

76. Clara Collet, 'Women's work', in Charles Booth (ed.), *Life and Labour, vol. I: East London* (Williams & Norgate, London, 1889), p. 470; Clara Collet, 'Prospects of marriage for women', *Nineteenth Century*, 31 (1892), pp. 542, 551. Margaret Bateson referred to this kind of work as 'industrial cannibalism' (*Girls' Own Paper*, 3 October 1896, p. 15).

77. Clara Collet Papers, Modern Records Centre, University of Warwick, MSS 29/8/1/73 (xerox copy of Collet diary, 4 December 1904).

78. Eliza Orme, 'How poor ladies live', *Nineteenth Century*, 41 (1897), p. 617.

79. Bulley and Whitley, *Women's Work*, p. 7. The salaries of women journalists varied widely. Margaret Bateson wrote that they started at £50 to £100 (*Professional Women*, p. 129), while at the other end of the scale up to two dozen women could earn £600 or £700 'or, in a few cases, much more', Evelyn March-Phillipps told the International Congress of Women in 1899 ('The economic position of women journalists', in Countess of Aberdeen (ed.), *The International Congress of Women*, vol. IV, *Women in Professions – II*, pp. 70-2).

80. *Seventh Annual Report of the Society of Women Journalists 1900-1901*, pp. 3-5, 12-13.

81. Katharine Tynan, *The Middle Years* (Constable, London, 1916), pp. 119-20.

82. *The Young Woman*, 8 (1899), p. 93.

83. Marie Belloc Lowndes, *The Merry Wives of Westminster* (Macmillan, London, 1946), pp. 14-15.

84. E.A. Bennett, *Journalism for Women* (John Lane, London, 1898), *passim*.

85. *The Humanitarian*, 12 (1898), p. 230.

86. *ibid.*, 17 (1900), pp. 37-41. Dorothy Peel, one of the most accomplished women journalists of her generation, acknowledged her indebtedness to Bennett's scathing but helpful criticism (*Life's Enchanted Cup*, pp. 64-5).

87. Frances Low, *Press Work for Women* (Upcott Gill, London, 1904), pp. 5, 13, 91.

88. *The Humanitarian*, 17 (1900), p. 38.

89. Low, *Press Work*, p. 5.

90. *The Times*, 8 and 11 January 1894.

91. Readers of a verse published in *Punch* (20 January 1894, p. 34) might easily have come to such a conclusion.

92. Olga Meier (ed.), *The Daughters of Karl Marx: Family Correspondence 1866-1898* (Deutsch, London, 1982), p. 210.

7

Women in industry

The work experience of wage and salary-earning women exhibited certain common features. The gregarious conditions of work in large establishments encouraged a sense of solidarity with other women. Paid employment and a consequent separate income fostered a spirit of independence. On the other hand, most women were paid significantly less than men and worked in worse conditions. Relatively few enjoyed the protection of trade unions. They were rarely placed in positions of authority over men. Their male co-workers usually treated them with condescension or suspicion and often with contempt and hostility. Their work was usually unremitting drudgery, offered to women because they were a cheap and generally docile form of labour. Protest at their conditions of work was limited by fear of losing their jobs and by the vision of work as a phase of life soon to be ended by marriage.[1]

There were, however, important differences between wage and salary earners. The latter enjoyed the advantages of superior education, more money and a more assured social position. Middle-class women might also experience a sense of change and hope, generated by the growth of the movement for the emancipation of women. This sense was absent from the lives of most working-class women. Finally, the barriers between women of different social classes inhibited the development of gender solidarity, despite the sympathetic contribution to trade unionism and the amelioration of working conditions made by a not inconsiderable number of middle-class women.

Change took place in the nature and extent of working-class women's employment in the 1890s, but its direction is not easy to assess. Census data discussed in the last chapter suggested that a rather smaller proportion of women was employed in the 1890s than previously and that if this was the case it was the working-class woman who stayed at home. Middle-class champions of women's rights asserted that the operation of the factory acts resulted in women being displaced by men in industrial employment,[2] but the evidence of this process taking place on a

significant scale is slight. There is more evidence that women were displacing men at lower wages, and an old Yorkshire weaver spoke for many in saying that he 'went in daily fear o' being jostled o' one side by a lass'.[3] Sidney Webb's view was that employment patterns were shifting: 'The economic boundary between men and women is constantly retreating on the men's side.' Men and women seldom did the same work, for as women began to undertake skilled work previously performed by men new forms of skilled male employment became available.[4]

The 1901 census report partly confirmed this analysis. It also suggested that employment patterns had changed, but it found cases in which each sex had displaced the other as new forms of machinery had developed. Thus men operated machines in laundries and in lace manufacture, while women machinists had been introduced into bootmaking and tailoring. This process was an aspect of the growth of semi-skilled labour, a development which offered new opportunities for women's employment, notably in engineering and allied trades where the number of women workers rose from 58,000 in 1891 to 85,000 in 1901.[5] Such changes took place against a background of considerable turmoil, in which the British economy was assailed by foreign competition and domestic anxiety.[6] This uncertainty increased pressures on employers, but at the same time helped to give rise to a new social consciousness of which women were an important beneficiary. The attention given to the conditions of women in industry in the period is therefore easily understood.

Women themselves, especially unskilled workers, were by no means the universally sullen victims of exploitation. Clara Collet discovered cheerful acclimatisation to working conditions among unskilled Irish workers in Leeds in 1891:

> Unpleasant as rag sorting must be to those who have prejudices in favour of cleanliness, I have never seen any group of workers suffering less from depression In every room the girls were singing, and in one 'I am the Ghost of John James Christopher Benjamin Binns,' chanted in chorus, was quite impressive.[7]

Millicent Garrett Fawcett, who investigated working conditions among East London match girls in 1898 when public opinion had been alarmed by cases of 'phossy jaw' (necrosis),

was told by one girl that her head sometimes suffered from the noisy combination of machinery and singing. Fawcett and her daughter Philippa had been 'particularly struck by the happy and robust look of the girls' employed by Bryant and May.[8] She was anything but an impartial witness, but there is no need to doubt the truth of her report. No matter how cheerful factory women and girls may have been at their work, however, they were unquestionably victims. As Joseph White points out, they were 'hemmed in from all sides'.[9]

Women were exploited above all by the operation of the economic system and the actions of their employers. The late nineteenth century was a period characterised by small factories and workshops which often had primitive machinery, large numbers of home-workers and intensive competition. Factory inspectors were few, the laws they administered were half-hearted and inadequate, and outside Lancashire not many women belonged to trade unions. Many women on the other hand were desperate for work, no matter how badly paid. The mixture was an ideal recipe for exploitation of a particularly vicious type. Moreover, the middle-class public had little knowledge of factory conditions. As Amy Bulley and Margaret Whitley observed in 1894: 'So widely separated are classes in this country that a man may grind the faces of the poor and pass for a saint among those of his own class.' A few years later Keir Hardie exposed such an employer as a fraud and a hypocrite.[10]

The evidence of the few women witnesses and the four lady assistant commissioners to the Royal Commission on Labour are eloquent testimony to the abysmal conditions of most women factory workers. Contemporary articles in the monthly reviews confirmed the evidence.[11] So too did Ada Nield's letters to the *Crewe Chronicle*, first published in 1894 and recently reprinted. They describe conditions in a clothing factory working on government contracts, in which the terms of the 'Fair Wages' resolution passed by the House of Commons in 1891 should have applied. Instead, we read of low wages which usually averaged around eight shillings a week, 'favouritism' which often had a sexual basis, fines and deductions and the absence of trade unions. No reference is made to visits by factory inspectors.[12] In such conditions young girls could be struck, knocked down, 'their heads pushed down upon the spinning frames', as Rose Squire discovered on a visit to a West Riding

spinning mill in 1900.[13] Even if detected, as here, overlookers and owners stood in little danger of punishment.

Apart from a brave handful like Ada Nield (who promptly lost her job after the publication of her letters) women workers accepted their conditions except during occasional, brief periods of crisis and strike. They generally knew nothing better and they feared worse. To many outsiders they often seemed to be their own worst enemies. They ignored safety precautions, were apathetic about working conditions and, on the few occasions that they gave evidence to official inquiries, chorused that they had no complaints to make.

A series of women workers told a departmental committee that they were naturally pale and unaffected by the lead with which they worked, though the lead industry was universally recognised as a dangerous trade with a high illness and mortality rate.[14] Similarly, most women working in cotton weaving sheds failed to complain to employers or factory inspectors about the damp heat in which they worked. An inspector told an investigating committee that workers were reluctant to report abuses, doubting the confidentiality or effectiveness of complaints. A few women, who in Lancashire had the advantage of trade union support, did confess to disliking the steam, but this pathetic interchange between the committee chairman and a weaver named Margaret Keighley speaks volumes about the helplessness of the women:

> 2474. (Chairman) You have never complained to the inspector about the amount of moisture being too great? — No.
> 2475. Why have you not done so? — I thought it might, perhaps, be against me to do it.
> 2476. But do not you know that the inspector is specially appointed to look after these things, and that he is willing to be your friend and to help you when things are done wrong? — Yes.[15]

Isabella Ford, the socialist feminist whom we have previously met as the author of 'new woman' fiction, was president of a woman's tailoring union in Leeds. An extremely well-informed observer and participant in industrial struggles, she wrote several perceptive analyses of the attitudes of women factory workers, apathetic towards their conditions and obstructive

towards the inspectors who attempted to enforce the law. Their employer, she wrote in an article published in 1900, was regarded as 'a thieving tyrant', but he was a familiar figure and the source of the weekly wage. The inspector belonged to the same class and was in addition an interloper. It was thus a good joke to deceive him, and the adroitness of masters in doing so was admired. Ford explained the infrequency of complaints against fines and deductions by the fact that the magistrates were always men and usually wealthy. Funds to assist workers who complained and were consequently dismissed were also administered by wealthy people. This was regarded by the workers 'as a slightly illogical arrangement'. Ford also argued that rescue workers who tried to reduce the number of prostitutes merely fulfilled the economic function of preventing the market from being overstocked and prices from falling. Trade unionism and strikes, on the other hand, were condemned by Sunday school teachers and district visitors as 'unwomanly and intensely vulgar'. Ford asserted that the only way to help women industrial workers effectively was to secure for them the parliamentary vote, and to encourage 'intelligent discontent' and 'a discriminating and well-organised rebellion'.[16] Few analyses were so clearsighted.

An interesting letter written by George Turner to Sidney Webb in 1891 provides an excellent summary of the explanations given by many contemporaries of the level of women's wages, which were not only low but possibly falling relative to men's during the period.[17] Webb was gathering material for an address to the British Association on the wages of men and women, later published in the *Economic Journal* as the article previously mentioned.[18] Turner, who was employed by a London firm of bank-note printers, replied to Webb's appeal for information and advice in *Fabian News*, the journal of the Fabian Society.[19]

He told Webb that women had replaced men in some processes at his firm. They were paid ten shillings a week for machine work which had previously been done by male handworkers. Most of the women were the daughters of skilled men who allowed them to keep the bulk of their earnings. A large factory near his home had replaced men earning fifteen to twenty shillings a week by women earning seven to ten shillings. They were of a much lower class than the first group and eked

out a 'miserable existence' by prostitution or the financial assistance of their lovers. To both groups marriage seemed likely within a few years (with probably more reason than in the case of middle-class women),[20] and until its arrival they were prepared to work for a pittance. Employers, as a result, replaced men by women as frequently as possible. Moreover, women did not require as high a wage as men. They did not travel as much, they spent less time in public houses and in reading, they did not smoke or take educational classes. The lighter nature of their work meant that they needed less and cheaper food than men. 'In a word, their standard of comfort is altogether lower. Owing to their peculiar bringing up they have not so much backbone, and, as I have said, look forward to marriage as the Ultima Thule of their existence.'[21]

Although, as suggested above, it is not easy to diagnose the ebb and flow of employment from one sex to the other in the 1890s, Turner's evidence of women replacing men at lower wages was supported by other sources. In an article in the *Fortnightly Review* in 1893 Evelyn March-Phillipps cited a number of similar cases, in the most extreme of which women were employed for less than half the wages formerly paid to men.[22] Another case mentioned by Emilia, Lady Dilke, a leading champion of women's trade unionism, concerned male carpet weavers in Halifax who had struck against a threatened reduction in their 35-shilling wage and been 'betrayed' by women who replaced them at 20 shillings.[23] May Abraham reported from the Yorkshire textile industry to the Royal Commission on Labour that in many branches of the industry men and women did different work but that in some cases where they worked together they received the same pay. The pattern was different in weaving and wool combing, however, particularly in Huddersfield:

> At some places ... men and women were paid alike *upon the women's scale* The tendency with all employers is to substitute women's labour for that of men, and some have almost entirely done so I found one employer ... who had offered his men weavers £5 each if they would find employment elsewhere.[24]

The same point was strongly made by male trade unionists from Yorkshire who appeared before the Commission. J. W. Downing summarised the position as seen by union officials in his

description of the common experience of men who sought work at the mills. The reply, Downing asserted, was: 'Oh, you are the wrong sort, we want them with petticoats on.'[25]

It was commonly said that women and girls lacked ambition and that they were uninterested in acquiring skills which would have raised their wages.[26] A woman investigator enquiring into the printing trades early in the new century as part of a team led by Ramsay MacDonald reported: 'The progressive young woman, eager to show that she is man's equal and can do man's work, seems to be a product of the middle classes.' The investigator had never met girls with such ambitions in her enquiries among women manual workers. When she asked forewomen and others in the bookbinding trade why women workers did not undertake certain easy processes she was told: 'Why, that is man's work and we shouldn't think of doing it!'[27]

Although the employment of married women was firmly entrenched in a number of industries, notably in the cotton mills of the north-west, belief in the 'family wage' was pervasive, as Jill Liddington and Jill Norris point out in their influential study of women factory and suffrage workers in Lancashire and Cheshire. The husband and father should support his family and woman's place was the home.[28] Tom Mann, a leading socialist and 'new unionist' of the period claimed that the employment of married women was accompanied by relatively low men's wages, an assertion which finds qualified support from modern historians.[29] As a Royal Commissioner Mann asked W. H. Wilkinson, secretary of the Northern Counties Amalgamated Association of Weavers, whether it was satisfactory that several members of a family should have to seek work in order to maintain their home in modest comfort. The reply was: 'I think the husband, the head of the family, ought to be able to keep his wife at home to look after her household duties, and that he ought to earn as much as would keep the family in a satisfactory condition.'[30]

The concept of the family wage was natural in a society which took the subordination of women for granted. From birth women were socialised to believe in their own inferiority, and as Ramsay MacDonald's researcher noted only certain educated middle-class women had begun to follow the long path leading to equality. Most working-class women were willing to work for wages below subsistence level since they saw no realistic alter-

native. Moreover, they (like middle-class women workers) were subsidised at home by the male members of the families, who must as workers have inveighed against the effect of low women's wages in dragging down their own and putting them out of work. Such was the situation, Lady Dilke wrote, of 'masses of women', the consequence of the theory that women should be 'economically dependent', their wages supplementary to those of men.[31]

The normal submissiveness of most women workers and the state of oversupply in the labour market meant that many male workers and some of their unions bitterly condemned the employment of married women. Given the contemporary assumption that it was the woman's function to look after the home and children their case was not without strength. The paid employment of young mothers, a subject fraught with controversy and special pleading, may have resulted in a significant increase in the level of infant mortality;[32] certainly it was easy enough to find evidence to suggest that it did so. Eliza Orme reported to the Labour Commission that the homes of employed women in the Black Country were 'very nearly desolate', the children in 'deplorable' condition and the women themselves ignorant of cookery and diet. (But like Clara Collet and Millicent Garrett Fawcett she found that women workers sang and chatted cheerfully, and she warned that the abolition of the employment of married women would lead to fewer legal marriages.)[33] Among the claims made to the Commission that working wives neglected their homes was a vivid description of the Yorkshire woollen district by J.W. Downing:

> I think, myself, taking it as a whole, that it is a disgrace to humanity to see married women pulling their children out of bed in the morning, wrapping them in shawls, and taking them in all kinds of weather — in some cases half-a-mile — to nurse, so that they can go into the mill, and in the long run take the men's places and throw the men into the street; it is a regular occurrence in our district.[34]

However much male workers wished to do so they were in no position to secure the abolition of the employment of married women. It would, however, be a mistake to think that the labour market was flooded with married women seeking employment. No reliable figures exist for the 1890s,[35] but it is unlikely that

more than 10 per cent of married women were employed in the period. (The employment of married women and widows was first tabulated in the 1901 census, when 13.2 per cent were employed; comparison with 1911, when the two groups were enumerated separately, suggests a figure of about 10 per cent of married women in 1901.)[36]

The most important problem of male workers was not female competition but the organisation of effective trade unions. Here, as will be seen, lay their real complaint against women workers. In towns with over 25,000 inhabitants in 1901 the highest percentage of employed married women and widows (between 25 and 40 per cent) was frequently found amongst the home-workers of East London, the domestic servants of West London and the textile workers of Lancashire and Cheshire.[37] The situation aroused little protest from London working-men, for their jobs did not overlap with those of married women. In the Lancashire cotton weaving industry the employment of married women at least until their first child was born was generally taken for granted, for they posed no competition to men. The majority of women were weavers, earning the same piecework rates as men, though their work was often lighter and their wages consequently lower. (W.H. Wilkinson, the weavers' union leader, told the Royal Commission on Labour that women were as good workers as men, 'in fact in most cases better', and earned as much money, but a more accurate picture was given to Sidney Webb by one of his informants in 1891: 'A clever woman will earn more than a slow man. The best paid employments are reserved for men.')[38]

The Labour Commission heard complaints about the employment of married women from male trade unionists in the Black Country and the East Midlands, where many women worked in the metal and knitting industries.[39] But the bitterest complaint came from Downing and his West Riding colleagues, where women's wage rates were in some (though not all) cases much lower than men's and trade-union membership was small. Yet in the West Riding towns the percentage of employed married women and widows, at least in 1901, was generally no higher than the national average.[40]

The efforts made to organise women into trade unions in the 1890s will be examined in the next chapter, but it should be noted that such efforts often followed unsuccessful attempts to

secure the exclusion of women workers. Surface work in coal mining was an example which recurred periodically. Angela John has shown in her study of pit brow lasses that attempts to ban women from surface work were inspired by a variety of motives. Male trade unionists were genuinely concerned about the effect of the work on the women themselves and on family life, but they were also anxious to increase their own wages and employment opportunities. It was not until the changes brought about by the First World War had been felt that the Lancashire and Cheshire Miners Federation set about recruiting women members.[41]

The printing unions paid lip service to the principle of women members at an earlier stage. Robert Johnstone, secretary of the Scotch Typographical Association, told the Royal Commission on Labour that his society did not object to the employment of women provided that they were paid the same rates as men for the same work. Reminded that women would not be employed under such conditions Johnstone replied simply: 'We know that.'[42] The compositors' ban on women members had yielded in 1886 to a policy of admitting women who were paid the men's rate while declaring simultaneously that women were incapable of the physical effort required of compositors. In the subsequent ten years only one woman was admitted to membership of the London Society of Compositors.[43] It is not surprising that Cynthia Cockburn calls this stance 'studied hypocrisy',[44] but the behaviour of the men should also be seen as a response to the lower wages of women printers and to their use as strike-breakers, which in turn resulted partly from their original exclusion from the unions.

The woman member of the LSC was employed at William Morris's Kelmscott Press,[45] but Morris was no more sympathetic to the employment of women than were most of the male trade unionists of his day. In an interview in 1894 he said that pit brow women would be better employed at home than doing 'the hard, rough work of the pit-bank'. He called housekeeping 'a woman's special work' and declared that women were only employed in industry because their wages were low. Their employment had 'a serious effect in keeping wages down'.[46]

Under these conditions advocacy of equal pay for workers of both sexes was used, as in the case of the printers, as a tactic to exclude working women rather than as a step towards sex

equality. The uncertainty of male trade unionists faced by the growing strength of the women's movement, and their realisation that the simple policies of the past must be reformulated in intellectually respectable terms was exemplified in Frank Delves's presidential speech to the Trades Union Congress in 1894:

> We must make women workers our equals. They must be paid the same as men workers, and this will relieve the labour market of their presence in many cases where they are only at work to make up their husband's wages to the standard which their very competition has destroyed Equal pay for equal work, fair play and no favour, is the condition under which women will discover what is women's work, and do it, leaving men free to do what is men's work. And as the proper work of a good many women now in mill or factory lies at home with their children, this would lead to a considerable relief in the labour market.[47]

Working women in the 1890s needed friends. They were exploited by their employers. They were handicapped by contemporary attitudes towards women and by their often desperate need of employment. They were only beginning to emerge from a long period of treatment as enemies by male workers and by trade unions. They were championed by middle-class women whose sincerity and ability were not in doubt, but whose remoteness from the labour movement and opposition to protective legislation for women made them friends of somewhat doubtful value. They also had the support of the dedicated band of advocates of women's trade unionism, but as Joseph White (to whose analysis I am indebted) points out, they received little assistance from the work of Beatrice and Sidney Webb, whose *Industrial Democracy* (1897) provided a highly influential and ostensibly pro-labour justification for the continuation of the status quo.[48]

The Webbs were concerned to promote the achievement and maintenance of what they called the standard rate, the union-negotiated minimum wage. They regarded women, with their lower living standards, family-subsidised wages and frequent lack of dependants as 'the most dangerous enemies' of this rate. 'No employer', they insisted, 'would dream of substituting women for men, unless this resulted in his getting the work done below the men's Standard Rate.' In the large majority of cases,

they asserted, women's work was distinctly differentiated from men's. They accepted that women's wages should be lower than men's provided that there was no competition between the sexes for the same work.[49]

There are a number of objections to this rather complacent perspective. It is doubtful that the work of men and women overlapped as seldom as the Webbs claimed. Their implicit belief that women were always less capable workers was even less tenable. It could, however, be maintained that the argument was thus far in the interests of the working class as a whole. The labour market was chronically overstocked and there was urgent need for the development of strong trade unions and a relatively high minimum wage. Moreover, the Webbs insisted that women should have their own standard rate, 'even though this may have to be fixed lower than that of the men'.[50]

The strongest count against the Webbs and against those influenced by their views was the fact that they shared many of the common prejudices of their day about working women. They reported with some sympathy the hostility of 'the average working man' to the employment of women. They accepted that for reasons of sexual morality men and women should not work together in many trades. They saw as unobjectionable the use of equal pay as a device to exclude women. Above all, they were convinced that male workers needed higher incomes than females. In arguing the case for a 'national minimum' they carefully refrained from suggesting specific wage differentials between the sexes, but made clear their view that women needed a lower minimum than men. The justification was in part that the heavier work of men required higher wages in order to maintain health and efficiency.[51] Their central point was put as follows:

> It is unfair, and even cruel, to the vast army of women workers, to uphold the fiction of the equality of the sexes in the industrial world. So far as manual labo[u]r is concerned, women constitute a distinct class of workers, having different faculties, different needs, and different expectations from those of men.[52]

With friends like these, it may be thought, working women hardly needed enemies. Yet the case against treating the sexes as equals in the labour market was by no means a weak one. It will be further examined in the next chapter.

Notes

1. A measured account of women's employment in the later nineteenth century may be found in E. H. Hunt, *British Labour History 1815-1914* (Weidenfeld & Nicolson, London, 1981), esp. pp. 17-25, 102-7.

2. *See*, for example, the *Englishwoman's Review*, 25 (1894), pp. 149-56, esp. p. 154; 35 (1904), p. 9. Hunt, *British Labour History*, concludes that new techniques did much more to increase than to inhibit the employment of women (pp. 22-3).

3. Quoted by Evelyn March-Phillipps, 'The progress of women's trade-unions', *Fortnightly Review*, 54 n.s. (1893), p. 98.

4. Sidney Webb, 'The alleged differences in the wages paid to men and women for similar work', *Economic Journal*, 1 (1891), pp. 638-49, 657.

5. Census of England and Wales, 1901, *General Report*, P.P. 1904, CVIII, Cd. 2174, pp. 85-6; James A. Schmiechen, *Sweated Industries and Sweated Labor: the London Clothing Trades 1860-1914* (University of Illinois Press, Urbana and Chicago, 1984), pp. 34-5; Hunt, *British Labour History*, pp. 30, 105, 298; Barbara Drake, *Women in the Engineering Trades* (Fabian Research Department and Allen & Unwin, London, 1917), pp. 7-13.

6. S. B. Saul, *The Myth of the Great Depression, 1873-1896* (Macmillan, London, 1969), esp. pp. 36-52; Peter Mathias, *The First Industrial Nation: an Economic History of Britain 1700-1914* (Methuen, London, 1969), pp. 395-404; R. S. Sayers, *A History of Economic Change in England, 1880-1939* (Oxford University Press, London, 1967), pp. 32-7.

7. Clara Collet, 'Women's work in Leeds', *Economic Journal*, 1 (1891), p. 466.

8. *The Standard*, 23 July 1898.

9. Joseph White, *The Limits of Trade Union Militancy: the Lancashire Textile Workers, 1910-1914* (Greenwood Press, Westport, Connecticut, 1978), p. 52.

10. A. Amy Bulley and Margaret Whitley, *Women's Work* (Methuen, London, 1894), p. 84. For Keir Hardie's exposure of Lord Overtoun in 1899 see William Stewart, *J. Keir Hardie* (1921; Independent Labour Party, London, 1925), pp. 147-9. David Martin reminded me of this reference.

11. The only women among the 583 witnesses who appeared before the Labour Commission were Clementina Black, Amie Hicks, Clara James and Elizabeth Amy Mears. (The lady assistant commissioners were appointed to gather evidence from women at their place of work.) Among the many useful articles on women's work are three which appeared in the *Fortnightly Review* in 1893-4: Evelyn March-Phillipps (note 3 above), Emilia F. S. Dilke, 'The industrial position of women' (54 n.s., pp. 499-508) and A. Amy Bulley, 'The employment of women. The lady assistant commissioners' report' (55 n.s., 1894, pp. 39-48).

12. Doris Nield Chew, *The Life and Writings of Ada Nield Chew* (Virago, London, 1982), pp. 75-134.

13. Chief Factory Inspector's Report, P.P. 1901, X, Cd. 668, p. 356.

14. Evidence to the Departmental Committee on the Various Lead Industries, P.P. 1893-4, XVII, C. 7239-I, *passim*, esp. qs. 2721-2.

15. Evidence to the Committee on the Cotton Cloth Factories Act 1889, P.P. 1897, XVII, C. 8349, qs. 2474-6, 3506-7 and *passim*.

16. Isabella O. Ford, 'Industrial women, and how to help them', *Friends' Quarterly Examiner*, 34 (1900), pp. 171-84.

17. G. H. Wood, writing soon after the end of the period, concluded that women's wages rose more slowly than men's in the late nineteenth century (appendix A of B. L. Hutchins and Amy Harrison, *A History of Factory Legislation* (P. S. King, London, 1903), pp. 282-3). Wood has long been regarded as an authoritative source, but E. H. Hunt, who not unreasonably calls Wood's figures 'rather vague and incomplete', gives persuasive arguments for the opposite conclusion (*British Labour History*, pp. 105-6).

18. *See above*, p.83.

19. *Fabian News*, July 1891, p. 18. Marjory Pease, the wife of the secretary of the Fabian Society, wrote tartly to Webb: 'With all due respect to you I cannot see why a woman was not appointed to write this paper!' (Webb Papers, Trade Union Documents, A. XLVII, 30, f. 87v., 10 July 1891).

20. Clara Collet concluded from a study of census figures that one woman in six would remain unmarried in England and Wales (one in five in London), and that the proportion was specially high among the educated middle class ('Prospects of marriage for women', *Nineteenth Century*, 31 (1892), p. 540). *See also* below, p. 189 and 205 n.21.

21. Webb Papers, Trade Union Documents, A. XLVII, 31, ff. 88-91, undated but obviously 1891. Turner, who later wrote a Fabian tract on old age pensions, was described by Edward Pease in his *History of the Fabian Society* (1916; Cass, London, 1963) as 'one of the cleverest of the younger members' (p. 159). His conclusion about the wage levels required by men and women was echoed in a letter from the Anglo-American Fabian and feminist Harriot Stanton Blatch, who told Webb that women generally needed 'less food than men'. Cheap women's clothes were less expensive than men's. Women could often find inexpensive accommodation by offering to keep it clean without domestic help. A woman could make her own bonnet, while 'her brother must buy his head covering at a shop' (Webb Papers, Trade Union Documents, A. XLVII, 20, ff. 64-64v., 4 July 1891).

22. March-Phillipps, 'Progress of women's trade-unions', p. 98.

23. Dilke, 'Industrial position of women', pp. 504-5. This incident was referred to in May Abraham's report to the Royal Commission on Labour; P.P. 1893-4, XXXVII-I, C. 6894-XXIII, p. 100.

24. *ibid.*

25. P.P. 1892, XXXV, C. 6708-VI, q. 5026.

26. For example, by Amy Bulley, 'The employment of women', p. 41.

27. J. Ramsay MacDonald (ed.), *Women in the Printing Trades* (P.S. King, London, 1904), pp. 52, 65; also Amy Linnett, 'Women compositors', *Economic Review*, 2 (1892), p. 49. Refusal to do 'man's work' could also be based on the desire not to deprive men of employment (MacDonald (ed.), p. 53) or the fear of reduced earnings if men were no longer available to perform certain tasks (Carol Adams, Paula Bartley, Judy Lown, Cathy Loxton, *Under Control: Life in a Nineteenth-Century Silk Factory* (Cambridge University Press, Cambridge, 1983), pp. 33-4).

28. Jill Liddington and Jill Norris, *One Hand Tied Behind Us* (Virago, London,

1978), pp. 53, 59, 238-9. This subject has given rise to a formidable literature, including the following: Jane Humphries, 'The working class family, women's liberation, and class struggle: the case of nineteenth century British history', *Review of Radical Political Economics*, 9 (3) (1977), pp. 25-41; Michèle Barrett and Mary McIntosh, 'The "family wage": some problems for socialists and feminists', *Capital & Class*, 11 (1980), pp. 51-72; Hilary Land, 'The family wage', *Feminist Review*, 6 (1980), pp. 55-77.

29. Tom Mann, 'The standard of living of English workers', *Social Economist* (New York), 4, 1893, pp. 97-8; Hunt, *British Labour History*, pp. 102-3; Elizabeth Roberts, *A Woman's Place* (Basil Blackwell, Oxford, 1984), p. 147. As Jill Liddington points out, the 1894 conference report of the Independent Labour Party, at which Mann was elected secretary, expressed sympathy with the 'brutally enslaved . . . wives and mothers who are compelled to go to the mills and the factories' (*The Life and Times of a Respectable Rebel: Selina Cooper (1864-1946)* (Virago, London, 1984), p. 473).

30. P.P. 1892, XXXV, C. 6708-VI, q. 1771. Mann pressed the same point with other witnesses. George Silk, president of the Amalgamated Society of Card and Blowing Room Operatives replied that in Oldham, where he lived, the employment of married women was declining as a result of higher wages and added: 'I do not think that anyone, if they were in a position to keep their wives at home, would insist upon their going to the mill' (*ibid.*, qs. 612-16).

31. Dilke, 'Industrial position of women', p. 500. Clementina Black's poignant comment on this situation (from *Sweated Industry and the Minimum Wage*, 1907) is quoted in part in Humphries, 'The working class family', p. 35.

32. This is the conclusion of Margaret Hewitt, *Wives and Mothers in Victorian Industry* (Rockliff, London, 1958), *passim*, esp. ch. VIII, and appendix II. Contradictory evidence is summarised by Carol Dyhouse, 'Working-class mothers and infant mortality in England, 1895-1914' in Charles Webster (ed.), *Biology, Medicine and Society, 1840-1940* (Cambridge University Press, Cambridge, 1981), pp. 78-84, 97-8. *See also* Roberts, *A Woman's Place*, pp. 164-8, and Michael Anderson, *Family Structure in Nineteenth Century Lancashire* (Cambridge University Press, London, 1971), pp. 71-4.

33. P.P. 1892, XXXVI-I, C. 6795-IV, pp. 574-5.

34. P.P. 1892, XXXV, C. 6708-VI, q. 4999.

35. Clara Collet's attempt to compile minimum percentages of employed wives and widows for 1881 and 1891 (*Report by Miss Collet on the Statistics of Employment of Women and Girls*, P.P. 1894, LXXXI-II, C. 7564, p. 26) bears little resemblance to later census figures.

36. Census of England and Wales, 1901, *General Report* (P.P. 1904, CVIII, Cd. 2174), p. 76; *ibid.*, 1911, *General Report* (P.P. 1917-18, XXXV, Cd. 8491, p. 159; Lee Holcombe, *Victorian Ladies at Work* (David & Charles, Newton Abbot, 1973), p. 217.

37. A useful summary of the position in 1901 can be found in the Board of Trade's *Tenth Abstract of Labour Statistics of the United Kingdom* (P.P. 1905, LXXVI, Cd. 2491), pp. 210-11.

38. P.P. 1892, XXXV, C. 6708-VI, qs. 1624-5 (W.H. Wilkinson); also evidence of David Holmes, *ibid.*, qs. 1060-1; Webb Papers, Trade Union Documents, A. XLVII, 63, f. 270 [1891]; Beatrice and Sidney Webb, *Industrial Democracy*, vol. II (Longmans, London, 1897), p.501. See also *Fifth Annual Abstract of Labour Statistics of the United Kingdom* (P.P. 1898, LXXVIII, C. 9011), pp.122-3; White, *Limits of Trade Union Militancy*, pp.32-3.

39. P.P. 1892, XXXVI-I, C. 6795-IV, qs. 16,936, 17,114-15, 17,223 (Thomas Homer); 17,853-4, 17,859-60, 18,080 (Richard Juggins); P.P. 1892, XXXVI-II, C. 6795-VI, q. 12,806 (James Holmes). About a quarter of married women and widows were employed in Leicester and Nottingham in 1901 (P.P. 1905, LXXVI, Cd. 2491, pp.210-11) and as many as 43.3 per cent in Redditch (P.P. 1904, CVIII, Cd. 2174, p.81).

40. *ibid.*, p.80; P.P. 1905, LXXVI, Cd. 2491, pp.210-11.

41. Angela John, *By the Sweat of Their Brow* (Croom Helm, London, 1980), *passim*, esp. pp.199-203, 227.

42. P.P. 1893-4, XXXIV, C. 6894-IX, qs. 27,131-51. Charles Bowerman of the London Society of Compositors was more evasive but no more sympathetic to the employment of women (*ibid.*, qs. 23,004-16, 23,057-61, 23,079-82).

43. Webb, *Industrial Democracy*, vol. II, p.500 and n.

44. Cynthia Cockburn, *Brothers: Male Dominance and Technological Change* (Pluto Press, London, 1983), p.34.

45. Webb, *Industrial Democracy*, p.500n.

46. *Woman's Signal*, 19 April 1894, pp.260-1; *Young Woman*, 5 (1897), pp.442, 444.

47. *Report of the Twenty-Seventh Annual Trades Union Congress, 1894* (Co-operative Printing Society, Manchester, 1894), p.32.

48. White, *Limits of Trade Union Militancy*, pp.51-2.

49. Webb, *Industrial Democracy*, pp.496-7, 501, 506.

50. *ibid.*, p.504.

51. *ibid.*, pp.496, 497n., 500, 505-6, 774-5. I have profited from correspondence with Adrian Vinson of the University of Southampton on this point.

52. *ibid.*, p.505.

8

Factory acts and trade unions

The low wages and extensive exploitation of working women were widely publicised in the 1890s. The abundant supply of women seeking unskilled manual employment made difficult the formation of strong and permanent trade unions. The consequent defencelessness of women workers and the ignorance of working conditions among the wider public buttressed the position of unscrupulous employers. Low wages, further reduced by fines and deductions, were a disincentive to technological improvement and safer working conditions. The system of factory inspection was weakened by the complications and omissions of the law, the inadequate number of inspectors and the absence of women inspectors until 1893. The subordination of women in the home and in society at large discouraged industrial militancy among women workers. But while descriptions of the problems faced by working women caused little controversy, bitter disagreement began with proposals for reform.

How to improve working conditions raised large questions about contemporary society. It is hardly surprising that curious alliances were forged or that those who took up entrenched positions found it easy to identify their own special interests with the common good. Though opposition to regulatory action by the state had declined in society at large, policies of social reform were still strongly contested by many members of the middle and upper classes. They included a strong contingent of women's emancipationists, who espoused the right of women to work untrammelled by new regulations which did not also apply to men. Supporters and opponents of strengthened legislation accused each other of profound ignorance of the conditions in which working-class women were employed, and of their real wishes. Women involved in the labour movement found themselves in a position of special difficulty, since the rights of women and the growth of the interventionist state, both desired ends, appeared to be irreconcilable.

The nub of the controversy was simple. Working-class

women desperately needed employment on whatever terms they could get. Restrictive legislation was a potential or actual threat to their efforts to find work, and could lead in the extreme to the workhouse or prostitution. On the other hand, society as a whole had an interest in the conditions in which women were employed. To allow complete freedom of action to women whose bargaining position was feeble or non-existent was to set in reverse the gradually improving standards of industrial society. The antagonists were women of exceptional ability, who marshalled compelling theoretical arguments and practical illustrations in their support. Both sides claimed to speak in the name of working women. It is not surprising that their unresolved debate became topical many years later, when the rights of women had again become the subject of controversy.[1]

The most prominent opponents of new factory legislation in the 1890s were the group of women who produced the *Englishwoman's Review*, the long-established and respected advocate of women's rights, and their allies in the growing women's suffrage movement. Their best-known spokeswomen were Helen Blackburn, editor of the *Review*, Jessie Boucherett, the veteran protagonist of women's employment, and Millicent Garrett Fawcett, the intellectual and political leader of the campaign for the parliamentary vote. They were a formidable trio who, with many supporters particularly in women's organisations, mounted a powerful campaign. Factory Acts were passed in 1891, 1895 and 1901, but the efforts of this group ensured that the acts were much weaker, the exclusions and exceptions more numerous than the advocates of legislation had hoped.[2]

These advocates constituted less of an organised faction than the first group. Many were men. Some were trade unionists, motivated primarily by the desire to curb female competition. Some were politicians, usually radical Liberals, who were often, like Sir Charles Dilke and H. J. Tennant, tied by marriage and friendship to the leaders of the women's trade union and factory inspection movements. The intellectual case for extending the factory acts was marshalled by a group of social reformers, some of them socialists. Almost all were women, but they were not identified with the women's emancipation movement, with which they were seldom in sympathy. Their leaders were the young Beatrice Webb, mounting her first sustained campaign, such middle-class trade union organisers as Clementina Black

and Gertrude Tuckwell, and researchers and political figures like Margaret MacDonald.[3]

Opponents of legislation claimed that working women them-selves, although accepting existing factory acts, did not wish them to be extended. The claim was rebutted. Supporters of extending the acts mounted campaigns like one which un-successfully demanded the inclusion of laundresses in the 1891 bill. A London canvass revealed an almost unanimous desire among laundresses for inclusion, and a Hyde Park rally attract-ed a huge crowd of laundry and other workers. Opponents, however, claimed with the Home Secretary, Henry Matthews, that the rally had been 'adroitly got up' by agitators who were unconnected with laundries.[4] Whatever the truth of that parti-cular allegation, evidence about working women's attitudes is ambiguous and opponents of extended legislation may have been correct in claiming their support, for workers desperate for a few shillings at the end of the week were not well placed to reject any opportunity to earn additional wages.[5] The *Daily Chronicle* strongly advocated control of laundresses' hours, but a correspondent in 1895 pointed out that Parliament seldom entered the calculations of such workers ('"Parliament is for making war and voting pensions to royalties," said one with unconscious irony') and that it was unemployment which was most feared.[6] Mary Paterson, the Scottish factory inspector, wrote in a report on laundry workers in 1893 that the women objected to working long hours, but that a factory act would not be universally popular if its provision for more regular hours resulted in lower wages. Many laundresses were attracted by working conditions which allowed occasional days off as com-pensation for the length of the normal working day.[7]

In the course of her enquiries into phossy jaw among East London matchgirls in 1898 Millicent Fawcett was told by the workers that it could be avoided by washing before eating: 'I told them some people wanted to forbid girls and women working at all where phosphorus was used. They expressed great indignation "Where are we to go," they said, "to earn the same money?" "'Oo's going to keep my widder mother and two little 'uns too small to work?" and so on.'[8]

Opponents of extended legislation stressed that working women, being voteless, were unable to protest as directly as men could do against legislative attempts to alter their working

1 George Egerton, 28 March 1894

2 Edith Lanchester, 1897

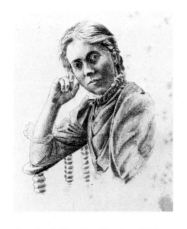

3 *Isabella O. Ford, 1889*

4 *Annie Marland,*
 2 February 1895

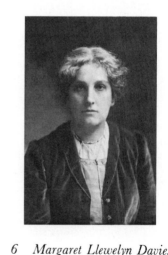

5 *Elizabeth Wolstenholme Elmy,*
 probably about 1908

6 *Margaret Llewelyn Davies,*
 probably about 1890

7 'Past and Present: "No, thanks; I never smoke before ladies!"'
 26 December 1894

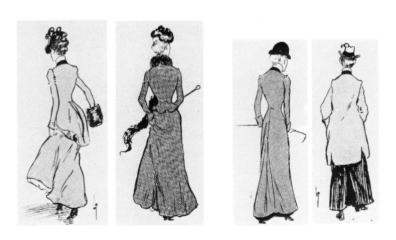

8 'A Study in Backs' March 1900

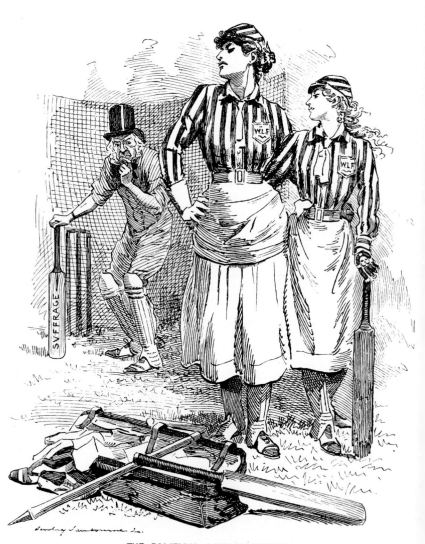

THE POLITICAL LADY-CRICKETERS.

Lady Cricketer. "A TEAM OF OUR OWN? I SHOULD THINK SO! IF WE'RE GOOD ENOUGH TO SCOUT FOR YOU, WHY SHOULDN'T WE TAKE A TURN AT THE BAT?"

9 *'The Political Lady Cricketers' 28 May 1892*

SHALL WOMEN HAVE THE VOTE?

GREAT

MASS MEETING

IN THE

FREE TRADE HALL,

ON

MONDAY, JUNE 25th,

In Support of the Women's Suffrage Amendment to the Registration Bill,

Called by the Manchester National Society for Women's Suffrage.

SUPPORTED BY

Lancashire and Cheshire Union of Women's Liberal Association;
Gorton Habitation of the Primrose League;
National British Women's Temperance Association;
Manchester Women's Christian Temperance Association;
Manchester Women's Co-operative Guild;
Pendleton Women's Co-operative Guild;
Manchester and Salford Federation of Women Workers.

SPEAKERS:

LADY HENRY SOMERSET

Mrs. HENRY FAWCETT,
Mrs. SCATCHERD,
Mrs. EVA M'LAREN,
Mrs. WYNFORD PHILIPS,
Miss ENID STACY,
WALTER M'LAREN, Esq., M.P.

CHAIR TO BE TAKEN AT EIGHT O'CLOCK BY

Hon. Mrs. ARTHUR LYTTELTON

Mdme. ANTOINETTE STERLING

WILL SING.

Doors Open at Seven o'clock. **ORGAN RECITAL** from 7 to 8 o'clock.

RESERVED BODY (numbered) 2s. each; RESERVED GALLERY (unnumbered) 1s.

Reserved Seat Tickets may be had from Messrs. FORSYTH BROS. 122 & 124. Deansgate. Manchester.

TAYLOR, GARNETT, EVANS, & CO. (Cooperative Printing Works, Blackfriars Street, Manchester.

11 *'The Women's Suffrage Appeal to Parliament' 21 May 1896*

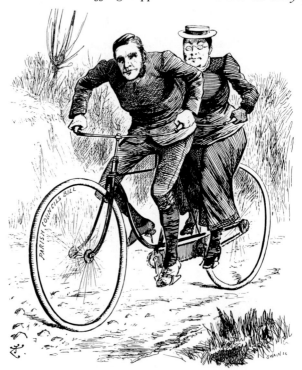

"A BICYCLE BUILT FOR TWO."

12 *'A Bicycle Built for Two' 2 December 1893*

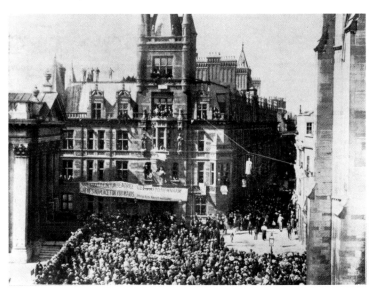

13 *Degrees for Women: Voting Day at Cambridge 21 May 1897*

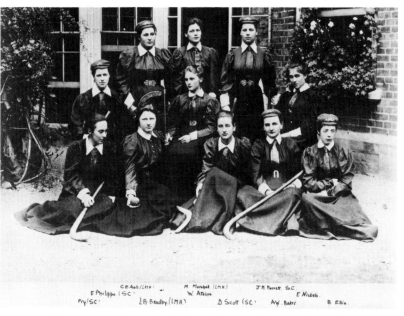

14 *The Oxford Women's Colleges' Hockey Side (Barbara Bradby is second from left in the front row), about 1896*

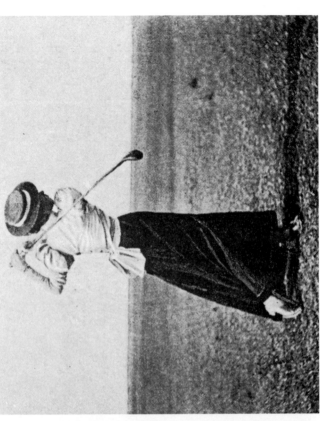

16 'Lady Margaret Scott (After the Drive)' 1893

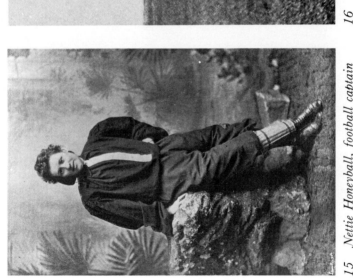

15 Nettie Honeyball, football captain
6 February 1895

conditions. This was one of the principal arguments used by advocates of votes for women, an argument which drove a wedge between the suffrage campaign and some of those whose primary concern was social reform.[9] Jessie Boucherett pointed out in 1896: 'The political power is always with the men, so that it is most difficult for members of the House of Commons to withstand the demands made by the men of any trade for Acts of Parliament to restrict or prohibit the employment of women in that trade.'[10] Millicent Fawcett was fond of quoting in this context a comment made to her by a member of a deputation of chainmaking women to Home Secretary Matthews. Referring to Matthews' evident ignorance of working conditions one of the women reflected: 'It's very hard for him, poor gentleman, to have to make the laws and not know nothing about it.'[11]

While admitting the benefits of past legislation in the textile industry, which effectively applied to both sexes, women prominent in the emancipation movement were adamant that the law should encroach no further on women's right to work. It was not only that many women were wholly dependent on their own earnings and that, as Jessie Boucherett insisted, every occupation involved the risk of injury or disease to somebody.[12] Most women who joined political organisations were convinced that like the parliamentary vote and access to the professions, the right of working-class women to employment without special restrictions on grounds of sex was an essential part of the emancipation of women. The privations imposed by the law would be more severe than any privations which might be found at work. The *Englishwoman's Review* summarised their position in an article published in 1894: 'Women must have some command of money in order to secure their own dignity and self respect. Rich men know this, and insist on marriage settlements for their daughters. Poor women know this, and seek to earn some addition to the family income which may be within their own control.'[13] It is this pride in independence to which Patricia Malcolmson draws attention in quoting a Birmingham woman, who by the early twentieth century had worked in factories for sixty years: 'A shilling you earn yourself is worth two given you by a man.'[14]

Women who sought the right of unfettered employment were concerned to develop the self-reliance of working women and their equal treatment before the law. Helen Blackburn argued

113

in a striking sentence: 'The kindly legislator who wishes to protect women because they are helpless and ignorant only makes that helplessness greater by treating them as hopelessly helpless.'[15] She and others who took this point of view had been reared in a *laissez-faire* school; Millicent Fawcett, herself a capable economist, had married a leading exponent of the school. But many who opposed the extension of the factory acts in the 1890s claimed that they were not hostile to the principle of protective legislation but to laws which restricted only one sex[16] — a characteristic of any conceivable factory act in the period. This was the position of the Women's Liberal Federation in the mid-1890s, and it was also the position of some women socialists. The WLF passed a resolution at its 1895 conference in opposition to the clauses of the Factory Bill then before Parliament which applied exclusively to women. The resolution's mover was the Fabian Society member Harriot Stanton Blatch, who in a letter to the *Woman's Signal* written jointly with other prominent Liberal women insisted that she believed in 'the necessity of protective legislation'. Very few of the thousand delegates had supported 'a purely individualistic policy'. Women in the skilled trades suffered from restrictive laws, while unskilled workers of both sexes needed protection.[17]

Harriot Blatch's view was shared by others in the Fabian Society, for a conference of Fabian women and the society's executive, held shortly before the WLF meeting, passed a resolution urging that the bill should be amended to apply to both sexes.[18] A similar line was taken by Enid Stacy, a leading figure in the Independent Labour Party, who told an interviewer in 1895 that women could never achieve economic equality while subject to special restrictions on their labour. Restrictive legislation tended to lower wages and might drive women out of certain trades.[19] Two years later she wrote that the state had the right and duty to protect its most vulnerable citizens, which might include certain groups of women. She was clearly unhappy about this position, however, which she acknowledged would be contested by some supporters of women's rights outside the ranks of 'the middle-class individualistic section'. The labour of both sexes should be controlled by law, and women alone should not be tied down 'under the guise of benefiting the community'.[20]

Few middle-class women could claim such intimate know-

ledge of working women as Isabella Ford, and as a prominent member of the Independent Labour Party she could not be accused of confusing outworn economic theory with the rights of women. But she too opposed legislation applicable to a single sex. In a letter written in 1891 she pointed out that it was regarded as an act of kindness to women to put forward legal restrictions which would throw women out of work. Had the same provisions applied to men they would have been regarded as tyranny. Women themselves were not consulted about proposed legislation and would not be until they gained the parliamentary vote. She acknowledged that women's unskilled labour drove down the wages of the men with whom they competed, but pointed out that low wages and heavy work were preferable to 'lives of shame and drunkenness and starvation'. Protection of living standards and of women themselves could not be achieved 'by crippling women's paths with legislation'. If women were treated by men as 'equals and comrades' and allowed to enter all employments they would spread over a wider field and in time abandon heavy and harmful work.[21] A similar line was followed by other women socialists or sympathisers, including Dora Montefiore, Elizabeth Wolstenholme Elmy, and the woman's columnist of the ILP paper, *Labour Leader*.[22]

The struggle over factory legislation was inconclusive not only because both sides had strong cases but because to some extent they aimed at different targets. To opponents of extended restrictions women's work was a right and state regulation an evil, at least if it did not apply equally to both sexes. It should be repeated that most women who took part in the emancipation movement were found in this camp. Though they would of course have rejected the mocking tone of a satirical verse printed in the *St. James's Gazette* in 1895 they were in no doubt that harsh working conditions were a lesser evil than restrictions and prohibitions determined by a parliament of men:

> British women, old and new
> Whom your 'tyrants'' mercies irk
> Sacred 'Freedom' cries to you:
> 'Claim the right to overwork.'
> Fight your saviours' tyranny,
> And be slaves, to prove you're Free.
>
> Fight for fourteen hours a day,

115

Work in foul and fetid air,
Little time for ease and play,
Recreation, rest or prayer.
Grind and groan in misery,
Poisoned, sweated — but be Free.[23]

The primary concern of social reformers was the standard of living of the working class as a whole. They looked upon women manual workers as exploited workers rather than as exploited women. As Eleanor Marx put it: 'We see no more in common between a Mrs. Fawcett and a laundress than we see between Rothschild and one of his employees.[24] Those who shared this point of view agreed that women should be protected from themselves by the imposition of minimum legal standards. They should not, by working for subsistence wages, drive better-paid men out of jobs. As social reformers acknowledged on suitable occasions, in an overstocked labour market some unskilled women workers should not be employed.

Margaret MacDonald, one of the most capable researchers into the conditions of women's employment and wife of a rising Labour politician, told the International Congress of Women meeting in London in 1899 that the loss of women's employment 'in a few cases' because of restrictive laws was an acceptable price to pay for a system of regulation which raised the living standards of all workers. 'True freedom for a woman', she said elsewhere, 'is not freedom to earn *any* wage under *any* conditions.'[25] Amy Bulley, the writer, educationist and supporter of trade unions, denied that women had the right to work at the best wage they could get irrespective of the consequences to male workers: 'It would surely be better for the wives and daughters to stay at home and leave the original breadwinner to his labour rather than combine to undersell him until the whole family earn little more for their work than the head of it earned before.'[26] This succinct statement can be taken as representative of the views of women supporters of the factory acts.

Beatrice Webb's penetrating intelligence and decisive personality made her the most formidable and respected advocate of factory legislation. In a series of lectures delivered to women's groups and the Fabian Society in 1895-6 she confronted the question of individual freedom and insisted that it was not reduced but increased by factory legislation: 'Everyone knows that the Lancashire woman weaver, whose hours of labo[u]r

and conditions of work are rigidly fixed by law, enjoys, for this very reason, more personal liberty than the unregulated laundry-woman in Notting Hill.' Legislation was also a prerequisite, not an alternative to the formation of effective trade unionism for women. It was unrealistic to recommend to unskilled women workers the formation of unions, for this was advice they were seldom able to take:

> Before wage-earners can exercise the intelligence, the deliberation, and the self-denial that are necessary for Trade Unionism, they must enjoy a certain standard of physical health, a certain surplus of energy, and a reasonable amount of leisure. It is cruel mockery to preach Trade Unionism, and Trade Unionism alone, to the sempstress sewing day and night in her garret for a bare subsistence; to the laundrywoman standing at the tub eighteen hours at a stretch; or to the woman whose health is undermined with 'Wrist-drop', 'Potter's-rot', or 'Phossy-jaw.'

Uncontrolled bargaining between capitalist and individual workers led not to high wages but to a bare subsistence standard of living. She dismissed the idea of applying the factory acts to both sexes alike as impracticable: 'Were all sections of Labour to wait for better conditions until all sections got them at once?' Women had long been industrial blacklegs; middle-class women should not encourage their continued occupation of that role.[27]

The analysis of other social reformers was influenced by the work of the Webbs. A contribution by Clementina Black to a book edited by Beatrice Webb asserted that men's and women's labour seldom overlapped. It was 'an amazing perversity' to suggest that male workers wanted factory acts to reduce female competition, for the men were in reality interested in legislation primarily as a device to improve their own conditions. There was no question of dismissing women because of legislative constraints; rather, their low wages made them so attractive to employers that any irritation caused by legal regulations faded into insignificance.[28] A pamphlet whose author was almost certainly Margaret MacDonald[29] described factory legislation as women's substitute for trade unionism. She asserted that the nature of women's clothes, hair and physical constitution necessitated provision of special protective measures at their workplaces. She vigorously dismissed the claim that employment opportunities had been reduced by factory legislation,[30] and insisted that if men's hours were legally regulated women

117

would not be affected, while to end the regulation of women's work 'would be to remove the chief barriers they have against wholesale oppression'. With more optimism than realism she asserted that the interests of men and women industrial workers were not antagonistic. Men, she declared, 'do not oppose women: they oppose cheap labour'.[31]

With such different ideological perspectives individualists and social reformers could hardly have reached agreement on the difficult question of protective legislation for women workers. They were in apparent agreement about the importance of women joining trade unions, but most opponents of extended factory legislation had no enthusiasm for militancy. Believing that the interests of capital and labour were essentially in harmony and that low wages were an important means for women to secure employment their support for independent trade unions was more nominal than real. Jessie Boucherett suggested typically: 'Benevolent ladies could do no better deed than to start trades-unions for women, managed by working women; or if that is too difficult, to set up provident clubs and manage them at first.'[32]

The struggle to create effective unions, involving problems at least as great as those of securing effective factory legislation, was an essential part of the attempts made in the 1890s to protect and improve the position of women workers. It was a struggle left mainly to social reformers and their friends, though the support of Isabella Ford for women's unions in Leeds was as strong as that of the most dedicated advocate of factory acts. Women trade unionists have been the subject of a number of recent studies,[33] and there is no need to give a detailed account of their progress here. It is important to note, however, that women's unions in the period could hardly have functioned successfully in opposition to established men's unions. It was inevitable that the new breed of educated women who wished to integrate women workers into the wider labour movement and who moved against a background of previously unsuccessful women's trade unionism and an intellectual climate increasingly sympathetic to state intervention should support factory acts, minimum wages, a reduced workforce of unskilled women and the family wage. By 1891 the original Women's Protective and Provident League of 1874 had shed its equivocal name and

most of its individualistic sponsors. As the Women's Trades Union League, led by Lady Dilke and her niece Gertrude Tuckwell, a former London School Board teacher, it became a firm supporter of legislation and the family wage.[34] So too did the Women's Co-operative Guild,[35] a more genuinely working-class wing of the labour movement than the leadership of the League,[36] though few of its members belonged to the oppressed class of subsistence wage-earners to whom extended legislation would have applied.

Although the trade union organisation of women began in the 1890s to expand outside the cotton industry, the task of organisation was almost insuperable. A major problem was the hostility of employers. Clara James, herself a confectionery worker and the secretary of a union of London confectionery workers, told the Royal Commission on Labour in 1891 that she had been dismissed for joining a union. Workgirls, spied upon by their foremen and forewomen, were afraid to join. An employer had told her: 'My girls are treated properly, but if I catch any of them coming to your meetings I will dismiss the lot of them.' This policy of intimidation, she added, was general.[37]

Clara James's experience in London was supported by Ada Nield's in Crewe, where a number of the 'factory girls' who attended meetings held to discuss union organisation in 1894 were observed by management agents and subsequently dismissed. The factory made clothes for government contracts and would accordingly have been sensitive to pressure, but there was little to fear from a government which did not enforce the parliamentary Fair Wages resolution of 1891 in its dealing with contractors,[38] let alone encourage the spread of effective trade unionism. The Crewe girls who watched the dismissal of their bold colleagues, some of whom had no other means of support than their wages, were not in a position to take Ada Nield's earnest advice to organise, however much they might agree that it was 'the only way to accomplish anything substantial'.[39]

Employers' pressure was a strong disincentive, but it could not have prevented the formation of viable unions among women workers. Men had formed successful unions despite employers' hostility and had forced their legalisation on a reluctant parliament. Every account of women's trade union organisation in the period cites the women themselves as the primary obstacle. None is more graphic than that by Evelyn

March-Phillipps, a close student of women's industrial work. Intimidation by employers was still common, she wrote, but it had begun to yield to 'a more intelligent attitude'. The greatest difficulty was that presented by the women, whose outlook was shaped by the conditions of the labour market and, one should add, their upbringing and socialisation in late Victorian society. Women workers, in her view, generally lacked the qualities of steadiness and perceptiveness required of good trade unionists.

> More often than not they are timid, indifferent, frivolous, excitable, and for a new Sunday hat or a walk with the Tom or Dick who happens to be in the ascendent would sacrifice the best interests of all the women in the world without a pang. The majority are young, and look forward to marriage to release them from work At women's meetings . . . if the audience is composed of factory girls amusement seems to be their chief object. The jokes and chatter are irrepressible; the most discreet allusion to the topic of marriage is the signal for shrieks of laughter. The petty jealousies, too, are heartbreaking and promises cannot be relied upon At one meeting a man who was speaking turned away in despair. 'What can we do with these women?' he said; 'it is impossible to get any hold over them.'[40]

A similar comment was made a few years later by the Manchester, Salford and District Women's Trades Union Council. 'The great difficulty', their report observed, was the women's 'extreme apathy'. Single women looked forward to marriage, married women had no time to attend union meetings. Moreover, women workers felt, no doubt correctly, that 'there are such vast numbers of women competent to work, that any display of independence on their part would oust them from the labour market entirely'.[41] Margaret MacDonald's pamphlet to which reference has been made also stressed the importance of the prospect of marriage and the reality of home responsibilities for older women. Writing in the name of the City of London branch of the Independent Labour Party she declared that 'women trade unionists must always be comparatively few and inefficient, and Trade Unionism can never do for women what it has done for men'.[42]

A review of the pamphlet in the *Women's Trades Union Review* was accurate in describing the tone of this passage as pessimistic.[43] Assessments like those of Lady Dilke and the Scottish

mill union leader John Hendry, dating from opposite ends of the decade, were also accurate; women had for so long been treated as isolated and inferior, taught to regard themselves as 'dependent and subordinate', that they did not trust the men who attempted to organise them and lacked confidence in themselves.[44] A legacy of hostility and denigration claimed a grim revenge. But a generation of male trade unionists newly anxious to recruit women was driven to shoulder-shrugging defeatism or despair. John Burns, still an influential voice of radical trade unionism, told a meeting in 1893 that it was 'almost impossible' to organise working women in most occupations. The effort involved would be better devoted to returning labour candidates to Parliament and to passing factory legislation. In subsequent newspaper correspondence Burns blamed women's 'apathy and disorganisation' on their low and unequal pay, 'their sex' and the prospect of their early retirement from the labour market. Only where they worked with men was there real hope of making successful trade unionists of them. 'That this is regrettable is true. That it is true is the fact.'[45]

It should be remembered that in addition to the tyranny of employers, the prospect of marriage and the apathy of the poverty-stricken woman worker taught to believe in her own inferiority, many women were effectively beyond the reach of trade unions because they worked in small, unregulated workshops or in their own homes. Home-workers formed a much higher proportion of the female workforce than of the male, and women who worked in factories might well regard themselves as belonging to a relatively privileged species. Half of the 340,000 women dressmakers discovered by the 1901 census compilers worked at home as did over a third of the nearly 85,000 shirtmakers and seamstresses.[46] James Schmiechen estimates in his valuable study of sweated work in London that there were between 100,000 and 125,000 outworkers in the capital in the early twentieth century, the large majority of whom were women; it was to this *'army* of off and on out-workers in our vast cities' that a correspondent drew the attention of the Women's Trades Union League late in 1897. There was 'a keen demand for the work' for as little as five or six shillings a week.[47] In the chainmaking industry there was a striking contrast between the strength of unionised male factory workers and the weakness of unorganised women outworkers.[48] To the problem of home-

workers must be added the much larger category of female domestic servants, working in different conditions but equally isolated and equally untouched by trade unions.

Eight men and two women who contributed to a symposium in the *Women's Trades Union Review* in January 1900 took a generally gloomy view of 'Women as Trade Unionists'. Several of the writers pointed to the difficulties involved in persuading women to join unions and to remain members. Margaret Bondfield, who as a leader of the shopworkers represented a new breed of woman unionist, asserted that most women had no understanding of the meaning of trade unionism and hence could not be relied upon in a crisis. Home influences and the prospect of marriage were mentioned by most of the writers. Only David Shackleton painted a brighter picture of women trade unionists.[49] Shackleton, later an MP and civil servant, was a Lancashire cotton weaver, and the organisation of women in the cotton weaving unions was successful to an extent unparalleled elsewhere. The reasons are easily ascertained. Men and women worked together and their wages, as seen above, were similar. The impossibility of disentangling women's work from men's ensured that the benefits of factory legislation applied to both sexes. The high degree of organisation of women owed nothing to altruism on the part of men and everything to self-interest. Women weavers predominated numerically and men's wages could be maintained only by recruiting both sexes into common unions and maintaining adequate wage levels. The fact that a relatively high proportion of women weavers were married made the task of organising them much easier than in industries dominated by younger, single women.[50]

Within the Lancashire unions, however, women played a generally insignificant role. Beatrice Webb, interviewed in 1894, could point to only one woman official, the newly-elected president of the Oldham weavers.[51] Asked if there should be more women officials she replied that women should be appointed if competent, but added: 'The secretaries of the weavers' unions require to be excellent arithmeticians, many of them mathematicians, in order to calculate the elaborate piece-work prices of the cotton trade; therefore, until working women are more highly educated, they cannot fill these posts efficiently.'[52]

Beatrice Webb believed that men and women should join the

same union. So too did the Women's Trades Union League, reversing its earlier policy in 1890.[53] Lady Dilke wrote in 1891 that women were generally poor officials and that it was very difficult to find effective 'organisers and agitators' among working women. Only where there were no male workers, no union or where women were refused membership should they set about organising unions of their own. Most women's unions, she said in a speech three years later, were no more than 'tiny benefit societies'. As such they were 'useless from every point of view', an opinion in sharp and revealing contrast to that of Jessie Boucherett quoted earlier.[54]

Lady Dilke knew and explained the psychological and practical difficulties faced by women trade unionists. Nonetheless, she believed, with Evelyn March-Phillipps, that 'women only combine successfully when they join forces with men'. When the excitement of a strike was over, March-Phillipps wrote, women lacked men's qualities of calm, steady, methodical application. 'Besides which', she added, 'it is, and perhaps always will be, natural to the mass of womenkind to defer to and be led by masculine judgment and authority.'[55] Lady Dilke may not have used these words but there is every reason to suppose that she, like other WTUL officials, shared the same view, ignoring the fact that unions of unskilled men faced similar problems to those involved in organising women.[56] It is difficult to imagine such sentiments on the lips or pen of Millicent Garrett Fawcett, or other supposed champions of exploitation and starvation wages.

The efforts made by the women of the League and their male allies to recruit women workers into unions in the 1890s were far more systematic and persistent than any made previously. Progress was apparent but very limited. The first official estimate of women trade unionists was a cautious global figure of 63,000 for 1895. (March-Phillipps, who estimated 45,984 for 1890 and 82,362 for 1893, excluding the membership of all-women unions, seems from the trend of later figures to have been rather more accurate in her estimates than contemporary civil servants.) The detailed official estimate of 108,578 in 1896 was periodically raised as new information came to light, but there is little doubt about the pattern of female membership. The Board of Trade's final detailed calculation for 1896 was 117,030 women trade unionists, excluding teachers, though the global total for the year was later fixed at 142,000.[57]

Table 3: Trade union membership 1896

| Trade | All members of unions | | Female members of unions | | |
	Total no. of unions	No. of members	No. of unions with female members	No. of female members	Females as percentage of all unionists
Building	135	193,643	—	—	—
Mining & Quarrying	90	291,015	—	—	—
Metal, Engineering & Shipbuilding	284	305,412	5	638	0.2
Textiles					
Card & Blowing Room (Cotton)	+	+	18	19,310	
Cotton Weaving	+	+	55	73,015*	
Other	+	+	26	13,823	
Total	255	219,271	99	106,148	48.4
Clothing	50	76,457	17	5,036	6.6
Transport	61	134,050	—	—	—
Employees of Public Authorities	38	44,782	—	—	—
Other Trades	389	239,109	28	5,208	2.2
Total	1,302	1,503,739	149	117,030	7.8

+ Not stated in the 1906 report. The first detailed report for 1896 showed that 80.9 per cent of card and blowing room operatives and 67.0 per cent of weavers who belonged to trade unions were female (P.P. 1897, XCIX, C. 8644, pp. 158-60).

* This figure was 62.4 per cent of the total number of female trade unionists.

Source: calculated from Board of Trade's *Report on Trade Unions in 1902-04* (P.P. 1906, CXIII, Cd. 2838), pp. lx-lxi, lxvi.

The outstanding point in each tabulation was that the overwhelming proportion of women trade unionists were recruited among cotton workers, especially weavers. Without the Lancashire cotton industry women trade unionists would have been in short supply. Moreover, the Board of Trade's various calculations showed that the exertions of the League and its friends did little more than ensure that the number of women unionists remained stable while the number of men rose, at least until the beginning of the new century. Thus the 117,030 women of 1896

represented 7.8 per cent of all union members, while the 125,738 of 1900 were only 6.4 per cent (in the final revision the 142,000 women were 8.8 per cent of all union members, while the 154,000 in 1900 represented 7.6 per cent), and it was not until 1904 that the percentage of women among trade unionists began to rise perceptibly. The figures were not so unfavourable to women as they appeared, however, since the large number of women who worked in home industries and as domestic servants were as previously mentioned virtually impossible to organise. The Board of Trade's officials estimated that in 1897 about 25 per cent of adult males in manual occupations outside agriculture and fishing belonged to unions, while 12 per cent of women who worked in factories and workshops were unionists. Finally, it should be noted that the figures included a number of unions whose membership was restricted to girls and women, a few of which had male secretaries. There were 20 women-only unions in 1896 with 6,974 members and 27 in 1900 with 8,974 members.[58]

The efforts made by the Women's Trades Union League to recruit women unionists and the frustrations involved were most clearly shown in the career of Annie Marland. Described by *The Star*, the sympathetic radical paper, as 'a Lancashire lass, with a broad accent', she came from Mossley, where she belonged to the Card and Blowing Room Operatives' society. She created a minor sensation at the Women's Liberal Federation in 1891, where she defended unions against the charge of attempting to limit the employment of women: 'Women were freely admitted into the trade unions associated with the textile trades. [Men and women] worked hand-in-hand smoothly and harmoniously.'[59] Seizing the opportunity presented by the sudden appearance of a woman trade unionist with organising potential Lady Dilke agreed to pay a salary of £72 a year to Annie Marland, who in 1892 became the League's first full-time working-class organiser. Interviewed by the Manchester *New Weekly* in 1895 she drew on her experience of eighteen years as a card room operative in Mossley, from the age of ten. She regarded mixed unions as the ideal, for men were 'more business-like' and experienced than women, and were consequently a good influence on women members, though women often made good committee members and could make 'neat little speeches'. Men's hostility to women trade unionists was a

thing of the past. She denounced the increased employment of women at reduced wages in Yorkshire in significant terms: 'You see the men hanging about the street idle. I have even seen them scrubbing floors, whilst the women and children are at the mill.' Her ideal, like that of other social reforming women, was for wives to stay at home: 'We are trying very hard to improve opinion on this matter.'[60]

Marland was the League's principal and most effective campaigner in the 1890s, though a number of other talented working-class women with roots in the labour movement were also appointed, including Sarah Reddish and Ada Nield (Chew). Marland married a glassblower and active trade unionist named Brodie in 1895, reduced her League workload in about 1898 and emigrated to Florida in the new century. In her six years or so as full-time organiser for the League she travelled constantly, facing the gibes and insults of opponents and the apathy of those whom she attempted to organise.[61] On a visit to the Potteries in 1897 she found women eating in their workrooms beneath signs forbidding them to do so: 'the women sat actually taking cake, bread and butter, etc., from off their laps with their dirty fingers all daubed with glaze. The employers were keeping the rules and the girls were breaking them!' The following year she took part in a long campaign to recruit women penmakers in Birmingham. In some cases pressure from foremen or others made the girls unwilling or afraid to speak to her. Having distributed about 3,000 handbills and talked to many women she held a general meeting; about fifty workers attended, but only a handful joined the union: 'Apathy and indifference, with some marked exceptions, seem to be general. They are all ready for improvement and more just conditions if someone else will work for them.'[62]

Marland did not always meet with discouragement. She addressed successful meetings at the annual Trades Union Congress and elsewhere, including one in Manchester which attracted an audience of a thousand. As a result of the work which she and the WTUL's other organisers carried out, the more sympathetic attitude of men unionists and the financial and practical support of Sir Charles and Lady Dilke, the League firmly implanted itself in the trade union world. The ten organisations which affiliated or subscribed to it in 1891 rose to fifty-eight in 1900.[63] Although the League was much the most

126

important women's trade union organisation in the 1890s it was not the only body which attempted to organise working women. The Women's Trade Union Association, in which Clementina Black played a leading role, worked hard among London women before fading away at the end of 1894, but it was succeeded by the Women's Industrial Council, whose investigations and publications provided valuable support for trade union work amongst women.[64]

Nonetheless, the experience of Annie Marland and her colleagues was generally discouraging. Addressing the International Congress of Women in 1899 she appealed for the increased support of male unionists, the churches and wealthy women, and spoke of her work as hard, monotonous and weary: 'It is no uncommon thing for women at the factory gates to jostle you, to tear up the handbills and throw them in your face — a personal experience of my own almost every week in some districts. All these things we have to meet cheerfully.'[65]

By the 1890s women delegates were well established at the annual meetings of the Trades Union Congress. The fact that they were almost exclusively working-class women, the League's changed position on factory legislation and the successful meetings which it held for local workers during Congress week ensured that past controversies about women delegates did not recur.[66] The presence of a handful of women among several hundred men, however, was easy to ignore. Moreover, the regular attendance of Eleanor Whyte, secretary of the long-established London union of women bookbinders, meant that the voice of women hostile to protective laws restricted to women continued to be heard. Eleanor Whyte missed only one TUC in the 1890s. In 1891 she was one of seven women delegates, all of whom represented women-only unions. A few women were subsequently sent by mixed unions; one of the first was Annie Marland, who represented the Mossley district of the Card and Blowing Room Operatives in 1894. Her colleagues in the League proudly noted that, unlike most women delegates, she could be heard all over the hall, 'a fact much commented on!'[67] Rule changes in 1895 more narrowly defined the qualifications of delgates and contributed to the fact that the number of women was reduced from nine in 1892 and 1894 to only one in 1899.[68]

With a single exception women delegates stuck closely to a

narrow range of subjects which, like factory legislation, could be classified as 'women's issues'. The exception was Margaret Bondfield, the only women among 384 delegates in 1899 and the only representative of the 3,500 shop assistants affiliated to the TUC. Bondfield, then 26, was to become the first woman member of the General Council of the TUC and the first woman cabinet minister, but she was never to have a triumph greater than that at the 1899 TUC. She spoke six times, on a variety of subjects including municipal housing and the resolution in favour of increased labour representation which led to the formation of the Labour Representation Committee, the fore-runner of the Labour Party. In her first contribution she 'surprised and delighted the Congress with her stirring speech', in the words of the otherwise matter-of-fact Congress report. She was received with 'loud applause'.[69] But though Bondfield's success in 1899 was an indication of things to come, her first appearance was not a signal for an immediate increase in the number of women delegates. The 1900 female contingent to the TUC comprised only Eleanor Whyte and Julia Varley of the Bradford textile workers, another remarkable trade unionist in the new century.

The League's philosophy was enunciated by Emilie Holyoake, speaking as its secretary: 'True and lasting reform must come from below and not above.'[70] Reform from below was blocked in the 1890s by the over-supply of unskilled labour, women's lack of experience as trade unionists, the still significant hostility or scepticism of many male workers towards women, and the education and socialisation of women, which encouraged apathy and inconsistent attitudes towards trade unionism. Reform from above in the form of more effective factory legislation was blocked by the class and political composition of the House of Commons and by the vocal lobby of middle-class women's rights individualists.

As the new century began the outlook for women's trade unionism was considerably more promising than it had been a decade earlier. Among the causes was the existence in the 1890s of a small number of women dedicated to the transformation of the women's union movement. They included middle-class women like Clementina Black, Margaret MacDonald and Gertrude Tuckwell, and women with extensive personal experience of working conditions like Clara James, Annie Marland

and Ada Nield. Women were now established as trade unionists and as acknowledged authorities on the problems of employment of their sex. Between the start of the century and 1914 the percentage growth of women unionists was considerably greater than that of men, a trend which gathered pace during The Great War.[71] It was a real achievement to set against the frustrations and defeats which the women's union movement had suffered so often in the 1890s and which by no means disappeared after 1900.

Notes

1. The conclusion of an Equal Opportunities Commission report, that 'there is no longer justification for maintaining legal provisions on hours of work which require men and women to be treated differently' (Equal Opportunities Commission, *Health and Safety Legislation: Should we Distinguish between Men and Women?* (EOC, Manchester, 1979), pp. 96, 127) and related recommendations were subjected to severe criticism by the Trades Union Congress in the *Report of 111th Annual Trades Union Congress, 1979* (TUC, London, ?1979, pp. 56, 454-5, 477-80). I am grateful to Christine Jackson of the Equal Opportunities Commission for assistance on this point.
2. B.L. Hutchins and Amy Harrison consider this question in their classic *History of Factory Legislation* (1903; Cass, London, 1966), chs. 9, 10 and 11, esp. pp. 191-5. The authors were strong partisans of factory legislation.
3. The members of this group are termed 'social feminists' by Ellen Mappen in *Helping Women at Work: the Women's Industrial Council, 1889-1914* (Hutchinson, London, 1985), pp. 11, 27.
4. *The Times*, 15 June 1891; *Parl. Deb.*, 3rd ser., 354 (19 June 1891), cols 931-2, 937.
5. *See* James A. Schmiechen, *Sweated Industries and Sweated Labor: the London Clothing Trades 1860-1914* (University of Illinois Press, Urbana and Chicago, 1984), pp. 147-53.
6. 'The truth about laundries', by a 'lady laundress', *Daily Chronicle*, 4 June 1895.
7. Factory Inspectors' Reports on Conditions in Laundries, P.P. 1894, XXI, C. 7418, p. 11. For an authoritative account of the subject see Patricia Malcolmson, 'Laundresses and the laundry trade in Victorian England', *Victorian Studies*, 24 (1981), pp. 439-62.
8. *The Standard*, 23 July 1898. Another article in *Victorian Studies*, Lowell J. Satre, 'After the match girls' strike: Bryant and May in the 1890s', 26 (1982), pp. 7-31, provides useful information about the phossy jaw controversy of 1898.
9. An obvious example was Beatrice Webb, for many years an opponent of and never an enthusiast for women's suffrage. *See* Deborah Epstein Nord, *The Apprenticeship of Beatrice Webb* (Macmillan, Basingstoke and London,

1985), pp. 149-52, 272; Beatrice Webb, *Our Partnership* (ed. Barbara Drake and Margaret I. Cole; Longmans, London, 1948), pp. 360-3.

10. Jessie Boucherett, Helen Blackburn and others, *The Condition of Working Women and the Factory Acts* (Elliot Stock, London, 1896), pp. 21-2.

11. Ray Strachey gives an account of the deputation, which probably took place in April 1891 *(The Times,* 20 April 1891), in *The Cause* (1928; Virago, London, 1978), pp. 236-7. The 'authorised version' of the comment to Mrs Fawcett, quoted here, was published in the *Women's Industrial News,* February 1896, p. 4.

12. *Englishwoman's Review,* 25 (1894), p. 13; 26 (1895), pp. 80-1; 29 (1898), pp. 80-1.

13. *ibid.,* 25 (1894), pp. 146-7.

14. Malcolmson, 'Laundresses', p. 462 (from Edward Cadbury, M. Cécile Matheson and George Shann, *Women's Work and Wages* (T. Fisher Unwin, London, 1908), p. 212). As Sandra Holton shows, Emmeline Pankhurst was among those who endorsed this observation ('Feminism and Democracy: the Women's Suffrage Movement in Britain, with Particular Reference to the National Union of Women's Suffrage Societies 1897-1918' (unpublished Ph.D. thesis, University of Stirling, 1980), pp. 31, 51).

15. Boucherett, Blackburn and others, *The Condition of Working Women,* p. 75.

16. Even Helen Blackburn claimed in 1895: 'We . . . are not against Factory Legislation. There must be certain restrictions and certain regulations. We ... are against their unequal pressure upon men and women.' (*Women Workers: the Official Report of the Conference Held at Nottingham in 1895* (James Bell, Nottingham, 1895), p. 65).

17. *Daily Chronicle,* 15 and 16 May 1895; *Woman's Signal,* 16 May 1895, p. 318; 30 May 1895, pp. 348-9.

18. *ibid.,* 16 May 1895, p. 310; *Fabian News,* June 1895, p. 14. See Harriot Stanton Blatch and Alma Lutz, *Challenging Years: The Memoirs of Harriot Stanton Blatch* (G.P. Putnam's Sons, New York, 1940), pp. 84-5.

19. *Woman's Signal,* 12 September 1895, p. 161.

20. Enid Stacy, 'A century of women's rights', in Edward Carpenter (ed.), *Forecasts of the Coming Century* (Labour Press, Manchester; Clarion Office, London, 1897), pp. 96-8.

21. *Factory Times,* 10 April 1891, p. 7. I owe this reference to Joyce Bellamy.

22. *See* Angus McLaren, *Birth Control in Nineteenth-Century England* (Croom Helm, London, 1978), pp. 164, 170; Schmiechen, *Sweated Industries and Sweated Labor,* p. 160 and sources cited therein.

23. Reprinted in *Woman's Signal,* 30 May 1895, p. 338.

24. Quoted in Hal Draper and Anne G. Lipow, 'Marxist women versus bourgeois feminism', in Ralph Miliband and John Saville (eds), *The Socialist Register 1976* (Merlin, London 1976), p. 225. The passage quoted was published in the Austrian socialist women's journal *Arbeiterinnenzeitung* in 1892. For a critique see Sheila Rowbotham's introduction to Olga Meier (ed.), *The Daughters of Karl Marx: Family Correspondence 1866-1898* (Deutsch, London, 1982), pp. xxxv-xxxviii.

25. Margaret Ethel MacDonald, 'Factory legislation', in Countess of Aberdeen (ed.) *The International Congress of Women of 1899,* vol. VI, *Women in Industrial Life* (T. Fisher Unwin, London, 1900), p. 55. The second

passage quoted is from p.20 of the ILP pamphlet to which reference is made in note 31 below. The passage is identified as his wife's by Ramsay MacDonald in his moving *Margaret Ethel MacDonald* (Hodder & Stoughton, London, 1912) and quoted on pp. 177-8.

26. *Morning Post*, 1 December 1894.

27. The essence of Beatrice Webb's lectures can be found in the report of the 1895 conference of the National Union of Women Workers (note 16 above), pp.41-50, 69-71, in her Fabian Tract, *Women and the Factory Acts* (Fabian Society, London, 1896), and in chapter 4 of Beatrice and Sidney Webb, *Problems of Modern Industry* (Longmans, London, 1898). The first two passages quoted are from *Women and the Factory Acts*, pp. 5, 9, the third from the *Daily Chronicle*, 22 May 1895.

28. Clementina Black, 'Some current objections to factory legislation for women', in Beatrice Webb (ed.), *The Case for the Factory Acts* (Grant Richards, London, 1901), pp. 197-9. 210-11.

29. The papers of Margaret Ethel MacDonald in the British Library of Political and Economic Science (vol. 2, item 34) contain an undated typescript lecture entitled 'That the economic position of women can best be improved by legislation'. The similarities between lecture and pamphlet, and the extracts quoted by Ramsay MacDonald (*Margaret Ethel MacDonald*, pp. 177-82) show that Margaret MacDonald was at least a principal author.

30. A prolonged and searching study carried out by a committee of the British Association came to twenty-one conclusions which strongly supported the factory acts. The great benefits conferred by the acts, the committee decided, were 'out of all proportion to any inconveniences or injury they have caused'. They had had little apparent influence on the general demand for women's labour (*Report of the Seventy-Third Meeting of the British Association for the Advancement of Science held at Southport in September 1903* (Murray, London, 1904), pp. 340-2). Ramsay MacDonald (ed.), *Women in the Printing Trades* (P.S. King, London, 1904) quoted an employer who, upon being told that legislative restrictions allegedly hindered women's employment, 'replied scathingly that it was rubbish, but that "ladies must have something to talk about"' (p. 82). Studies of women compositors admitted that the factory acts had prevented them from working on morning newspapers, but even in this field the main barrier to women's employment was not factory acts but trade unions (see *Economic Review*, 2 (1892), pp.46-8; *Economic Journal*, 9 (1899), pp.264-6).

31. Independent Labour Party (City of London Branch), *Labour Laws for Women, their Reason and their Results* (ILP, London, 1900), *passim*. The quotations are from pp. 18 and 20.

32. Boucherett, Blackburn and others, *The Condition of Working Women*, p. 38.

33. Teresa Olcott, 'Dead centre: the women's trade union movement in London, 1874-1914', *London Journal*, 2 (1976), pp. 33-50; Sheila Lewenhak, *Women and Trade Unions* (Benn, London, 1977); Norbert Soldon, *Women in British Trade Unions 1874-1976* (Gill & Macmillan, Dublin, 1978); Sarah Boston, *Women Workers and the Trade Union Movement* (Davis-Poynter, London, 1980); Schmiechen, *Sweated Industries and Sweated Labor*, ch. 4.

34. *See ibid.*, pp. 150-1. Soldon discusses the first League's opposition to restrictive legislation (pp. 7-8, 13-14, 21) and rightly calls attention to personal influences in the revamped League's policy changes (pp. 28-9), but wider social changes were surely of greater importance. For the League's support for the family wage see *Women's Trades Union Review*, 15 (1894), p. 10; for Lady Dilke's, *Newcastle Daily Chronicle*, 8 March 1890. *See also* Jane Lewis, *Women in England 1870-1950* (Wheatsheaf, Brighton, 1984), pp. 49-51.

35. *Co-operative News*, 13 July 1895, p. 735. The annual meeting of the Guild rejected a plea from Miss Morant of the Independent Labour Party to oppose factory legislation which applied only to women (*ibid.*).

36. A survey of over 700 married Guild members, more than 10 per cent of its membership, indicated that work in industry and domestic service had been the most common occupations before marriage (*Labour Gazette*, 1 (1893), p. 57). *See also* below pp. 148-50.

37. Royal Commission on Labour, P.P. 1892, XXXV, C. 6708-VI, qs. 8410-11, 8429, 8486. Extracts from Clara James's evidence are reprinted in Erna Olafson Hellerstein, Leslie Parker Hume, Karen M. Offen (eds), *Victorian Women* (Harvester Press, Brighton, 1981), pp. 404-8. *See also* Mappen, *Helping Women at Work*, pp. 41-3, 47-8. For Clara (or Claire) James see Lilian Gilchrist Thompson, *Sidney Gilchrist Thomas* (Faber, London, 1940), pp. 305-9 and Margaret Bondfield, *A Life's Work* (Hutchinson, London [1949]) p. 34.

38. A House of Commons committee enquiring into the observance of the Fair Wages resolution was told by several highly placed government witnesses that they would not intervene if a contractor replaced men with women earning a lower rate of wages (Committee on Government Contracts, P.P. 1896, X, H.C. 277, qs. 586-7, 629, 1016-19, 1120, 1848-53, 1863-5). Marian Barry, a woman trade unionist, told the committee that none of the tailoring firms which did government contract work paid their workers the agreed wage rate (P.P. 1897, X, H.C. 334, qs. 2890-969). Brian Bercusson, writing of the resolution in a more general context, calls it 'a total and miserable failure in achieving its stated objectives' (*Fair Wages Resolutions* (Mansell, London, 1978), p. 104).

39. Doris Nield Chew, *The Life and Writings of Ada Nield Chew* (Virago, London, 1982), pp. 125-30.

40. Evelyn March-Phillips, 'The progress of women's trade-unions', *Fortnightly Review*, 54 n.s. (1893), pp. 99, 102.

41. *First Annual Report of the Manchester, Salford and District Women's Trades Union Council 1895-6*, p. 7 (Gertrude Tuckwell Collection, Trades Union Congress Library, file 300/2).

42. ILP, *Labour Laws for Women*, pp. 7, 8, 19. Her typescript lecture (see note 29) declared flatly: 'Marriage must always make the economic position of women very different from that of men' (f. 102).

43. *Women's Trades Union Review*, 38 (1900), pp. 30-1.

44. *ibid.*, 36 (1900), p. 8 (Hendry); 'Trades-unions for women', *North American Review*, 153 (1891), p. 234 (Dilke). Men's anxiety to recruit women trade unionists was still not universal; see Barbara Drake, *Women in Trade Unions* (Labour Research Department, London, 1920), part I, chs III and IV.

45. *Daily Chronicle*, 25 September, 6 October 1893.
46. Census of England and Wales, 1901, *General Report* (P.P. 1904, CVIII, Cd. 2174), p. 85.
47. Schmiechen, *Sweated Industries and Sweated Labor*, esp. pp. 37-43, 196; *Women's Trades Union Review*, 28 (1898), pp. 19-20. *See* Duncan Bythell, *The Sweated Trades* (Batsford, London, 1978), pp. 147-8 for a contradictory view of the size and importance of the outwork problem.
48. *ibid.*, pp. 134-5.
49. *Women's Trades Union Review*, 36 (1900), pp. 3-15.
50. As Soldon points out, *Women in British Trade Unions*, p. 40.
51. *Woman's Signal*, 12 July 1894, p. 18; Soldon, p. 40; Jan Lambertz, 'Sexual harassment in the nineteenth century English cotton industry', *History Workshop Journal*, 19 (1985), pp. 44-5. About a quarter of the Oldham weavers' committee were women in the 1890s, again a highly unusual situation. In addition to Mary Callaghan, the subject of Beatrice Webb's comment, Helen Silcock was the president of the Wigan weavers' union in 1894 (Jill Liddington and Jill Norris, *One Hand Tied Behind Us* (Virago, London, 1978), pp. 96-8).
52. *Woman's Signal*, 12 July 1894, p. 18.
53. Olcott, 'Dead centre', p. 43.
54. *North American Review*, 153 (1891), pp. 233-4; *Women's Trades Union Review*, 15 (1894), p. 10. The success of the Nelson weavers in 1891-2 in tackling a blatant example of bullying and immoral behaviour by a male over-looker may be regarded as a vindication of the policy of joint unions led by men, but it was an exceptional and ambiguous case (Lambertz, 'Sexual harassment', pp. 34-6, 39-42, 50-1; Alan and Lesley Fowler, *The History of the Nelson Weavers Association* (Burnley, Nelson, Rossendale & District Textile Workers Union, Nelson [1984], pp. 8-10).
55. March-Phillips, 'Progress of women's trade-unions', p. 102.
56. I am grateful to Graham Johnson for reminding me of this point.
57. March-Phillipps, pp. 93-4; Board of Trade Reports on Trade Unions: P.P. 1896, XCIII, C. 8232, p. xxi; 1897, XCIX, C. 8644, pp. xvii, xlii-xliii; 1906, CXIII, Cd. 2838, p. lxvi; *Ministry of Labour Gazette*, 45 (1937), p. 380. I have been guided through the maze of figures by H. A. Clegg, Alan Fox and A. F. Thompson, *A History of British Trade Unions since 1889, vol. I, 1889-1910* (Oxford University Press, London, 1964), pp. 469-70, 489-90. For criticism of the Board of Trade's Labour Department as a collector of data on trade unions see Roger Davidson, *Whitehall and the Labour Problem in Late-Victorian and Edwardian Britain* (Croom Helm, London, 1985), pp. 150-2.
58. *Ministry of Labour Gazette*, 45 (1937), p. 380; Board of Trade Reports on Trade Unions, P.P. 1897, XCIX, C. 8644, pp. xviii-xix; 1898, CIII, C. 9013, pp. xxi-xxiii; 1901, LXXIV, Cd. 773, pp. xxi-xxii; 1906, CXIII, Cd. 2838, pp. lxi, lxvi; *Seventeenth Abstract of Labour Statistics of the United Kingdom*, P.P. 1914-16, LXI, Cd. 7733, pp. 200, 202.
59. *The Star*, 18 May 1892; *Daily Chronicle*, 29 May 1891.
60. *Nineteenth Annual Report of the Women's Trades Union League* (1893), p. 4; *New Weekly*, 2 February 1895, p. 3.
61. Her work can be traced in the League's *Annual Reports* and in the pages of

the *Women's Trades Union Review*. After her marriage she was known as Annie Marland-Brodie. Gertrude Tuckwell wrote of her as 'a delightful genial Lancashire lass' and of her emigration in her typescript 'Reminiscences' (Tuckwell Collection, Trades Union Congress Library), pp. 104, 191.

62. *Women's Trades Union Review*, 26 (1897), p.15; 31 (1898), pp. 24-5.
63. *Annual Reports of the Women's Trades Union League*; 1891 (accounts section), pp.1-3; 1893, p.4; 1901, pp.14-15.
64. Olcott, 'Dead centre', pp.41-3; *The Times*, 27 November 1894; *Woman's Signal*, 29 August 1895, p.130; Mappen, *Helping Women at Work, passim,* esp. pp.16-17, 62.
65. Annie Marland-Brodie, 'Women's trades unions in Great Britain and Ireland', in Countess of Aberdeen (ed.), *The International Congress of Women*, vol. VI, *Women in Industrial Life*, p.185.
66. Soldon, *Women in British Trade Unions*, pp.21, 34-6, 47. Lady Dilke's lavish hospitality was doubtless an added attraction to Congress delegates, if not to Beatrice Webb, who looked askance in an 1895 diary entry at its 'large, I might almost say, gross scale', including 'champagne lunches and elaborate dinners' (Beatrice Webb's typescript diaries (British Library of Political and Economic Science), vol. 16, 9 September 1895, p.1410). For a similar entry for 1892 see Norman and Jeanne MacKenzie (eds), *The Diary of Beatrice Webb, vol. 2, 1892-1905* (Virago, London, 1983), pp.20-1.
67. *Women's Trades Union Review*, 15 (1894), p. 1. The 'inexperienced woman speaker' was frequently inaudible (Margaret Llewelyn Davies in *Co-operative News*, 22 September 1894, p.1082).
68. *Women's Trades Union Review*, 19 (1895), p.5; *Twenty-First Annual Report of the Women's Trades Union League* (1896), p.6. The names of delegates were stated in the opening pages of each annual TUC report.
69. *Report of the Thirty-Second Annual Trades Union Congress, 1899* (Co-operative Printing Society, Manchester, 1899), pp.11, 64, 65-6, 69-70, 74, 77-8. A graphic account is given by Mary Agnes Hamilton in *Margaret Bondfield* (Parsons, London, 1924), pp.65-8.
70. Emilie Holyoake, 'The need of organisation among women', in Frank W. Galton (ed.), *Workers on their Industries* (1895; Swan Sonnenschein, London, 1896), p.210. Emilie Holyoake was the daughter of the co-operator and secularist George Jacob Holyoake.
71. *Ministry of Labour Gazette*, 45 (1937), p.380.

III. WOMEN AND POLITICS

9

Women's suffrage

By the 1890s the parliamentary vote had come to symbolise to an unprecedented extent the inferior status of middle-class women and their demand for emancipation. Some of the burning issues raised by advocates of women's rights in the past had been resolved in their favour. Married women enjoyed general control of their property, the Contagious Diseases Acts had been repealed, access had been gained to secondary schools and to higher education, and a number of professional occupations had begun to admit women. In certain fields, including education and employment, progress had been real but limited. In others, such as divorce and the guardianship of infants, reforming legislation had emphasised women's inequality. It was clear that if more fundamental progress was to be made women would have to exercise as voters a direct influence on the law-making process.

The movement for women's suffrage was, like other reforming campaigns, a minority cause. Opposition and apathy were widespread, and ridicule, always the most effective method of opposing women's claims, was freely deployed. The vote, however, did not possess the dangerous implications of the 'new woman' movement, which appeared to attack the institutions of existing society, particularly the domination of father and husband, and even the family itself. Women's suffrage was in principle a simple, easily understood demand, though one capable of endless parliamentary complication and obfuscation. It too had subversive implications, but its threat was less immediate and its claims on grounds of natural justice were strong. As a result, the vote was a cause which attracted many women whose views were otherwise conventional.

As a mature industrial economy took form in the late nineteenth century social and political change took place at an unprecedented rate. Reform Acts in 1867 and 1884, the introduction of the secret ballot in 1872 and the Corrupt Practices Act in 1883 created a mass electorate which could not easily be manipulated by the crude methods of the past. Political parties

137

now required the services of large numbers of voluntary work-
ers, and women were both qualified and willing to take part in
the effort of securing votes for one side or another.[1] Women's
organisations were set up within the parties to administer this
activity and, at least on the Liberal side, their members soon
turned from an exclusive preoccupation with men's votes to
demanding that women should also take a direct part in the
process of electing representatives to Parliament.

The passage of the Reform Acts, reflecting deeper changes in
society, meant that however effective the tactics of delay might
be, politicians would have to learn to cope with a new kind of
electorate. The rise of the labour movement demonstrated the
trend towards increasing self-confidence on the part of under-
privileged groups. Trade unions grew outwards from their roots
in the skilled trades to reach most groups of male workers, and
the ties of the political labour movement with the Liberal Party
were gradually weakened. Influenced by the growth of moder-
ate socialism in the 1890s the Labour Representation Commit-
tee was established in 1900 and soon became the Labour Party.
Many contemporaries resisted the growth of political democ-
racy and others resisted the conclusion, self-evident to a later
generation, that democracy could not be based on the exclusion
of over half the potential electorate from the political process.
But it was commonly noticed that the working class and women
were the two majority groups in society, and that their struggles
for political emancipation were part of the same process of social
transformation.[2]

It was in this context that women's suffrage assumed an
unprecedented importance in the 1890s. Andrew Rosen has
suggested that the period between 1884 and 1897 marked a low
ebb for the women's suffrage movement and that few members
of Parliament took the subject seriously in the 1890s. This is a
perspective natural to the historian of the subsequent militant
suffrage movement, but it is not an adequate assessment of the
position in the 1890s. Rosen contrasts the vigour of the women's
movement in the late 1860s and 1870s, when parliamentary
debates on women's suffrage were an almost annual event, with
the barren period after 1884.[3] It is a comparison between the
novelty of the initial campaign and the realism of the long
march. It is undoubtedly true that the failure of the women's
advocates to secure their inclusion within the terms of the

Reform Act in 1884 marked a turning point in parliamentary fortunes; there were only three debates in the subsequent twenty years, two of them in the 1890s.[4] As women's suffrage could only be achieved by act of Parliament, the failure of the House of Commons to discuss the subject was certainly a setback.

But this is by no means the whole story. A later generation discovered what suffragists before 1900 could hardly have known, that only a combination of years of strenuous militancy and the impact of total war would give women the vote. Opposition and indifference were too strong and too well entrenched in Parliament for the tactics of reason and persuasion to have succeeded before the twentieth century. Nonetheless, the suffrage movement enjoyed more support and was taken at least as seriously by press and parliamentarians in the 1890s as at any previous time. It was better led, for Millicent Garrett Fawcett was more effective than Lydia Becker, her predecessor as the dominant figure in the movement. Women were far more intimately involved in the political process than they had been in previous decades, and they gained experience and knowledge which were essential to the suffragette movement, above all the gradual realisation that they could not hope to win the vote without a radical shift in tactics from reasoned argument to militancy. This is not to suggest that 'the suffragettes won the vote', but rather that they imparted a new sense of urgency into the movement without which votes for women might have been even longer delayed.

Leslie Parker Hume also writes unenthusiastically about the suffragists of the 1890s. Millicent Garrett Fawcett was in her view 'in many ways a colorless and aloof figure', especially when compared to Emmeline and Christabel Pankhurst. She and her group formed a kind of 'cousinhood', closely connected by personal or family ties. They were conformist and respectable, closely identified with the upper-middle class. As a result they behaved in decorous but ineffective fashion. They naively put their faith in members of Parliament, most of whom belonged to their own social class, and in the patient methods which had gained occupational and educational reforms and political reforms at local level. Above all, they attempted to work from within the power structure rather than to challenge it from without: 'In no sense, except in terms of sex, were they "outsiders".'[5]

These criticisms are unconvincing. Millicent Fawcett's leadership was marked by reason rather than passion, but in consequence she was a highly respected figure, not vulnerable to gibes at feminine volatility and instability.[6] She may seem colourless when compared to the Pankhursts, but so too do most other political leaders of both sexes. Almost all pressure groups of the period were dominated by the middle class, including the suffragette Women's Social and Political Union. Indeed, working-class women suffragists found themselves in increasing sympathy with Fawcett and her National Union of Women's Suffrage Societies rather than with the WSPU.[7] This development is the more remarkable since the strongest support for women's suffrage among working-class women came from cotton trade unionists in Lancashire, the county in which the Pankhursts had their roots. As for being outsiders, sexual discrimination was of course the point at issue. Fawcett and her group of educated women had as personal an interest in working to end their exclusion from the political process as any other women.

The 1890s marked an important stage in the political education of women. It would be a mistake to suggest that parliamentary frivolity and bad faith had been unknown in previous years, but it was in this decade that a significant number of women came to realise the ineffectiveness of existing methods of persuasion. Elizabeth Wolstenholme Elmy, one of the most remarkable women in the history of the suffrage struggle, had been supporting feminist causes against domestic and political obstacles since the early 1860s.[8] Her letters to her friend Harriett McIlquham, herself an active suffragist, and her articles published under the pseudonym 'Ignota' in the *Westminster Review*[9] show that by the end of the decade her outlook combined determination with a sceptical appraisal of contemporary politicians. A letter written in 1898 suggested that 'strenuous effort' on the part of women might bring about women's suffrage before the next election, but in the previous year she had expressed the view that little was to be expected of the parliamentary opposition: 'If we are to wait for Women's Suffrage until the Liberal party is educated up to the point of bestowing it, I fear it will not come either in my lifetime or yours I think it a mistake on the part of any woman to be a party woman first and a Suffragist only in the second place.' In another 1898

letter she commented that 'some men are with us heart & soul, but they are *very few*'.[10]

The Women's Liberal Federation split over the suffrage question in 1892;[11] the Women's National Liberal Association was established as a body primarily interested in general political questions and unenthusiastic about women's suffrage. The WLF itself continued to support the suffrage, but within its ranks some members felt that a stronger stand should be taken. An attempt at the annual council meeting in 1896 to commit the Federation to work only for those Liberal candidates who did not oppose women's suffrage was defeated in favour of adherence to local autonomy.[12] The 'forward' movement was led by the Union of Practical Suffragists, a group of WLF members who sought to instil a sense of greater urgency on the suffrage question. Valentine Munro-Ferguson, a member of the union, wrote to Millicent Fawcett earlier in 1896 to ask her advice, though Fawcett had left the Liberal Party over the Irish Home Rule question and hence did not suffer from the divided loyalties of many Liberal women. Munro-Ferguson, who had 'worked and waited' for women's suffrage for many years, enclosed a leaflet she had written, pointing out that the issue was 'treated as a jest by members of Parliament'. The situation would not change 'unless we take up a more decided attitude'. If the women wished to wait another quarter of a century, she concluded, 'we are going the right way to do so'.[13] It is a measure of the intractability of the problem that the introduction of methods far more militant than Munro-Ferguson envisaged and the transformations of war reduced her hypothetical waiting period by only three years.

These passages typify the growing feeling amongst women suffragists in the 1890s that the campaign for the vote was entering a new phase. There was, however, no easy or universal movement from the constitutional methods of the 1890s to the militancy adopted by some suffragists several years after the start of the new century. The outbreak of the South African war led to a general suspension of suffrage activity for which Millicent Fawcett may be justly criticised,[14] and it was not until shortly before the election of a Liberal government in 1906 that the introduction of militant methods took the suffrage question onto a new plane. But there was in the earlier period a dawning but incomplete realisation that new weapons might have to be

141

used against the implacable obduracy faced by the movement. Kathleen Lyttleton, a consitutional suffragist leader of impeccable social standing, optimistically told a meeting in 1896: 'The day of ridicule is more or less passed', but she was more realistic in pointing out that 'the day of virulent opposition may be to come.... Our cause will only be gained by hard fighting'.[15] How hard and how long the fight would be she could not have known.

This is not the place to write a narrative account of the suffrage movement of the 1890s, nor to dilate on the nature of male opposition, which has received admirable treatment at the hands of Brian Harrison.[16] It is important to remind ourselves, however, of Elizabeth Wolstenholme Elmy's observation that few men were fully committed to the movement. Ambitious politicians had no wish to sacrifice a promising career by struggling for a cause whose advocacy laid them open to charges of frivolity or crankiness. Three rising Liberals of the period, who as young members had jointly sponsored the Women's Disabilities Removal Bill of 1889, had not aided the cause 'for many years past', Wolstenholme Elmy wrote to Harriett McIlquham in 1899: 'Mr. [Tom] Ellis and Sir Edward Grey ceased their help the moment they took office [in 1892] and Mr. [R.B.] Haldane as soon as he began to seek office.'[17]

Suffragists were placed in a frustrating position. Many politicians, unwilling to court vocal opposition and wishing to avail themselves of women's unpaid work at elections, found it easy to profess bland public support and trust to parliamentary procedures to bury suffrage bills.[18] Women were well aware that the assurances of politicians often meant little, but they were in no position to treat them with contempt. Suffragists enjoyed the languid support of Lord Salisbury and A. J. Balfour, the Conservative leaders, for the extension of the existing parliamentary franchise to women would have given the vote only to the minority of independent householders and occupiers, not to the much larger numbers of women who lived with their enfranchised husbands. Safe in the assumption that in the unlikely event of a women's suffrage bill being passed their party would have been the beneficiary, Salisbury and Balfour could afford to toy with the issue and smile on the occasional support expressed by the party organisation.[19] In the Liberal Party the position was in sharp contrast. There is no reason to doubt that Glad-

stone and other leaders opposed women's suffrage on principle, nor that part of their principle was the winning of elections, which seemed less likely if a select band of women was able to vote. As the issue always had more potential support among Liberals than Conservatives the opposition of party leaders had to be firmly expressed. The result, as Ray Strachey pointed out acidly, was that 'the women, being voteless, could alter neither situation, but got the worst of it in both cases.'[20]

Suffragists had to face not only opposition, apathy and unreliability from without, but division within their own ranks. The question of married women's access to the franchise caused sharp disagreement, though the most ardent of their supporters proposed to enfranchise only those married women who paid rates on property held in their own names. However, enfranchising such women, whose numbers were estimated in 1893 at about 200,000, would have established a vital principle and held out the hope that the franchise would subsequently be extended to women on terms of complete equality with men. The cause of married women was championed by the Women's Franchise League, founded in 1889. In a paper read to an international audience in 1893 Ursula Bright, the League's secretary, declared that the English wife's legal position was 'a scandal to civilisation' and asserted: 'We hold that raising the status of the wife is of more importance than giving votes to a few women because they are not married.'[21] Another of the League's leading members was Florence Fenwick Miller, a pioneer woman journalist who became editor in 1895 of the *Woman's Signal*, the most important feminist paper of the period. Fenwick Miller pointed out that wives were regarded as a means of providing a 'fa[g]got' vote, a second vote for their husbands, and that the reverse argument was also deployed; married women voters would be a constant source of family strife.[22]

The Women's Franchise League, however, was a minority among suffragists. The majority supported a policy of attempting to enfranchise rate-paying widows and unmarried women, whose numbers were estimated at rather less than a million when Sir Albert Rollit's women's suffrage bill was debated in the House of Commons in 1892. Millicent Fawcett defended the decision to accept a relatively small number of women voters on the grounds that they would be women of all social classes, and

that the wisest policy was to seek to enfranchise a relatively small number in the hope of later increase.[23] This point of view was given qualified support by Elizabeth Wolstenholme Elmy, originally a strong supporter of the right of married women to vote and a friend and co-worker of Ursula Bright in the struggle to secure property rights for married women.[24] Changing her position in the early 1890s Elmy left the Women's Franchise League and founded the Women's Emancipation Union in 1892 to work for the enfranchisement of women by stages.[25] Those who urged that all categories of women should be included in the terms of suffrage bills, she wrote in a pamphlet published in 1897, 'are, in my opinion, *simply and deliberately asking us never to enfranchise any women*'.[26]

Supporters of the extension of the franchise to all qualified women were present in large numbers at a riotous meeting held in the St James's Hall, London, in April 1892 on behalf of the Rollit bill. Richard Pankhurst, an influential member of the Women's Franchise League, opposed the bill for its failure to include the principle of votes for all women. Bernard Shaw supported it, while the meeting grew noisier by the minute. Eventually Herbert Burrows, a prominent socialist and adherent of the WFL, led an attack on the platform, causing the collapse of the reporters' table and the discomfiture of the fifteen or twenty reporters present. A hand-to-hand fight ensued, in which the brass railings protecting the platform were torn down. The WFL and its friends emerged victorious, took over what remained of the platform and carried a resolution denouncing the bill.[27]

Opposition to the Rollit bill on the grounds that it excluded married women was not confined, however, to those whose aim was to enfranchise more women than Rollit and his supporters intended. Root and branch opponents of women's suffrage like Gladstone and H. H. Asquith found that the terms of the bill offered them a convenient weapon. Gladstone wrote with more art than candour that the bill excluded women who, he insisted, were 'not less reflective, intelligent, and virtuous, than their unmarried sisters'. For his part Asquith poured scorn on 'this half-hearted and illogical Bill' which disqualified a woman voter 'the moment she approaches the altar'.[28] It was easy to ridicule a movement whose adherents came to blows in public places; *Punch* claimed that the floor of the St James's Hall had

been 'nearly ankle-deep in loose hair'.[29] The problem, as Lady Dilke pointed out in a pessimistic article in 1897, was that limited women's suffrage had powerful enemies, while adult suffrage had too little popular support for it to appear high on political agendas. Even manhood suffrage, whose enactment would indirectly assist the women's cause, did not arouse political passions.[30]

Disagreement over strategy among supporters of women's suffrage was inevitable given the political realities of the day. With the exception of such incidents as the St James's Hall meeting, however, it was generally possible despite divergence of party affiliation to work for the common end, especially after the Women's Franchise League faded away around the middle of the decade. The ability of suffragists of all political views to work together was a considerable achievement, and an effective reply to those who argued that women were too quarrelsome to establish successful organisations. Political women had been sharply divided by the Home Rule crisis of 1886 and by differing views over the affiliation to suffrage societies of political organisations, particularly branches of the Women's Liberal Federation. Despite the existence of separate societies relations remained reasonably cordial, and by 1897 it was possible for the different groups to reunite as the National Union of Women's Suffrage Societies, under the presidency of Millicent Garrett Fawcett.[31]

One independent organisation, however, aroused confusion and division. This was the Parliamentary Committee for Woman Suffrage, which first came to public notice early in 1895. Not only did the committee operate without reference to existing organisations, but its secretary and moving spirit, Mary Cozens, later endangered the movement's non-party status by making clear her support for the Conservative Party as the party most likely to enact women's suffrage.[32] Such behaviour on the part of a woman who had already caused dissension in the Women's Franchise League and controversy in the Women's Emancipation Union[33] naturally roused Liberal hostility and played into the hands of anti-suffragists. A leading suffragist, Lady Frances Balfour, wrote to her friend and ally Millicent Fawcett in February 1895 that she had found Cozens '[r]ather a pleasing woman', but denouncing her as a 'little reptile' for promoting a parliamentary bill which clashed with

145

the plans of the older societies.[34] Cozens again put forward her own bill in 1896-7 and lobbied leading politicians on its behalf. Arthur Balfour told Lady Frances, his sister-in-law: 'I am constantly being written to by a woman whose name I forget.' Lady Frances supplied the name, she reported to Fawcett, and 'gave, as I have done before, strict orders never to answer her. She is really an extraordinary woman.'[35] But Cozens was undismayed. In reply to a letter from Lady Frances in *The Times* in March 1897 she claimed that she had been responsible for taking the women's suffrage issue out of the drawing room and placing it before Parliament and press. She added with considerable effrontery: 'It is well that these senseless jealousies and bickerings between rival societies should cease. They retard the movement.'[36]

The women's suffrage societies, though infuriated by the diversionary tactics employed by Cozens, worked hard to achieve favourable results in Parliament. Rollit's bill was defeated at its second reading in 1892 by 177 to 154, a margin regarded as unexpectedly narrow, especially in view of Gladstone's well-publicised and influential attack on women's suffrage published shortly before. The hostility and apprehension inspired by the bill was indicated by an unofficial whip signed by ten government supporters and ten members of the opposition; the twenty names included some of the most prominent members of the House of Commons.[37]

The next women's suffrage bill was introduced in 1897 by Ferdinand Faithfull Begg, who like Rollit was a Conservative backbencher. It passed its second reading by 230 to 159. This was not the first women's suffrage bill to survive a second reading, but it was the first in which over 200 votes were recorded in favour of votes for women, and the bill secured nearly 70 more votes in its favour than any of its predecessors.[38] The vote does not suggest that the women's suffrage movement was a declining force or that it was taken less seriously than in the past. The bill's fate, however, shows that the women's agitation was regarded as a serious nuisance, whose opponents wished to defeat it without discussion. (This consideration may help to explain both the fact that pressure on debating time delayed the Begg bill's second reading for nearly nine months[39] and the reduction in the number of women's suffrage bills discussed during the period.) After further delay occasioned by

Queen Victoria's jubilee celebrations its committee stage was scheduled for 7 July. Led by the irrepressible Henry Labouchere, a master at wielding the rapier of ridicule, the House of Commons discussed the preceding Verminous Persons Bill at such length that the suffrage bill was not reached.[40]

A number of conclusions were reached about the significance of this episode by interested parties. 'We have no votes', a group of women's leaders wrote to *The Times*, 'and therefore can safely be neglected and treated with contempt by Parliament'.[41] The *Englishwoman's Review* pointed to the waste of 'all the labour of months and years', the failure of petitions, meetings, demonstrations and appeals: 'All melt off Parliament like snow-flakes, forgotten directly.' It opposed such militant action as smashing windows,[42] but the fact that this kind of behaviour was mentioned in so respectable a journal is significant. It was increasingly understood that women must rely on their own efforts if the suffrage was ever to be achieved. Conservative politicians were no more reliable than Liberals. Frances Balfour told Millicent Fawcett in 1895 that Arthur Balfour was 'longing for an opportunity to say he is not so warm an advocate as he was'. The year after the Begg debacle she cast doubt on the reliability of George Wyndham, another leading Conservative supporter: 'I don't think he cares for a subject unless it is a burning one.'[43] The view that women's suffrage was too important a subject to be left to the luck of the draw for backbenchers' private bills was increasingly heard,[44] but government bills being beyond their reach suffragists were compelled to continue to rely on backbenchers until they finally turned to the militant action which made their subject 'a burning one'.

The contention that the women's suffrage movement enjoyed increased support in the 1890s is lent force by the 'Appeal from Women of all Parties and all Classes', a petition in favour of women's suffrage organised by a committee under the leadership of Millicent Fawcett after the defeat of the 1892 bill. By July 1894 over 3,500 helpers and 140 meetings had succeeded in collecting nearly 250,000 signatures of 'women of all classes, parties and occupations', among them many women eminent in the professions and arts, and most of the leading women educationists of the day.[45] No petition of the kind had been presented to Parliament since the days of the Chartists half a century

earlier. The organisers intended to present it in support of a women's suffrage amendment to a government Registration Bill, whose purpose was to simplify registration procedures and thus increase the number of male voters. The bill was first delayed and then abandoned, and it was finally decided to present the appeal, which now had 257,000 signatures, to Parliament in May 1896. By a combination of audacity and good fortune the organisers managed to secure Westminster Hall as an assembly point and display centre for the petition. There a numerous and representative crowd of women gathered, including well-known suffrage leaders like Millicent Garrett Fawcett, Helen Blackburn and Elizabeth Wolstenholme Elmy, as well as 'dames' of the Primrose League, 'new women' from the Pioneer Club, members of suffrage societies and working women who represented women's Liberal organisations or trade unions. As the appeal contained an implicit attack on factory legislation, however, it further stamped women's suffrage as a cause hostile to social reform.[46]

The sectarian outlook of its sponsors did not prevent their cause from enjoying a wide appeal. This is shown by the large numbers, in both cases extending to overflow meetings, who attended rallies held in London and Manchester in 1894 in support of the women's suffrage amendment to the Registration Bill. The size of the audiences is the more impressive in view of the fact that the amendment was little more than a forlorn hope and not the subject of parliamentary attention. The Manchester meeting was supported not only by the usual middle-class women's bodies but also by branches of the Women's Co-operative Guild. Among the speakers was Enid Stacy, the well known socialist.[47] Support of this kind does not suggest a movement in decline.

The fact that support for women's suffrage was much stronger among middle- and upper-class women than in the working class was used to good advantage by opponents of the movement, who accused it with some justice of lacking mass support. But as the number of organised women grew in the 1890s there was a perceptible increase in working-class interest in securing the vote. The development of support for women's suffrage in the Women's Co-operative Guild demonstrates this trend. The Guild was established as an offshoot of the co-operative movement in 1883.[48] In 1889, the year that the remarkable Margaret Llewelyn

Davies became its general secretary, a membership of between 1,700 and 1,800 was organised into 51 branches. Stimulated by her leadership and by the favourable circumstances of the 1890s the Guild grew rapidly. In 1900 there were 12,809 members and 273 branches.[49] Unlike their secretary few members came from middle-class homes. Members tended to belong to the more prosperous sections of the working class, and their numbers were greatest in north-west England, where the co-operative movement had its strongest roots and where the number of women trade unionists was exceptionally high. Though the Guild's view of women's suffrage was therefore probably not typical of all working-class women, it was significant as the considered opinion of the only large self-governing organisation of women of their class.

In the Guild's early years its interests were largely confined to matters of immediate concern to its members as co-operators. As early as 1894, however, its annual meeting enthusiastically adopted a resolution in favour of women's suffrage, and 2,200 signatures to the Appeal from Women, the women's suffrage petition, were obtained by the 7,511 Guild members.[50] With the strong encouragement of Margaret Llewelyn Davies educational and social questions received greatly increased attention at Guild meetings in the later 1890s, and the parliamentary bill in 1897 encouraged further expressions of support for women's suffrage. Sectional conferences held to discuss the subject were followed by a unanimous resolution in favour of votes for women at the Guild annual meeting in July.[51] It was clear that the vote was demanded for practical reasons stemming from the economic and social position of women. At the southern section conference in March Mrs Morley, a London delegate, pointed out that girls were 'trained from their earliest days to take the lower place'. Women were capable of washing their husbands' moleskin trousers, she added in a reference to a well-known statement of a wife's duty: 'But she did not consider that was all they were there for.'[52] Speaking at another sectional conference Annie Martin of Bristol condemned in strong terms the low esteem in which husbands held the work which their wives performed as 'general servant, cook, nurse, washerwoman, tailoress, and mother all at once'. She also attacked the low wages paid to women, which she thought would be ameliorated by the grant of the suffrage, since belief in women's inferiority

and supposed need of a lower income would as a result 'soon die a natural death'.[53] Mrs Loxton of Long Eaton pointed to a change in women's attitude to the vote: 'It is perhaps true that women have not exerted themselves in the past in endeavouring to obtain their political rights as they ought to have done; but, however true it may have been in the past, it is no longer true to-day.'[54]

The Guild's commitment to votes for women did not disappear after the crescendo reached in the summer of 1897. A few months later showers of denunciatory resolutions from Guild branches greeted a speech in which Henry Broadhurst, the Liberal–Labour MP, opposed women's suffrage in derogatory terms. At the end of the decade Guild members were heavily involved in collecting signatures for the women's suffrage petition drawn up on behalf of women workers in the Lancashire cotton industry, a campaign which has been described by Jill Liddington and Jill Norris. By spring 1901 the petition had obtained nearly 30,000 signatures.[55] This kind of activity was the first sign of a working-class commitment to women's suffrage which was to develop further in the early years of the new century.

The formation of women's political organisations in the 1880s had taken place under the stimulus of the legal and political changes of the period. The activities and expansion of these bodies in the 1890s is one of the most important aspects of women's political work in the period. The sharply contrasting composition and functions of the Women's Liberal Federation and the Primrose League illustrate the varying approaches of Liberals and Conservatives to political activity.

Following the establishment of a number of local women's Liberal associations[56] the Women's Liberal Federation was inaugurated in 1886, holding its first general meeting in February 1887, when Catherine Gladstone was elected its president. The Home Rule schism in the Liberal Party in 1886 did not spare its women members, and the Women's Liberal Unionist Association was formed in 1888. Despite the adhesion of Millicent Garrett Fawcett to the Liberal Unionists the WLF remained much the larger body. When the two organisations held their annual meetings in 1891 the WLF had 177 affiliated associations with 66,721 members, of whom about 15,000 were

men; the WLUA had 26 branches and over 5,000 members, about a third of whom lived in Birmingham, the centre of Liberal Unionism.[57] A second schism, to which reference has been made above, resulted in the formation in 1892 of the Women's National Liberal Association as a body less interested in women's suffrage than in furthering social reform, priorities at odds with those of many Liberal women. The WNLA was a vigorous body, whose members or sympathisers included Beatrice Webb, Eliza Orme, May Abraham, Margaret Bondfield and Gertrude Tuckwell, but it appears not to have challenged the WLF's numerical preponderance among Liberal women. By 1897 the WLF had 501 local associations and about 80,000 members before losing ground at the end of the century.[58]

Martin Pugh writes that the formation of the WLF 'was taken as a Gladstonian ploy to divert suffragists into the safer area of organisation'.[59] If such an intention existed it was remarkably unsuccessful, for the WLF and its smaller sister bodies gave women an experience in public affairs and organisation, and a confidence in speaking which they would otherwise have been unable to obtain. After an apparently deferential beginning, the WLF became a forum for the discussion of a wide range of political questions, among which women's suffrage and factory legislation were prominent. It was often a turbulent forum. The Countess of Aberdeen, who briefly replaced Mrs Gladstone as president in 1893, commented: 'Between resolutions and amendments and riders, manifestoes of the progressives saying what they will and won't accept, appeals from both sides to rule strictly on points of order, I am inclined to tear my hair out.'[60] This and other accounts suggest a thriving, committed group of women, some of them from relatively humble backgrounds, whose enthusiasm more than compensated for their initial lack of experience.[61] Lady Aberdeen's successor was the Countess of Carlisle, whose impetuous and dominating personality made life difficult for those nearest to her but ensured that the causes which she supported did not languish in the shadows. Dorothy Henley, one of her daughters, wrote in a memoir: 'Her flow of talk was like a flow of lava, and made her a hypnotic speaker on a platform.'[62] Another daughter, Lady Mary Murray, was also an active member of the WLF. The activities and eccentricities of the countess–president attracted a degree of glamour to the Federation and, at least in the case of the suffrage bill of 1897, a

151

significant measure of support from parliamentarians.[63] Lady Aberdeen also popularised the women's cause; she was described in 1897 as 'the unofficial lady leader of the opposition'.[64]

The Women's Liberal Federation was the most important women's organisation of its type. The expansion of public activity among women was also demonstrated by the National Union of Working Women, a product of the 1890s. Its interests were economic and social rather than party political, but it attracted the same type of educated, socially conscious membership as the WLF. The union's annual conferences were well attended and drew the attention of the press and wider public to questions of particular interest to educated women. Its activities in the decade culminated in the organisation of the International Congress of Women, which met under Lady Aberdeen's presidency in London in 1899. The congress was unprecedentedly well-attended, and while the interest which it attracted was not always sympathetic, it did demonstrate that women could successfully organise a large-scale forum for the public discussion of a wide range of current, often controversial topics.[65]

The activities of the Primrose League were very different from those of the women's Liberal organisations and from the serious intellectual content of NUWW conferences. Although its political aim was the primary concern of its leaders, its functions were as much social as political. It was originally intended that membership should be limited to men, but women members were admitted within a few weeks of its foundation in 1883. The League attracted a mass membership of all social classes and by 1891 it boasted a million 'knights', 'dames' and associates. By 1901 the membership exceeded $1\frac{1}{2}$ million. It is unfortunate that the associates, who formed the vast bulk of members, were not distinguished by sex, but if the proportion of men and women associates reflected that of knights and dames the female membership must have stood at about 700,000 in the later year.[66]

The League's methods and preoccupations lack the recognisably modern feel of the women's Liberal bodies. The early interest shown by some of its 'habitations' (branches) in women's suffrage was discouraged by the Grand Council, which from 1889 periodically issued instructions that habitations were not to take part in suffrage activities. This policy apparently stem-

med from the potential divisiveness of the suffrage issue: 'No question divides politics more than women', Lord Salisbury warned in 1896.[67] But in spite of its emphasis on social and charitable activities the Primrose League deserves the 'curious footnote' to the women's struggle accorded to it by its historian, and indeed her tribute to its 'yeoman work' for women's political emancipation.[68]

Through the League, women in suburbs and the countryside were drawn from domestic loneliness into organisational activity. For many, political work was an extension of village social life, and many women moved naturally between politics and charity, with little consciousness of a dividing line between the two.[69] Lady Frances Balfour, though a Liberal by background and a Liberal Unionist in the 1890s, was well acquainted with the Primrose League, being not only Arthur Balfour's sister-in-law but for a period a League member. In her autobiography she gave it credit for 'the whole idea' of interesting women in politics, and while this tribute is far too generous it contains an important element of truth: 'Knights and Dames worked side by side, received the same Diploma in Gothic lettering, and organised political tea parties over the land With all its absurdities, the Women's Cause gained much from the existence and the teapot life of the "P.L.".'[70]

The women's political organisations were more active than ever before during the three general elections held between 1892 and 1900. It must be admitted that the role of women at election times was not wholly satisfactory to those who championed their emancipation. Party organisations encouraged the participation of women in election work primarily because the enlarged electoral system created in the 1880s required a greater number of voluntary workers than previously. Women, being generally more willing to work without payment than men, relieved party funds and presented no challenge to the requirements of the Corrupt Practices Act of 1883.[71] Moreover, the electorate thus created was composed mainly of working-class men. It was widely and no doubt justifiably felt that men with no great interest in political issues were more likely to succumb to the persuasion of women of a superior social class than to canvassers of their own sex. The line between persuasion and corruption was a fine one, susceptible to effortless and undetected crossing.

The Primrose League seems to have been guilty more often than its Liberal rivals of underhand methods. Evidence is impressionistic, but the greater number of organised Conservative women, the League's extensive social and charitable activities and the appeal which the party made to sympathy between social classes make such a conclusion difficult to avoid. Conservative MPs who reported that 'the ladies' were very useful in a working-class constituency, that they walked 'through the tenements like weasels in a rabbit warren', that ladies with experience of charitable visiting were particularly valuable to the party and that a 'lady canvasser' was 'twice as effective as a man' were likely to have had in mind a combination of charm, hinted bribery and veiled threats.[72] Less complimentary was the view of Andrew Provand, a Glasgow Liberal MP. In his eyes women lacked a 'sense of judicial fairness. Their main election work consists of frightening gardeners, coachmen or tradesmen.' He did not spare his own side, but he reserved his strongest condemnation for the Primrose League: 'I have heard a Conservative Primrose dame deplore the existence of the Ballot Act, which prevented her from knowing whether her bribes gained her votes.'[73]

Charges of this kind cannot be dismissed despite their anecdotal nature and despite occasional evidence of a greater sense of political rectitude. (One example was the 'great indignation' expressed by the Ladies' Grand Council of the League at a notice in the *Primrose League Gazette* which aimed to increase advertising revenue by implicitly threatening tradespeople. Their demand for its withdrawal was immediately obeyed.)[74] But there is also overwhelming evidence of more legitimate work by women in all aspects of electioneering, including (to the alarm of the orthodox) platform speaking.[75] *The Gentlewoman*, which asked MPs in 1895 and 1900 about the assistance of women in election campaigns, recorded many tributes to their work. Thomas Lough, an Islington Liberal, referred to women who had spoken 'with great effect' on his behalf, mentioning in particular Florence Balgarnie, a prominent member of the Women's Liberal Federation. Henry Seton-Karr, who sat as a Conservative for St Helens, reported: 'One lady spoke very effectively at a large meeting (about 3,000) a few days before the election.' Sydney Gedge, a Walsall Conservative, praised the women who had assisted him and added a honeyed sentence

hinting that genteel corruption had been at work on the other side: 'On the other hand, my opponent, "Lady Hayter's husband", was immensely assisted by his wife's clever and lively speeches made at many meetings, as well as by the sympathetic visits which she made to the houses of the poorer electors.' F.J. Horniman, a Cornish Liberal, wrote that his party had been kept alive in Falmouth in the previous five years by women, to whose 'past labours and efforts at the election I attribute my success'. Sir John Rolleston echoed this sentence from the perspective of a Leicester Conservative: 'I believe that my election was won by ladies.'[76]

The *Primrose League Gazette* also contained numerous tributes at election times from Conservative candidates to their women workers. A comment by Arnold Statham, a barrister and an unsuccessful candidate in Bethnal Green in 1895, conjures up a vivid image of election work in 1895 as experienced by his thirty-one women assistants:

> For hours and hours they trudged up and down the steep stairs of model dwellings, delivering literature, converting doubtfuls, hunting up removals, pursuing inquiries to check the register, and going into minute details as to the best means of securing the votes of absentees. Toiling daily from street to street and alley to alley, penetrating the recesses of the most forbidden quarters, they laboured patiently and quietly.

As in other constituencies some of Statham's women workers addressed large and turbulent meetings.[77] The mounting electoral activity reached a high point in 1900, when the absence of men serving in the South African war made the efforts of their wives indispensable. Two wives wrote and signed election addresses and many others addressed election meetings on behalf of their absent husbands.[78] Conservative Central Office lavishly thanked the Ladies' Grand Council of the Primrose League for its assistance in securing the votes of non-resident 'outvoters' in the same election, and Miss Goldson, secretary of the League's Hastings and St Leonard's habitation, received special mention for her outstanding election work.[79]

The most dedicated and indefatigable election work, however, did not necessarily imply that women sought their own political emancipation. The selfless campaigning of women was in some respects an extension of the selflessness to which

they were accustomed as wives and mothers. This point was made indirectly by an American named Rebecca Insley, who observed the election of 1900 and the manner in which wealthy, elegantly dressed ladies waited on workingmen in their cottages to beg their votes. Such behaviour would be unheard of in the United States, where a woman 'goes into politics only for herself; for her husband or her brother, never'.[80] A similar point was made by Elizabeth Banks, an adventurous American journalist and author, who lived for some years in London and reported in lively fashion on her experiences.[81] In an article on the 1900 election she commented on the willingness of the English woman, unlike her American counterpart, to canvass for votes: 'Sisters canvass for their brothers, daughters for their fathers, wives for their husbands, and dainty maidens for the men they expect to marry Little care you for "causes" in the abstract. Little cares any woman for "causes", but only for the men who represent those causes.'[82]

Women's election work demonstrated their subordination to men, but also their capacity in a field previously supposed to be beyond their capabilities. Although their work in parliamentary elections was necessarily performed on behalf of others, the experience gained and the consequent rebuttal of traditional stereotypes marked a stage in the long struggle to gain a direct part in the political process. Moreover, the hard work done by women's political organisations during elections resulted in increasing attention being paid to the suffrage question by women, including some who might have been expected to be indifferent or hostile. The case of Maud Illingworth, organiser of the Women's National Liberal Association at the end of the nineteenth century, is instructive in this context. The WNLA, which owed its existence to its lack of enthusiasm for the franchise, provided extensive assistance to the Liberal Party during both general and by-elections. Shortly after a Petersfield by-election in 1897 in which six WNLA canvassers had each walked ten miles a day in all types of weather in the course of their duties, Illingworth made a speech in favour of women's suffrage, asserting that its enactment was blocked principally by prejudice.[83] After the general election of 1900 she turned her attention to organisational work in the Shipley division, where she soon achieved the remarkable feat of raising the number of Women's Liberal Association members to well over a thousand,

and helped to convert the Liberal parliamentary candidate, her cousin Percy Illingworth, to support for women's suffrage. A dozen years later Maud Illingworth was still the organiser of the Shipley Liberal women, who still numbered over a thousand, and was described as 'a staunch and ardent advocate of women's suffrage'.[84]

The contrast between the anxiety of politicians for women's assistance at elections and their indifference to women's suffrage once safely elected could hardly pass unnoticed. The most vehement opponent, Millicent Fawcett wrote optimistically in 1892, 'hesitates to declare that politics are unwomanly, or that women who care for politics are unsexed harridans' when faced with the approach of a general election.[85] The point was not lost on some men. The Irish historian and politician W. E. H. Lecky asked: 'Can any one suppose that voting for members of Parliament is a more unfeminine thing than canvassing for them ...?'[86] Even *Punch*, which could usually be relied upon to ridicule women's claims, carried a Linley Sambourne cartoon in 1892 showing the Women's Liberal Federation as 'political lady-cricketers' who demanded 'a turn at the bat' from the 'Grand Old Slogger', Gladstone.[87]

The argument was of no avail, for most politicians were content to use women as indispensable election workers without political recompense as long as women allowed them to do so.[88] But the political work of the period had two consequences for the revived movement which emerged after the temporary eclipse following the defeat of 1897 and the onset of war in South Africa. The experience of electioneering gave women collectively a new confidence on which the revived movement was to build after 1903. Moreover, their flourishing political organisations allowed women to enter into the heart of party politics and to demand the vote from within.

The general committee of the National Liberal Federation passed resolutions in favour of women's suffrage in 1897 and 1899, though the question of enfranchising working-class women caused difficulties on both occasions.[89] As for the Conservatives the ambiguous role of the Primrose League as a socio-political movement and the party ban on its participation in the suffrage movement meant that Conservative women played a less obvious role within the party as suffragists than their Liberal counterparts. Moreover, Conservative women

were in general less enthusiastic than Liberal women about the parliamentary vote. A more important influence on Conservative attitudes to the suffrage question than pressure from women was the assumption that enfranchised women ratepayers would be likely to vote predominantly Conservative. But the election work of the Primrose women may have helped to influence Conservative opinion in favour of women's suffrage, which was supported by the party conference in 1887, 1891 (after an address by Millicent Garrett Fawcett) and 1894, before falling victim to a counterattack in 1897.[90]

There was little solid success to show for the efforts of the women's suffrage movement in the 1890s. The period was irretrievably thrown into the shade by the glamour and heroism of the suffragette years, and it has been surrounded by obscurity and indifference in the memoirs of participants and the work of historians. Lady Frances Balfour, for example, recalled the years between 1880 and 1906 as a 'backwater period', when despite increased recognition and support there was little real progress and the movement 'snatched at every encouraging symptom'.[91] Although Millicent Fawcett wrote of 'very great progress towards our goal' before 1903, her account of the 1890s was limited to unimportant anecdotes.[92] But it should now be clear that the suffrage and other political campaigns undertaken by women at the end of the nineteenth century were a significant stage in the growth of an inevitably lengthy movement, which faced unique problems of levity, hostility and indifference. Viewed in this light the 1890s deserve to be regarded not as a backwater but as a period of steady, though inevitably limited progress.

Notes

1. Martin Pugh, *Women's Suffrage in Britain 1867-1928* (Historical Association, London, 1980), p. 12.
2. The link between the position of labour and women was made by, among others, Millicent Garrett Fawcett, in her introduction to Mary Wollstonecraft, *A Vindication of the Rights of Women* (1792; T. Fisher Unwin,

London, 1891), p. 3; *Shafts*, 3 November 1892, p. 8; Karl Pearson, 'Woman and labour', *Fortnightly Review*, 55 n.s. (1894), pp. 561-77; Thomas Burt, *The Times*, 10 May 1894.

3. Andrew Rosen, *Rise Up, Women!* (Routledge & Kegan Paul, London, 1974), pp. 9-13.

4. Brian Harrison, *Separate Spheres* (Croom Helm, London, 1978), pp. 28-9.

5. Leslie Parker Hume, *The National Union of Women's Suffrage Societies 1897-1914* (Garland, New York, 1982), pp. 9, 13-14.

6. Georgiana Hill, *Women in English Life*, vol. II (Bentley, London, 1896), p. 340; Maude Royden in Margot Asquith (ed.), *Myself When Young* (Muller, London, 1938), pp. 381-2; Helena Swanwick, *I Have Been Young* (Gollancz, London, 1935), pp. 185-7. An excellent, balanced assessment of her life and career is given by Ann Oakley in Dale Spender (ed.), *Feminist Theorists* (Women's Press, London, 1983), pp. 184-202.

7. This point is fascinatingly elaborated by Jill Liddington and Jill Norris in *One Hand Tied Behind Us* (Virago, London, 1978), ch. 12.

8. There is an affectionate glimpse of her in E. Sylvia Pankhurst, *The Suffragette Movement* (Longmans, London, 1931), pp. 31-3. See also Dora B. Montefiore, *From a Victorian to a Modern* (Archer, London, 1927), pp. 42-3. For a contemporary biographical sketch by her husband Ben Elmy see 'Ellis Ethelmer', 'A woman emancipator', *Westminster Review*, 145 (1896), pp. 424-8.

9. Nine articles by 'Ignota' appeared in the *Review* between October 1897 and August 1899; a tenth in July 1901 and others subsequently.

10. BL Add. Mss. 47,451, f.222, 29 June 1898; f.134v., 1 September 1897; f. 264, 1 November 1898.

11. *The Times*, 19 December 1892.

12. *Englishwoman's Review*, 27 (1896), p. 191; *Woman's Signal*, 18 June 1896, p. 389.

13. Fawcett Library Archives, Box 89, vol. I, letter 20: Valentine Munro-Ferguson to Millicent Garrett Fawcett, 12 February 1896. The history of the Union of Practical Suffragists is outlined in one of its leaflets, held by the Fawcett Library: *Origin and Growth of the Union*, leaflet XII, 1898.

14. Fawcett, who worked in South Africa for several months in 1901, later wrote: 'Two fires cannot burn together, and the most ardent of the suffragists felt that, while the war lasted, it was not a fitting time to press their own claims and objects' (*Women's Suffrage* (T.C. & E.C. Jack, London [1912]), p. 58).

15. Central Committee, National Society for Women's Suffrage, *Speeches Made at the General Annual Meeting 1896*, pp. 4-5. (Kathleen Lyttleton had married into a remarkable family of soldiers, educationists, cricketers, clergymen and politicians. Her husband Arthur was Bishop of Southampton from 1898 until his early death in 1903.) A few years earlier Maria Salès, an active woman Liberal, had asked: 'Did Mr. Gladstone expect them to use the argument of physical force, which alone seemed to be able to penetrate the thick masculine skulls of the majority of the present Cabinet?' (*The Times*, 2 September 1893).

16. *Separate Spheres*, part one.

17. BL Add. Mss. 47,451, f. 307v., 12 April 1899. For a similar comment see

Millicent Garrett Fawcett, 'The women's suffrage question', *Contemporary Review*, 61 (1892), p. 762.

18. As *The Times* suggested in scathing terms on 8 July 1897.

19. For typical mellifluous utterances by Salisbury and Balfour see Constance Rover, *Women's Suffrage and Party Politics in Britain 1866-1914* (Routledge & Kegan Paul, London, 1967), pp. 106-7.

20. Ray Strachey, *The Cause* (1928; Virago, London, 1978), p. 283; *see also* Rover, *Women's Suffrage*, pp. 117-18, and Millicent Garrett Fawcett, quoted in Rosen, *Rise Up, Women!*, pp. 11-12.

21. Ursula Bright, 'The origin and objects of the Women's Franchise League of Great Britain and Ireland', in May Wright Sewall (ed.), *The World's Congress of Representative Women* (Rand McNally, Chicago and New York, 1894), pp. 416-18.

22. Florence Fenwick Miller, *On the Programme of the Women's Franchise League* (Women's Franchise League, Congleton, 1890), pp. 14-15. For Fenwick Miller see Rosemary T. VanArsdel, *Florence Fenwick-Miller, Feminism and the Woman's Signal, 1895-1899* (University of Puget Sound, Tacoma, 1979), typescript at the Fawcett Library.

23. Millicent Garrett Fawcet, *A Reply to the Letter of Mr. Samuel Smith, M.P., on Women's Suffrage* (Central Committee of the National Society for Women's Suffrage, London, 1892), pp. 4-5; letter in *Daily Chronicle*, 13 June 1895.

24. Pankhurst, *Suffragette Movement*, pp. 48-9, 97; Lee Holcombe, 'Victorian wives and property', in Martha Vicinus (ed.), *A Widening Sphere* (1977; Methuen, London, 1980), pp. 13, 25; Lee Holcombe, *Wives and Property* (Martin Robertson, Oxford, 1983), pp. 119, 126, 131, 185, 204.

25. Women's Emancipation Union, *Report* of Inaugural Meeting, October 1892, pp. 2-3; Pankhurst, *Suffragette Movement*, p. 96.

26. Elizabeth C. Wolstenholme Elmy, *Women's Suffrage* (Women's Emancipation Union, Congleton, 1897), p. 4.

27. *The Times*, 27 April 1892; Pankhurst, *Suffragette Movement*, p. 96. A similar meeting was held in 1893, but on this occasion the democratic faction, which included Mary Gray (later prominent as Edith Lanchester's friend and landlady) and Eleanor Marx, was less riotous and less successful (*The Times*, 11 November 1893).

28. W. E. Gladstone, *Female Suffrage, A Letter from the Rt. Hon. W. E. Gladstone, M.P., to Samuel Smith, M.P.* (Murray, London, 1892), p. 3; *Parl. Deb.*, 4th ser., 3 (27 April 1892), cols 1511-12.

29. *Punch*, 7 May 1892, p. 228.

30. Emilia F. S. Dilke, 'Woman suffrage in England', *North American Review*, 164 (1897), p. 159. The view that manhood suffrage would help women was not universal; see *Englishwoman's Review*, 29 (1898), p. 28.

31. Helen Blackburn, *Women's Suffrage* (Williams & Norgate, London, 1902), pp. 175-7, 206-9; Rover, *Women's Suffrage*, pp. 53-6.

32. *Englishwoman's Review*, 29 (1898), pp. 22-3; BL Add. Mss., 47,451, ff. 187, 190 (Elizabeth Wolstenholme Elmy to Harriett McIlquham, 13, 23 February 1898); *The Times*, 23, 25 February 1895.

33. Women's Franchise League, *Annual Report* 1891-2, p. 13; *The Times*, 27 October 1892; *Personal Rights Journal*, November 1892, p. 213.

34. Fawcett Library, Autograph Letter Collection, vol. 1, part B1, Frances Balfour to Millicent Garrett Fawcett, 20, 22 February 1895.
35. *ibid.*, 2 November 1896. Arthur Balfour's remark was reported in Lady Frances's words.
36. *The Times*, 16 March 1897.
37. *ibid.*, 21 April 1892; *Englishwoman's Review*, 23 (1892), p. 163; Blackburn, *Women's Suffrage*, pp. 195-6.
38. Harrison, *Separate Spheres*, pp. 28-9.
39. *Englishwoman's Review*, 27 (1896), pp. 93, 167; Rover, *Women's Suffrage*, pp. 220-1.
40. The affair has often been described; *see* e.g., Ray Strachey, *Millicent Garrett Fawcett* (Murray, London, 1931), pp. 176-7. 'No lower depth of coarseness, levity and vulgarity can be reached', Elizabeth Wolstenholme Elmy wrote of the debate ('Ignota', 'Women's Suffrage', *Westminster Review*, 148 (1897), p. 367).
41. *The Times*, 12 July 1897.
42. *Englishwoman's Review*, 28 (1897), pp. 153-4.
43. Fawcett Library, Autograph Letter Collection, vol. 1, part B1, Frances Balfour to Millicent Garrett Fawcett, 5 February 1895, 5 November 1898.
44. As early as 7 December 1891 Lady Frances wrote to Fawcett: 'The extending the suffrage to women is so much a matter of far-seeing policy, that I dispair [sic] of getting the average M.P. to take much interest in it, till it becomes a Government question' (*ibid.*, vol. 1, part A).
45. *The Times*, 13 July 1894; *Englishwoman's Review*, 25 (1894), pp. 170-1; Blackburn, *Women's Suffrage*, pp. 197-201.
46. *Daily Graphic*, 21 May 1896; *St. James's Gazette*, 21 May 1896; Blackburn, *Women's Suffrage*, p. 197; Strachey, *Millicent Garrett Fawcett*, pp. 160-1. *See* Plate 1. The Helen Blackburn Papers at Girton College, Cambridge, contain a scrapbook on the women's appeal and its presentation, filed at 396.05.
47. *The Times*, 11 June 1894; *Manchester Guardian*, 26 June 1894; *Shafts*, 15 June 1894, pp. 266-9. *See* Plate 10.
48. There are several histories of the Women's Co-operative Guild (whose name was changed to Co-operative Women's Guild in 1963). The centenary history by Jean Gaffin and David Thoms is *Caring & Sharing* (Co-operative Union, Manchester, 1983).
49. Manuscript summary *Annual Reports* of Women's Co-operative Guild; 1888-9, p. 14; 1899-1900, p. 78 (Women's Co-operative Guild Papers, University of Hull Library, DCW 2/1).
50. *Co-operative News*, 7 July 1894, pp. 781-2.
51. *ibid.*, 17 July 1897, p. 801.
52. *ibid.*, 27 March 1897, p. 339. Securing the freedom to attend WCG conferences represented a considerable achievement for many wives and mothers (*ibid.*, 6 August 1892, p. 872).
53. Women's Co-operative Guild, *Why Working Women Need the Vote* (WCG, Kirkby Lonsdale, 1897), pp. 22, 26. The autobiography of Hannah Mitchell, a working-class socialist and suffragette, contains a number of bitter reflections about husbands: 'Even as Socialists they seldom translate their faith into works, being still conservatives at heart, especially

where women are concerned' (*The Hard Way Up*, Faber, London, 1968), p. 149. She married in 1895.

54. WCG, *Why Working Women Need the Vote*, pp. 32-3.

55. *Co-operative News*, 25 December 1897, p. 1451; 22, 29 January, 5, 12 February 1898, pp. 104, 131, 155, 179 (etc.); Liddington and Norris, *One Hand Tied Behind Us*, pp. 141, 144-8; Jill Liddington, *The Life and Times of a Respectable Rebel: Selina Cooper (1864-1946)* (Virago, London, 1984), pp. 104-7.

56. The earliest such association may have been founded about 1877, when one took part in a Birmingham demonstration (*Illustrated London News*, 9 June 1877, p. 545), but it was apparently not followed by others until about 1880.

57. *The Liberal Year Book 1888*, pp. 150-1; Hill, *Women in English Life*, II, p. 301; *The Times*, 28 May, 4 June 1891. The Women's Liberal Unionist Association maintained a quiet presence throughout the period, as reports of its annual council meetings show: e.g., *ibid.*, 9 May 1896, 19 June 1900.

58. Women's Liberal Federation, *Annual Reports*, 1897, p. 9; 1899, p. 10; Women's National Liberal Association, *Quarterly Leaflets*, 1895-1900. The WNLA also lost ground at this time, blaming its difficulties on the 'standstill' in Liberalism as a whole (*ibid.*, 22 (January 1901), p. 7).

59. Pugh, *Women's Suffrage*, p. 12.

60. Quoted in Marjorie Pentland, *A Bonnie Fechter* (Batsford, London, 1952), p. 100. In contrast, the American feminist Elizabeth Cady Stanton recalled the WLF's initial tameness as 'an insult to women' (*Eighty Years and More* (T. Fisher Unwin, London, 1898), p. 398).

61. Hill, *Women in English Life*, II, pp. 303-4; A. Lawrence Lowell, *The Government of England*, vol. II (1908; Macmillan, New York, 1912), pp. 13-15.

62. Dorothy Henley, *Rosalind Howard, Countess of Carlisle* (Hogarth Press, London, 1958), p. 38. Another biography is by a son-in-law, Charles Roberts: *The Radical Countess: the History of the Life of Rosalind, Countess of Carlisle* (Steel Brothers, Carlisle, 1962). The best of many anecdotes about Lady Carlisle is an apocryphal story told by Nancy Mitford in *The Ladies of Alderley* (Chapman & Hall, London, 1938), pp. xviii-xix.

63. Strachey, *Millicent Garrett Fawcett*, p. 174.

64. 'Ignota', 'Leading ladies of the opposition', *Pearson's Magazine*, 3 (1897), p. 199.

65. Lady Aberdeen edited its proceedings in seven volumes (T. Fisher Unwin, London, 1900). *The Times*, typically, expressed 'some difficulty in apprehending what the objects of this formidable organisation are or how it expects to promote them' (29 June 1899), while Beatrice Webb, a participant, judged the Congress 'not a failure, but hardly a success' Norman and Jeanne Mackenzie (eds), *The Diary of Beatrice Webb, vol. 2, 1892-1905* (Virago, London, 1983), p. 162).

66. Janet Robb, *The Primrose League 1883-1905* (1942; Ams Press, New York, 1968), pp. 53, 109, 112, 228; Lowell, *Government of England*, II, pp. 8-12; Martin Pugh, *The Making of Modern British Politics 1867-1939* (Blackwell, Oxford, 1982), pp. 50-3.

67. Robb, *Primrose League*, pp. 124, 126.
68. *ibid.*, p. 137.
69. *ibid.*, pp. 95, 131, 135-6.
70. Frances Balfour, *Ne Obliviscaris: Dinna Forget,* vol II (Hodder & Stoughton, London [1920]), pp. 114-15.
71. *See* W. B. Gwyn, *Democracy and the Cost of Politics in Britain* (Athlone Press, London, 1962), pp. 51-6, 125-7.
72. *The Gentlewoman,* 27 July 1895, p. 116; 10 August 1895, p. 190; 20 October 1900, p. 529; 17 November 1900, p. 655.
73. *ibid.*, 3 August 1895, p. 142. *See also* Robb, *Primrose League*, pp. 94-5, 98; Lowell, *Government of England,* II, pp. 11-12.
74. Manuscript Minutes of the Executive Committee of the Ladies' Grand Council of the Primrose League, 18 November 1892 (Bodleian Library).
75. 'There is something repugnant to the ordinary Englishman in the idea of a woman mounting a platform and facing the noisy, gaping, vulgar crowd of an election meeting' (Mary Jeune, 'English women in political campaigns', *North American Review,* 161 (1895), p. 453).
76. *The Gentlewoman,* 3 August 1895, p. 142; 20 October 1900, p. 529; 10 November 1900, p. 619.
77. *Primrose League Gazette,* 1 August 1895, pp. 8-9, 11-12.
78. *Englishwoman's Review,* 32 (1901), pp. 3-4; Roger Fulford, *Votes for Women* (Faber, London, 1957), p. 99.
79. Manuscript Minutes of the Executive Committee of the Ladies' Grand Council of the Primrose League, 2 November 1900; Manuscript Minutes of the Grand Council of the Primrose League, 18 October 1900 (Bodleian Library).
80. Article reprinted from the *Daily Express* in the *Primrose League Gazette,* 1 November 1900, p. 11.
81. Her principal accounts of her English experiences were *Campaigns of Curiosity: Journalistic Adventures of an American Girl in London* (Cassell, London, 1894) and *The Autobiography of a 'Newspaper Girl'* (Methuen, London, 1902).
82. Elizabeth L. Banks, 'Electioneering women — an American appreciation', *Nineteenth Century,* 48 (1900), pp. 795. 798.
83. Women's National Liberal Association, *Quarterly Leaflets,* 1 (December 1895), p. 8; 8 (June 1897), p. 22; 11 (April 1898), p. 7; 21 (October 1900), pp. 2-5, 17-20; WLNA, *Annual Report,* 1901, p. 4.
84. WNLA, *Quarterly Leaflet,* 22 (January 1901), p. 13; *Shipley Times,* 25 October, 6 December 1901; *Bradford Weekly Telegraph,* 7 March 1913. I owe the final reference to Miss E. M. Willmott, the Bradford City Local Studies Librarian.
85. Millicent Garrett Fawcett, 'The women's suffrage question', *Contemporary Review,* 61 (1892), p. 763. Twenty years later she was still insisting that the Liberal Party 'cannot long maintain' that women were fit to canvass but not to vote (Fawcett, *Women's Suffrage,* p. 32).
86. W. E. H. Lecky, *Democracy and Liberty,* vol. II (Longmans, London, 1896), p. 452.
87. *Punch,* 28 May 1892, pp. 254-5 *See* plate 9.
88. Progress towards the vote might have been faster had more Liberal

women emulated the pugnacious Maria Salès, who declared her opposition to canvassing for a party led by Gladstone, the supporter of women canvassers and enemy of women's suffrage. In her view he was 'too weak-minded and inconsistent to be worthy to head any great party' (*The Times*, 28 April 1892).

89. Eliza Orme told the NLF in 1897 that a bill extending the franchise to married working-class women could not pass and Henry Broadhurst reinforced his earlier remarks by asking in 1899: 'Were they prepared to admit every woman over twenty-one, including factory girls, barmaids, house-maids, kitchen-maids and the widows of working men?' (*Englishwoman's Review*, 29 (1898), p. 29; 31 (1900), p. 21). 'Would anyone seriously propose to give the vote to the girls at the A.B.C.'s?' a woman's suffrage meeting was asked in 1892 (Henry Holiday, *Reminiscences of My Life* (Heinemann, London [1914], p. 383).

90. Manuscript Reports of Annual Conferences of the National Union of Conservative and Constitutional Associations, 1887, pp. 166-7; 1891, pp. 58-66; 1894, pp. 514-26 (Harvester Press Microform, Brighton, 1982); *Englishwoman's Review*, 23 (1892), pp. 12-15; 29 (1898), p. 23; *The Times*, 18 November 1897; Rover, *Women's Suffrage*, pp. 111-12.

91. Balfour, *Ne Obliviscaris*, II, p. 136.

92. Millicent Garrett Fawcett, *What I Remember* (T. Fisher Unwin, London, 1924), pp. 146-8, 176.

10

The experience of local government

Male opposition to granting women the parliamentary franchise found little support from the logic of contemporary politics. Women were active members of thriving political organisations in the 1890s. Their assistance in political campaigns was indispensable. Moreover, they could vote in local elections and serve as elected representatives on local government bodies. An official return in 1890 showed that 685,202 women were eligible to vote in certain local elections in England and Wales; by 1897 the number had risen to 729,758, some 13.7 per cent of the electorate of 5,326,879.[1]

However, the situation was, as Elie Halévy later pointed out, 'extremely confused and illogical'.[2] The qualifications required of women voters and candidates for elected office were almost impenetrable to contemporaries and have remained so to historians. Complication was compounded by the vagueness of the law and consequent judicial interpretation. In some cases married women could vote, in others they could not. In some cases women could be elected to office, in others not. In general it was easier to satisfy the requirements for being elected than for voting.[3]

Nonetheless, women made a significant impact on local government for the first time in the 1890s. They were entitled to vote and to stand where qualified for election to the thousands of school boards set up in and after 1870, and a number took advantage of the opportunity thus offered. The 1870 election had resulted in the return in Manchester of Lydia Becker the women's suffrage leader, and in London of Emily Davies, the pioneer of women's education and Elizabeth Garrett, who as Elizabeth Garrett Anderson was to become the most prominent woman doctor in the final quarter of the century. Garrett's resounding victory in Marylebone, with a majority which hardly admits of a parallel, was an important psychological triumph; its size was made possible by the 'plumping' system adopted in board elections.[4] These elections were followed by others, resulting in a slow accretion of the number of women

members, particularly in London, where they constituted near-
ly ten per cent of the board's membership in its thirty-four year
history.[5] The exact number of women who served as school
board members at any one time is unknown, but there was
undoubtedly growth in the 1890s. One may cite an estimate of
80 in 1891, and further calculations which suggested that there
were 200 or more women members at the end of the century.[6]

There were about 2,500 school boards in the 1890s and as
there was at most one woman for every ten boards their
influence is difficult to isolate. Moreover, much of their work as
board members reflected their political standpoint rather than
their sex. On the London School Board, however, the relatively
large numbers of women consistently attempted to secure equal
treatment for girls and women at all levels of the board's work,[7]
and efforts on parallel lines may have been undertaken else-
where.[8] Women members also did much to improve the teach-
ing of domestic subjects and to protect the interests of handi-
capped and deprived children.[9] In addition, exceptional indi-
viduals made a particularly significant contribution to the work
of the boards. One such was Annie Besant, who served only one
three-year term on the London board, to which she was elected
in 1888. In concert with her fellow socialist Stewart Headlam
she forced through a number of resolutions in support of trade
union wage rates, free schools, the provision of pianos in schools
and an examination of the problem of malnutrition. By May
1890 the jubilant Headlam was writing that Besant 'does pretty
well what she likes with us' and that she was 'the real leader of
the advanced party'.[10] Other outstanding individuals included
Flora Stevenson, a member of the Edinburgh School Board
from its inception in 1873 and its chairman from 1900 until her
death in 1905, and Margaret McMillan, the famous social
reformer who was a member of the Bradford School Board from
1894 to 1902.[11]

Although women had been elected to school boards before
they began to serve on other authorities, it was as poor law
guardians that they attracted most public attention as well as
most frequent elected office. The fact that poor law unions were
concerned with the destitute, the sick, the aged, helpless child-
ren and the insane encouraged the belief that the office of
guardian was particularly appropriate for women. In this
context it was seen as an extension of the philanthropic work

which they had long undertaken, notably in improving the administration and alleviating the harshness of the deterrent poor law.[12] Women ratepayers had been eligible to vote for members of boards of guardians since the passage of the Poor Law Amendment Act in 1834. Their eligibility to stand for election as guardians long remained untested, and the property qualification required of guardians acted as a strong disincentive to women. In 1875, however, Martha Merrington was elected guardian in South Kensington and her election was followed by a smattering of others. In 1885 there were fifty women guardians in England and Wales.[13]

Women's participation in poor law administration was encouraged when the rating qualification of guardians, which varied from board to board but had often been as high as £40, was reduced to a uniform £5 in 1892. This measure was followed early in 1893 by a Local Government Board order which authorised boards of guardians to appoint committees of women, whether they were guardians or not, to visit and inspect those parts of workhouses where women and children were accommodated.[14]

The Local Government Act passed the next year made 1894, in the words of the *Lady's Realm*, 'an *annus mirabilis* in the annals of the enfranchisement of women'.[15] The act created urban and rural districts and civil parishes; rural district councillors became automatic members of boards of guardians. Qualified women ratepayers and occupiers were entitled to vote and to stand for election, though most married women, not being ratepayers in their own right, were unable to vote and even unmarried women were disqualified in certain circumstances. Nor were women chairmen of district councils eligible, as were men, for automatic appointment as justices of the peace. The relatively generous provisions of the act, moreover, were not passed without pressure from women's organisations and their friends, and a government defeat in the House of Commons.[16] The £5 property qualification for guardians was abolished by the act, which further provided that any adult could be elected by satisfying a residence qualification. This opened the door to a great increase in the number of women guardians, from an estimated 136 out of a total of 28,000 in 1892, to between 800 and 900 in 1895.[17]

The novelty of being an elected woman, her minority status and the inhibitions of education and socialisation meant that it

was often difficult to institute policies of aggressive reform. Nonetheless, it is clear that women guardians, who have been the subject of more detailed study than their school board colleagues, attempted with considerable success to humanise the administration of the poor law, building on the foundations laid by women's earlier philanthropic work. Their efforts were concentrated on improving the conditions of children and the aged, providing more amenities in the workhouses, expanding the functions of guardians into other fields than the relief of destitution and encouraging the employment of trained staff. Moreover, being in general of a higher social class than their male colleagues they were often self-confident and influential figures, who enjoyed more leisure than men to carry out their heavy official duties.[18]

The future suffragettes Emmeline Pankhurst and Charlotte Despard were among those whose introduction to active political life came in their work as poor law guardians. Mrs Pankhurst, elected in Chorlton, Manchester, in 1894 described in some detail her attempts to alleviate the hardships of the poor law by such amenities as more privacy and comfort for the old and a well-equipped school for pauper children. The plight of unmarried mothers and their babies, she wrote, was an important factor in her education as a future militant.[19] Mrs Despard, who was elected in the same year in Vauxhall, South London, did much, according to her biographer, to introduce a more humane outlook among the guardians towards the poor law and to ameliorate the conditions of workhouse inmates. As in Emmeline Pankhurst's case her experience of the poor law convinced Charlotte Despard that the poor law could not be reformed without sweeping social change; she soon became a socialist and then a leading figure in the suffrage campaign.[20]

Even before the election of Pankhurst, Despard and hundreds of other women in the wake of the 1894 legislation the potential of women guardians to improve conditions in the workhouse had been demonstrated. The most prominent of the earlier pioneers was Louisa Twining, who by the 1890s could look back on a career of over forty years as a poor law worker and reformer, including membership of the Kensington Board of Guardians from 1884 to 1890. In 1893 at the age of seventy-two she was elected to the Tonbridge Board, where she served for a further three years. Though not a radical of the Pankhurst-

Despard stamp she soon made her mark as a reformer, especially of the conditions of children, the old and the sick. It was this kind of indefatigable work which caused such a commentator as Joseph Oakeshott, a Fabian writer, to remark in a lecture early in 1894 that the election of women had been 'the cause of a complete revolution in many workhouses'. Every board of guardians, he added, should have two or three women members; Twining herself advocated 'at least six' in a large union.[21]

The advances made in the 1890s were far from sweeping. The sudden rise in the number of women guardians which followed the passage of the Local Government Act was followed by a much more gradual increase. In 1899 the Society for Promoting the Return of Women as Poor Law Guardians calculated that there were about 975 women guardians in England and Wales, and that 300 boards, nearly half the total number, still had no women members. Two years later the number of women guardians had not increased.[22] Moreover, in other tiers of local government created by the 1894 act the number of elected women was small. Elizabeth Wolstenholme Elmy estimated that about 200 women were members of the nearly 8,000 parish councils of England and Wales in 1898, and at the end of the century there were only about 150 women rural district councillors and ten urban district councillors. Fifteen women served as members of London vestries, the local councils which were superseded by metropolitan borough councils after the passage of the London Government Act of 1899.[23]

Honnor Morten, a member of the London School Board, wrote that the 1894 act had produced inadequate enthusiasm for elected office among women, and the *Englishwoman's Review* admitted that after an education in reticence and passivity many women needed to be encouraged even to become active voters.[24] When they did stand for election women sometimes faced strong opposition on grounds of their sex. This may have been the case in the London vestry elections of 1894, in which many of the women who stood were defeated.[25] Honnor Morten pointed out that women were reluctant to stand for election because they lacked speaking experience and in some cases understanding of the importance of the work to be done. In addition, they were often unwilling to face the expense involved, which she calculated at about £200 in the case of a London School Board election. Once elected to the London

Board the member faced a full-time job and the wearying pomposity of her male colleagues: 'The silent, hard, conscientious committee work done by women, as opposed to the blatant mouthing of the men on board days is most noticeable on large bodies.'[26]

Among the women elected to local authorities was a not inconsiderable number of working-class women, who took advantage of the easily satisfied conditions to stand for election to boards of guardians. Thirty-six members of the Women's Co-operative Guild served as guardians in 1898, and although most of them were probably of a higher social class than the majority of members,[27] it was not always easy for them to win the support of party organisations. At Rotherham a search produced a member who also belonged to the local Women's Liberal Association and who agreed to stand. But a problem arose, as the Guild's annual report explained: 'The branch considered her a very suitable candidate. But "we were told", says a member of the branch, "that it must be a 'lady', and not a 'woman'!" That was the opinion of the "Gentlemen's" Liberal Association.' The story was greeted at the Guild's annual meeting, the *Co-operative News* reported, with 'indignant laughter'.[28] Hannah Mitchell suffered rejection on grounds of sex rather than class, but her story had a happy ending. She was asked to stand as a guardian in 1904 for Ashton-under-Lyne by the local Independent Labour Party. When the ILP invited a retiring Labour guardian to combine in a joint campaign he refused, thinking that he would suffer from association with a woman. In the event a wealthy Liberal woman headed the poll, Mitchell was second and the Labour man lost his place.[29] Selina Cooper also stood as a socialist candidate. She was elected to the Burnley Board of Guardians in 1901, but only after a campaign which largely ignored the normal political issues and 'became virtually a sex war' in the words of her biographer.[30]

The fact that such bodies as school boards and boards of guardians were concerned with social questions generally regarded as 'women's subjects' was one explanation of the fact that women were enabled to vote and stand for election to positions in local government. Moreover, membership of local bodies involved much more drudgery and much less glamour than membership of the House of Commons. Women also benefited from the fact that their participation in local govern-

ment had evolved in unsystematic fashion over several decades and had never become a parliamentary battleground as in the case of the suffrage question or, indeed, as local government itself was to become before the end of the decade.

Men's tolerance of elected women, however, generally stopped short at what the Liberal *Daily Chronicle*, which took a severe view of their capacities, termed 'the humbler side of local government'.[31] Although women in certain categories had been enfranchised as municipal electors by an act passed in 1869 and confirmed in 1882, they could not serve as borough councillors or as members of the new county and county borough councils created in 1888. Their right to elected office in county councils had remained in doubt when the first elections took place. Margaret, Lady Sandhurst, and Jane Cobden were elected to the London County Council and they were joined by Emma Cons, who was appointed an alderman. However, their service was short-lived, for legal judgments in 1889 and 1891 declared that Sandhurst and Cobden could not hold office.[32] The position remained unchanged until 1907, when an act was passed entitling women to serve as members of all local authorities. Elizabeth Garrett Anderson was elected mayor of Aldeburgh the following year, but the restrictive terms of the legislation allowed few women to benefit.[33]

Supporters of women's rights believed that voting and election to local office were important matters of principle, but they also thought in terms of what elected women could achieve. They shared the common and perhaps accurate view that women's understanding of the conditions of the poor was greater than men's, and realised that working-class women would find it easier to communicate with other women than with male officials. Moreover, it was appreciated that the election of women at local level encouraged an increase in the number of women sanitary, school and factory inspectors and other local and national officials, including members of royal commissions and other government bodies, whose appointment was a notable innovation of the period. In turn such bodies were in a position to recommend the appointment of further women inspectors.[34] The International Congress of Women was told in 1899 that the London School Board employed seventeen women to 'do inspector's work, or something closely akin to it' and that eight other local education authorities also had women

inspectors.[35] At the end of the century the London County Council employed a woman organiser of domestic economy classes and an assistant, two inspectors under the Infant Life Protection Act and three under the Shop Hours Act.[36] By 1904 over 100 women were employed by local authorities either as sanitary inspectors or more tactfully (and cheaply) as health visitors to investigate and improve conditions in workshops and homes.[37]

The claim that women councillors and board members had an essential role to play in assisting less fortunate women and their children was much heard. A leaflet by Mary Stewart Kilgour published early in the new century by the Women's Local Government Society asked why women were wanted on rural district councils and answered that a labourer's wife would 'more readily show her home to a woman'. Women and children living in unhealthy conditions, she continued, suffered more than men who were often away during the day, 'and what is needed to transform such homes can be best realised by a woman'. She added that the election of women councillors should lead to the appointment of women as health visitors or district nurses.[38] A leaflet on urban district councils again linked elected and official women: '[T]he appointment by the Councils of Women Sanitary Inspectors is becoming general, and these officers work at a disadvantage unless there are Women as Members of the Body to which they report.'[39]

The potential of elected women to improve social conditions was illustrated by the official career of Alice Busk, who was elected to the poverty-stricken London vestry of St George-the-Martyr, Southwark, in 1894, in collaboration with a second woman and a group of working men. She had then managed poor properties in East London for twelve years and her colleague Elizabeth Kenny had had eight years' experience of nursing the poor. The new members set out to repair the ravages of neglect of housing and health, involving Busk in long and arduous duties. What she described as the vestry's 'boldest venture' was the appointment of a woman inspector in 1896 to enforce the housing by-laws in the poorest areas. This was work which had never been undertaken by a woman, but the inspector, Anne Elliott, proved highly successful, Busk told the annual meeting of the Women's Local Government Society in 1899. She had met no incivility, and 'in some cases she has even been

thanked by the men for the improvement effected in their homes'. Although no other vestry made a similar appointment St George employed a second woman in 1899 and was planning a third in the last stage of its existence as a local authority. Busk also told the meeting that Matilda Evans, a member of the vestry of St Martin-in-the-Fields, served on six of the vestry's committees, besides serving as the only overseer of the poor in London.[40] She concluded that women candidates for election to vestries 'need not be bright stars, but they must be women willing to drudge, and to give ample time to their duties'.[41] Among the few women willing to consecrate their lives in this manner was Jane Escombe, who was elected to the Penshurst, Kent, parish council in 1894. Her determination and effort helped to secure a hospital for the parish, an improved water supply and cottages to house local people. In a pamphlet published about 1901 she appealed to other women who enjoyed more leisure than men and cared about sanitary matters to rally to council work.[42]

The anomalies which marked women's participation in civic responsibilities resulted at times in comedy, at others in prolonged controversy. Even the former, however, illustrated the complex nonsense of the law. One such case involved Louis Ellis, who was summoned in 1898 for jury service at the City of London coroner's court. This seemed an innocuous matter, but resulted in embarrassed confusion when Louis Ellis arrived in court and was discovered to be a woman. The ward beadle and the clerk to the court behaved with flustered pomposity, Ellis with aplomb. Told by the beadle that Louis Ellis was not her name she observed that she had never been told so before. The beadle tried again: 'But we summoned Louis Ellis', to be told firmly: 'Well, I am here; I have answered my name three times.'[43]

A case in 1898-9 illustrated the disadvantages faced by married women in trying to assert the civic rights to which they were legally entitled. Section 43 of the Local Government Act of 1894 provided that a woman whether married or unmarried was qualified for the local vote but that both husband and wife should not be qualified by paying rates on the same property. (The case of *Drax* v. *Ffooks* subsequently whittled away the rights supposedly gained by stipulating that actual occupation rather than mere ownership was required of women electors.)[44] Louisa

Samson took the lease of a house in Hampstead for which she paid with her own money. Her husband owned property in another district and was therefore a local voter. Neither the collectors of rates or water rates, nor the gas company, however, would allow her to be charged in her own name without protest. When she refused to pay her rates unless charged as sole occupier her husband was ordered to pay them. She then approached the Women's Local Government Society, which in turn enlisted the support of the Hampstead Liberal Association. That body objected before an election court to Mr Samson's name appearing on the register of parochial electors. The decision was that Mrs Samson as lease-owner and ratepayer should enjoy the parochial vote, but the rating authority still insisted that it could keep Mr Samson's name on their ratebook. As the WLGS pointed out, if both names appeared the question of who should be allowed to vote could be raised annually, though the right of a married woman to be regarded as an occupier and to enjoy the local government franchise independently of her husband had apparently been settled in her favour in the case of *Prentice* v. *Markham* (1892). 'Moreover', the Society's *Report* added, 'if it be conceded that the Overseers may thus enter a husband as ratepayer when he is not such, the way is open for a man to unjustly claim that his name and not his wife's be placed on the Register.'[45]

The problems which affected women like Mrs Samson who tried to exercise the rights of the citizen also affected women appointed to official positions. The most celebrated case was that of Rebecca Price, whose husband was relieving officer of the Oswestry Board of Guardians, Shropshire, until his death in May 1897. During her husband's long illness Mrs Price had performed many of his duties and had been appointed temporary relieving officer during the last six months of his life. The guardians then enquired of the Local Government Board whether a woman could be appointed to the position. Since the board gave no clear guidance the guardians, after examining seventeen applications, appointed Mrs Price. The Local Government Board, however, refused to agree to her appointment, pointing out that one of a relieving officer's duties was to accompany pauper lunatics to the justices of the peace and the county asylum, work which it judged that women could not perform as satisfactorily as men. It acknowledged that it was

unwilling to create a precedent by permitting the appointment of a woman, and threatened to make its own appointment if the Oswestry guardians did not give way. The guardians duly re-advertised, receiving twenty-eight applications, but with the support of the Women's Local Government Society it decided to reappoint Mrs Price on a temporary basis.

The WLGS consulted R. B. Haldane, QC, MP, who informed them that although there was no legal impediment to the appointment of a woman the Local Government Board could impose a surcharge or dismiss a relieving officer without stating a reason. In January 1898, however, the LGB finally relented and agreed to the appointment of Mrs Price for a probationary year, without altering its view that the appointment of a woman was in general undesirable. In the sequel she remained in her post for less than two years, resigning due to the ill health of her child, but early in 1900 the Local Government Board sanctioned the appointment of a second woman relieving officer. In this instance Mrs Arrowsmith also succeeded her dead husband, in the Suffolk union of Nutford and Lotting-land.[46] The two cases illustrated the fact, becoming slowly apparent to contemporary opinion, that in women lay a hither-to untapped, often highly qualified reservoir of labour. As the spokesman of the Hampstead Board of Guardians said when a woman was appointed dispenser at the workhouse in 1899, the seven women who had applied for the post were 'as good as the 20 men put together'.[47]

Thus far the picture of women and local government is one of broadening opportunities for both elected and appointed women and benefit for local communities. As might be expected, however, not all elected women were competent in their work. Louisa Twining admitted in 1897 that '[a] few unsuitable women Guardians ... had been elected'. Deficiencies, she pointed out, were magnified in the glare of the spotlight which beat mercilessly on women who entered public life.[48] In an age slowly emerging from wholesale electoral corruption, cases like those of the candidate who held election meetings in her husband's public house, and of Jane Sumpter, a twenty-three year-old London School Board teacher and guardian who offered her vote to poor law contractors in exchange for payment were undoubtedly not unique.[49] There were also complaints from men who found women colleagues an irritation. Charles

Selby Oakley, for example, complained in 1896 that the presence of women in elected assemblies distorted the proceedings. Women assumed that they could say what they pleased to men without contradiction, and men were unwilling to reply in kind: 'It is much like mixed lawn-tennis. The real deadly unapproachable serve does not get delivered by the man to the woman, not even to the professed lawn-tennis-playing woman.'[50]

Difficulties of this kind were no more than growing pains. Between 1899 and 1902, however, the movement for local emancipation went into reverse, paralleling the eclipse suffered by the movement for the parliamentary franchise after the contemptuous treatment of Faithfull Begg's women's suffrage bill in 1897 and the outbreak of the South African war in 1899. Detailed consideration of the Education Act of 1902 lies outside the scope of this book, but it should be noted that the abolition of the school boards which lay at its heart was a severe blow to women's participation in local educational administration. Women did not lose the right to be co-opted onto the committees which administered the further education service of the counties and county boroughs, but a parliamentary return in 1900 showed that only nine of the sixty-two counties and ten of the sixty-four county boroughs in England and Wales had women members of their technical education or instruction committees.[51] Although the proportion was higher than in the case of the school boards the passage of the 1902 act, which encompassed both elementary and secondary education, meant that women could gain places on local education authorities only by the indulgence of all-male councils. This was in sharp contrast to the women school board members, whose numbers had increased in the 1890s and who for a generation had owed their position to their own efforts and the support of the local electorate.[52]

It was, however, over the eligibility of women to serve as members of the new London borough councils that women's final local government battle of the decade was fought and lost. The London Government Act of 1899 abolished the vestries and replaced them with twenty-eight metropolitan boroughs with more power and, it was hoped, less susceptibility to corruption. Although few women had found seats on vestries there was obviously room for many more of the stamp of Alice Busk. Qualified women, including married women, were granted the

right to vote but not to election as councillors, despite leafleting and lobbying by the women's suffrage movement. Their failure owed much to the fact that since the passage of the Local Government Act of 1894, in which the rights of women had stirred relatively little controversy, advances in local government had come increasingly to be regarded as a means of furthering the campaign for the parliamentary vote. This was the surest indication of the growth of the movement and its impact on the political world. *The Times*, whose professed support for improving the status of women rarely extended to current campaigns, expressed a general feeling: '[T]he working woman is freely used as the stalking-horse of the political woman, who is a totally different being.... The real aim of those, or of most of those [who urge that women are needed in 'certain departments' of local government] is to drive the political wedge, not to push the interests of poor people in sanitation.'[53] Lady Frances Balfour found support for this view among members of Parliament, as she wrote to Millicent Fawcett after dining at the House of Commons: 'What interested me was the feeling, that many expressed, namely that at the bottom of it, lay the deepest hostility to the Suffrage.'[54]

Looking back, crumbs of comfort might be salvaged from defeat, although, as Lady Frances admitted, 'the drubbing [was] complete & severe'.[55] Women's political rights had briefly become a topic of major importance in press and Parliament. The arguments on which much of the opposition to women's political participation was based had been exposed as a sham. This was notably true of the claims that women were not suited to the rough and tumble of local politics and that attracting persons of a higher calibre to London government meant excluding women. As Augustine Birrell reminded the House of Commons in a typically witty speech, cultivated ladies were entitled to sit on boards of guardians, 'cheek by jowl with greasy publicans and small shopkeepers'. They could also sit on vestries, he added,

> when Bloggins the ironmonger pulls the nose of Scroggins the greengrocer. That does not interfere with the purity of their characters; but the moment you reform these vestries, and make them more popular and more suitable to persons of refinement and education, you select that very moment to turn round on

women and say, 'You are no longer fit to sit here; these are not the places for you; out you go.'[56]

Lord Salisbury and A.J. Balfour, who described himself as one of 'the more timid and weak-kneed of the[ir] supporters',[57] had spoken in the women's favour. Finally, there was evidence that their claim enjoyed a measure of popular support. The women had been defeated not in the House of Commons, which voted consistently in their favour, but in the Lords. Lady Frances Balfour, indeed, claimed that the issue was partly one of class. Women vestry members were popular in poor areas, where their work was necessary for 'the immediate welfare of the struggling masses in our great city'. It was only in 'certain rich quarters' that opposition existed to women in local government.[58]

The 1890s was a period of mixed fortune for women in local government. They were given unprecedented opportunity by the Local Government Act of 1894, and by the end of the decade their position as locally elected members had been transformed. Women had become a considerable force in local government and individuals had had a notable impact on their local authorities. On the other hand, their numbers did not continue to rise significantly after the initial expansion in the wake of the 1894 act. They were restricted to those spheres of local government judged suitable by contemporary opinion and even here they faced the scepticism and hostility of their male colleagues. In 1899, on the one occasion when their role in local government became controversial, they suffered humiliating defeat.

As in so many other respects the record of the decade was ambiguous. It would be perverse, however, to deny the evidence of achievement. Moreover, their work in local government helped to create new confidence in the competence of women. Even in the short run this was a development of greater significance than their success in combating bumbledom and ameliorating social conditions.

Notes

1. *Women's Suffrage (Local Government)*, House of Lords Papers 1890, XVII, H.L. 11, pp. 2, 5; *Local Government (Registered Electors)*, P.P. 1897, LXXVI-I H.C. 265, p. 13. These figures relate to county, county borough and municipal borough elections, in which married women were not qualified to vote. The number of voters in other local elections was not published.
2. Elie Halévy, *A History of the English People: Epilogue vol. II* (1932; English translation: Benn, London, 1934), p. 504n.
3. A summary of the position after the passage of the Local Government Act of 1894 was given by 'Ignota' (Elizabeth Wolstenholme Elmy), 'Women's suffrage', *Westminster Review*, 148 (1897), pp. 362-3. Mrs Elmy also provided an excellent factual and analytic account of 'The part of women in local administration' in four articles in the same *Review*, 150-1 (1898-9).
4. Louisa Garrett Anderson, *Elizabeth Garrett Anderson* (Faber, London, 1939), pp. 154-5. Her 47,848 votes were nearly four times as many as those of the next successful candidate, T. H. Huxley.
5. Twenty-nine of the London School Board's 326 members were women (School Board for London, *Return of All Members of the Board During its Existence*, 20 April 1904).
6. *The Star*, 26 May 1891 (80); Honnor Morten, *Questions for Women (and Men)* (Black, London, 1899), p. 60 (188); *Parl. Deb.*, 4th ser., 83 (23 May 1900), col. 1036 (220); Women's Local Government Society, *Ninth Annual Report* (1902), p. 22 (270).
7. Annmarie Turnbull, '"So extremely like Parliament": the work of the women members of the London School Board, 1870-1904', in London Feminist History Group, *The Sexual Dynamics of History* (Pluto Press, London, 1983), ch. 7.
8. *See* Peter Gordon, *The Victorian School Manager* (Woburn Press, London, 1974), pp. 184-5.
9. Rosamond Davenport-Hill, *Women on School Boards* (Women's Local Government Society, London, 1898), 4 pp. An account of Davenport-Hill's own efforts and achievements as a member of the London School Board between 1879 and 1897 is given in Ethel E. Metcalfe, *Memoir of Rosamond Davenport-Hill* (Longmans, London, 1904).
10. David Rubinstein, 'Socialisation and the London School Board 1870-1904', in Phillip McCann (ed.), *Popular Education and Socialisation in the Nineteenth Century* (Methuen, London, 1977), pp. 243-4. Thomas Gautrey describes Annie Besant and other women members of the London School Board in '*Lux Mihi Laus*': *School Board Memories* (Link House, London [1937]), pp. 28, 53-4, 55-6, 78-9.
11. Stevenson's work is discussed in the *Englishwoman's Review*, 31 (1900), pp. 108-9; McMillan's in Albert Mansbridge, *Margaret McMillan* (Dent, London, 1932), ch. 2.
12. M. A. Crowther, *The Workhouse System 1834-1929* (1981; Methuen, 1983), p. 77; Frank Prochaska, *Women and Philanthropy in Nineteenth-Century*

England (Clarendon Press, Oxford, 1980), p. 226; Anne Summers, 'A home from home — women's philanthropic work in the nineteenth century', in Sandra Burman (ed.), *Fit Work for Women* (Croom Helm, London, 1979), pp. 46-51.

13. Erna Reiss, *Rights and Duties of Englishwomen* (Sherratt & Hughes, Manchester, 1934), p. 199; Ronald G. Walton, *Women in Social Work* (Routledge & Kegan Paul, London, 1975), p. 30; Beatrice and Sidney Webb, *English Poor Law History, Part II: the Last Hundred Years,* vol. I, (1929; Cass, London, 1963), p. 234. The first married woman guardian was Elizabeth Wolstenholme Elmy's friend Harriett McIlquham, who was elected in Tewkesbury in 1881.

14. Webb, *Poor Law History,* I, p. 232; *Twenty-Third Annual Report of the Local Government Board, 1893-94,* P.P. 1894, XXXVIII, C. 7500, pp. xci, 62-3; *Englishwoman's Review,* 24 (1893), p. 6.

15. *Lady's Realm,* 6 (1899), p. 751.

16. The complicated parliamentary manoeuvrings are fully described in the *Second Report* of the Women's Emancipation Union (1894), pp. 2-12. See also *Punch,* 25 November, 2 December 1893, pp. 252, 264.

17. *The Times,* 24 November 1892; Webb, *Poor Law History,* I, p. 234; *Englishwoman's Review,* 26 (1895), pp. 143-6. Even the low 1892 figure was a considerable increase on the previous year (*ibid.,* 22 (1891), pp. 175-7).

18. Elizabeth M. Ross, 'Women and Poor Law Administration 1857-1909', (unpublished thesis, University of London, 1956), ch. 8; Crowther, *The Workhouse System,* pp. 77-8.

19. Emmeline Pankhurst, *My Own Story* (Eveleigh Nash, London, 1914), pp. 22-31; E. Sylvia Pankhurst, *The Suffragette Movement* (Longmans, London, 1931), pp. 128-32; E. Sylvia Pankhurst, *The Life of Emmeline Pankhurst* (T. Werner Laurie, London, 1935), pp. 34-7.

20. Andro Linklater, *An Unhusbanded Life: Charlotte Despard, Suffragette, Socialist and Sinn Feiner* (Hutchinson, London, 1980), pp. 72-86, 89-94.

21. J. F. Oakeshott, *The Humanising of the Poor Law* (Fabian Society, London, 1894), pp. 18-19; Louisa Twining, *Recollections of Life and Work* (Arnold, London, 1893), pp. 258-62; Louisa Twining, *Workhouses and Pauperism* (Methuen, London, 1898), chs. 4 and 5. For other experiences of women elected to school and poor law boards see Jane Lewis, *Women in England 1870-1950* (Wheatsheaf, Brighton, 1984), pp. 94-5; Jill Liddington, *The Life and Times of a Respectable Rebel: Selina Cooper (1864-1946)* (Virago, London, 1984), pp. 97-8, 109-18.

22. *Englishwoman's Review,* 30 (1899), p. 206; Women's Local Government Society, *Ninth Annual Report* (1902), p. 22. In 1907 there were 1,141 women guardians (Webb, p. 234).

23. WLGS, *Ninth Annual Report,* pp. 22-3; 'Ignota', 'The part of women in local administration', *Westminster Review,* 150 (1898), p. 249; *Parl. Deb.,* 4th ser., 83 (23 May 1900), col. 1036. One of the rural district councillors was the Countess of Carlisle, who served for many years in both Cumberland and Yorkshire (Charles Roberts, *The Radical Countess: the History of the Life of Rosalind, Countess of Carlisle* (Steel Brothers, Carlisle, 1962), p. 147).

24. Morten, *Questions,* p. 65; *Englishwoman's Review,* 30 (1899), pp. 8-9.

25. *The Times,* 20, 22 November, 17, 18 December 1894.
26. Morten, *Questions,* pp.61-2. £200 may be accepted as a fair estimate of the average cost of a London School Board election, but Rosamond Davenport-Hill spent between £1,400 and £1,500 on three elections in the 1880s (Metcalfe, *Memoir,* p.117).
27. As Jill Liddington maintains: *Selina Cooper,* p.97.
28. Women's Co-operative Guild, *Fifteenth Annual Report 1897-98* (1898), pp. 8-9; *Co-operative News,* 2 July 1898, p.777.
29. Hannah Mitchell, *The Hard Way Up* (Faber, London, 1968), pp. 122-4.
30. Liddington, *Selina Cooper,* pp.109-12. Other working-class and co-operative women guardians included Ada Nield (Chew) and Sarah Reddish; an anonymous guildswoman wrote an account of her experiences in Margaret Llewelyn Davies (ed.), *Life as We Have Known It* (1931; Virago, London, 1977), pp.129-31.
31. *Daily Chronicle,* 24 September 1895.
32. Reiss, *Rights and Duties,* pp.200-1; Albie Sachs and Joan Hoff Wilson, *Sexism and the Law* (Martin Robertson, Oxford, 1978), pp.25-7.
33. Reiss, pp.206-7; Halévy, *Epilogue II,* p.510 and n.; Millicent Garrett Fawcett, *Women's Suffrage* (T.C. & E.C. Jack, London [1912]), pp.49-50. Jane Frances Dove, the well-known headmistress of Wycombe Abbey, was elected mayor of High Wycombe in 1908 in an initial vote, but opposition to a woman mayor caused her election to be overturned (*The Times,* 26 October, 10, 11 November 1908).
34. As did the Departmental Committee on Metropolitan Poor Law Schools, of which the social worker Henrietta Barnett of Toynbee Hall was a member (P.P. 1896, XLIII, C. 8027, p.151).
35. Sarah Anne Byles, 'The work of women inspectors', in Countess of Aberdeen (ed.), *The International Congress of Women of 1899,* vol. III, *Women in Professions – I* (T. Fisher Unwin, London, 1900), p.100.
36. Emily Janes (ed.), *The Englishwoman's Year-Book and Directory 1901* (A. & C. Black, London, 1901), p.212.
37. T. Orme Dudfield, *Woman's Place in Sanitary Administration* (Woman Sanitary Inspectors' Association, London, 1904), pp.1-2; Byles in Aberdeen (ed.), *International Congress,* pp.97-8.
38. Mary Stewart Kilgour, *Why are Women Wanted on Rural District Councils?* (Women's Local Government Society, London [?1906]), 2 pp. Mary Stewart Kilgour was an official of the WLGS and a strong advocate of women's suffrage.
39. Anon., *Why are Women Wanted on Urban District Councils?* (WLGS, London, 2nd edn 1907), one page. Similar points to those in this paragraph were made by Bernard Shaw, *Women as Councillors* (Fabian Society, London, 1900), 3 pp.
40. For Mrs Evans see 'Ignota', 'The part of women in local administration', *Westminster Review,* 150 (1898), pp.387-9; 'Ignota', 'Privilege v. justice to women', *ibid.,* 152 (1899), p.135. She was unfortunately unseated in 1899 for infringing the Corrupt Practices Act by illegally hiring a carriage on election day (*The Times,* 3 August 1899; *Englishwoman's Review,* 30 (1899), pp.263-4).
41. Alice E. Busk, *Women's Work on London Vestries* (Women's Local Govern-

ment Society, London, 1899, 4 pp.); also Alice E. Busk, 'Administrative work for women on urban and rural governing bodies', in Aberdeen (ed.), *International Congress*, vol. V, *Women in Politics*, pp. 103-12; Alice E. Busk, 'Women's work on vestries and councils', in J. E. Hand (ed.), *Good Citizenship* (Geo. Allen, London, 1899), pp. 379-93.

42. Jane Escombe, *The Housing Problem in Rural Districts* (n.p. [?1901]); Jane Escombe, *Sanitary Work in Rural Districts* (Women's Local Government Society, London [1903]); Mary Stewart Kilgour, *Women as Members of Local Sanitary Authorities* (Baillière, Tindall & Cox, London [1900]), p. 7. Another vigorous parish councillor was Mrs Barker, chairman of the parish of Sherfield-on-Loddon (Hampshire). I have quoted her account of her successful efforts in 1895-6 to preserve local footpaths and bridleways in *Rucksack* (journal of the Ramblers' Association), April 1985, p. 7.

43. *Englishwoman's Review*, 29 (1898), pp. 123-4.

44. 1 Q.B. (1896), 1-3, 238-43.

45. *Englishwoman's Review*, 29 (1898), pp. 284-6; 30 (1899), pp. 260-1; Women's Local Government Society, *Seventh Annual Report* (1900), pp. 17-18; *The Times Law Reports*, 9 (1892-3), p. 58. I am grateful to Karen Wyld for assistance on this point.

46. WLGS, *Fifth Annual Report* (1898), pp. 8-11; *Seventh Annual Report* (1900), p. 16; *Parl. Deb.*, 4th ser., 51 (26 July 1897), col. 1086; 52 (5 August 1897), cols 396-7. Not all such cases ended happily. For the Irish Local Government Board's dissolution of the Clogher Board of Guardians for insisting on the appointment of Ann Magill as rate collector see *ibid.*, 61 (15 July 1898), cols 1224-6; 68 (16 March 1899), cols 952-3; *Englishwoman's Review*, 30 (1899), p. 44 and 'Ignota'. The part of women in local administration', *Westminster Review*, 150 (1898), pp. 255-60, 151 (1899), pp. 159-65.

47. *The Times*, 20 January 1899.

48. *Englishwoman's Review*, 28 (1897), pp. 112-13; Twining, *Workhouses and Pauperism*, pp. 178-9.

49. *Englishwoman's Review*, 30 (1899), pp. 261-3; Louisa M. Hubbard (ed.), *The Englishwoman's Year-Book and Directory 1894* (F. Kirby, London, 1894), p. lii.

50. Charles Selby Oakley, 'Of women in assemblies', *Nineteenth Century*, 40 (1896), pp. 561, 564. I have been unable to discover any relevant information about Oakley.

51. P.P. 1900, LXVI, H.C. 289, p. 3.

52. As early as 1900 a committee was formed to work for the eligibility of women to serve as members of the anticipated new secondary education authorities (*The Times*, 30 March 1900).

53. *ibid.*, 7 July 1899.

54. Fawcett Library, Autograph Letter Collection, vol. 2, part C, Frances Balfour to Millicent Garrett Fawcett, July 1899.

55. *ibid.*, 'I have never felt in a more suicidal & assassinating mind!', the letter began.

56. *Parl. Deb.*, 4th ser., 74 (6 July 1899), col. 58.

57. *ibid.*, 70 (27 April 1899), col. 747.

58. *The Times*, 22 May 1900.

IV. EXPANDING HORIZONS

11

Higher education

The ambivalence which characterised the development of women's employment and political role in the 1890s was mirrored in the education of girls and young women of the upper-middle and upper class. The pioneering age in education had passed, to be followed by a period of consolidation and growth. Secondary and higher education were now more readily available, and the educational institutions created over the previous twenty years made their contribution to the sense of expanding horizons which found an expression in the revolt of the daughters and the birth of the new woman. But the contribution of education was indirect, for the aims of schools and colleges were relatively modest, and there were severe constraints on the freedom of staff and students. When the male establishment was challenged, as in the attempt to obtain degrees at Oxford and Cambridge, it reasserted its domination with uncompromising decisiveness.

Girls' secondary day or 'high' schools can be dated from the founding of the North London Collegiate School by Frances Mary Buss in 1850, but it was in the 1870s that the movement began to develop.[1] The Girls' Public Day School Company, founded in 1872, controlled thirty-three schools by the end of the century. Over ninety girls' schools were created under the terms of the Endowed Schools Act of 1869, as Sheila Fletcher has shown in a careful study of the subject. Daniel R. Fearon, who had long been involved with the endowed schools movement in a variety of capacities, pointed out in the 1890s that girls' education had moved out of darkness into 'days of light'.[2]

Although girls' public schools grew more slowly than high schools there were several examples by the 1890s. The first was St Leonard's, which opened at St Andrews in 1877. It was followed in England by Roedean in 1885 and Wycombe Abbey in 1896. By this time it was no longer novel to assume that girls from prosperous homes should attend secondary schools or even, as in the public schools, board away from home. The

Royal Commission on Secondary Education called attention in 1895 to 'the great change in public opinion' on girls' education which had taken place since the report of the Schools Inquiry Commission in 1868, and declared that 'there has probably been more change in the condition of the Secondary Education of girls than in any other department of education'.[3]

The higher education of women was also well established by the 1890s. Women were admitted to most faculties in almost all the universities and university colleges in the United Kingdom.[4] There were women's colleges in London at Bedford, Westfield and, at some distance, Royal Holloway, as well as a Ladies' Department at King's and equal access to all courses except engineering and medicine at University College. By 1893 there were four women's colleges at Oxford and two at Cambridge; the latter, Girton and Newnham, were at once the cradle and the jewel of the women's higher education movement.[5] Women students at Oxford and Cambridge were not entitled to take degrees and hence lacked the status of undergraduates, but they were allowed to attend most lectures at men's colleges and to take most university examinations. In the second half of the 1880s two remarkable examination results at Cambridge provided striking evidence of women's intellectual capacity and demonstrated the central position occupied by higher education in the women's emancipation movement.

In 1887 Agnata Ramsay of Girton took the only first-class degree in the classics examination. This feat achieved widespread publicity, most famously a *Punch* cartoon by George du Maurier showing the successful scholar being ushered to a first-class compartment labelled 'For Ladies Only'. Not long afterwards she married Henry Montague Butler, the Master of Trinity, who was over thirty years her senior.[6] The impact was even greater three years later when Philippa Fawcett, a Newnham student, was classed above the senior wrangler in the mathematics tripos. A century later one cannot read Millicent Garrett Fawcett's account of her daughter's achivement and its reception unmoved.[7] The proud mother was in no doubt that the success was much more than a purely personal matter: 'You will know that I care for it mainly for the sake of women', she wrote to well-wishers.[8] *Punch* asked: 'Who [now] says a girl is only fit to be a dainty, dancing dangler?', and *The Times* admitted that women had answered for themselves the question

whether they should enjoy the same opportunities of higher education as men.[9] In the 1890s this kind of success had become too common to cause a sensation outside academic and feminist circles,[10] and comparatively little attention was paid in 1893 to Maria Ogilvie's London D.Sc., in 1894 to Ada Johnson's position at the head of the Cambridge mathematical tripos and in 1896 to Barbara Bradby's Oxford double first.[11]

Modern feminist writers have stressed that girls' schools and women's colleges did not consciously set out to broaden the human spirit or nurture a sense of revolt against women's position in society. It would have been astonishing had they done so. Headmistresses, as Joyce Senders Pedersen has convincingly shown, were not revolutionaries but conservative social reformers who had no feminist image in which they wished to reshape society.[12] Coming from sheltered, conventional middle-class homes they naturally accepted without demur what Sara Delamont calls 'the Victorian domestic ideal'.[13] As Carol Dyhouse comments, educational reformers redefined the existing concept of women's role; they did not reject it.[14] In an age in which formal education for girls and women of the upper-middle class was still very limited, to provide educated wives and mothers, to reject ignorance and stereotyped 'feminine' pursuits in favour of academic knowledge previously restricted to men were measures of considerable, if unheroic feminism.

A subsidiary reason for the conservatism of women educationists is that schools and colleges were dependent upon favourable public opinion and the sympathetic support of men. The women's colleges in particular had struggled against constant shortages of money and facilities, in the face of 'much opposition, indifference, and disdain'.[15] To attempt to move faster than the general contemporary tide of liberal opinion, particularly as manifested in Oxford and Cambridge academic circles, would have been to court disaster.

Like the educationists themselves parents were conventional people, influenced by ridicule of the often drably dressed women students and the suspicion or hostility which they still faced in some quarters.[16] Nearly two-thirds of the fathers of Oxbridge women students whose occupations have been traced by Joyce Pedersen were professional men in the period from the founding of the colleges until 1894. Nearly 40 per cent of this

group, about a quarter of the total, were clergymen.[17] (Daughters of aristocrats and the very wealthy were still usually educated at home and seldom received higher education.) For such men and their wives it was a bold venture to send their daughters to university, and one which might involve a measure of financial sacrifice. There could be no question of frightening them away by socialistic, freethinking or feminist teaching. A probably typical father in this respect was the Rev. Joseph Mayor. Upon learning to his dismay that his daughter Flora, the future novelist, had been lent a copy of Olive Schreiner's *Story of an African Farm* shortly after going up to Cambridge in 1892, he wrote to her in revealing terms:

> You will probably meet people of advanced views at Newnham, and some of our friends thought we were rash in letting you go there, but it is no longer possible for women to go through the world with their eyes shut, and if the highest education is reserved for those who have already a tendency to scepticism, or who belong to agnostic homes, it will be a very bad look-out for English society in the future.[18]

The conservatism of women's colleges was reinforced by the fact that a university education seemed to be a one-way ticket to an exploited position as a teacher in 'some sad seminary'.[19] The aim of educating future wives and mothers was often blighted by demographic and social factors which resulted in a high proportion of university-educated women remaining unmarried. This was apparently a matter of little concern to the students themselves, who found in education an alternative to the marriage which might not come their way or which they might be unwilling to accept. As a writer in the *Westminster Review* pointed out in 1891, the Girton or Newnham student could not 'be expected to become as easy a conquest to the brainless masher or some wealthy noodle as her uncultured sister'.[20] But parents were much more likely to be concerned, and opponents of women's emancipation found an easy target for derision and ridicule.

A widely noticed article by Alice Gordon published in 1895 calculated that of 1,486 women who had had a university education only 208 had married, while 680 had become teachers. She concluded: '[M]others will be prudent if they realise that, on the whole, the statistics, so far as we can judge at present, do

not lead one to the conclusion that marriage is either desired or attained by the majority of very highly educated women.'[21] Such a situation might lead to a more alarmist conclusion; the Italian sociologist Guglielmo Ferrero announced that women's emancipation in England was in the process of creating a 'third sex' of highly educated, passionless women, without interest in marriage or the family.[22] Until at least 1914, as Carol Dyhouse points out, it was often assumed that to send a daughter to a university meant to deprive her of the opportunity to marry.[23]

The colleges reacted by stressing the importance of marriage.[24] Elizabeth Wordsworth, principal of Lady Margaret Hall, Oxford, was particularly celebrated in this respect. Winifred Peck recalled that Wordsworth had told her that it was not important that certain of her contemporaries had barely missed firsts, 'for they are quite sure to marry'. She warned the mother of a prospective student that 'our girls do not marry well!' and admonished 'a rather cultured young prig' by saying: 'I really don't know ... what all you girls are up here reading for. You should be at home learning to be good plain cooks; any man would value you then!'[25] If this kind of remark was made in jest, its underlying seriousness was obvious enough. It should be added, however, that Elizabeth Wordsworth and Lady Margaret Hall certainly did not stifle and probably did much to develop the personalities and the potentialities of the galaxy of extraordinarily talented young women who studied there between the mid-1880s and the start of the new century, including Gertrude Bell, Barbara Bradby (later Hammond), Kathleen Courtney, Janet Hogarth (later Courtney), Eglantyne Jebb, Winifred Knox (later Peck), Ida O'Malley and Maude Royden.

Under the weight of these circumstances and given the generally repressive nature of English education in the late nineteenth century and the urgent need to avoid sexual scandal, the timorous, restrictive behaviour of college authorities is hardly surprising. Although the women's colleges were generally accepted by the 1890s they remained on trial. Rita McWilliams-Tullberg, the historian of *Women at Cambridge*, suggests that male resentment of competition from women began to grow after Philippa Fawcett's triumph in 1890.[26] In any case the picture given of Girton in the early 1870s by Constance Maynard, writing much later as mistress of Westfield College, London, was still recognisable in the nineties: 'The very least

deviation, whether in dress or manner, from the ordinary rules of society was laid down in unwritten laws to be avoided. The main idea in all these matters was to escape observation.' It was a matter for rejoicing when a woman member of respectable Cambridge society asked a student to dinner and subsequently told a friend: 'My dear, she was a nice girl, with nice rosy cheeks, nice manners, and nicely dressed, and you wouldn't have thought she knew anything.'[27]

The juvenile picture given of women university students in L. T. Meade's popular novel *A Sweet Girl Graduate* (1891) had some basis in fact, for students were widely regarded as overgrown schoolgirls.[28] Restrictions on behaviour were accepted without demur. Supervision of movement outside the colleges remained close, but there was some indication of the development of a slightly freer atmosphere. The rule that Lady Margaret Hall students should not leave the college alone fell into disuse in the 1890s and 1893 was notable at Oxford, as a contemporary report commented jubilantly, 'for the systematic and total abolition of that relic of a rapidly dying and effete civilisation, the chaperon at lectures' at the men's colleges.[29] On the other hand this new freedom applied only to groups of students; the individual, who might feel the restriction most closely, was still subject to the rule of the chaperon, as Winifred Knox found when she went up to Lady Margaret Hall in 1901.[30] Elsewhere too chaperonage continued haphazardly. Newnham students could attend lectures unchaperoned at King's in 1908 but not at Trinity, and vestiges of chaperonage continued at Girton as late as 1934.[31] Until about 1904 Westfield College students had normally to be accompanied on pleasure trips, though they were encouraged to undertake social or religious work in poor areas alone if necessary.[32]

Evening outings in Oxford and Cambridge were strictly controlled. Mary Balcombe, who went up to Newnham in 1901, recalled having to leave a twenty-first birthday party at 9.0 p.m. to return to college in the custody of a porter at a charge of 6d.[33] Dorothy Howard (later Henley), daughter of the formidable Lady Carlisle, wrote in one of her many vivid letters to her mother:

> 13 of us went to Hamlet last night.... We were miserable at having to leave an hour before the end — it finished at 11.30 & we had to be back at the College at 11. We were made to go in

190

the middle of a scene, which was bitter both for us, & for the people round whom we disturbed. ... Our don was as annoyed as we were. ... In Cambridge the exodus of such a party as ours from any entertainment is known as 'Girton going to bed', which we consider ignominious.[34]

Relations with men were of course subject to particularly strict control, a control accepted with little apparent protest or even concern before 1914, if the testimony of such reliable witnesses as Mary Agnes Hamilton and Margaret Cole may be accepted.[35] Romances did take place and students became engaged, both at Oxford and Cambridge, but the college authorities did their best to prevent such attachments or, in particular cases, took steps to rid themselves of offenders.[36] Chaperonage rules were complicated and could lead to intricate negotiations, as even an ordained don and celebrated writer like C. L. Dodgson (Lewis Carroll) discovered in 1890 when he attempted to arrange meetings with his niece Edith Dodgson and with her friend Florence Wilkinson, both students at Lady Margaret Hall.[37] Quarter of a century later Vera Brittain as a Somerville (Oxford) student discovered that the 'chap. rules' would not permit her to receive her brother and her college friends at the same time.[38] Helena Sickert (later Swanwick, the suffragist, writer and internationalist) was able to entertain a male visitor at Girton in the 1880s in her study provided that she left the door open and did not sit down, a privilege apparently later rescinded.[39] In 1908 Violet Cooper (later Brown) wrote from the same college to her fiancé: 'It really is rather nice to talk to a man occasionally. Miss S. had the Lewises out and I met them at coffee. — Wasn't it ridiculous Miss S. had to invite one of the College dons to coffee as Mrs. Lewis was not sufficient chaperone for Mr., if Miss S. had people to meet them.'[40]

Such grotesque restrictions were no more onerous than those faced by students or their unmarried seniors at home. Gertrude Bell, who was subsequently to undertake a career of independent and adventurous travel, was aged twenty-two and an ex-Lady Margaret Hall student when she guiltily wrote to her stepmother Florence Bell in 1891 to inform her that through force of circumstances she had driven away alone with a young man from an afternoon party in a hansom cab: 'I don't think many of our watchful acquaintances saw me on Sunday, it was a

streaming afternoon. I felt sure you wouldn't like it, but you know, I didn't either!'[41]

Even within the colleges women were closely supervised. Edith Read (later Read Mumford), who went up to Girton in 1888, reported that Emily Davies, the college's founder, was reputed to patrol the corridor in bedroom slippers in search of miscreants. Finding Read looking at the June sunshine Davies asked: 'Is this the way you do your work in the morning?' In founding Girton Davies had stressed the importance of self-discipline, but by the end of the 1880s she appeared to regard the students more as schoolgirls than as responsible young women.[42] By Margaret Cole's time, shortly before the Great War, the lisping Constance Jones was mistress of Girton. Discovering Cole (then Postgate) moving noisily about the college Jones asked reproachfully: 'Oh Mith Pothgate ... if we *all* whithled and thang in the corridorth, where *thould* we all be?'[43] Anne Jemima Clough, principal of Newnham until her death in 1892, also behaved in a fashion which now seems more appropriate to a nursery than to a university. Proposing Philippa Fawcett's health after her examination success in 1890 Clough told the students: 'I hope, my dears, it will be a lesson to you all to go to bed early.'[44] As in Elizabeth Wordsworth's case there is no doubting the serious intention underlying an apparently light-hearted comment.

The women dons were circumscribed by restrictions less childish but no less irksome. Very few of them at Oxford and Cambridge were married, and not being members of the university staff their position was anomalous and isolated. They could not participate in the academic organisation of the courses they taught, they lacked research funds and in Cambridge the university library was open to them only during hours when they were normally teaching.[45] A talented scholar like Charlotte Angas Scott felt herself forced to leave Girton in 1885 in the face of an offer of vastly superior conditions in the United States.[46] No woman appears to have been appointed to a university teaching post until Alice Cooke was made an assistant lecturer in history at Owens College, later the University of Manchester, in 1893.[47] Mary Paley Marshall, who was married to the economist Alfred Marshall, was a highly qualified economist in her own right and taught at Newnham, but she systematically effaced herself intellectually and socially before her

husband.[48] The unfashionable appearance of many women dons also contributed to their low status and to the dismay or derision of their students.[49]

Previous pages have shown that it is easy to construct a scaffolding of restrictions and prohibitions from which to hang the women's colleges and university life for the gratification of a later age. It is also easy to show that women's higher education in the period was marked by little innovation. But the image of the woman student in chains did not correspond to contemporary reality.[50] What most impressed women students was the feeling of liberation, a sense of expanding horizons. Coming from homes and schools in which they had been subject to an oppressive lack of privacy they were struck by the ability to organise their own lives, to place an 'engaged' notice on their doors and exclude even Emily Davies.[51] The recollections of contemporaries like Eleanor Lodge, Helena Swanwick, Winifred Peck and Margaret Cole are significant and moving. As Cole pointed out, the freedom of the Girton student 'was enjoyed within a framework of regulation which modern Cambridge might well think only a slight improvement on a concentration camp; but to creatures fresh from school it was next door to Utopia'.[52]

Letters written at the end of the decade by Maude Royden, later a famous preacher and writer, to her friend Kathleen Courtney, also a prominent public figure in later life, are particularly interesting because they were uncoloured by the subsequent experiences and second thoughts of the autobiographer. Royden, who left Lady Margaret Hall in 1899, wrote from her home in Birkenhead to Courtney, who was still a student at LMH:

> It is extraordinary — don't you think so? — how very few things one has to do at Oxford that one doesn't want to.... But oh Kathleen I would like to be there, with a room to hide in & work to do (or not)[53] & 'engaged' to keep out the cold world. Ochone! Those were good days.... But after all it is as well that one has to 'begin' some time; & we were lucky, weren't we, dear heart, in not having to start life when we left school (as most girls do) before we had sufficient judgment to think for ourselves.[54]

In Maude Royden's case part of the process of learning to think

for herself was to become a feminist; in another letter she confided that the 'Position of women' had become of prime importance to her.[55]

Women students found self-realisation in a variety of ways. For Eleanor Rathbone, another leading public woman of the future, it was a Somerville discussion group dealing with social, economic and philosophical issues.[56] For some at Girton it might lie in attending college lectures by Isabella Ford and Adelaide Anderson, or in debating factory conditions and regulations.[57] For others less serious-minded it was the cocoa, tea or coffee parties which at Girton were known as 'tray'. As described by Margaret Lea in 1888 these were evening occasions in which half-a-dozen girls gathered in the rooms of a hostess, each balancing a tray on her knees. Hot water, cake and jam were provided: 'The parties are generally very jolly, and a great amount of "shop" and nonsense is talked.'[58] Pernel Strachey, who in 1895 was a nineteen-year-old Newnham student and much later became the college principal, wrote in more jaundiced tones to her sister Philippa, striking the world-weary, self-confident note of the emancipated *fin-de-siècle* woman:

> In one minute and a half … I have got to go to a hideous entertainment called a cocoa; you are given a spoonful of powdery cocoa and one spoonful of 'cow' that is to say condensed milk. These you mix together in a cup till they look like mud; boiling water is then poured on, the next process being to try and drink it. Weird cakes are also handed round. At ten o'clock at night this depresses me somewhat.[59]

For the college dons the 1890s may have marked more of a new departure than for the students. There were more of them than in earlier years, and if such women as Grace Chisholm Young and the electrical engineer Hertha Ayrton[60] worked outside universities, Newnham alone boasted researchers of the quality of the classicist Jane Ellen Harrison, the historian Mary Bateson and the botanist Edith Saunders; Harrison became the first college research fellow in 1900.[61] The scholars of the next generation who received their university education in the period included the historians Eleanor Lodge and Barbara Bradby (Hammond) at Lady Margaret Hall. The woman scholar, no longer a freak, was gradually becoming an accepted figure.

It is a simpler matter to write about women's experience of Oxford and Cambridge than of other universities and colleges. Student numbers were larger than almost anywhere else, residential institutions were full of incident, many former Oxbridge students wrote autobiographies or reminiscences, archives have been collected and the colleges have received the detailed attention of historians. Moreover, women at Oxford and Cambridge experienced in exaggerated form the advantages and drawbacks of higher education in the period. Women students elsewhere had generally similar experiences. Westfield College students, as seen above, were subject to quixotic rules of chaperonage, and the women at Owens College, Manchester, were required to provide a written statement that study would not injure their health. They too were carefully segregated from their male colleagues to the extent that they did not visit the college library, sending a young, unchaperoned maid of all work for their requirements. It is small wonder that, as their historian writes, they felt for some years that they attended the college on sufferance, 'as indeed they did'.[62]

Small numbers and dilettantism, problems from which Oxford and Cambridge were not wholly free, were far more acute elsewhere. In the years 1886-91 there were on average only sixty-eight women students at Owens College, of whom an average of sixteen were studying for degrees. The students who took a single course were known as 'ladies'; registered examination students were called 'women'.[63] Westfield College had to struggle to keep up its numbers; when filled to capacity in 1897 it had only forty-six students, many of whom were either reading for matriculation or 'general' students. The college report noted that students were not compelled to take a degree course or any university examinations, 'but they are all encouraged to take one or more of these examinations, when their health, abilities, and the time at their disposal make it advisable'.[64] Bedford College, London, was effectively a girls' secondary school as well as a university institution in the early 1890s, many of the students being under eighteen.[65]

The Ladies' Department of King's College, London, typified much that was wrong with the higher education of women. The department, which was based in Kensington, was chronically short of money, so that even a new doormat was a considerable item of expense. Students were mostly 'ladies living at home'

who expressed interest in particular subjects, and the lectures, which were necessarily self-supporting, bore the mark of 'the requirements of a wealthy London suburb'.[66] When Lilian Faithfull took charge in 1894 she found it difficult to cope with her students' lack of intellectual commitment. One girl, intent on social success, found the Puritan Revolution no rival to a new hat. A music student listed having her hair washed among reasons for not practising: 'Then there were elderly women who seemed to think lectures would act as a panacea for the ills of life. "I want to take a course of lectures on Ethics or Browning. I have had a very strange life," began one of these.'[67]

It was not an easy task to alter this situation, but the process began in the 1890s. Faithfull introduced a more serious purpose into her Ladies' (from 1902, Women's) Department. She encouraged her students to study English literature systematically and to prepare for examinations.[68] In 1897 there were still only about 100 women students at Owens College, but about 70 of them were studying for degrees, and they had become more integrated members of the college community. Their numbers continued to rise in subsequent years.[69] The number of students at Bedford College doubled in ten years, from 111 in 1892-3 to 222 in 1902-3; just after the turn of the century about half the students were studying for degrees and Bedford had effectively become a university college.[70] The women were serious students; the percentage of women candidates who passed the London University B.A. and B.Sc. examinations was generally higher than in the case of men, and women rose from 21.4 per cent of graduates in 1890 to 33.7 per cent in 1897.[71]

About a third of the students at University College London were women, as were 87 of the 281 students who enrolled in the new London School of Economics in 1895-6.[72] It was not accidental that such developments took place in London. The fact that London University was primarily an examining body meant that the kind of opposition encountered at teaching and residential institutions was much reduced.[73] The size of the capital, the liberal foundation and tradition of the university and University College, the existence of a relatively large and sympathetic middle class and the consequent opportunity for students to live at home all encouraged women to study for degrees or take the many other courses offered by the London

colleges. If progress at Oxford and Cambridge had been as steady as in London the 1890s would have been a highly successful decade in the history of the higher education of women.

The most notable new departure in the lives of the women students of the period was their participation in organised games, a development which had made little progress before the beginning of the decade. The introduction of physical education, an earlier development, owed much to the stimulus of the schools. Paul Atkinson begins his important article on 'Fitness, Feminism and Schooling': 'Women's emancipation was not won on the playing fields of Roedean',[74] but much of his evidence contradicts this assertion. Miss Buss and Miss Beale encouraged callisthenics and gymnastics from the 1850s, and the foundation of the Girls' Public Day Schools in 1872 carried the movement a stage further. Roedean placed much emphasis on physical education from its foundation by the formidable Lawrence sisters in 1885, and its first prospectus announced: 'Special pains will be taken to guard against overwork, and from two to three hours daily will be allotted to out-door exercise and games.'[75]

Physical education was also encouraged by the increasing supply of teachers of the subject. Martina Bergman (later Bergman-Österberg) was appointed to teach Swedish exercise to girls for the London School Board in 1881, and in 1885 she opened her 'gymnasium', later college of physical education in Hampstead. A decade later it moved to Dartford. It provided teachers for schools and universities at home and abroad and stimulated the foundation of a number of other physical education colleges, of which the first was Anstey in 1897.[76]

By the later 1890s the value of physical exercise for girls was widely, though not universally, accepted. Alice James, a headmistress and an experienced teacher of physical education, expressed the common sentiment in 1898: 'Mental education can *only* successfully be carried on with a thorough physical education.'[77] In the same year a government volume of educational papers included several articles on physical education, three of them relating to girls. Their publication was an indication of the recognition which the subject had gained; significantly two of the articles dealt not only with exercise but

with games. One of the authors, Penelope Lawrence of Roedean, drew attention to the fact that public opinion had been subject to 'a wave of change' concerning the physical training of girls since the founding of the school, when Roedean 'stood almost alone' in its advocacy of sports and games.[78] Jane Frances Dove, who had moved from St Leonard's to found Wycombe Abbey in 1896, was a crusader for physical fitness. In her contribution to an influential book on *Work and Play in Girls' Schools* (1898) Dove laid particular emphasis on games, encouraging participation in all except football. Girls had already made great strides in learning to play games and they would make greater strides, to their own benefit and that of the nation as a whole.[79]

The introduction of organised games seems to have been the contribution of the women's colleges.[80] Janet Hogarth recollected hockey, tennis, boating and swimming at Oxford in the mid-1880s, but a short-lived ban was placed on hockey in 1885[81] and games did not become central to college life before the start of the new decade, when hockey swept all before it. Catherine Holt wrote home from Newnham in December 1891, exulting in victory in a hockey match 'after a tremendous fight.... I never played a harder or faster game'.[82] Philippa Fawcett was not only a brilliant scholar but played hockey for Newnham; bursting with pride, Flora Mayor wrote to her family in 1892: 'Miss Fawcett asked me if I'd played hockey before and on hearing not said I showed *very great* promise.'[83] At Lady Margaret Hall Barbara Bradby, another brilliant scholar, was hockey captain, an outstanding tennis player, head of boating and the hall's first cyclist.[84] In February 1897 Kathleen Courtney wrote home from the same college:

> You will be interested to hear, that on Thursday I played my first game of hockey; I liked it very much, but found it very exhausting.... The following day I was so stiff in my legs and hands and round my waist, that it was painful to move, however I played again that afternoon.... I can assure [you] that hockey is most distinctly 'violent exercise'.[85]

The passion for games reached such a pitch by the end of the decade that girls who did not participate ran some risk of social isolation, as Dorothy Howard told her mother from Girton in 1901. She had met a student whom at first she took to

be thirty-five but whom she later found was only twenty. 'She seems to be a little lonely', Dorothy reported,

> as she cannot play any games, which are the principal thing after work, & not many of the students have other interests. For instance there is a college etiquette of speaking nothing but games at all meal hours, & that is dull. I know that for the hundreth [sic] time I have explained that my bicycle is coming down & that I am only a very moderate swimmer.[86]

The position was much the same at Oxford. Winifred Peck, who went up to Lady Margaret Hall in 1902 after a thorough exposure to games at Wycombe Abbey, later wrote: 'For my first year, at any rate, I looked upon Lady Margaret as a glorified Wycombe, and hockey and the river were main interests.'[87] It is not surprising that Elizabeth Wordsworth, who is described by her biographer as an enthusiast for games for girls, began to have her doubts. As early as 1894 she asked: 'Are we not carrying the reaction in favour of physical culture a little too far?'[88] Outside the Oxbridge colleges women took as active a part in games as conditions permitted; Lilian Faithfull, for example, recalled ample opportunities at the residential Holloway College, and King's students and administrative staff cheerfully boarding a bus to play hockey in mud and fog beneath the prison walls at Wormwood Scrubs.[89]

Apart from hockey the physical activity which most affected college life in the 1890s was cycling. The suddenness with which women took up the bicycle in the mid-1890s led to some hesitation on the part of the colleges, but they were in no position to withstand the tide. A Lady Margaret Hall report noted in 1895 that a bicycle club had been started; two years later a new cycle shed with space for thirteen cycles was too small: 'the number of bicycles brought up by students increases every term'.[90] Women students were thrilled: 'My Sunbeam is simply delightful', Kathleen Courtney wrote in 1897: 'I wonder now how I got on without it, I bicycle to all my coachings [i.e. tutorials] and lectures, and that way save time, and then there are such splendid rides to be made round here, and awfully interesting places to see.'[91] Dorothy Howard, a keen hockey, golf and tennis player, received her bicycle about a month after going up to Girton. She wrote to her mother on the day of its arrival to say that it would 'be a means of real pleasure here, &

of the utmost use'; she immediately set out to conquer the mysteries of the free wheel and the next day 'got broiled up bicycling into Cambridge', two miles away.[92]

Physical exercise and games were subject to the usual restrictions affecting women students. Elizabeth Wordsworth discouraged Sunday cycling, though it was permitted if a visit to a village church was included.[93] Students at Westfield College were forbidden to cycle alone, after dark or in the direction of central London. Coasting was also forbidden and cycling dress was subject to the approval of the mistress, Constance Maynard, herself an enthusiastic cyclist.[94] Cambridge women were subject to severe limitations on their unchaperoned access to the river, though the most ardent rowers were willing to take advantage of the unrestricted period in the early morning.[95] Men were not permitted to umpire or even to watch Newnham hockey matches, although skirt lengths were, by modern standards, grotesquely long.[96] Eleanor Lodge recalled in her memoirs Elizabeth Wordsworth and her vice-principal Edith Pearson kneeling on the floor and measuring the skirts of the hockey side with great care to ensure that they were no more than six inches from the ground.[97] It should be remembered, however, that by the standards of contemporaries hockey was played in the 'very short skirt' to which Kathleen Courtney referred in a letter to her mother.[98]

The participation by women students in physical activities developed not only their bodies but also their self-confidence and their will to break out of the mould of Victorian middle-class propriety. With the decline in belief in their physical incapacity came a decline in belief that study was bad for women and would cause the health of the next generation to deteriorate. Women students, conscious of being on trial, worked long hours, and participation in games was a necessary form of relaxation and recuperation. The growth of this type of activity provided a useful, though by no means decisive riposte to medical men like Sir James Crichton-Browne, who feared that higher education would injure the health of future mothers.[99] It may have contributed to a more favourable view of the effects of education among doctors; the *British Medical Journal,* for example, asserted in 1896 that the children of mothers who had taken university courses were as healthy as other children, a point which women had themselves been attempting to make

for some years.[100] The effect of games was illustrated by *Punch*, abandoning for the moment its customary and highly successful war of ridicule on the 'advanced' woman. Seeking to investigate the truth of Crichton-Browne's allegations its representative ventured to 'Girnham' College. There he found a tribe of young Amazons who caught him on the shin with a hockey stick, threw him over the parallel bars and raised him by his coat collar 'and deposited me on the top of a tall bookcase'. Whatever ridicule these energetic girls might incur in the eyes of readers owed nothing to physical incapacity.[101].

The importance of the 1890s in women's history has often been undervalued because its victories were gradual and evolutionary while its defeats were specific and devastating. One of the most important of these defeats was the refusal of Oxford and Cambridge to award the B.A. degree to women students. The struggle at Oxford in 1895-6, though contentious,[102] was gentle in comparison to the boisterous controversy at Cambridge in 1896-7. The decision of the Cambridge Senate, taken by a crushing majority, was followed a few weeks later by the contemptuous treatment of Faithfull Begg's women's suffrage bill. The women's movement took some time to recover from the two defeats and women students remained imprisoned in a mould of restrictions from which they were only released by the liberating impact of the Great War.

Rita McWilliams-Tullberg has analysed the struggle over degrees at Cambridge,[103] and it is unnecessary to cover the same ground in detail. She notes that as the issue became a burning controversy the women's support steadily fell away, a revealing indication of the strength of prejudice and the unwillingness of most men to suffer obloquy for the sake of justice to women. The parallel with the debate over women's suffrage is striking; women and their male supporters put forward closely reasoned arguments and were met with emotional defence of entrenched positions of superiority by men who possessed the sole power of decision. As in the suffrage case the thin edge of the wedge was brandished; it was widely argued that women would use victory in the degree struggle to press for full membership of the university, a self-evident evil. C. V. Stanford, the composer and professor of music, asked: 'But if the existing Universities are to grant degrees to women, by what logic are they to be denied the

further rights of academical citizenship, the tenure of professor-
ships and readerships, the troublesome routine of proctorships,
and even the position of Vice-Chancellor or Chancellor?'[104]

The assertions of the women's opponents were often difficult
to rebut by rational argument. Stanford insisted that the 'most
injurious principle' of competition between men and women
had results which might take decades to measure accurately.[105]
T. Clifford Allbutt, supported by the prestige of the regius
professorship of medicine, maintained that women were intel-
lectually inferior to men.[106] Alfred Marshall, the professor of
political economy and the single most effective enemy of degrees
for women, wrote that many years of teaching and examining
both sexes had convinced him that women lacked men's
capacity for originality and spontaneity, however good their
examination results might be. He went on to state that 'the
Tripos is for most of them the end of all vigorous mental
work',[107] a claim of doubtful value from a prejudiced source
who did all he could to ensure its accuracy.[108]

The case for degrees for women was argued mainly on
severely practical grounds. Although women students enjoyed
most of the facilities open to men 'they have everything on
sufferance', as Eleanor Mildred Sidgwick, principal of Newn-
ham, explained. They could at any time be denied access to
lecture rooms or laboratories, she and Elizabeth Welsh, mistress
of Girton, pointed out.[109] More pressing was the fact that their
students were at a severe disadvantage when it came to the
teaching jobs which so many of them took up. Some took both
Cambridge exams and the London B.A., a combination which
could adversely affect their work or their health.[110] Molly
Thomas (later Hughes) was amused to discover that her London
B.A. was responsible for many invitations when she visited the
United States in 1893, while 'others from Oxford and Cam-
bridge were considered inferior because they had no letters
after their names. Explanation useless', she added succinctly.[111]
A letter from Alice Williams in the Girton College archives is
typical of many. It was written in November 1896, shortly after
her Girton certificate and her Irish B.A., 'those two magic
letters', had obtained her an appointment with the London
School Board. Her experience was tabulated as follows:

If you have a B.A. Degree however low from *any*

University you are all right.
If not, nothing will convince *the world in
general* (& many people who *ought* to know
better) that you are entitled to one.
Endless and fruitless explanation required from
Cambridge women-students of their standing —
or want of standing.[112]

The supporters of the women's cause took such comfort as
they could from the Cambridge debacle. Gertrude Wilson, a
Girton student, wrote to her mother: 'The College does not
seem to have been much perturbed for everyone expected
defeat, though not quite such a crushing one.'[113] If this was what
was being put about at Girton defeat was harder to accept at
Newnham, which had been at the centre of the struggle. Henry
Sidgwick, husband of the principal, moral philosophy professor
and tireless supporter of the higher education of women, wrote
to a friend that the vote, 662 in support of the principle of
women's degrees and 1,713 against, had shown that the women's
cause retained enough friends to prevent 'a serious danger of
reactionary measures'.[114] But it is significant that 'reactionary
measures' were being spoken of in this context; the cause had
suffered what Millicent Garrett Fawcett assessed as 'the worst
throwback we have had for a very long time'.[115]

For the women students themselves the vote meant that there
would be little change in a regime which, as seen above, most of
them valued for its freedom more than they chafed at its
restrictions. The real though necessarily long-term consolation
was that as with the contemporary suffrage issue a new peak had
been reached, though not climbed. The massive vote against
women's degrees, followed by an alarming undergraduate riot,
was not a demonstration of hostility against the docile, hard-
working women of the university community. The real enemy
was the growth of feminism; it was not chance that one of the
effigies which floated above the demonstrating crowds was the
new woman, riding her bicycle in knickerbockered 'rational
dress'. The women's movement, suffering from the weight of
decisive defeats in both the suffrage and degrees struggles, had
won a considerable moral victory. It is hardly surprising,
however, that to contemporaries it appeared in the guise of
crushing, unredeemed defeat.

Notes

1. Carol Dyhouse, *Girls Growing Up in Late Victorian and Edwardian England* (Routledge & Kegan Paul, London, 1981), pp. 55-7; Josephine Kamm, *Hope Deferred: Girls' Education in English History* (Methuen, London, 1965), chs 12-15.
2. Josephine Kamm, *Indicative Past* (Allen & Unwin, London, 1971), p. 96; Sheila Fletcher, *Feminists and Bureaucrats* (Cambridge University Press, Cambridge, 1980), pp. 171, 191 (Fearon quotation).
3. Royal Commission on Secondary Education (Bryce Commission), P.P. 1895, XLIII, C. 7862, *Report of the Commissioners*, pp. 75, 76.
4. Useful contemporary assessments were provided by C. S. Bremner, *Education of Girls and Women in Great Britain* (Swan Sonnenschein, London, 1897), and Alice Zimmern, *The Renaissance of Girls' Education in England* (A. D. Innes, London, 1898). A summary may be found in the *Cambridge University Reporter*, 1 March 1897, pp. 618-19.
5. Towards the end of the decade there were 162 women at the four Oxford colleges, including 73 at Somerville and 48 at Lady Margaret Hall. There were 109 students at Girton and 166 at Newnham. The largest number of women students was at University College London, where 310 of the 720 students of arts, laws and science were women (Eleanor Mildred Sidgwick, *The Place of University Education in the Life of Women* (Women's Institute, London [1897]), appendix by C. S. Bremner, pp. 35-9).
6. *See* Sara Delamont, 'The domestic ideology and women's education' in Sara Delamont and Lorna Duffin (eds), *The Nineteenth-Century Woman* (Croom Helm, London, 1978), pp. 183, 187.
7. Millicent Garrett Fawcett, *What I Remember* (T. Fisher Unwin, London, 1924), ch. 15.
8. Fawcett Library Archives, Box 89, vol. I, letter 16, MGF to Mr and Mrs Field, 13 June 1890. This letter was sent to many others; *see* Ray Strachey, *Millicent Garrett Fawcett* (Murray, London, 1931), pp. 145-6.
9. *Punch*, 14 June 1890, p. 280; *The Times*, 9 June 1890.
10. Bremner, *Education of Girls and Women*, p. 133.
11. *Englishwoman's Review*, 24 (1893), p. 249; 25 (1894), p. 179; 28 (1897), pp. 25-6.
12. Joyce Senders Pedersen, 'Some Victorian headmistresses: a conservative tradition of social reform', *Victorian Studies*, 24 (1981), pp. 463-88. *See also* her 'The Reform of Women's Secondary and Higher Education in Nineteenth Century England: a Study in Elite Groups' (unpublished Ph.D. thesis, University of California, Berkeley, 1974), esp. pp. 575-92.
13. Delamont, 'Domestic ideology', p. 184.
14. Dyhouse, *Girls Growing Up*, p. 59. The substance of the next sentence, though not its conclusion, is drawn from *ibid.*, p. 58. *See also* Margaret Forster, *Significant Sisters* (Secker & Warburg, London, 1984), ch. 4, esp. pp. 162-4.
15. *The Times*, 9 June 1890.
16. *See* Rita McWilliams-Tullberg, *Women at Cambridge* (Gollancz, London,

1975), pp. 144, 239. Flora Mayor was told in 1894 that an aunt would not invite her to pay a visit while she was at Newnham (Sybil Oldfield, *Spinsters of this Parish* (Virago, London, 1984), p. 31).

17. Joyce Senders Pedersen, 'Schoolmistresses and headmistresses: elites and education in nineteenth-century England', *Journal of British Studies*, 15 (1975), p. 153; also Pedersen, 'Reform of Women's Secondary and Higher Education', pp. 357-60, 390-4.

18. Quoted in Oldfield, *Spinsters of this Parish*, p. 39.

19. For this phrase of Eglantyne Jebb's father *see* above, p. 77.

20. 'Eugenius', 'The decline of marriage', *Westminster Review*, 135 (1891), p. 20.

21. Alice M. Gordon, 'The after-careers of university-educated women', *Nineteenth Century*, 37 (1895), pp. 958, 960 (Alice Gordon, an occasional writer, married J. G. Butcher, MP, in 1898). Westfield College, London, was not included in this survey, but the marriage rate of its former students was similar; Janet Sondheimer, *Castle Adamant in Hampstead* (Westfield College, London, 1983), p. 68. Other former students may have married subsequently, but their marriage rate was undeniably and exceptionally low.

22. Guglielmo Ferrero's *L'Europa Giovane* (Fratelli Treves, Milan, 1897) was discussed by Stephen Gwynn in 'Bachelor women', *Contemporary Review*, 73 (1898), pp. 866-8.

23. Dyhouse, *Girls Growing Up*, pp. 159-60.

24. *ibid.*, p. 73.

25. Winifred Peck, *A Little Learning* (Faber, London, 1952), pp. 163, 166, 178. Winifred Peck, a talented writer, was the sister of E. V. and Ronald Knox.

26. McWilliams-Tullberg, *Women at Cambridge*, p. 102.

27. Constance L. Maynard, *Between College Terms* (Nisbet, London, 1910), pp. 189-90. Constance Maynard's emotional relationships with other women and their impact on her work are considered by Martha Vicinus in a revealing article: '"One life to stand beside me": emotional conflicts in first-generation college women in England', *Feminist Studies*, 8 (1982), pp. 603-28. I regret that the same author's *Independent Women: Work and Community for Single Women 1850-1920* (Virago, London, 1985) was not published until the present book was completed.

28. *See* Mary Cadogan and Patricia Craig, *You're a Brick, Angela!* (Gollancz, London, 1976), pp. 53-4. Immaturity in their student days is a common theme of the reminiscences of university-educated women; for example, Peck, *A Little Learning*, p. 157.

29. Lady Margaret Hall, *Brown Book*, December 1928, pp. 98-9; Eleanor C. Lodge, *Terms and Vacations* (ed. Janet Spens; Oxford University Press, London, 1938), p. 49; Muriel St Clare Byrne and Catherine Hope Mansfield, *Somerville College 1879-1921* (Oxford University Press, Oxford [1922]), p. 77.

30. Georgina Battiscombe, *Reluctant Pioneer: a Life of Elizabeth Wordsworth* (Constable, London, 1978), p. 155; Peck, *A Little Learning*, p. 155.

31. Ann Phillips (ed.), *A Newnham Anthology* (Cambridge University Press, Cambridge, 1979), pp. 58-9; Barbara Megson and Jean Lindsay, *Girton*

College 1869-1959 (Heffer, Cambridge [1961]), p. 44.

32. Catherine B. Firth, *Constance Louisa Maynard* (Allen & Unwin, London, 1949), pp. 250-1.

33. Phillips (ed.), *A Newnham Anthology*, pp. 48-9.

34. Girton College Archives; letters to her family from Girton by Dorothy Howard (Lady Henley), 22 May 1901.

35. Mary Agnes Hamilton, *Remembering My Good Friends* (Cape, London, 1944), pp. 45-6; Margaret Cole, *Growing Up Into Revolution* (Longmans, London, 1949), pp. 44-5.

36. Peck, *A Little Learning*, p. 166; Battiscombe, *Reluctant Pioneer*, p. 134; McWilliams-Tullberg, *Women at Cambridge*, p. 144. Such cases would inevitably include those involving the pupil–teacher relationship, as Elizabeth Hopkinson found when she became engaged to her tutor, the Rev. F. J. Lys of Worcester College, towards the end of 1893. Although described in the Lady Margaret Hall Council minute book as 'a most promising "Greats" student' she was at once asked to return home (manuscript report for October term 1893, unpaginated). I am grateful to Mr James Campbell of Worcester College for assistance on this point.

37. Sotheby's *Catalogue of Valuable Autograph Letters ...*, vol. II, 14 March 1979, pp. 301-2; letters from C. L. Dodgson to Elizabeth Wordsworth, 21 and 28 October 1890.

38. Vera Brittain, *Testament of Youth* (Gollancz, London, 1933), p. 111.

39. Helena Swanwick, *I Have Been Young* (Gollancz, London, 1935), p. 122. At the same college thirty years later Margaret Postgate (later Cole) and her contemporaries could entertain in their sitting rooms no unchaperoned male other than a father or uncle or juvenile brother (Cole, *Growing Up Into Revolution*, p. 37 and n.).

40. Violet E. L. Brown, *The Silver Cord* (privately published, Sherborne [?1954]), p. 33.

41. Elsa Richmond (ed.), *The Earlier Letters of Gertrude Bell* (Benn, London, 1937), pp. 237-9. It is appropriate that Bertie Crackanthorpe, the young man in question, was Hubert Crackanthorpe, a writer and the son of the B. A. Crackanthorpe who launched the 'revolt of the daughters' controversy in 1894 (ch. 2 above).

42. Edith Read Mumford, *Through Rose-Coloured Spectacles* (Edgar Backus, Leicester, 1952), pp. 40-1; Patricia Hollis (ed.), *Women in Public: the Women's Movement 1850-1900* (Allen & Unwin, London, 1979), p. 153.

43. Cole, *Growing Up Into Revolution*, p. 37: 'But she was a kind old body, for all that, and interfered with us very little' (*ibid.*).

44. Blanche Athena Clough, *A Memoir of Anne Jemima Clough* (Arnold, London, 1897), p. 334 and *passim*. Florence Ada Keynes, mother of the economist, discussed Clough's prying concern with student behaviour in an earlier period in *Gathering Up the Threads* (Heffer, Cambridge, 1950), p. 38.

45. McWilliams-Tullberg, *Women at Cambridge*, p. 105.

46. Swanwick, *I Have Been Young*, pp. 119-20. Swanwick was unusual in writing scathingly about the restrictions of college life, though she appreciated her new-found privacy (*ibid.*, pp. 118-23).

47. McWilliams-Tullberg, *Women at Cambridge*, p. 143; Mabel Tylecote, *The*

Education of Women at Manchester University 1883 to 1933 (Manchester University Press, Manchester, 1941), pp. 46, 96; Isaline B. Horner, *Alice M. Cooke, a Memoir* (Manchester University Press, Manchester, 1940), p. 9.

48. J. M. Keynes, 'Mary Paley Marshall (1850-1944)', *Economic Journal*, 54 (1944), pp. 274-7.

49. Kathleen Courtney wrote to her mother about Edith Pearson, the Lady Margaret Hall vice-principal: '[S]he is exactly like those pictures one sees of the new woman, having short grey hair, spectacles, a well-defined nose, hideous boots and no figure. She also wears very short skirts, and takes the most enormous strides when she walks, and rolls from side to side' (Kathleen Courtney Papers, Fawcett Library, KDC/A3/4, 31 January 1897). The letter added that Pearson was 'alarmingly clever,... very pleasant, and most amusing'. Elizabeth Lodge, when a young don, was remembered by one of her students as 'tall and muscular-looking with long legs'. When she walked in the Pyrenees 'she dumb-founded the natives, who were not sure if she was a man or a woman, and if the latter they were thunder-struck at a woman who wandered about the mountains alone' (Clara Burdett Patterson (born Money-Coutts), undated typescript memoirs of 1897-8, p. 99, LMH Archives). *See also* Dyhouse, *Girls Growing Up*, pp. 76-7.

50. *See* Margaret Bryant, *The Unexpected Revolution* (University of London Institute of Education, London, 1979), p. 119.

51. As the historian Dorothy George recalled in a letter to Muriel Brad-brook, then mistress of Girton (Girton Archives, file C 3/1, 23 February 1969). But Dorothy Howard told her mother in a letter written on 30 April 1901 that the students did not like Emily Davies, who behaved as if the college were her own '& [went] into their rooms without knocking & so on' (Howard Letters, Girton Archives).

52. Cole, *Growing Up Into Revolution*, p. 38.

53. Maude Royden wrote in her autobiography that her tutors' attempts to help her to get a first 'were defeated by my own complete idleness and absorbed interest in everything but my work' (*A Threefold Cord* (Gollancz, London, 1947), pp. 77).

54. Lady Margaret Hall Archives, letters from Maude Royden to Kathleen Courtney, 5 July (1899), 17 October 1899, 24 June 1900 (archive ref. 3/1, 3/2).

55. *ibid.*, 22 December 1900 (ref. 3/2). Both Royden and Courtney played prominent parts in the women's suffrage movement in the new century.

56. Mary Stocks, *Eleanor Rathbone* (Gollancz, London, 1949), pp. 43-7.

57. Fawcett Library, Autograph Letter Collection, vol. 4, part B, Gertrude M. Wilson to her mother, 21 March 1897; Howard Letters, Girton Archives, 22 April, 15, 16 May, 7 June 1901.

58. Margaret Lea, 'Life at Girton', typescript in Girton Archives, p. 2.

59. Quoted in Betty Askwith, *Two Victorian Families* (Chatto & Windus, London, 1971), pp. 72-3.

60. For whom see Evelyn Sharp, *Hertha Ayrton 1854-1923* (Arnold, London, 1926). Hertha Ayrton, born Marks, had been a Girton student.

61. Mary Agnes Hamilton, *Newnham, an Informal Biography* (Faber, London,

1936), pp. 146-7; Jessie Stewart, *Jane Ellen Harrison* (Merlin Press, London, 1959), p. 12; *Newnham College Register*, 1 [1965], p. 28.

62. Tylecote, *The Education of Women*, pp. 31, 33, 34.

63. *ibid.*, p. 27.

64. Westfield College *Report*, 1897, pp. 6-9, 14-15; Firth, *Constance Louisa Maynard*, pp. 256-7; Sondheimer, *Castle Adamant in Hampstead*, pp. 48, 52.

65. Margaret J. Tuke, *A History of Bedford College for Women 1849-1937* (Oxford University Press, London, 1939), chs. 8 and 9.

66. Bremner, *Education of Girls and Women*, pp. 142-3; Lilian M. Faithfull, *In the House of My Pilgrimage* (Chatto & Windus, London, 1924), p. 110.

67. *ibid.*, p. 105.

68. *ibid.*, p. 104; Hilda Oakeley, 'King's College for women', appendix A of F. J. C. Hearnshaw, *The Centenary History of King's College London 1828-1928* (Harrap, London, 1929), pp. 494-500; Gordon Huelin, *King's College London 1828-1978* (King's College, London, 1978), p. 38.

69. Tylecote, *The Education of Women*, pp. 48, 52-3; Edward Fiddes, *Chapters in the History of Owens College and of Manchester University 1851-1914* (Manchester University Press, Manchester, 1937), pp. 110-11, 210.

70. Tuke, *Bedford College*, pp. 157-8, 164.

71. *University Degrees for Women* (Spottiswoode, London, 1898), copy in Emily Davies Papers, Girton Archives (ED XVI/72), pp. 21-2. 'Even on Presentation-Day [at the University of London] special allusions to the lady-graduates are seldom made in the speeches; it is no longer considered a matter of surprise that women should hold their own intellectually' (Zimmern, *Renaissance of Girls' Education*, p. 128).

72. H. Hale Bellot, *University College London 1826-1926* (University of London Press, London, 1929), pp. 372-3 and end chart of student numbers; Sydney Caine, *The History of the Foundation of the London School of Economics and Political Science* (LSE and Bell, London, 1963), p. 50.

73. Bremner, *Education of Girls and Women*, p. 140; Zimmern, *Renaissance of Girls' Education*, p. 126.

74. Paul Atkinson, 'Fitness, feminism and schooling', in Delamont and Duffin (eds), *The Nineteenth-Century Woman*, pp. 92-133. *See also* Kathleen McCrone, 'Play up! play up! and play the game! Sport at the late Victorian girls' public school', *Journal of British Studies*, 23 (1984), pp. 106-34.

75. Quoted in Atkinson, p. 110. When one of the Lawrence sisters came to a gate, according to legend: 'She lays her hand on the top and lightly vaults over it.' (Alicia Percival, *The English Miss To-day & Yesterday* (Harrap, London, 1939), p. 218).

76. Atkinson, pp. 95-9; Jonathan May, *Madame Bergman-Österberg* (Harrap, London, 1969); Colin Crunden, *A History of Anstey College of Physical Education 1897-1972* (Anstey College, Sutton Coldfield, 1974). Sheila Fletcher's valuable *Women First* (Athlone Press, London, 1984) stresses the work of Bergman-Osterberg in the creation of a 'female tradition' of physical education (p. 5 and *passim*). Both Bergman-Österberg and Rhoda Anstey were strong supporters of women's suffrage (*ibid.*, pp. 29, 58, 71).

77. Alice R. James, *Girls' Physical Training* (Macmillan, London, 1898), p. 2.

Some of the illustrations in this book are reproduced in Bryant, *The Unexpected Revolution,* p. 110.

78. Penelope Lawrence, 'Games and athletics in secondary schools for girls', in Education Department, *Special Reports on Special Subjects,* vol. 2, P.P. 1898, XXIV, C. 8943, p. 145.

79. Jane Frances Dove, 'Cultivation of the body', in *Work and Play in Girls' Schools,* by Three Head Mistresses (Dorothea Beale, Lucy H. M. Soulsby, Jane Frances Dove) (Longmans, London 1898), pp. 396-423.

80. Atkinson, 'Fitness, feminism and schooling', p. 113.

81. Janet E. Courtney, *Recollected in Tranquillity* (Heinemann, London, 1926), pp. 105-6; Battiscombe, *Reluctant Pioneer,* pp. 90, 133.

82. Phillips (ed.), *A Newnham Anthology,* p. 35.

83. Oldfield, *Spinsters of this Parish,* p. 40.

84. Vera Brittain, *The Women at Oxford* (Harrap, London, 1960), p. 93; LMH *Brown Book,* December 1928, p. 97. Violet Craigie Halkett, the student poet of the day, wrote in March 1896 a celebration of Oxford's victory in the women's inter-university hockey match, with a special tribute to the red-haired Bradby:

> I watched each maiden prompt and fleet
> And those who ably stopped the ball
> And those whose strokes so strong and neat
> Awoke the rapture of the Hall.
> And where the fight was thickest — there
> Gleamed beacon-like — the Captain's hair.
> (LMH Archives)

85. Courtney Papers (KDC/A3/9), Fawcett Library, 14 February 1897.

86. Howard Letters, 22 April 1901. The student was Ethel Mary Heap, daughter of a Rotherham clergyman and schoolmaster.

87. Peck, *A Little Learning,* p. 157.

88. Elizabeth Wordsworth, *First Principles in Women's Education* (James Parker, Oxford, 1894), p. 12; Battiscombe, *Reluctant Pioneer,* p. 90.

89. Faithfull, *In the House of My Pilgrimage,* pp. 94, 114. *See* below, p. 212.

90. LMH *Brown Book,* 1895, p. 9; 1897, p. 8.

91. Courtney Papers (KDC/A3/26), 4 June 1897.

92. Howard Letters, 23, 24 April 1901.

93. Battiscombe, *Reluctant Pioneer,* p. 159. Maude Royden, however, recalled a total ban on Sunday cycling (in Margot Asquith (ed.), *Myself When Young* (Muller, London, 1938), pp. 369-70).

94. Sondheimer, *Castle Adamant in Hampstead,* p. 51; Firth, *Constance Louisa Maynard,* pp. 259-60.

95. Phillips (ed.), *A Newnham Anthology,* p. 38; Hamilton, *Newnham,* pp. 141, 162.

96. Phillips, p. 52; McWilliams-Tullberg, p. 104.

97. Lodge, *Terms and Vacations,* p. 57.

98. Courtney Papers (KDC/A3/3), 28 January 1897.

99. *See* above, p. 6.

100. *British Medical Journal,* 15 February 1896, p. 417. The most important study was Eleanor Mildred Sidgwick, *Health Statistics of Women Students*

of Cambridge and Oxford and of their Sisters (Cambridge University Press, Cambridge, 1890). Mrs Sidgwick wrote that the health of about 5 per cent of women students fell off temporarily, partly as a result of overwork and 'want of attention to well known laws of health', including adequate exercise (pp. 89, 91). Six or seven years later more alarm might have been occasioned by the violent nature of hockey matches than by lack of exercise. See also Dyhouse, *Girls Growing Up*, pp. 157-9.

101. *Punch*, 21 May 1892, p. 241.

102. The conflict was described by a prominent participant as 'fiercer and more bitter than any I had been engaged in' (Lewis R. Farnell, *An Oxonian Looks Back* (Martin Hopkinson, London, 1934), p. 280).

103. McWilliams-Tullberg, ch. 8.

104. *The Times*, 5 February 1896.

105. *ibid.*, 18 March 1897.

106. *ibid.*, 24 February 1896.

107. Alfred Marshall, 'To the Members of the Senate', 3 February 1896, pp. 6-7 (Emily Davies Papers, Girton Archives, ED XVI/94). Copies of this pamphlet and of Mrs Sidgwick's spirited reply, 'Proposed Degrees for Women', 12 February 1896, can also be found in the Millicent Garrett Fawcett Papers at the Manchester Reference Library, M50/3/3/10 and 12. The two documents are briefly summarised by McWilliams-Tullberg, pp. 112-13, 115-16.

108. *See* above, pp. 4, 74 and 192-3. Marshall's attitude to women is further documented by Phillips, p. 47; McWilliams-Tullberg, pp. 88-9, 106-7 and ch. 8; J. M. Keynes and F. Y. Edgeworth in A. C. Pigou (ed.), *Memorials of Alfred Marshall* (Macmillan, London, 1925), pp. 55, 72-3; Norman and Jeanne MacKenzie (eds), *The Diary of Beatrice Webb, vol. 1, 1873-1892* (Virago, London, 1982), pp. 273-5, 286.

109. *Cambridge University Reporter*, 1 March 1897, pp. 615, 617.

110. *ibid.*, pp. 614-17.

111. *Admission of Women to the B.A. Degree at Oxford* (Association for Promoting the Education of Women in Oxford, Oxford, 1895) (Emily Davies Papers, ED XVI/67), p. 9; M. V. Hughes, *A London Home in the 1890s* (1937; Oxford University Press, Oxford, 1983), p. 45.

112. A. M. Williams to Katharine Jex-Blake (Emily Davies Papers, ED XVI/55-6), 3 November 1896.

113. Fawcett Library, Autograph Letter Collection, vol. 4, part B, Gertrude M. Wilson to her mother, 23 May 1897. Another part of this letter has been published in Kamm, *Hope Deferred*, p. 261 n.

114. Quoted in Arthur Sidgwick and Eleanor Mildred Sidgwick, *Henry Sidgwick, a Memoir* (Macmillan, London, 1906), p. 552. Critical assessments of Sidgwick and Alfred Marshall, 'the two dominant [and antagonistic] figures in late Victorian Cambridge' and an evocation of the intellectual ambience of time and place may be found in Robert Skidelsky, *John Maynard Keynes*, vol. I (Macmillan, London, 1983), ch. 2.

115. Quoted in Strachey, *Millicent Garrett Fawcett*, p. 167.

12

Leisure

The majority of middle-class women did not suffer from lack of leisure in the late nineteenth century. Their problem was rather, as Georgiana Hill pointed out, that they had 'more leisure than means'. The frequent surrender of employment to 'men and machinery' in the wake of the industrial revolution[1] and the simultaneous growth of 'the doctrine of feminine domesticity',[2] the increase of domestic servants in the mid-Victorian years[3] and women's numerical superiority meant that many of them had little to do after the mid-century except to hope and wait for marriage, a condition unforgettably described in the novels of Trollope. This process had by no means ended by the 1890s, but by this time a strong reaction had set in, a development which is one of the themes of this book. As Eleanor Mildred Sidgwick pointed out in 1897 in putting the case for the higher education of women of the prosperous classes, 'nothing can be more dreary and demoralising, nothing more harmful to a woman in body and mind, and nothing more likely to lead to an unhappy marriage, than waiting for marriage, which may never come, as the only career in life worth having'.[4]

By the 1890s women had been taking part for some decades in the kind of philanthropic work explored by Frank Prochaska, work which led to participation in new fields of employment.[5] They were also participating in political and social causes of a variety of types. Few middle-class women could be brilliant students with a choice of careers open to them like Philippa Fawcett,[6] champions of emancipation like her mother or pioneering professionals like her aunt Elizabeth Garrett Anderson, and not many more could escape the confines of teaching by entering the higher reaches of business or commerce.[7] Leisure, however, was another matter. Even the most dedicated of social workers, the most exploited of teachers were not deprived of all opportunity to enjoy their hours of freedom.

The use which educated and other middle-class women made of their leisure made a significant contribution to their emancipation.[8] Upper-class women had by the 1890s long been taking

211

part in active sports and pastimes, notably hunting and other field sports. A Ladies' Golf Club was established in Westward Ho! as early as 1868, and women had been taking part in lawn tennis since its modern invention in the 1870s.[9] But under the stimulus of developments in girls' schools and colleges, and the growing liberation from the tyranny of convention which was such an important development in the period, women by the 1890s could for the first time claim to be 'a power in the land, in the matter of sport'.[10]

The Ladies' Golf Union was formed in 1893 with eleven clubs. The first championship match was staged the same year and was won by Lady Margaret Scott, a player of exceptional ability who won again in the two following years. It was estimated in 1897 that there were 80 or 90 ladies' golf clubs in the United Kingdom, 54 of them in England; two years later the figure had apparently risen to 220.[11] Tennis was also widely played by women. The first women players competed for the Wimbledon championship in 1884, seven years after the beginning of the men's competition, and mixed doubles began in 1888. Here the dominant figure was the redoubtable Lottie (Charlotte) Dod, who won the Wimbledon championship five times between 1887 and 1893.[12] Cricket was not much played by women outside schools and colleges, though two women's sides were formed under the aegis of the English Cricket and Athletic Association in 1890.[13] Hockey, however, soon carried its academic popularity into the wider world. The Ladies' Hockey Association was created at the end of 1895, changing its name the following year to the All England Women's Hockey Association. Its first president was Lilian Faithfull, an enthusiast not only for developing the minds of her students at King's College London but their bodies as well. The ten founding clubs were twenty-eight by 1897 and by 1904 had risen to over 300. The Association's journal, the *Hockey Field*, was begun in 1901.[14]

Other competitive sports which were introduced or became popular in the 1890s included lacrosse, rounders, basketball (soon to become netball), athletics, swimming and rowing.[15] The only sport which crusaders like Penelope Lawrence and Jane Frances Dove failed to advocate for women was football. Despite widespread disapproval, however, women footballers were not unknown.[16] The press found them an irresistible spectacle and huge crowds gathered to watch their occasional

matches. As in other sports the participants belonged to the middle class, for as *The Sketch* was told by Nettie Honeyball, captain of the British Ladies' Football Club, only they could afford the time and expense required to practice.[17]

It could not be expected that sport would be free of the restrictions which affected women in all spheres of life. Sporting women remained ladies in behaviour and clothing. Lottie Dod, described by her friend Mabel Stringer in 1924 as 'the most versatile and unrivalled sportswoman the world has ever known', advised her readers to serve underhand and wrote that most women players preferred mixed doubles to the fatigue of singles.[18] Maud Marshall, contributing to *The Sportswoman's Library* in 1898, counselled against the use of 'forward or volleying tactics' and pointed out that tennis as played by women was 'a very different thing' from the man's game.[19] It was widely doubted that women would be capable of organising successful golf competitions or observing the same techniques as men; they were commonly advised to drive with a half or three-quarter swing.[20] Lord Wellwood (the future Lord Moncreiff), in the course of condescending remarks about women golfers in 1890, commented that a drive of 70 or 80 yards was sufficient for a woman, since 'the posture and gestures requisite for a full swing are not particularly graceful when the player is clad in female dress'.[21]

Clothes presented many problems, even more severe in tennis and golf than in hockey, where skirts generally remained six inches from the ground. Lottie Dod expressed concern about women's dress but obviously felt that there was little prospect of changing it. Players were impeded in every limb and often found difficulty in breathing: 'A suitable dress is sorely needed, and hearty indeed would be the thanks of puzzled lady-players to the individual who invented an easy and pretty costume.' In another article she again stressed that the dress must be becoming, thus effectively ruling out the possibility of its being non-restrictive.[22] As for golf, Louie Mackern wrote in 1899 that women could be neat and pleasing in their dress and still play well.[23] This was not how Mabel Stringer recalled her early golfing days in her reminiscences a quarter of a century later. 'The great wonder', she commented, 'is that in spite of our clothes we actually did manage to acquire a certain proficiency in sports and games.' Stiff collars, the tightly laced corsets

needed to produce the desired 'wasp waist', voluminous sleeves, long skirts and heavy petticoats were severe handicaps.[24]

Yet even in the short period in the 1890s when women's sports took shape significant changes took place. 'Overhand serving has been adopted very much more of late years by ladies', Lottie Dod admitted in 1897. While preferring underhand she acknowledged that it was 'generally much feebler' and that it was inevitable that it should be so.[25] The ladies' golf championship, which by 1897 attracted over one hundred entrants,[26] produced an amusing amendment to the relevant volume of the Badminton Library. Lord Wellwood was allowed in successive editions to write of women golfers in unchanged terms, but from 1893 an enthusiastic account was published of the first championship, played that year. Two photographs of Lady Margaret Scott in full swing should have been sufficient to dismiss Wellwood's point of view as outdated prejudice even without the comment: 'Her style is beautifully easy, ... and is a striking contradiction of the assertion often heard that golf is not a graceful game for ladies.'[27] A few years later the champion Mary Hezlet claimed that most younger women played with a full swing and A.W.M. Starkie-Bence, celebrated for her 'drive immense', wrote that 'players think nothing of a carry of 140 yards'.[28] It is not surprising that Louie Mackern, writing in 1899, noted that in the past few years there had been 'an extraordinary improvement in women's play'.[29]

Even clothes, while continuing to hamper freedom of play, were less confining than they had been in past decades. The crinoline had faded away by 1870 and the bustle by the end of the eighties. Writing rather optimistically in 1898 Kathleen Waldron claimed that '[a]ctive pastimes' had enabled many women to 'cast off the artificial trammels of barbarous fashion'. The crinoline, she added, was an unimaginable tyranny to the sportswomen of her day.[30] Fashion continued to exercise its tyranny, but the new woman and the sporting woman did much to popularise clothes which made possible greater freedom of movement. The cult of healthy clothing, a significant feature of the late nineteenth century, was encouraged by the vogue for Jaeger underwear, which was first marketed in England in 1884 and provided an alternative to tightly laced corsets and starched petticoats; Aertex for women followed in 1891. The tailored

costume and the skirt and blouse were particularly identified with the new woman, who was able to move much more freely than previous generations of women had been able to do. If women were still hampered by their clothes, such costumes at least heralded future liberation.[31]

There is no doubt that women's emancipation was advanced by participation in sport. It is significant that *Punch* imagined that one of the rules of the 'Ladies' Universal Athletic Association' was that its members should be granted the vote.[32] Ouida, in christening the new woman, included among her targets women who took part in sport and attended sporting events.[33] As Marie Pointon comments, sportswomen challenged existing stereotypes and codes of behaviour, deserting the frivolity of the 'garden-party approach' for serious participation in competitive sport.[34] The fact that most of them were not consciously aiming to bring about the emancipation of their sex does not mitigate their achievement, for in the conditions of the 1890s indirect emancipation through sport enjoyed more obvious success than direct assaults on Parliament or the Cambridge Senate. It could not have been expected that the inhibitions of dress, conventions of suitable behaviour and confinement within dominant patterns of morality rightly stressed by modern writers[35] should be suddenly discarded. To participate in sport was itself to discard inhibition; it was this fact which struck contemporaries, not the restrictions which were the condition of participation.

The competitive games here briefly examined played an important part in the lives of a number of women of the comfortable classes. Far more important than any or all of them, in terms both of numbers and impact, was the bicycle. It was in the mid and later 1880s that the conditions for modern cycling had been created by the invention of the improved Rover safety bicycle by John Kemp Starley and the pneumatic tyre by John Boyd Dunlop.[36] By 1894 cycling in the new conditions created by these inventions had become more popular and women cyclists were no longer a rarity. In the next year the bicycle was taken up as a fashion by society ladies and by the summer of 1895 it had become a passion with women as well as men. The London parks drew thousands of fashionable cyclists and for a period other recreations were eclipsed. In August 1895 the sport correspondent of *The Englishwoman* noted

that cricket, 'like everything else, is suffering through the present craze for cycling'.[37] By 1896 about a third of orders were for women's cycles, compared with only one in fifty in 1893; one consequence, as *The Princess* noted in the later year, was complaints in the fashion industry that women were spending their dress allowances on cycling costumes. Those whose living depended upon the provision and maintenance of horses also suffered from two-wheeled competition.

It was significant that the bicycle became a craze in the 1890s and that it was particularly identified with the new woman. No such means of freedom had ever been available to women, and the explosion of popularity in mid-decade meant that bicycles could be purchased sufficiently cheaply to extend their use to a wider social spectrum, including at least some working-class girls,[38] than could take part in organised sport and games. Girls in the property-owning classes were able to escape the ministrations of their chaperons at least temporarily, for it is unlikely that the Chaperon Cyclists' Association formed in 1896 had many clients. More generally, cycling symbolised the defeat of orthodox conservative opinion. Its vigorous, independent movement, the opportunity which it offered to go where the spirit moved and the unprecedented freedom and equality between the sexes which it made possible were a heady mixture. Eliza Lynn Linton, still the scourge of the modern girl as for nearly thirty years past, fixed on the bicycle as the target of her final sustained campaign. She regretted the woman cyclist's loss of the 'sweet spirit of allurement' and warned against the 'sturdy tramp' whom she might meet on her travels. But her principal target, revealingly, was 'the intoxication which comes with unfettered liberty'.

It is this intoxication which large numbers of women who were young or middle-aged in the period recalled in their memoirs. Typical of many was the teacher and headmistress Sara Burstall, born in 1859, whose study of architecture and history on cycling holidays was put to good use in the classroom. But the bicycle meant more than scholarly knowledge. To her generation it typified the break-up of Victorian convention: 'It is difficult for the modern woman . . . to realise what the bicycle meant to us who were in the prime of life in the 'nineties.'[39] Similar statements could be cited from many other autobiographies.[40]

It was not only restrospectively that the liberating influence of the bicycle was proclaimed. Louise Jeye, writing in the *Lady Cyclist* in 1895, pointed out that it was responsible for 'a new dawn, a dawn of emancipation'. A more carefully considered but no less enthusiastic tribute was paid by Clementina Black, the social reformer and trade unionist:

> I believe the bicycle is doing more for the independence of women than anything expressly designed to that end. It is perhaps a mark of the change of view which has come over us, that nobody expects a woman to go cycling escorted by a chaperon, a maid, or a footman. It is an amusement — perhaps the first amusement — which woman has taken up to please herself, and not to please man, and it is one which can only be followed in a moderately comfortable and healthy kind of dress. It is absolutely independent, and yet not necessarily unsociable, and it involves time in the open air. Is there any other fashionable recreation for women for which all these things can be said?[41]

The popularity of cycling contributed to the reforms of women's dress which took place in the period,[42] but the long skirt was a constant problem, for fashion did not allow the woman cyclist the six-inch margin between skirt and ground granted to the hockey player. Accidents were common and gave rise to injury and embarrassment. Helena Swanwick, who was one of the first women cyclists in Manchester and London, wrote feelingly in her memoirs of the anguish which she suffered from falling onto stone setts and finding that her skirt was caught so firmly that she was unable to unwind herself.

The obvious solution to this problem was to wear some form of trousers, a remedy first advocated by the American dress reformer Amelia Bloomer and her followers in the middle of the century. 'Bloomers' had been ridiculed out of existence, but thirty years later a new movement began under the leadership of Florence, Viscountess Harberton. She was then instrumental in the establishment of the Rational Dress Society in 1881 and became its president. The society led an intermittent existence until the early 1890s and published a quarterly journal in 1888-9. A number of reforms were advocated, but the society was most closely identified with the divided skirt.[43] The formation of the Healthy and Artistic Dress Union in 1890 was another sign

of the times. The union, which aimed at the reform of the dress of both sexes, advocated the abolition of the corset and the adoption of clothes which conformed to the figure, in the conviction that the supporters of rational dress placed too much emphasis on health and utility and too little on beauty. In 1893-4 the union published three numbers of *Aglaia*, a journal whose title suggested the inspiration drawn from the clothes of the ancient Greeks. The union survived for about twenty years and boasted some prominent names among its members and sympathisers, but its designs were more appropriate to the drawing room than to the bicycle.[44]

Rational dress, in the form of a knickerbocker outfit, was revived by the growth of cycling for women and by its popularity among French women cyclists. An early example of its use was a sensational occasion in 1893 when the sixteen-year-old Tissie Reynolds raced from Brighton to London and back,[45] and other adventurous and courageous women also adopted 'rationals'. But even so independent-minded a woman as Helena Swanwick dared to wear rational dress only at night, and the fiction and drawings of the period give a misleading impression of the extent of its use.[46] Their reward was publicity, hostility, ridicule and in some cases violence. Alys Russell, wife of Bertrand and formerly a spokeswoman of the revolting daughters, lost a friend who had seen her in rational dress,[47] and the editor of the *Rational Dress Gazette* was struck by a meat hook while cycling in Kilburn, north London. The hazards involved were summed up by Kitty Jane Buckman in a letter written in August 1897 to her brother S. S. Buckman, geologist and cyclist:

> It certainly can't be worse to ride in Oxford than in London, especially London suburbs. It's awful. One wants nerves of iron, & I don't wonder now in the least so many women having given up the R.D. Costume & returned to skirts. The shouts & yells of the children deafen one, the women shriek with laughter or groan & hiss & all sorts of remarks are shouted at one, occassionally [sic] some not fit for publication. One needs to be very brave to stand all that.[48].

Lady Harberton, now in her early fifties, was nothing if not brave and determined, qualities which she demonstrated by walking up Regent Street in rational dress. It is surprising that she did not revive the old Rational Dress Society or create a new

one when the cycling boom began, but she became the leading figure in the Rational Dress League after its foundation in March 1898. The League enjoyed more prominence than the earlier society, and its principal object, 'to promote the wearing by women of some form of bifurcated garment, especially for such active purposes as cycling' and other forms of recreation,[49] was advocated more vigorously and attracted more publicity than ever before. Its lively and informative *Gazette* was published monthly between June 1898 and January 1900.

Rational dress reached a peak of notoriety following the refusal of the Hautboy Hotel of Ockham, Surrey, to serve Lady Harberton in its coffee room and the reluctant and unsuccessful prosecution of the landlady by the Cyclists' Touring Club in April 1899. The League faded away at the turn of the century and women's legs were not seen again in public except on the stage and at the seaside until after the outbreak of the war in 1914. It was left to a later generation in changed circumstances to build on the brave but fruitless campaign of the 1890s. Clad in her rationals the woman cyclist was a fitting symbol of a generation struggling for emancipation. Such diverse figures as Sarah Grand and H. M. Hyndman, the Marxist leader, were careful to dress impeccably when preaching their revolutionary gospel, but to the advocates of rational dress the reform of women's clothing was itself a revolution.

With the partial exception of the bicycle active forms of recreation were practically confined to women of the prosperous classes, who alone possessed the means and leisure to participate in them. Another exception was the Hammersmith Sculling Club for Girls and Men (*sic*), founded in 1896 by the philologist F. J. Furnivall, then aged over seventy, who in youth had been a famous oarsman. As the feminist Charlotte Carmichael Stopes recalled in a memorial volume, Furnivall spent many hours in the A.B.C. tea-room on Oxford Street. His sympathy for the enclosed lives of the waitresses encouraged him to find a means of providing them and other working girls and women with open air and exercise on the river. Although men were admitted to the club chiefly in order to launch the heavier boats, women were predominant in its affairs, and several of them wrote with pleasure and pride of their association with Furnivall and the club.[50]

As already pointed out, by taking part in sport women

challenged assumptions about their role in the family and in society. This process was encouraged by the obvious fact that their physical capacity was much greater than had previously been supposed. The fainting, helpless woman, prone to dependency and ill health, was out of date in the age of the hockey stick and the bicycle. Millicent Garrett Fawcett commented in 1892 that girls were much taller and better developed than their mothers and grandmothers, a recent change on which 'almost every one is remarking'.[51] Susan, Countess of Malmesbury, a well-known cycling enthusiast, reflected in 1897: 'We can now scarcely realise that in years gone by delicacy was considered interesting, and that many girls would then have regarded it almost as an insult to be called robust.'[52]

Observations of this kind, also found commonly in the women's magazines of the period, were not limited to feminists or even to women. T.H.S. Escott, the writer and journalist who had formerly edited the *Fortnightly Review,* attributed to the bicycle the 'lofty stature' of the modern woman, 'towering majestically above the thrones of wheel-work',[53] though few women had cycled for more than three years when his widely noticed book was published in 1897. Dr W.H. Fenton, a prominent gynaecologist, asserted in 1896 that women's participation in games and recreation had been 'productive of nothing but good to mind and body alike',[54] and the Oxford don and writer George C. Brodrick welcomed the 'discovery' that girls possessed muscular powers, a discovery which had resulted in a 'remarkable increase of strength and stature among young ladies'.[55] Brodrick was not to know that the strength of body and mind gained by women in the 1890s would shortly be turned to the more testing challenges presented by hunger strikes and other features of the suffragette struggle.

It could not be expected that the sporting woman would be universally loved. However docile she might be in other spheres the challenge which she posed to prevailing stereotypes represented a threat to a male-dominated society. Social Darwinism and the newer doctrine of eugenics, which stressed the role of women as 'mothers of the race', often in imperialist terms, were sometimes called in aid by advocates of physical exercise and games, who argued that the playing field would produce healthier mothers.[56] More frequently, however, such pseudo-

sciences were used as a weapon in the struggle to circumscribe women's activities in sport as well as in the wider fields of higher education and employment.[57] A number of educationists and medical women reacted with alarm as they discovered how enthusiastically their encouragement of physical exercise had been followed. Evidence is impressionistic but suggestive. Sara Burstall, the cycling headmistress, warned in 1907: 'The pendulum has probably swung too far.'[58] Dr Jane Walker writing in 1897 praised the value of 'active physical exercise' for girls, recommended all sports except football and rugby and, while welcoming women's improved health, maintained that they were still insufficiently robust. In 1906, however, she told the conference of the National Union of Working Women that there was 'a danger of making a fetish of exercise'.[59] Dr Mary Scharlieb wrote in 1895 that all girls, and especially students, should belong to a tennis club, a gymnasium or a swimming class and that they should engage daily in 'real exercise, that will throw every muscle into action', but by 1911 she too was warning against 'excessive devotion to athletics and gymnastics'.[60]

The best-known woman opponent of the sporting woman before the turn of the century was Arabella Kenealy, doctor and novelist, who had previously shown some sympathy with the aspirations of her sex. In an article in *The Humanitarian* in 1896 she had written: 'Thank heaven for the New Woman!' She praised higher education, teaching, nursing, poor law work and cycling, 'in all of which capacities she is broadening her horizon', confronting reality and overcoming the grip of convention.[61] Three years later, however, she wrote two remarkable articles in the *Nineteenth Century,* asserting that woman's primary role was that of mother, and that both home life and 'the welfare of the race' suffered at the hands of the energetic woman: 'Nature had no vainglorious ambitions as to a race of female wranglers or golfers; she is not concerned with Amazons, physical or intellectual. She is a one-idea'd, uncompromising old person, and her one idea is the race as embodied in the Baby.'[62] In her second article Kenealy introduced two mothers, one delicate, the other muscular, whose children's health was the reverse of their own. While insisting that she did not oppose the bicycle she stressed the importance for women of mental and physical repose: 'In every instance the children of the less

muscular and less robust women carry off the palm, some in beauty, some in intelligence, some in high mental or moral development.'[63]

Kenealy remained unconvinced of the advantages of sport and returned to the attack on 'the cult of Mannishness' as late as 1920 in a book on *Feminism and Sex-Extinction.*[64] Champions of women's physical education, however, were undismayed.[65] So were girls and women themselves, who continued to vote with their feet, arms and hands. The genie had escaped and could not be returned to the bottle.

Sport was the principal leisure activity of the 1890s to expand horizons in previously unprecedented fashion. Another leisure activity, the ladies' club, had a similar effect, though its influence was almost wholly limited to the handful of wealthy or middle-class working women who enjoyed access to London. Few of the clubs aimed consciously to advance the cause of women's emancipation, but as Eva Anstruther, a writer and wife of a member of Parliament, pointed out in a thoughtful article in 1899, it was the 'advanced woman' who had been responsible for the inception of the movement. Moreover, the very existence of clubs for women tended 'to prove the utter fallacy of the dictum of the German Emperor that women's interests are only three — *Kinder, Küche,* and *Kirche*'.[66] The earliest clubs dated from the 1870s, but before 1892 only a handful had been formed. By 1899 there were twenty-four in London, two in Edinburgh and Glasgow, and one in Dublin, Bath, Leeds, Liverpool and Manchester.[67]

The club movement was transformed by Emily Massingberd, who, after inheriting her father's Lincolnshire estate in 1887, abandoned her married name, Langton, in favour of her family name and took up a variety of social and women's causes. In 1892 she opened the Pioneer Club in London. From its inception the club was intended as a home for women of advanced views, as its membership badge, a brooch in the shape of a silver axe, was intended to show. Members were expected to hew a path through the jungle of prejudice and outdated ideas, guided by their own convictions and uninhibited by the constraints of convention. If any single institution could claim to be the home of the new woman it was the Pioneer Club, whose members included Sarah Grand, Mona Caird and other cham-

pions of women's rights. Another member was Margaret Shur-
mer Sibthorp, in the pages of whose little-known feminist
journal *Shafts* the activities of the Pioneer Club featured prom-
inently. Debates were held weekly; one, on modern fiction,
pitted Ménie Muriel Dowie, author of the feminist novel *Gallia*
(1895) against Annie S. Swan, an author of a more traditional
type. Other topics included socialism, Wagner, charity and
theosophy. Alice Zimmern, in an article on women's clubs in
1897, noted that the debates at the Pioneer had 'a tendency to
make almost every subject lead up to the New Woman, — her
rights, duties and responsibilities'.[68]

The club speakers included such prominent political and
social reformers as Millicent Garrett Fawcett, Isabella Ford,
Amie Hicks and Florence Harberton. A debate in 1892 was
perhaps the occasion when Lady Harberton made her appear-
ance in rational dress on Regent Street, the club's first home. A
report of the meeting commented: 'She and some other of the
ladies were dressed in the particular style each advocated.' Men
were also invited to address the club; among them were Tom
Mann, George Bernard Shaw and the painter and dress re-
former Henry Holiday. By 1894 the club had a membership in
excess of 500.[69]

The Pioneer Club was the target of much publicity and many
gibes, and some aspects of its activities were easy targets of
ridicule. Members were known by number rather than name, a
practice which, as Beatrice Knollys observed in *The English-
woman*, 'perhaps rather savours of the convict system'.[70] The
club had several 'improving' mottoes, including a riposte to Mrs
Grundy inscribed in stained glass: 'They say. What say they?
Let them say.'[71] Hulda Friederichs, reporting a visit for the
Young Woman, pointed out that though the club was not affil-
iated to a political party, 'it is not difficult to imagine to which
side the majority of these progressive women incline, politi-
cally'. Stereotype was confirmed: 'I *must* say that the last thing I
saw in the hall was a lady with short hair, pince-nez, and very,
very masculine gait and attire.' Mrs Massingberd's own hair
was short and her dress 'mannish', but she inspired confidence
rather than derision; Friederichs at once found her graceful and
captivating.[72]

Although the Pioneer Club was a model for the formation of
other clubs[73] and the recipient of far more publicity than any

other, its feminist outlook was not general. The cost of membership meant that many clubs catered for the wealthy, leisured and fashionable. The 'gaunt, unsexed, aggressive' woman was seldom seen even at the Pioneer.[74] The Alexandra, Green Park, Empress and County provided social and musical functions rather than lecture programmes. Membership of this type of club was usually limited to women eligible to be presented at court. The County boasted 1,300 members in 1897; the Empress over 2,000 in 1898. The Victoria acted as a town house for country members needing a base in London.[75]

The growth of women's clubs in the 1890s was the result of three overlapping developments in the period: the increase in the number of wealthy women with money of their own, the women's emancipation movement and the employment of middle-class women who lacked home life or companionship. Emily Morgan Dockrell had the last group in mind when she commented in 1898:

> What life can be more pitiably lonely than that of the cultured unmarried woman earning her daily bread hardly in London, living perhaps alone in dingy lodgings. Picture one of them returning day after day, year in, year out, to the same atmosphere of dreary ugliness, partaking of her badly-cooked, slovenly-served, solitary meal, which she hurries through to rid her sight of the hideous table appointments.[76]

It was to serve the need of women like these that the Camelot Club was opened as a Sunday centre. During the week they could patronise the New Somerville Club, which aimed to act as a discussion and social centre across a wide social spectrum, but catered particularly for women who lived in cramped lodgings. Its utilitarian premises were appropriately located above the A.B.C. in Oxford Street. The Pioneer Club also attempted to mix classes and included milliners, printers, typists, dressmakers and others among its members, encouraged by Massingberd's generous subsidies.[77]

Several other clubs filled the gap between the feminist, the fashionable and the middle-class fringe. The Victoria Commemoration Club catered for nurses and workers in related fields. The Writers' Club was founded in 1892 by the journalist Frances Low and other women writers, and provided a social and working centre for authors and journalists, with whom it

224

proved extremely popular. The University Club for Ladies, like the Writers' Club, was limited to 300 members, including graduates or women with similar qualifications, students and lecturers. Founded in 1886 it was one of the earliest clubs; in 1921 it changed its name to the University Women's Club and still survives. The Sesame Club, founded in 1895, was one of several clubs which admitted members of both sexes. Like the Pioneer it organised a literary and educational programme, which it seasoned with social activities. Ibsen was among its lecture subjects and, again like the Pioneer, it bore more than a passing resemblance to the Ibsen Club in Shaw's *The Philanderer,* though the play was originally written in 1893.[78]

From the point of view of women's emancipation the most significant club after the Pioneer was the Grosvenor Crescent Club, less notable for its own activities than as the parent body of the Women's Institute. After Emily Massingberd's death early in 1897 Leonora (Nora) Wynford Philipps, a stalwart of Women's Liberal Federation and wife of an MP, attempted to rescue the Pioneer Club from the difficulties which it faced, bereft of its proprietor and benefactor. Problems of various kinds arose and as an alternative she formed the Grosvenor Crescent Club, with the assistance of the majority of Pioneer members.[79] The Women's Institute, which should not be confused with the national organisation of rural women founded in 1915, was housed in adjacent premises. It contained a library, a lecture department, a secretarial agency, a general employment service for members and various social and educational features. By early 1900 the Institute contained over 800 members. It had established links with more than forty-five societies and had largely succeeded in its aim of acting as an information centre and meeting place for women engaged in professional, social and related work.[80] One of its most useful products was the publication in 1898 of a *Dictionary of Employments Open to Women,* written by Nora Philipps with the aid of three other women. It contained a comprehensive alphabetical summary of the salaried and manual employments open to women, with details of income and numbers employed. Appendices provided information on training establishments and employment agencies.[81] Thus through the means of the Women's Institute the club movement burst its bonds to become an economic and social resource for a wide circle of women.

The women's club movement of the 1890s can so far be regarded as a small but significant success story. But the movement had critics within its own ranks as well as scoffers outside. Several articles pointed out that the clubs were marred by personal friction and the inexperience of members. The novelist Dora Jones suggested that clubs had done little to develop solidarity among women workers, and Emily Morgan Dockrell wrote disparagingly that 'the eternal feminine comes to the surface, the personal element'.[82] Eva Anstruther was a severe critic. She deplored the tendency to 'blackball' applicants for membership who were not personal friends and the consciousness of status demonstrated by the insistence that the clubs should cater for 'ladies' rather than 'women'. Supercilious men who said that women were 'not clubbable' were not wholly unfair, for women tended to regard their clubs in utilitarian fashion as sources of food, education or entertainment, rather than as centres of relaxed companionship. Too few clubs were available as places for women of different social grades to meet on terms of equality.[83]

These criticisms had some foundation. Women's organisations, political as well as social, did suffer from personal and administrative difficulties. But problems of this type were not limited to women and many women's clubs seem to have operated relatively smoothly, given the wide range of members for which they necessarily catered. Moreover, women were doing more than men to create the kind of clubs which Anstruther was seeking. With all their inadequacies and in all their variety clubs opened a new world to many women. As Alice Zimmern pointed out, they were a significant feature of a changing age: 'The rise of ladies' clubs in England is a fact that the social historian cannot afford to overlook; for it is a sign of the times.'[84]

Notes

1. Georgiana Hill, *Women in English Life,* vol. II (Bentley, London, 1896), pp.93-4. *See also* Ivy Pinchbeck, *Women Workers and the Industrial Revolution 1750-1850* (1930; Cass, London, 1969), ch. 12 and conclusion.
2. Ann Oakley, *Housewife* (Allen Lane, London, 1974), pp.43-56. I am grateful to Rona Fleming for reminding me of this source.

3. *See* J.A. Banks, *Prosperity and Parenthood* (1954; Routledge & Kegan Paul, London, 1969), pp. 83-5, 134-7; J.A. and Olive Banks, *Feminism and Family Planning in Victorian England* (Liverpool University Press, Liverpool, 1964), p. 65.

4. Eleanor Mildred Sidgwick, *The Place of University Education in the Life of Women* (Women's Institute, London, [1897]), p.20. Dr Jane Walker commented in the same year: 'I have been consulted by women who were anaemic from sheer boredom' (*A Book for Every Woman*, vol. II (Longmans, London, 1897), p.vi).

5. Frank Prochaska, *Women and Philanthrophy in Nineteenth-Century England* (Clarendon Press, Oxford, 1980.

6. In a letter to her daughter in 1891 Millicent Garrett Fawcett discussed the relative advantages of further study at Cambridge, electrical engineering and training with her uncle Sam Garrett to become a solicitor, 'a splendid opening for women' — or, rather, a splendid opportunity for women to challenge their exclusion (Fawcett Library Archives, Box 89, vol. I, letter 17, MGF to Philippa Fawcett, ?May 1891). *See also* Ray Strachey, *Millicent Garrett Fawcett* (Murray, London, 1931), pp. 204-5.

7. Michael Sanderson has shown that the London School of Economics was the only institution of higher education to provide a significant number of women entrants for business and industry before 1914 (*The Universities and British Industry 1850-1970* (Routledge & Kegan Paul, London, 1972), pp. 328-31). The position was no better for middle-class women who did not attend university.

8. I am grateful to Tony Mangan and other colleagues of the British Society of Sports History for opening my eyes to the importance of sport in the lives of women in the late nineteenth century and also for recommending a number of sources which would otherwise have escaped me.

9. Louis Mackern, 'Ladies' golf', in Earl of Suffolk and Berkshire, Hedley Peek and F.G. Aflalo (eds), *The Encyclopaedia of Sport*, vol. I, (Lawrence & Bullen, London, 1897), p. 470; Lottie Dod, 'Ladies' lawn tennis', in J. M. Heathcote *et al.*, *Tennis, Lawn Tennis, Rackets, Fives* (Longmans, Badminton Library, London, 1890), pp. 307-9.

10. Frances E. Slaughter, 'Englishwomen and sport', in Frances E. Slaughter (ed.), *The Sportswoman's Library*, vol. 1, (Archibald Constable, London, 1898), p.6. The claim is echoed by later research based on Birmingham; by about 1890 'there were definite signs that Birmingham women were asserting their separate identity in sports' (D.D. Molyneux, 'Early excursions by Birmingham women into games and sports', *Physical Education*, 51 (1959), p. 52).

11. Mackern in *Encyclopaedia of Sport*, vol. I, p.471; Louie Mackern and M. Boys (eds), *Our Lady of the Green* (Lawrence & Bullen, London, 1899), chs. 1 (Issette Pearson) and 2 (Louie Mackern).

12. Maud Marshall, 'Lawn-tennis', in *Sportswoman's Library*, II, pp. 315-17; Anne Crawford *et al.* (eds), *The Europa Biographical Dictionary of British Women* (Europa Publications, London, 1983), pp. 127-8; Mabel Stringer, *Golfing Reminiscences* (Mills & Boon, London, 1924), p. 225.

13. Marie C. Pointon, 'The Growth of Women's Sport in Late Victorian Society as Reflected in Contemporary Literature' (unpublished M.Ed.

thesis, University of Manchester, 1978), pp. 85-7. I am much indebted to this fine thesis and to David McNair for recommending it.

14. *ibid.*, pp. 79, 81-2; Marjorie Pollard, *Fifty Years of Women's Hockey* (All England Women's Hockey Association, London [1946]), pp. 5-9.
15. Paul Atkinson, 'Fitness, feminism and schooling', in Sara Delamont and Lorna Duffin (eds), *The Nineteenth-Century Woman* (Croom Helm, London, 1978), p. 113. Some of these sports, such as athletics, were in their earliest infancy; *see* Jonathan May, *Madame Bergman-Österberg* (Harrap, London, 1969), pp. 80-1. The Women's Amateur Athletic Association was founded in 1922, the year of the first Women's Olympiad, and British women did not compete in athletic events in the Olympic Games until 1932 (George Pallett, *Women's Athletics* (Normal Press, London, 1955), pp. 18, 22, 31, 36, 47).
16. Even some schoolgirls played football, as Sheila Fletcher points out: *Women First* (Athlone Press, London, 1984), pp. 34, 162.
17. *The Englishwoman*, 1 (1895), pp. 155, 233; *Punch*, 2 February 1895, p. 49; *The Sketch*, 6 February, 27 March 1895, pp. 60, 444-5. A recent interview with Carol Thomas, a Hull clerk and captain of the English women's football team, suggests that the problem faced by women footballers is now public indifference rather than notoriety (*Hull Daily Mail*, 15 October 1984).
18. Stringer, *Golfing Reminiscences*, p.224; Dod, 'Ladies' lawn tennis', in Heathcote *et al.*, pp.312-13. The sports in which Dod excelled included golf, at which she won the championship in 1904, skating, hockey, mountaineering, archery and billiards (Stringer, p. 225; *Europa Biographical Dictionary*, pp. 127-8).
19. Maud Marshall in *Sportswoman's Library*, vol. II, pp.337, 341-2.
20. Stringer, pp. 32-3; Mackern and Boys (eds), *Our Lady of the Green*, p. 68.
21. Lord Wellwood, 'General remarks on the game' in Horace G. Hutchinson, *Golf* (Longmans, Badminton Library, London, 1890), p. 51.
22. Lottie Dod, 'Ladies' lawn tennis', in Heathcote *et al.*, p. 312; Dod, 'Ladies' lawn tennis', in *Encyclopaedia of Sport*, vol. I, p.618.
23. Mackern and Boys (eds), *Our Lady of the Green*, p. 108.
24. Stringer, pp. 27-9. *See* Alison Adburgham, *A Punch History of Manners and Modes 1841-1940* (Hutchinson, London, 1961), pp. 153-4; I gratefully acknowledge my debt to this delightful book.
25. Dod in *Encyclopaedia of Sport*, vol. I, p.619.
26. Mackern in *ibid.*, vol. I, p. 472.
27. Hutchinson, *Golf* (4th edn, 1893), pp.464-6. *See* Plate 16.
28. Mary E.L. Hezlet, 'Hints to girl golfers', *Sandow's Magazine of Physical Culture*, 3 (1899), p.204; Stringer, pp.37-40; A. W. M. Starkie-Bence, 'Golf', *Sportwoman's Library*, vol. I, p. 312.
29. Mackern and Boys (eds), *Our Lady of the Green*, p. 107.
30. Kathleen Waldron, 'Clothes and the woman', *Physical Culture* (the original name of the journal cited in note 28), 1 (1898), pp. 92, 97-8.
31. Elizabeth Ewing's *Fashion in Underwear* (Batsford, London, 1971), chs 5 and 6, and her *History of Twentieth Century Fashion* (Batsford, London, 1974), pp. 19-22, are instructive. *See also* Pointon, 'The Growth of Women's Sport', ch. 5, and R.C.K. Ensor, *England 1870-1914* (Oxford

University Press, London, 1936), pp. 337-8. The position was summed up by Georgiana Hill in 1893: 'Women have fashioned their dress to their occupations and amusements, or rather are trying to do so, for we are yet a long way from success' (*A History of English Dress from the Saxon Period to the Present Day*, vol. II (Bentley, London, 1893), pp. 334-5).

32. *Punch*, 6 April 1895, p. 167.

33. Ouida, 'The new woman', *North American Review*, 158 (1894), pp. 613, 616-7, 618. She returned to the attack in 'Jules Lemaître on dress', *Lady's Realm*, 3 (1897): 'The sporting woman is a hybrid animal; she is an exaggeration and a caricature of the sporting man' (p. 67).

34. Pointon, pp. 117-18, 196.

35. Jennifer A. Hargreaves, '"Playing Like Gentlemen While Behaving Like Ladies": the Social Significance of Physical Activity for Females in Late Nineteenth and Early Twentieth Century Britain' (unpublished M.A. (Ed.) thesis, University of London, 1979), ch. II; Jennifer A. Hargreaves, '"Playing Like gentlemen while behaving like ladies": contradictory features of the formative years of women's sport', *British Journal of Sports History*, 2 (1985), pp. 42-3, 50; Kathleen McCrone, 'Play up! Play up! and play the game! Sport at the late Victorian girls' public school', *Journal of British Studies*, 23 (1984), pp. 127-32. I am particularly grateful to Jennifer Hargreaves for making a copy of her thesis available to me at some inconvenience to herself.

36. Except where otherwise indicated the sections on cycling and rational dress are drawn from my 'Cycling in the 1890s', *Victorian Studies*, 21 (1977), pp. 47-71.

37. 'Englishwomen's sports', *The Englishwoman*, 1 (1895), p. 483.

38. Among them 'Sarah Jane in the kitchen', according to one contemporary journal (quoted in Pointon, p. 72).

39. Sara A. Burstall, *Retrospect & Prospect: Sixty Years of Women's Education* (Longmans, London, 1933), pp. 131-2.

40. For example, Elizabeth S. Haldane's: 'No young woman of the present day realises the sudden sense of emancipation that [the bicycle] gave' (*From One Century to Another* (Maclehose, London, 1937), p. 145). The experiences of a number of contemporary cyclists have been collected in *Cycling*, compiled by Jeanne MacKenzie (Oxford University Press, Oxford, 1981).

41. *Woman's Signal*, 29 August 1895, p. 131.

42. Ewing, *Fashion in Underwear*, pp. 75-6; Haldane, *From One Century to Another*, p. 97; C. Willett Cunnington, *English Women's Clothing in the Nineteenth Century* (Faber, London, 1937), pp. 367, 399. *See also* note 59 below.

43. David Rubinstein, 'The Buckman Papers: S. S. Buckman, Lady Harberton and rational dress', *Notes and Queries*, 24 (1977), p. 42; Hill, *History of English Dress*, II, p. 284. An extract from an article by Lady Harberton published in 1882 appears in Janet Horowitz Murray (ed.), *Strong-Minded Women* (1982; Penguin Books, Harmondsworth, 1984), pp. 69-72; the Rational Dress Society's aims in 1886-7 are reprinted in Pointon, p. 226. The latest reference I have found to the Society is a report of its 'Coming Dress' bazaar in April 1891 (*Englishwoman's Review*, 22 (1891), pp. 161-2).

44. Henry Holiday, *Reminiscences of My Life* (Heinemann, London [1914], pp. 403-11.

45. *The Cyclist*, 13 September 1893, p. 805; Andrew Ritchie, *King of the Road* (Wildwood House, London, 1975), pp. 156-8.

46. Helena Swanwick, *I Have Been Young* (Gollancz, London, 1935), p. 164. The best of the works of cycling fiction is H.G. Wells's delightful *The Wheels of Chance* (Dent, London, 1896).

47. Barbara Strachey, *Remarkable Relations* (Gollancz, London, 1981), p. 150.

48. Quoted in Rubinstein, 'The Buckman Papers', p. 44.

49. The League's objects were prominently displayed on the masthead of the *Rational Dress Gazette*.

50. *Frederick James Furnivall, a Volume of Personal Record* (Henry Frowde, London, 1911), pp. lxxix-lxxxi, 33-4, 75, 77-80, 86, 193-4, 196-8. I owe this reference to John Lowerson.

51. Millicent Garrett Fawcett, 'The women's suffrage question', *Contemporary Review*, 61 (1892), p. 765.

52. Susan, Countess of Malmesbury, 'Bicycling for women', in *Encyclopaedia of Sport*, vol. I, p. 292.

53. T.H.S. Escott, *Social Transformations of the Victorian Age* (Selby, London, 1897), p. 203.

54. W.H. Fenton, 'A medical view of cycling for ladies', *Nineteenth Century*, 39 (1896), p. 797.

55. George C. Brodrick, *Memories and Impressions 1831-1900* (Nisbet, London, 1900), p. 203.

56. Atkinson, 'Fitness, feminism and schooling', p. 126; Hargreaves, '"Playing Like Gentlemen"' (thesis), pp. 162-3. For the eugenics movement *see* Donald A. MacKenzie, *Statistics in Britain 1865-1930* (Edinburgh University Press, Edinburgh, 1981), esp. ch. 2, and G.R. Searle, *Eugenics and Politics in Britain 1900-1914* (Noordhoff, Leyden, 1976). For social Darwinism and imperialism *see* Bernard Semmel, *Imperialism and Social Reform* (Allen & Unwin, London, 1960), esp. chs I and II.

57. The following may be cited from the considerable literature on the subject: Atkinson, pp. 124-6; Lorna Duffin, 'Prisoners of progress: women and evolution', in Delamont and Duffin (eds), *The Nineteenth-Century Woman*, ch. 3; Anna Davin, 'Imperialism and motherhood', *History Workshop Journal*, 5 (1978), pp. 9-65; Carol Dyhouse, 'Social Darwinistic ideas and the development of women's education in England, 1880-1920', *History of Education*, 5 (1976), pp. 41-58; Carol Dyhouse, *Girls Growing Up in Late Victorian and Edwardian England* (Routledge & Kegan Paul, London, 1981), *passim*.

58. Quoted by Atkinson, p. 126.

59. Walker (1897), *A Book for Every Woman*, II, pp. v, 120-1, 128-31; (1906) quoted by Atkinson, pp. 126-7. Walker also told the conference that the two principal causes of 'the improved physique of women [were] the bicycle and the blouse [which] might be described as an essential adjunct to the bicycle' (Jane Walker, 'Athletics for girls', *Women Workers: the Papers Read at the Conference Held at Tunbridge Wells 1906* (P.S. King, London, 1906), p. 100).

60. Mary Scharlieb (1895), *A Woman's Words to Women* (Swan Sonnenschein,

London, 1895), p. 14; (1911) quoted in Dyhouse, *Girls Growing Up*, p. 130.

61. Arabella Kenealy, 'The dignity of love', *The Humanitarian*, 8 (1896), p. 439.

62. Arabella Kenealy, 'Woman as an athlete', *Nineteenth Century*, 45 (1899), pp. 642-3, 644.

63. Arabella Kenealy, 'Woman as an athlete: a rejoinder', *ibid.*, 45 (1899), pp. 924-5. These extraordinary articles are considered by Fletcher, *Women First*, pp. 25-6, 27, 29.

64. *See ibid.*, pp. 74-7; Atkinson, p. 127.

65. *See* Fletcher, p. 28. Among the undismayed were the Lawrence sisters of Roedean; Margaret Cole, one of their pupils in 1907-11, recalled: 'We were *obsessed* with games' (*Growing Up Into Revolution* (Longmans, London, 1949), p. 29).

66. Eva Anstruther, 'Ladies' clubs', *Nineteenth Century*, 45 (1899), pp. 599, 602.

67. *ibid.*, pp. 600-2. A useful list of ladies' clubs may be found in Emily Janes (ed.), *The Englishwoman's Year-Book and Directory 1899* (A. & C. Black, London, 1899), pp. 147-9. A few appear to have resembled residential chambers more than clubs.

68. Alice Zimmern, 'Ladies' clubs in London', *The Forum* (New York), 22 (1897), pp. 648-8; B. S. Knollys, 'Ladies' clubs in London. No. 1. — The Pioneer Club in Bruton Street', *The Englishwoman*, 1 (1895), pp. 120-5. Beatrice Knollys, later Lady Wolseley, founded the Ladies' Park Club in 1907. For *Shafts* see Norman Brady, '*Shafts* and the Quest for a New Morality: an Examination of the "Woman Question" in the 1890s as Seen Through the Pages of a Contemporary Journal' (unpublished M.A. thesis, University of Warwick, 1978).

69. *Shafts*, 3 December 1892, p. 73; 15 February, 15 June, 15 August 1894, pp. 208-9, 276, 299; January 1898, p. 4; Zimmern, p. 687; *New Weekly*, 28 April 1894, p. 15.

70. Knollys, p. 121.

71. *ibid.*, p. 121; Zimmern, p. 686. The origin of this saying appears to have been an old Scottish family motto; *see* Lord and Lady Aberdeen, '*We Twa*', vol. II (Collins, London [1925]), p. 1 and n.

72. Hulda Friederichs, 'A peep at the Pioneer Club', *Young Woman*, 4 (1896), pp. 303-5; *Illustrated London News*, 6 February 1897, pp. 176, 194. In the course of several visits Beatrice Knollys discovered 'about four divided skirts, a dozen manly costumes, and six short-haired heads, out of over five hundred members' ('The Pioneer Club', p. 124).

73. Emily Morgan Dockrell, 'Women's clubs', *The Humanitarian*, 12 (1898), p. 346.

74. Coralie Glyn, 'Woman in clubland', *ibid.*, 4 (1894), p. 207.

75. Anstruther, pp. 600-1; Zimmern, pp. 693-4; B. S. Knollys, 'Ladies' clubs in London. No. 2. — The County Club', *The Englishwoman*, 1 (1895), p. 205; 'Ladies' County Club', *ibid.*, 4 (1897), p. 542; Dora M. Jones, 'The ladies' clubs of London', *Young Woman*, 7 (1899), pp. 409, 412-13; Jennie Croly, *The History of the Woman's Club Movement in America* (Henry Allen, New York, 1898), pp. 201-8.

76. Morgan Dockrell, pp. 349-50. The author, who was of Irish origin, was the wife of a prominent London doctor and probably the Mrs M.

Dockrell who was an Irish local councillor (*Englishwoman's Review*, 31 (1900), p. 194).

77. Morgan Dockrell, p. 351; Friederichs, pp. 304-5; Zimmern, pp. 688-9; *Shafts*, 15 September 1894, p. 314.
78. Anstruther, pp. 599-601; Zimmern, pp. 690-3; Jones, pp. 411-12; Grace Thornton, *Conversation Piece* (University Women's Club, London, 1979), pp. 25-7; Evelyn Wills, 'Ladies' clubs in London', *Lady's Realm*, 5 (1899), p. 318; 'Rita' (Eliza Humphreys), *Recollections of a Literary Life* (Andrew Melrose, London, 1936), pp. 110-11.
79. Sarah A. Tooley, 'Women's progressive clubs', *The Humanitarian*, 11 (1897), pp. 171-3; *The Times*, 12 May 1897.
80. *ibid.*, 7 November 1899, 16 March 1900; *Englishwoman's Review*, 29 (1898), pp. 195-6; Leonora Wynford Philipps, 'Women's clubs in England', Countess of Aberdeen (ed.), *The International Congress of Women of 1899*, vol. VII, *Women in Social Life* (T. Fisher Unwin, London, 1900), pp. 95-6.
81. Leonora Wynford Philipps and others, *A Dictionary of Employments Open to Women with Details of Wages, Hours of Work and Other Information* (Women's Institute, London, 1898).
82. Jones, p. 413; Morgan Dockrell, p. 348.
83. Anstruther, pp. 603-11.
84. Zimmern, p. 684.

Afterword

The historian soaked in so short a timespan as a decade risks forgetting the inadequacies of the Whig theory of history. There is a danger of enthusiastically intoning like some latter-day Dr Coué that everything in the chosen period became 'better and better' in defiance of allegiance to the rules both of scholarship and of common sense.

Undoubtedly women at the start of the twentieth century were subject to restrictions on their freedom at all levels. Their participation in higher education was limited and severely controlled. The expansion of opportunities in local government was restricted and the decade ended with an important defeat. The major battle of the 1890s for the parliamentary vote was decisively lost. Employment generally meant exploitation rather than the liberation which had been hoped. To make matters worse the new woman and her novelist champions faded from view.

But to say so much is to say little. A social movement is not a military campaign with its decisive Austerlitz or Waterloo. Progress is achieved despite defeat as well as through victory. The significance of the 1890s in the history of English women is that patterns and trends were established which subsequently became more marked. Building on developments which took shape in the decade, women after 1900 were able to bring the emancipation of their sex to a point close to the centre of the political and social stage.

It was frequently observed as the new century approached that a new world was being born. Sidney Webb wrote in 1901 that historians would 'recognise, in the last quarter of the nineteenth century, the birth of another new England',[1] and there is little doubt that he was correct. Under the pressure of profound economic and social change and the emergence of class-based political parties, the social gulf which had done so much to cocoon and inhibit girls and women of the wealthy classes began to be bridged. In an interesting and significant speech in 1897 Lady Frederick (Lucy) Cavendish considered

change in her lifetime from the point of view of the upper-class woman and listed some of the relevant agents: railways, the widening of the franchise, the spread of education, cheaper books and newspapers.[2] In a society in which established institutions were under unprecedented attack social cohesion was nonetheless closer than ever before, and gently born women required less stringent protection. What might be called caste ritual began to decline. Rail travel by second or even third class was no longer considered disgraceful; as Lady Frederick commented: 'All the world knocks about London by underground railway, and ladies of high degree meet inside and outside omnibuses.'[3] The bicycle, the class- and sex-levelling symbol of the decade, was of specially great importance in terms of women's emancipation. It is difficult to imagine it as a mass means of transport in an earlier period.

Lady Frederick called particular attention to 'the intermingling of classes'.[4] Such a process could hardly fail to enhance the position of women. The rise of a more democratic society was bound to include the larger, female half of the population. Even poorly paid clerical and civil service employment helped to create the beginnings of a new world for women. For the fortunate few who rose into more creative and responsible work as for those who were elected to positions in local government, opportunities were much greater. Their advance owed much to developments in industry and government and to economic and social changes independent of the activity of women's rights campaigners.[5] Yet, as Sidney Webb pointed out on another occasion, powerful as the time-spirit might be it could not pass acts of Parliament or build public libraries without human agency.[6] It was not 'history' or 'economic necessity' which demonstrated that women could equal or surpass men in university examinations, serve on school boards and boards of guardians, or embark on careers as factory inspectors or journalists. For the first time in industrial Britain 'history' was on the side of such middle-class women, but they pushed it on its way courageously and unceremoniously.[7]

It was inevitable that in the circumstances of the 1890s there was no single women's movement, no agreed programme of emancipation behind which all progressive women were united. To approach such a situation needed another three-quarters of a century of growth and education. Nonetheless, women ad-

vanced along a wide front. In favourable economic and social conditions a variety of women worked for the emancipation of their sex, though many of them would not have accepted that they were advocates of women's rights. Elizabeth Wordsworth, intent on producing good wives, helped to lift the ambitions of many middle-class women. Lottie Dod, clad as a lady and counselling a separate women's approach to sport, showed that women were capable of hard physical effort. Emily Jackson, seeking escape from an over-hasty marriage and her husband's roof, extended the rights of all married women. Deborah Gorham points out that expanded opportunities were accompanied by a continuing acceptance of a 'feminine', that is, subordinate role.[8] The point is a fair one, but the society of the late nineteenth century was not the society of today. A process of emancipation had begun which later generations of women were able to strengthen and transform.

It was observed in the period that while many women were unable to marry because of the imbalance of the sexes, others showed no sign of wishing to do so. The rejection of a wife's conventional role in favour of a greater measure of personal freedom was itself a significant step towards emancipation. The problems involved in the use of artificial methods of birth control, the social stigma attached to divorce and the hazards of abortion severely limited the development of sexual freedom, but the mirror held up to marriage in the period stimulated the growth of hostility to the presumed rights of husbands. It is easy to imagine an acerbic critic of marriage like Mona Caird in an earlier decade, but the technological means of distributing her views to a wide public, and the growth of a public eager to debate them were developments of the late years of the nineteenth century.

Technological and economic change did little to assist women engaged in manual occupations during the period. It was not for want of strenuous effort that little success was achieved. Middle-class women like Clementina Black, Isabella Ford and Gertrude Tuckwell worked with a seriousness of purpose and a far-reaching comprehension of the issues involved which compel respect and admiration. Working-class women like Annie Marland, Ada Nield and others struggled to improve the conditions of women workers, often in heartbreaking conditions.

The effort to liberate the working-class woman from the

chains of industrial exploitation did not enjoy the same support from economic and social change which assisted the middle- and upper-class woman. The over-supply of labour which led men to regard women workers as their rivals, primitive machinery which encouraged cheap labour, cut-throat competition, a climate of opinion which left employers largely free to exploit their women workers so long as their goods were cheap, the impossibility of a small contingent of inspectors adequately enforcing the law in thousands of factories and workshops, the inevitable willingness of working women and girls to connive in their own exploitation and the weakness of the industrial and political labour movements were problems which could not begin to be overcome until the political, social and economic structure was wrenched into new directions by the impact of the Great War.

Yet even in this sphere there was progress. Working-class women, better led and more conscious of their conditions, began to demand improvements, taking a relatively active role in Lancashire, where their trade union membership was of long standing. The growth of the Women's Co-operative Guild, giving for the first time a voice to the working-class woman in an organisation of her own, was a sign of the times. So too was the greater interest displayed by the middle-class public, by Parliament and government in the employment of the working-class woman. The exhaustive inquiries of the Royal Commission on Labour, the appointment of Clara Collet to the Board of Trade's labour staff, the admission by the Home Office that men inspectors were incapable of adequately protecting the women workers for whom factory legislation had been passed, and the attention paid to working women and to trade union efforts on their behalf by the serious monthly press all indicated a growing realisation that the conditions of working women had assumed a new importance. The fascinating, agonising battles waged between partisans and opponents of extended protective legislation which came to a head in the 1890s were another demonstration that the working woman had begun to occupy a more central role in the emancipation movement. Through this issue the meaning of women's rights was explored and problems discussed which still await solution.

The 1890s witnessed both defeats and victories. But it should be clear that to conjure up a picture of quiescence, the lull

between the storms of the emancipation movement, does not adequately depict the decade. This was a period in which the process of freeing women from the bonds of convention and legal restraint made unprecedented progress, in which the rights of women were never debated before. The subsequent outbreak of a militant suffrage movement was a suitable, though not an inevitable, flowering of the discussions and controversies which took place at the end of the nineteenth century.

Notes

1. Sidney Webb, 'Lord Rosebery's escape from Hounsditch', *Nineteenth Century and After*, 50 (1901), p. 369.
2. Lady Frederick Cavendish, 'The dangers of the luxury of modern life', *Women Workers: the Official Report of the Conference Held at Croydon 1897* (Roffey & Clark, Croydon, 1897), p. 53.
3. *ibid.*
4. *ibid.*
5. O. R. McGregor makes this point: 'The social position of women in England, 1850-1914: a bibliography', *British Journal of Sociology*, 6 (1955), pp. 54-5; *Divorce in England* (Heinemann, London, 1957), p. 87.
6. Sidney Webb, 'Historic', in G. B. Shaw (ed.), *Fabian Essays in Socialism* (1889; Walter Scott, London, 1908), p. 50.
7. *See* Harold Laski, quoted in Constance Rover, *Women's Suffrage and Party Politics in Britain 1866-1914* (Routledge & Kegan Paul, London, 1967), p. 101.
8. Deborah Gorham, *The Victorian Girl and the Feminine Ideal* (Croom Helm, London, 1982), p. 57 and *passim*.

Bibliography

I. Primary sources

1) ARCHIVE COLLECTIONS

2) PARLIAMENTARY PAPERS

3) NEWSPAPERS, PERIODICALS, ANNUAL REPORTS

4) FICTION

5) AUTOBIOGRAPHIES, MEMOIRS, DIARIES, LETTERS

6) OTHER CONTEMPORARY BOOKS AND PAMPHLETS

II. Secondary sources

1) BIOGRAPHIES

2) OTHER BOOKS AND PAMPHLETS

3) ARTICLES

4) UNPUBLISHED THESES

All books and pamphlets were published in London unless otherwise stated.

I. Primary sources

1) ARCHIVE COLLECTIONS
Bodleian Library, Oxford
 Primrose League Papers
British Library
 Elizabeth C. Wolstenholme Elmy Papers
British Library of Political and Economic Science (London School of Economics)

Margaret Ethel MacDonald Papers
Typescript Diaries of Beatrice Webb
Beatrice and Sidney Webb Papers, Trade Union Documents
Women's Co-operative Guild Papers
Fawcett Library (City of London Polytechnic)
 Archive Letters
 Autograph Letter Collection
 Kathleen Courtney Papers
Girton College, Cambridge
 Archive Letters and Documents
 Helen Blackburn Papers
 Emily Davies Papers
 Dorothy Howard Letters
Manchester Reference Library
 Millicent Garrett Fawcett Papers
Lady Margaret Hall, Oxford
 Brown Book (Reports of the Old Students' Association)
 College Minute Books and Annual Reports
 Violet Craigie Halkett Verses
 Clara Burdett Patterson Typescript Memoirs, 1897-8
 Maude Royden Letters to Kathleen Courtney
Modern Records Centre, University of Warwick
 Clara Collet Papers
Public Record Office
 Treasury Papers — T1
Trades Union Congress
 Gertrude Tuckwell Collection
University of Hull
 Sydney Savory Buckman Papers
 Women's Co-operative Guild Papers

2) PARLIAMENTARY PAPERS
Board of Trade Abstracts of Labour Statistics
 5th — P.P. 1898, LXXVIII
 10th — P.P. 1905, LXXVI
 17th — P.P. 1914-16, LXI
Board of Trade Reports on Trade Unions
 P.P. 1896, XCIII
 P.P. 1897, XCIX
 P.P. 1898, CIII
 P.P. 1901, LXXIV
 P.P. 1906, CXIII
Census of England and Wales
 1891, P.P. 1893-4, CVI
 1901, P.P. 1903, LXXXIV

1901, P.P. 1904, CVIII
1911, P.P. 1917-18, XXXV
Committee on the Cotton Cloth Factories Act 1889
P.P. 1897, XVII
Committee on Government Contracts
P.P. 1896, X
P.P. 1897, X
Departmental Committee on Metropolitan Poor Law Schools
P.P. 1896, XLIII
Departmental Committee on the Various Lead Industries
P.P. 1893-4, XVII
Education Department, Special Reports on Special Subjects, vol. 2
P.P. 1898, XXIV
Factory Inspectors' Reports on Conditions in Laundries
P.P. 1894, XXI
Interdepartmental Committee on Post Office Establishments
P.P. 1897, XLIV
Labour Department (Progress of Work)
P.P. 1893-4, LXXXII
Local Government Board, Twenty-Third Annual Report, 1893-4
P.P. 1894, XXXVIII
Local Government (Registered Electors)
P.P. 1897, LXXVI-I
Report by Miss Collet on the Statistics of Employment of Women and Girls
P.P. 1894, LXXXI-II
Reports of the Chief Inspector of Factories and Workshops
P.P. 1894, XXI
P.P. 1895, XIX
P.P. 1900, XI
P.P. 1901, X
P.P. 1903, XII
Return of the Number of Women on the Respective Technical Instruction Committees of County and County Borough Councils
P.P. 1900, LXVI
Return of Post Office Telegraphists
P.P. 1894, LXX
Royal Commission on Divorce and Matrimonial Causes
P.P. 1912-13, XVIII
Royal Commission on Labour
P.P. 1892, XXXV
P.P. 1892, XXXVI-I
P.P. 1892, XXXVI-II
P.P. 1893-4, XXXIV
P.P. 1893-4, XXXVII-I

P.P. 1894, XXXV
Royal Commission on Secondary Education
 P.P. 1895, XLIII
 P.P. 1895, XLVI
 P.P. 1895, XLVIII

House of Lords Papers
 Women's Suffrage (Local Government), 1890, XVII

3) NEWSPAPERS, PERIODICALS, ANNUAL REPORTS
The Adult
Atalanta
Blackburn Times
Blackwood's Edinburgh Magazine
British Association, *Report of the Seventieth Meeting* (1900); *Report of the
 Seventy-Third Meeting* (1903)
British Medical Journal
Cambridge University Reporter
Central Committee of the National Society for Women's Suffrage,
 Annual Reports
Clitheroe Times
Contemporary Review
Co-operative News
The Cyclist
Daily Chronicle
Daily Graphic
Daily Telegraph
Economic Journal
Economic Review
The Englishwoman
Engishwoman's Review
Englishwoman's Year-Book and Directory
Fabian News
Factory Times
Fortnightly Review
The Forum (New York)
Free Review
Friends' Quarterly Examiner
The Gentlewoman
Girls' Own Paper
Hull News
The Humanitarian
Illustrated London News
Judy
Justice

Labour Annual
Labour Gazette (later *Ministry of Labour Gazette*)
Labour Leader
Lady's Realm
Lady's World
The Lancet
Law Reports: Queen's Bench Division and Court of Appeal
Law Times
Law Times Reports
Liberal Year Book 1888
Manchester Guardian
Morning Post
National Union of Conservative and Constitutional Associations, Manuscript Reports of Annual Conferences (Harvester Press Microform, Brighton, 1982)
National Union of Women Workers, *Women Workers* (conference reports)
Newcastle Daily Chronicle
New Weekly
Nineteenth Century (and *Nineteenth Century and After*)
North American Review (New York)
Pall Mall Gazette
Parliamentary Debates
Pearson's Magazine
Personal Rights Journal
Physical Culture (later *Sandow's Magazine of Physical Culture*)
Primrose League Gazette
Punch
Quarterly Review
Rational Dress Gazette
Review of Reviews
St. James's Gazette
Saturday Review
Shafts
Shipley Times
Sketch
Social Economist (New York)
Society of Women Journalists, *Annual Report*, 1900-1
The Standard
The Star
The Times
Times Law Reports
Trades Union Congress, *Annual Reports*
Westfield College, *Report*, 1897
Westminster Review

Woman
Woman's Signal
Women's Co-operative Guild, *Annual Reports*
Women's Employment
Women's Emancipation Union, *Annual Reports*
Women's Franchise League, *Annual Reports*
Women's Industrial News
Women's Liberal Federation, *Annual Reports*
Women's Local Government Society, *Annual Reports*
Women's National Liberal Association, *Annual Reports*
Women's National Liberal Association, *Quarterly Leaflets*
Women's Trades Union League, *Annual Reports*
Women's Trades Union Review
Young Woman

4) FICTION

Allen, Grant, *The Woman Who Did* (John Lane, 1895)
Caird, Mona, *The Daughters of Danaus* (Bliss, Sands & Foster, 1894)
—— *The Wing of Azrael* (Trübner, 1889)
Dix, Gertrude, *The Image Breakers* (Heinemann, 1900)
Dixon, Ella Hepworth, *The Story of a Modern Woman* (Heinemann, 1894)
Egerton, George, *Discords* (1894; Virago, 1983)
—— *Keynotes* (1893; Virago, 1983)
—— *Rosa Amorosa: the Love Letters of a Woman* (Grant Richards, 1901)
Ellis, Edith, *Seaweed, a Cornish Idyll* (University Press, 1898)
Ford, Isabella, *On the Threshold* (Arnold, 1895)
Fothergill, Caroline, *The Comedy of Cecilia* (A. & C. Black, 1895)
Gissing, George, *The Odd Women*, three volumes (Lawrence & Bullen, 1893)
Grand, Sarah, *The Beth Book* (1897; Virago, 1980)
—— *The Heavenly Twins*, three volumes (Heinemann, 1893)
Grossmith, George and Weedon, *The Diary of a Nobody* ([1892]; Dent, 1940)
Iron, Ralph (i.e., Olive Schreiner), *The Story of an African Farm*, two volumes (Chapman & Hall, 1883)
Meade, L. T. (i.e. Elizabeth Thomasina Meade), *A Sweet Girl Graduate* (Cassell, 1891)
Nesbit, Edith, *In Homespun* (John Lane, 1896)
Sharp, Evelyn, *The Making of a Prig* (John Lane, 1897)
Syrett, Netta, *Nobody's Fault* (John Lane, 1896)
Travers, Graham (i.e., Margaret G. Todd), *Mona Maclean, Medical Student*, three volumes (Blackwood, Edinburgh and London, 1892)
Ward, Mary Augusta, *Marcella*, three volumes (Smith, Elder, 1894)

Wells, H.G., *The New Machiavelli* (John Lane, 1911)
—— *The Wheels of Chance* (Dent, 1896)

5) AUTOBIOGRAPHIES, MEMOIRS, DIARIES, LETTERS

Aberdeen, Lord and Lady, *'We Twa'*, two volumes (Collins [1925])

Anderson, Adelaide, *Women in the Factory: An Administrative Adventure, 1893 to 1921* (Murray, 1922)

Asquith, Margot (the Countess of Oxford and Asquith) (ed.), *Myself When Young* (Muller, 1938) (includes chapters by Sylvia Pankhurst and Maude Royden)

Balfour, Frances, *Ne Obliviscaris: Dinna Forget*, two volumes (Hodder & Stoughton [1930])

Banks, Elizabeth L., *The Autobiography of a 'Newspaper Girl'* (Methuen, 1902)
—— *Campaigns of Curiosity: Journalistic Adventures of an American Girl in London* (Cassell, 1894)

Blatch, Harriot Stanton and Lutz, Alma, *Challenging Years: the Memoirs of Harriot Stanton Blatch* (G.P. Putnam's Sons, New York, 1940)

Bondfield, Margaret, *A Life's Work* (Hutchinson [1949])

Brittain, Vera, *Testament of Youth* (Gollancz, 1933)

Brodrick, George C., *Memories and Impressions 1831-1900* (Nisbet, 1900)

Brown, Violet E.L., *The Silver Cord* (privately published, Sherborne [?1954])

Burstall, Sara A., *Retrospect & Prospect: Sixty Years of Women's Education* (Longmans, 1933)

Chew, Doris Nield, *The Life and Writings of Ada Nield Chew* (Virago, 1982)

Cole, Margaret, *Growing Up Into Revolution* (Longmans, 1949)

Courtney, Janet E., *Recollected in Tranquillity* (Heinemann, 1926)
—— *The Women of My Time* (Lovat Dickson, 1934)

Davies, Margaret Llewelyn (ed.), *Life as We Have Known It* (1931; Virago, 1977)

Dixon, Ella Hepworth, *'As I Knew Them': Sketches of People I Have Met on the Way* (Hutchinson [1930])

Faithfull, Lilian M., *In the House of My Pilgrimage* (Chatto & Windus, 1924)

Farnell, Lewis R., *An Oxonian Looks Back* (Martin Hopkinson, 1934)

Fawcett, Millicent Garrett, *What I Remember* (T. Fisher Unwin, 1924)

Fletcher, Margaret, *O, Call Back Yesterday* (Basil Blackwell, Oxford, 1935)

Gautrey, Thomas, *'Lux Mihi Laus': School Board Memories* (Link House [1937])

Gwynn, Stephen, *Experiences of a Literary Man* (Thornton Butterworth, 1926)

Haldane, Elizabeth S., *From One Century to Another* (Maclehose, 1937)

Hamilton, Mary Agnes, *Remembering My Good Friends* (Cape, 1944)

Harrison, Jane Ellen, *Reminiscences of a Student's Life* (L. & V. Woolf, 1925)

Holiday, Henry, *Reminiscences of My Life* (Heinemann [1914])

Hughes, M. V., *A London Home in the 1890s* (1937; Oxford University Press, Oxford, 1983)

Keynes, Florence Ada, *Gathering Up the Threads* (Heffer, Cambridge, 1950)

Lanchester, Elsa, *Charles Laughton and I* (Faber, 1938)

Lodge, Eleanor C., *Terms and Vacations* (ed. Janet Spens; Oxford University Press, 1938)

Lowndes, Marie Belloc, *The Merry Wives of Westminster* (Macmillan, 1946)

—— *Where Love and Friendship Dwelt* (Macmillan, 1943)

Lubbock, Sybil, *The Child in the Crystal* (Cape, 1939)

MacKenzie, Norman and Jeanne (eds), *The Diary of Beatrice Webb, vol. 1, 1873-1892* (Virago, 1982)

—— *The Diary of Beatrice Webb, vol. 2, 1892-1905* (Virago, 1983)

Marshall, Mary Paley, *What I Remember* (Cambridge University Press, Cambridge, 1947)

Martindale, Hilda, *From One Generation to Another, 1839-1944: a Book of Memoirs* (Allen & Unwin, 1944)

Maynard, Constance L., 'Girton's earliest years', *Between College Terms* (Nisbet, 1910)

Meier, Olga (ed.), *The Daughters of Karl Marx: Family Correspondence 1866-1898* (Deutsch, 1982)

Mitchell, Hannah, *The Hard Way Up* (Faber, 1968)

Montefiore, Dora B., *From a Victorian to a Modern* (Archer, 1927)

Mumford, Edith E. Read, *Through Rose-Coloured Spectacles* (Edgar Backus, Leicester, 1952)

Nevinson, H. W., *More Changes More Chances* (Nisbet, 1925)

Pankhurst, Emmeline, *My Own Story* (Eveleigh Nash, 1914)

Peck, Winifred, *A Little Learning, or a Victorian Childhood* (Faber, 1952)

Peel, Dorothy, *Life's Enchanted Cup: an Autobiography (1872-1933)* (John Lane, [1933])

Phillips, Ann (ed.), *A Newnham Anthology* (Cambridge University Press, Cambridge, 1979)

Priestley, J. B., *Margin Released* (1962; Reprint Society, 1963)

Richmond, Elsa (ed.), *The Earlier Letters of Gertrude Bell* (Benn, 1937)

'Rita' (Eliza Humphreys), *Recollections of a Literary Life* (Andrew Melrose, 1936)

Robins, Elizabeth, *Both Sides of the Curtain* (Heinemann, 1940)

Royden, Maude, *A Threefold Cord* (Gollancz, 1947)

Sharp, Evelyn, *Unfinished Adventure* (John Lane, 1933)

Smyth, Ethel, *As Time Went On ...* (Longmans, 1936)

Squire, Rose E., *Thirty Years in the Public Service* (Nisbet, 1927)

Stanton, Elizabeth Cady, *Eighty Years and More* (T. Fisher Unwin, 1898)

Stringer, Mabel, *Golfing Reminiscences* (Mills & Boon, 1924)

Swanwick, Helena, *I Have Been Young* (Gollancz, 1935)

Sweeney, John, *At Scotland Yard* (Grant Richards, 1904)

Syrett, Netta, *The Sheltering Tree* (Bles, 1939)

Thompson, Flora, *Lark Rise to Candleford* (1939; Oxford University Press, 1965)

Twining, Louisa, *Recollections of Life and Work* (Arnold, 1893)

Tynan, Katharine, *The Middle Years* (Constable, 1916)

Ward, Mary Augusta, *A Writer's Recollections* (Collins, 1918)

Webb, Beatrice, *My Apprenticeship* (Longmans, 1926)

—— *Our Partnership* (ed. Barbara Drake and Margaret I. Cole; Longmans, 1948)

6) OTHER CONTEMPORARY BOOKS AND PAMPHLETS

Aberdeen, Countess of (ed.), *The International Congress of Women of 1899*, seven volumes (T. Fisher Unwin, 1900)

Anderson, Elizabeth Garrett, 'Medical training of women in England', in Countess of Warwick (ed.), *Progress in Women's Education* (q.v.)

Anon., *Why are Women Wanted on Urban District Councils?* (Women's Local Government Society, 2nd edn, 1907)

Bateson, Margaret (ed.), *Professional Women Upon their Professions* (Cox, 1895)

Beale, Dorothea; Soulsby, Lucy H. M.; Dove, Jane Frances, *Work and Play in Girls' Schools* (Longmans, 1898)

Beaumont, Charles M., *Marriage and Money* (Elizabeth Wolstenholme Elmy, Congleton [1891])

Bennett, E. A. (Arnold), *Journalism for Women* (John Lane, 1898)

Billington, Mary (ed.), *Marriage, its Legal Preliminaries and Social Observances* (F. W. Sears [1900])

Black, Clementina, 'Some current objections to factory legislation for women', in B. Webb (ed.), *The Case for the Factory Acts* (q.v.)

Blackburn, Helen, *Women's Suffrage* (Williams & Norgate, 1902)

—— (ed.), *A Handbook for Women Engaged in Social and Political Work* (1881; Arrowsmith, Bristol, 1895)

Blandford, George Fielding, *Insanity and its Treatment* (1871; 4th edn, Oliver & Boyd, Edinburgh, 1892)

Boucherett, Jessie; Blackburn, Helen and others, *The Condition of Working Women and the Factory Acts* (Elliot Stock, 1896)

Bremner, Christina Sinclair, *Education of Girls and Women in Great Britain* (Swan Sonnenschein, 1897)

Bright, Ursula, 'The origin and objects of the Women's Franchise League of Great Britain and Ireland', in May Wright Sewall (ed.), *The World's Congress of Representative Women* (Rand McNally, Chicago and New York, 1894)

Brownlow, Jane M. E., *Women's Work in Local Government (England and Wales)* (David Nutt, 1911)

Bulley, A. Amy and Whitley, Margaret, *Women's Work* (Methuen, 1894)

Busk, Alice E., *Women's Work on London Vestries* (Women's Local Government Society, 1899)

—— 'Administrative work for women on urban and rural governing bodies' in Aberdeen (ed.), *International Congress*, vol. V

—— 'Women's work on vestries and councils' in J. E. Hand (ed.), *Good Citizenship* (Geo. Allen, 1899)

Byles, Sarah Anne, 'The work of women inspectors', in Aberdeen (ed.), *International Congress*, vol. III

Cadbury, Edward; Matheson, M. Cécile and Shann, George, *Women's Work and Wages* (T. Fisher Unwin, 1908)

Caird, Mona, *The Morality of Marriage* (George Redway, 1897)

Campbell, Harry, *Differences in the Nervous Organisation of Man and Woman* (H. K. Lewis, 1891)

Carpenter, Edward, *Love's Coming of Age* (Labour Press, Manchester, 1896)

—— *Marriage in Free Society* (Labour Press, Manchester, 1894)

—— *Sex-Love, and its Place in a Free Society* (Labour Press, Manchester, 1894)

—— *Woman, and her Place in a Free Society* (Labour Press, Manchester 1894)

A Century of Law Reform (Macmillan, 1901)

Chapman, A. B. W. and Chapman, M. W., *The Status of Women under the English Law* (Routledge, 1909)

Chapman, Elizabeth Rachel, *Marriage Questions in Modern Fiction* (John Lane, 1897)

Collet, Clara E., *Educated Working Women: Essays on the Economic Position of Women Workers in the Middle Classes* (P. S. King, 1902)

—— 'Women's work', in Charles Booth (ed.), *Life and Labour, vol. I: East London* (Williams & Norgate, 1889)

Corelli, Marie; Jeune, Mary; Steel, Flora Annie; Malmesbury, Susan, Countess of, *The Modern Marriage Market* (Hutchinson, 1898)

Croly, Jennie, *The History of the Woman's Club Movement in America* (Henry Allen, New York, 1898)

Davenport-Hill, Rosamond, *Women on School Boards* (Women's Local Government Society, 1898)

Dawson, Oswald, *The Outcome of Legitimation* (Legitimation League [1898])

—— (ed.), *The Bar Sinister and Licit Love: the First Biennial Proceedings of the Legitimation League* (W. Reeves, London and Geo. Cornwell, Leeds, 1895)

Devereux, Roy (i.e., Margaret Rose Roy Pember-Devereux), *The Ascent of Woman* (John Lane, 1896)

Dod, Lottie, 'Ladies' lawn tennis', in J. M. Heathcote *et al.*, *Tennis, Lawn Tennis, Rackets, Fives* (Longmans, 1890)

—— 'Ladies' lawn tennis', in Earl of Suffolk and Berkshire, Hedley Peek and F. G. Aflalo (eds), *The Encyclopaedia of Sport*, two volumes (Lawrence & Bullen, 1897, 1898)

Douglas, Fanny, *The Gentlewoman's Book of Dress* (Henry & Co. [1895])

Dudfield, T. Orme, *Woman's Place in Sanitary Administration* (Woman Sanitary Inspectors' Association, 1904)

Ellis, Edith, *A Noviciate for Marriage* (published by the author, [?Haslemere, Surrey, ?1894])

Ellis, Havelock, *Man and Woman: a Study of Human Secondary Sexual Characters* (Walter Scott, 1894)

Elmy, Elizabeth C. Wolstenholme, *Women's Suffrage* (Women's Emancipation Union, Congleton, 1897)

Escombe, Jane, *The Housing Problem in Rural Districts* (n.p. [?1901])

—— *Sanitary Work in Rural Districts* (Women's Local Government Society [1903])

Escott, T. H. S., *Social Transformations of the Victorian Age* (Selby, 1897)

Eversley, W. P., *The Law of the Domestic Relations* (Stevens & Haynes, 1906)

Fawcett, Millicent Garrett, *A Reply to the Letter of Mr. Samuel Smith, M.P., on Women's Suffrage* (Central Committee of the National Society for Women's Suffrage, 1892)

—— *Women's Suffrage: a Short History of a Great Movement* (T. C. & E. C. Jack [1912])

—— introduction to Mary Wollstonecraft, *A Vindication of the Rights of Women* (1792: T. Fisher Unwin, 1891)

Ferrero, Guglielmo, *L'Europa Giovane* (Fratelli Treves, Milan, 1897)

Gamble, Eliza Burt, *The Evolution of Woman: an Inquiry into the Dogma of her Inferiority to Man* (G. P. Putnam's Sons, New York, 1894)

Geddes, Patrick, and Thomson, J. Arthur, *The Evolution of Sex* (Walter Scott [1889].

Gladstone, W. E., *Female Suffrage, A Letter from the Rt. Hon. W. E. Gladstone, M.P., to Samuel Smith, M.P.* (Murray, 1892)

Grand, Sarah, *The Human Quest* (Heinemann, 1900)

—— *The Modern Man and Maid* (H. Marshall, 1898)

Greville, Beatrice Violet, *The Gentlewoman in Society* (Henry & Co., 1892)

Hardy, E. J., *Love, Courtship and Marriage* (Chatto & Windus, 1902)

Harrison, Frederic, *On Society* (Macmillan, 1918)

Hill, Georgiana, *A History of English Dress from the Saxon Period to the Present Day*, two volumes (Bentley, 1893)

—— *Women in English Life from Mediaeval to Modern Times*, two volumes (Bentley, 1896)

Hogarth, Janet, 'The education of women for business', in Countess of Warwick (ed.), *Progress in Women's Education* (q.v.)

Holyoake, Emilie, 'The need of organisation among women', in Frank W. Galton (ed.), *Workers on their Industries* (1895; Swan Sonnenschein, 1896)

Hutchins, B.L. and Harrison, Amy, *A History of Factory Legislation* (1903; Cass, 1966)

Hutchinson, Horace G., *Golf* (Longmans, 1890; 4th edn, Longmans, 1893)

Independent Labour Party (City of London Branch), *Labour Laws for Women, their Reason and their Results* (ILP, 1900)

James, Alice R., *Girls' Physical Training: Being a Series of Healthy and Artistic Movements to Music* (Macmillan, 1898)

Jeune, Mary, *Lesser Questions* (Remington, 1894)

Kilgour, Mary Stewart, *Why are Women Wanted on Rural District Councils?* (Women's Local Government Society [?1906])

—— *Women as Members of Local Sanitary Authorities* (Baillière, Tindall & Cox [1900])

Latimer, Caroline W., 'The medical profession', in *Ladies at Work: Papers on Paid Employment for Ladies* (introduction by Lady Jeune) (A.D. Innes, 1893)

Lecky, W.E.H., *Democracy and Liberty*, two volumes (Longmans, 1896)

Lee, Alice, assisted by Karl Pearson, 'Data for the problem of evolution in man. — VI. A first study of the correlation of the human skull', *Philosophical Transactions of the Royal Society of London*, series A, 196 (1901)

Legitimation League, *The Rights of Natural Children: Verbatim Report of the Inaugural Proceedings of the Legitimation League* (W. Reeves, London and Geo. Cornwell, Leeds, 1893)

Lilly, W.S., *On Shibboleths* (Chapman & Hall, 1892)

Lombroso, Cesare and Ferrero, Guglielmo, *La Donna Delinquente* (Roux, Turin, 1893); translated as *The Female Offender* (T. Fisher Unwin, 1895)

Low, Frances, *Press Work for Women* (Upcott Gill, 1904)

Lowell, A. Lawrence, *The Government of England*, two volumes (1908; Macmillan, New York, 1912)

MacDonald, J. Ramsay (ed.), *Women in the Printing Trades* (P.S. King, 1904)

MacDonald, Margaret Ethel, 'Factory legislation', in Aberdeen (ed.), *International Congress*, vol. VI

Mackern, Louie, 'Ladies' golf' in Suffolk and Berkshire, *et al.*,

Encyclopaedia of Sport, vol. I (Lawrence & Bullen, 1897)

—— and Boys, M. (eds), *Our Lady of the Green* (Lawrence & Bullen, 1899)

Mackintosh, Robert, *From Comte to Benjamin Kidd: the Appeal to Biology or Evolution for Human Guidance* (Macmillan, 1899)

March-Phillipps, Evelyn, 'The economic position of women journalists', in Aberdeen (ed.), *International Congress*, vol. IV

Marland-Brodie, Annie, 'Women's trades unions in Great Britain and Ireland' in *ibid.*, vol. VI

Marshall, Maud, 'Lawn-tennis', in F.E. Slaughter (ed.), *Sportswoman's Library* (q.v.), vol. II

Miller, Florence Fenwick, *On the Programme of the Women's Franchise League* (Women's Franchise League, Congleton, 1890)

Montefiore, Dora B., *'Singings Through the Dark': Poems* (Sampson Low, 1898)

Morten, Honnor, *Questions for Women (and Men)* (Black, 1899)

Nisbet, J.F., *The Human Machine* (Grant Richards, 1899)

Nordau, Max, *Entartung*, two volumes (C. Duncker, Berlin, 1892-3); translated as *Degeneration* (Heinemann, 1895)

—— *Paradoxe* (B.E. Nachfolger, Leipzig [1885]); translated as *Paradoxes* (Heinemann, 1896)

Oakeshott, J.F., *The Humanising of the Poor Law* (Fabian Society, 1894)

Ouida, *Views and Opinions* (Methuen, 1895)

Pankhurst, Christobel, *The Great Scourge and How to End It* (E. Pankhurst, 1913)

Parker, Gilbert, 'The housing of educated working women', in Aberdeen (ed.), *International Congress*, vol. I

Pearson, Charles H., *The Present Position of Women in Victoria* (Women's Emancipation Union, Congleton, 1893)

Pearson, Karl, *The Chances of Death*, two volumes (Edward Arnold, 1897)

Philipps, Leonora Wynford, 'Women's clubs in England', in Aberdeen (ed.), *International Congress*, vol. VII

—— and others, *A Dictionary of Employments Open to Women with Details of Wages, Hours of Work and Other Information* (Women's Institute, 1898)

Quilter, Harry (ed.), *Is Marriage a Failure?* (Swan Sonnenschein [1888])

Scharlieb, Mary, *A Woman's Words to Women on the Care of their Health in England and in India* (Swan Sonnenschein, 1895)

School Board for London, *Return of All Members of the Board During its Existence* (London County Council, 1904)

Shaw, George Bernard, *Women as Councillors* (Fabian Society, 1900)

Sidgwick, Eleanor Mildred, *Health Statistics of Women Students of*

Cambridge and Oxford and of their Sisters (Cambridge University Press, Cambridge, 1890)

—— *The Place of University Education in the Life of Women* (Women's Institute [1897])

Slaughter, Frances E. (ed.), *The Sportswoman's Library*, two volumes (Archibald Constable, 1898)

Stacy, Enid, 'A century of women's rights', in Edward Carpenter (ed.), *Forecasts of the Coming Century* (Labour Press, Manchester; Clarion Office, London, 1897)

Starkie-Bence, A. W. M., 'Golf', in Slaughter (ed.), *Sportswoman's Library*, vol. I

Swan, Annie S., *Courtship and Marriage and the Gentle Art of Home-Making* (Hutchinson, 1893)

Swiney, Frances, *The Awakening of Women* (1899; 2nd edn, William Reeves [1905])

Twining, Louisa, *Workhouses and Pauperism and Women's Work in the Administration of the Poor Law* (Methuen, 1898)

Union of Practical Suffragists, *Origin and Growth of the Union* (UPS, 1898)

Walker, Jane, *A Book for Every Woman*, two volumes (Longmans, 1895, 1897)

Warwick, Countess of (ed.), *Progress in Women's Education in the British Empire* (Longmans, 1898)

Webb, Beatrice, *Women and the Factory Acts* (Fabian Society, 1896)

—— (ed.), *The Case for the Factory Acts* (Grant Richards, 1901)

—— and Sidney, *Industrial Democracy*, two volumes (Longmans, 1897)

—— *Problems of Modern Industry* (Longmans, 1898)

Webb, Sidney, 'Historic' in George Bernard Shaw (ed.), *Fabian Essays in Socialism* (1889; Walter Scott, 1908)

Wells, H.G., *Mankind in the Making* (Chapman & Hall, 1903)

Wellwood, Lord, 'General remarks on the game' in Hutchinson, *Golf*

Women's Co-operative Guild, *Why Working Women Need the Vote* (WCG, Kirkby Lonsdale, 1897)

Wordsworth, Elizabeth, *First Principles in Women's Education* (James Parker, Oxford, 1894)

Zimmern, Alice, *The Renaissance of Girls' Education in England* (A.D. Innes, 1898)

II. Secondary sources

1) BIOGRAPHIES

Anderson, Louisa Garrett, *Elizabeth Garrett Anderson* (Faber, 1939)

Askwith, Betty, *Two Victorian Families* (Stracheys and Bensons)

(Chatto & Windus, 1971)

Battiscombe, Georgina, *Reluctant Pioneer: a Life of Elizabeth Wordsworth* (Constable, 1978)

Caine, Barbara, 'Beatrice Webb and the "woman question"', *History Workshop Journal*, 14 (1982)

Clough, Blanche Athena, *A Memoir of Anne Jemima Clough* (Arnold, 1897)

First, Ruth and Scott, Ann, *Olive Schreiner* (Deutsch, 1980)

Firth, Catherine B., *Constance Louisa Maynard* (Allen & Unwin, 1949)

Forster, Margaret, *Significant Sisters* (Secker & Warburg, 1984) (includes a biographical study of Emily Davies)

Fox, Alice Wilson, *The Earl of Halsbury Lord High Chancellor (1823-1921)* (Chapman & Hall, 1929)

Frederick James Furnivall, a Volume of Personal Record (Henry Frowde, 1911)

Grattan-Guinness, I., 'A mathematical union: William Henry and Grace Chisholm Young', *Annals of Science*, 29 (1972)

Grosskurth, Phyllis, *Havelock Ellis* (1980; Quartet Books, 1981)

Hamilton, Mary Agnes, *Margaret Bondfield* (Parsons, 1924)

Harris, Jose, *Beatrice Webb: the Ambivalent Feminist* (London School of Economics and Political Science, 1984)

Harrison, Frederic, *Memoir and Essays of Ethelbertha Harrison* (Pitman, Bath, 1917)

Henley, Dorothy, *Rosalind Howard, Countess of Carlisle* (Hogarth Press, 1958)

Heuston, R. F. V., *Lives of the Lord Chancellors 1885-1940* (Clarendon Press, Oxford, 1964)

Horner, Isaline B., *Alice M. Cooke, a Memoir* (Manchester University Press, Manchester, 1940)

Johnston, Johanna, *Mrs. Satan: the Incredible Saga of Victoria Woodhull* (Macmillan, 1967)

Jones, Enid Huws, *Mrs. Humphry Ward* (Heinemann, 1973)

Kent, William, *John Burns: Labour's Lost Leader* (Williams & Norgate, 1950)

Kersley, Gillian, *Darling Madame: Sarah Grand and Devoted Friend* (Virago, 1983)

Keynes, J. M., 'Mary Paley Marshall (1850-1944)', *Economic Journal*, 54 (1944)

Lewis, Jane, 'Re-reading Beatrice Webb's diary' *History Workshop Journal*, 16 (1983)

Liddington, Jill, *The Life and Times of a Respectable Rebel: Selina Cooper (1864-1946)* (Virago, 1984)

Linklater, Andro, *An Unhusbanded Life: Charlotte Despard, Suffrage, Socialist and Sinn Feiner* (Hutchinson, 1980)

Love, Rosaleen, '"Alice in Eugenics-Land"; feminism and eugenics

in the scientific careers of Alice Lee and Ethel Elderton', *Annals of Science*, 36 (1979)

MacDonald, J. Ramsay, *Margaret Ethel MacDonald* (Hodder & Stoughton, 1912)

Malleson, Hope, *A Woman Doctor: Mary Murdoch of Hull* (Sidgwick & Jackson, 1919)

Mansbridge, Albert, *Margaret McMillan, Prophet and Pioneer* (Dent, 1932)

Markham, Violet R., *May Tennant, a Portrait* (Falcon Press, 1949)

Martindale, Hilda, *Some Victorian Portraits and Others* (Allen & Unwin, 1948) (includes accounts of Adelaide Anderson, Emily Flemming and Louisa Martindale)

May, J. Lewis, *John Lane and the Nineties* (John Lane, 1936)

May, Jonathan, *Madame Bergman-Österberg* (Harrap, 1969)

Meade, Marion, *Free Woman: the Life and Times of Victoria W. Woodhull* (Knopf, New York, 1976)

Metcalfe, Ethel E., *Memoir of Rosamond Davenport-Hill* (Longmans, 1904)

Mitford, Nancy (ed.), *The Ladies of Alderley* (Chapman & Hall, 1938)

Moore, Doris Langley, *E. Nesbit* (1933; Rich & Cowan, 1936)

Nord, Deborah Epstein, *The Apprenticeship of Beatrice Webb* (Macmillan, Basingstoke and London, 1985)

Norton, Bernard J., 'Karl Pearson and statistics', *Social Studies of Science*, 8 (1978)

Oakley, Ann, 'Millicent Garrett Fawcett: duty and determination (1847-1929)' in Dale Spender (ed.), *Feminist Theorists* (Women's Press, 1983)

Oldfield, Sybil, *Spinsters of this Parish: the Life and Times of F. M. Mayor and Mary Sheepshanks* (Virago, 1984)

Pankhurst, E. Sylvia, *The Life of Emmeline Pankhurst* (T. Werner Laurie, 1935)

Pearson, E. S., *Karl Pearson* (Cambridge University Press, Cambridge, 1938)

Pentland, Marjorie, *A Bonnie Fechter: the Life of Ishbel Marjoribanks, Marchioness of Aberdeen & Temair* (Batsford, 1952)

Pigou, A. C. (ed.), *Memorials of Alfred Marshall* (Macmillan, 1925)

Roberts, Charles, *The Radical Countess: the History of the Life of Rosalind, Countess of Carlisle* (Steel Brothers, Carlisle, 1962)

Rowbotham, Sheila and Weeks, Jeffrey, *Socialism and the New Life: the Personal and Sexual Politics of Edward Carpenter and Havelock Ellis* (Pluto Press, 1977)

Rubinstein, David, 'The Buckman Papers: S. S. Buckman, Lady Harberton and rational dress', *Notes and Queries*, 24 (1977)

Sachs, Emanie, *'The Terrible Siren': Victoria Woodhull, 1838-1927* (Harper & Bros., New York, 1928)

Sharp, Evelyn, *Hertha Ayrton 1854-1923* (Arnold, 1926)

Sidgwick, Arthur and Sidgwick, Eleanor Mildred, *Henry Sidgwick, a Memoir* (Macmillan, 1906)

Sidgwick, Ethel, *Mrs. Henry Sidgwick, a Memoir by her Niece* (Sidgwick & Jackson, 1938)

Skidelsky, Robert, *John Maynard Keynes*, vol. I (Macmillan, 1983)

Stephen, Leslie, *The English Utilitarians, vol. III, John Stuart Mill* (Duckworth, 1900)

Stewart, Jessie, *Jane Ellen Harrison: a Portrait from Letters* (Merlin Press, 1959)

Stewart, William, *J. Keir Hardie* (1921; Independent Labour Party, 1925)

Stocks, Mary, *Eleanor Rathbone* (Gollancz, 1949)

Strachey, Barbara, *Remarkable Relations: the Story of the Pearsall Smith Family* (Gollancz, 1981)

Strachey, Ray, *Millicent Garrett Fawcett* (Murray, 1931)

Thompson, Lilian Gilchrist, *Sidney Gilchrist Thomas* (Faber, 1940) (for Clara James)

Trevelyan, Janet Penrose, *The Life of Mrs. Humphry Ward* (Constable, 1923)

VanArsdel, Rosemary T., *Florence Fenwick-Miller, Feminism and the Woman's Signal, 1895-1899* (University of Puget Sound, Tacoma, 1979)

White, Terence de Vere (ed.), *A Leaf from the Yellow Book: the Correspondence of George Egerton* (Richards Press, 1958)

Whyte, Frederic, *William Heinemann* (Cape, 1928)

Wilson, Francesca, *Rebel Daughter of a Country House: the Life of Eglantyne Jebb* (Allen & Unwin, 1967)

2) OTHER BOOKS AND PAMPHLETS

Adams, Carol; Bartley, Paula; Lown, Judy; Loxton, Cathy *Under Control: Life in a Nineteenth-Century Silk Factory* (Cambridge University Press, Cambridge, 1983)

Adburgham, Alison, *A Punch History of Manners and Modes 1841-1940* (Hutchinson, 1961)

Anderson, Gregory, *Victorian Clerks* (Manchester University Press, Manchester, 1976)

Anderson, Michael, *Family Structure in Nineteenth Century Lancashire* (Cambridge University Press, 1971)

Ashworth, William, *An Economic History of England 1870-1939* (Methuen, 1960)

Banks, J.A., *Prosperity and Parenthood* (1954; Routledge & Kegan Paul, 1969)

—— and Olive, *Feminism and Family Planning in Victorian England* (Liverpool University Press, Liverpool, 1964)

Banks, Olive, *Faces of Feminism* (Martin Robertson, Oxford, 1981)

Barker, Rodney, *Political Ideas in Modern Britain* (Methuen, 1978)

Bell, E. Moberly, *Storming the Citadel: the Rise of the Woman Doctor* (Constable, 1953)

Bellot, H. Hale, *University College London 1826-1926* (University of London Press, 1929)

Bercusson, Brian, *Fair Wages Resolutions* (Mansell, 1978)

Boston, Sarah, *Women Workers and the Trade Union Movement* (Davis-Poynter, 1980)

Boumelha, Penny, *Thomas Hardy and Women* (Harvester, Brighton, 1982)

Bowley, A.L., *Wages and Income in the United Kingdom since 1860* (Cambridge University Press, Cambridge, 1937)

Branca, Patricia, *Silent Sisterhood: Middle Class Women in the Victorian Home* (Croom Helm, 1975)

Brittain, Vera, *The Women at Oxford* (Harrap, 1960)

Bryant, Margaret, *The Unexpected Revolution* (University of London Institute of Education, 1979)

Burnham, Lord, *Peterborough Court, the Story of the Daily Telegraph* (Cassell, 1955)

Burstyn, Joan N., *Victorian Education and the Ideal of Womanhood* (Croom Helm, 1980)

Byrne, Muriel St Clare and Mansfield, Catherine Hope, *Somerville College 1879-1921* (Oxford University Press, Oxford [1922])

Bythell, Duncan, *The Sweated Trades* (Batsford, 1978)

Cadogan, Mary and Craig, Patricia, *You're a Brick, Angela! a New Look at Girls' Fiction from 1839 to 1975* (Gollancz, 1976)

Caine, Sydney, *The History of the Foundation of the London School of Economics and Political Science* (LSE and Bell, 1963)

Calder-Marshall, Arthur, *Lewd, Blasphemous and Obscene* (Hutchinson, 1972)

Carrier, N.H. and Jeffery, J.R., *External Migration: a Study of the Available Statistics 1815-1950* (HMSO, 1953)

Clegg, H.A.; Fox, Alan and Thompson, A.F., *A History of British Trade Unions since 1889, vol. I, 1889-1910* (Oxford University Press, 1964)

Cockburn, Cynthia, *Brothers: Male Dominance and Technological Change* (Pluto Press, 1983)

Crowther, M.A., *The Workhouse System 1834-1929* (1981; Methuen, 1983)

Crunden, Colin, *A History of Anstey College of Physical Education 1897-1972* (Anstey College, Sutton Coldfield, 1974)

Cruse, Amy, *After the Victorians* (Allen & Unwin, 1938)

Cunningham, Gail, *The New Woman and the Victorian Novel* (Macmillan, 1978)

Cunnington, C. Willett, *English Women's Clothing in the Nineteenth Century* (Faber, 1937)

Davidoff, Leonore, *The Best Circles: Society, Etiquette and the Season* (Croom Helm, 1973)

Davidson, Roger, *Whitehall and the Labour Problem in Late-Victorian and Edwardian Britain* (Croom Helm, 1985)

Drake, Barbara, *Women in the Engineering Trades* (Fabian Research Department and Allen & Unwin, 1917)

—— *Women in Trade Unions* (Labour Research Department, 1920)

Dyhouse, Carol, *Girls Growing Up in Late Victorian and Edwardian England* (Routledge & Kegan Paul, 1981)

Easlea, Brian, *Science and Sexual Oppression* (Weidenfeld & Nicolson, 1981)

Ensor, R. C. K., *England 1870-1914* (Oxford University Press, 1936)

Equal Opportunities Commission, *Health and Safety Legislation: Should we Distinguish between Men and Women?* (EOC, Manchester, 1979)

Ewing, Elizabeth, *Fashion in Underwear* (Batsford, 1971)

—— *History of Twentieth Century Fashion* (Batsford, 1974)

Fiddes, Edward, *Chapters in the History of Owens College and of Manchester University 1851-1914* (Manchester University Press, Manchester, 1937)

Fletcher, Sheila, *Feminists and Bureaucrats* (Cambridge University Press, Cambridge, 1980)

—— *Women First: the Female Tradition in English Physical Education 1880-1980* (Athlone Press, 1984)

Fowler, Alan and Lesley, *The History of the Nelson Weavers Association* (Burnley, Nelson, Rossendale & District Textile Workers Union, Nelson [1984])

Fraser, W. Hamish, *The Coming of the Mass Market 1850-1914* (Macmillan, 1981)

Fulford, Roger, *Votes for Women* (Faber, 1957)

Gaffin, Jean and Thoms, David, *Caring & Sharing: the Centenary History of the Co-operative Women's Guild* (Co-operative Union, Manchester, 1983)

Gordon, Peter, *The Victorian School Manager* (Woburn Press, 1974)

Gorham, Deborah, *The Victorian Girl and the Feminine Ideal* (Croom Helm, 1982)

Gwyn, W. B., *Democracy and the Cost of Politics in Britain* (Athlone Press, 1962)

Halévy, Elie, *A History of the English People: Epilogue vol. II* (Hachette, Paris, 1932; English translation: Benn, 1934)

Hamilton, Mary Agnes, *Newnham, an Informal Biography* (Faber, 1936)

Harrison, Brian, *Separate Spheres: the Opposition to Women's Suffrage in Britain* (Croom Helm, 1978)

Bibliography

Hellerstein, Erna Olafson; Hume, Leslie Parker; Offen, Karen M. (eds), *Victorian Women: a Documentary Account of Women's Lives in Nineteenth Century England, France and the United States* (Harvester Press, Brighton, 1981)

Hewitt, Margaret, *Wives and Mothers in Victorian Industry* (Rockliff, 1958)

Holcombe, Lee, *Victorian Ladies at Work* (David & Charles, Newton Abbot, 1973)

—— *Wives and Property: Reform of the Married Women's Property Law in Nineteenth-Century England* (Martin Robertson, Oxford 1983)

Hollis, Patricia (ed.), *Women in Public: the Women's Movement 1850-1900* (Allen & Unwin, 1979)

Horn, Pamela, *Education in Rural England 1800-1914* (Gill & Macmillan, Dublin, 1978)

Huelin, Gordon, *King's College London 1828-1978* (King's College, 1978)

Hume, Leslie Parker, *The National Union of Women's Suffrage Societies 1897-1914* (Garland, New York, 1982)

Hunt, E. H., *British Labour History 1815-1914* (Weidenfeld & Nicolson, 1981)

Hynes, Samuel, *The Edwardian Turn of Mind* (Princeton University Press, Princeton, 1968)

Jackson, Holbrook, *The Eighteen Nineties* (Grant Richards, 1913)

John, Angela, *By the Sweat of Their Brow: Women Workers at Victorian Coal Mines* (Croom Helm, 1980)

Kamm, Josephine, *Hope Deferred: Girls' Education in English History* (Methuen, 1965)

—— *Indicative Past: a Hundred Years of the Girls' Public Day School Trust* (Allen & Unwin, 1971)

—— *Rapiers and Battleaxes: the Women's Movement and its Aftermath* (Allen & Unwin, 1966)

Klein, Viola, *The Feminine Character: History of an Ideology* (Kegan Paul, Trench, Trubner, 1946)

Lewenhak, Sheila, *Women and Trade Unions* (Benn, 1977)

Lewis, Jane, *Women in England 1870-1950* (Wheatsheaf, Brighton, 1984)

Liddington, Jill and Norris, Jill, *One Hand Tied Behind Us: the Rise of the Women's Suffrage Movement* (Virago, 1978)

McGregor, O. R., *Divorce in England: a Centenary Study* (Heinemann, 1957)

—— Blom-Cooper, Louis; Gibson, Colin, *Separated Spouses* (Duckworth, 1970)

MacKenzie, Donald A., *Statistics in Britain 1865-1930* (Edinburgh University Press, Edinburgh, 1981)

MacKenzie, Jeanne (compiler), *Cycling* (Oxford University Press, Oxford, 1981)

McLaren, Angus, *Birth Control in Nineteenth-Century England* (Croom Helm, 1978)

McWilliams-Tullberg, Rita, *Women at Cambridge* (Gollancz, 1975)

Mappen, Ellen, *Helping Women at Work: the Women's Industrial Council, 1889-1914* (Hutchinson, 1985)

Martindale, Hilda, *Women Servants of the State 1870-1938* (Allen & Unwin, 1938)

Mathias, Peter, *The First Industrial Nation: an Economic History of Britain 1700-1914* (Methuen, 1969)

Megson, Barbara and Lindsay, Jean, *Girton College 1869-1959* (Heffer, Cambridge [1961])

Mitchell, B.R. (with Phyllis Deane), *Abstract of British Historical Statistics* (Cambridge University Press, 1962)

Mix, Katherine Lyon, *A Study in Yellow: the Yellow Book and its Contributors* (University of Kansas Press, Lawrence; Constable, London, 1960)

Murray, Janet Horowitz (ed.), *Strong-Minded Women: and Other Lost Voices from Nineteenth-Century England* (1982; Penguin Books, Harmondsworth, 1984)

North West Labour History Society, *Bulletin* 7, 1980-1: *Women & the Labour Movement* (NWLHS, Manchester)

Oakley, Ann, *Housewife* (Allen Lane, 1974)

Pallett, George, *Women's Athletics* (Normal Press, 1955)

Pankhurst, E. Sylvia, *The Suffragette Movement* (Longmans, 1931)

Pease, Edward, *The History of the Fabian Society* (1916; Cass, 1963)

Percival, Alicia, *The English Miss To-Day & Yesterday* (Harrap, 1939)

Pinchbeck, Ivy, *Women Workers and the Industrial Revolution 1750-1850* (1930; Cass, 1969)

Pollard, Marjorie, *Fifty Years of Women's Hockey* (All England Women's Hockey Association [1946])

Prochaska, Frank, *Women and Philanthropy in Nineteenth-Century England* (Clarendon Press, Oxford, 1980)

Pugh, Martin, *The Making of Modern British Politics 1867-1939* (Basil Blackwell, Oxford, 1982)

—— *Women's Suffrage in Britain 1867-1928* (Historical Association, 1980)

Reiss, Erna, *Rights and Duties of Englishwomen* (Sherratt & Hughes, Manchester, 1934)

Ritchie, Andrew, *King of the Road* (Wildwood House, 1975)

Robb, Janet, *The Primrose League 1883-1905* (1942; Ams Press, New York, 1968)

Roberts, Elizabeth, *A Woman's Place: an Oral History of Working-*

Bibliography

Class Women 1890-1940 (Basil Blackwell, Oxford, 1984)

Rosen, Andrew, *Rise Up, Women!: the Militant Campaign of the Women's Social and Political Union 1903-1914* (Routledge & Kegan Paul, 1974)

Rover, Constance, *Women's Suffrage and Party Politics in Britain 1866-1914* (Routledge & Kegan Paul, 1967)

Sachs, Albie, and Wilson, Joan Hoff, *Sexism and the Law* (Martin Robertson, Oxford, 1978)

Sanderson, Michael, *The Universities and British Industry 1850-1970* (Routledge & Kegan Paul, 1972)

Saul, S. B., *The Myth of the Great Depression, 1873-1896* (Macmillan, 1969)

Sayers, Janet, *Biological Politics: Feminist and Anti-Feminist Perspectives* (Tavistock, 1982)

Sayers, R. S., *A History of Economic Change in England, 1880-1939* (Oxford University Press, 1967)

Schmiechen, James A., *Sweated Industries and Sweated Labor: the London Clothing Trades 1860-1914* (University of Illinois Press, Urbana and Chicago, 1984)

Searle, G. R., *Eugenics and Politics in Britain 1900-1914* (Noordhoff, Leyden, 1976)

Semmel, Bernard, *Imperialism and Social Reform: English Social-Imperial Thought 1895-1914* (Allen & Unwin, 1960)

Showalter, Elaine, *A Literature of Their Own: British Women Novelists from Brontë to Lessing* (1977, Virago, 1978)

Smart, Carol, *The Ties That Bind: Law, Marriage and the Reproduction of Patriarchal Relations* (Routledge & Kegan Paul, 1984)

Soldon, Norbert, *Women in British Trade Unions 1874-1976* (Gill & Macmillan, Dublin, 1978)

Sondheimer, Janet, *Castle Adamant in Hampstead: a History of Westfield College 1882-1982* (Westfield College, 1983)

Sotheby's *Catalogue of Valuable Autograph Letters, Literary Manuscripts and Historical Documents including the Mercator Atlas of Europe*, vol. II, 14 March 1979

Strachey, Ray, *The Cause: a Short History of the Women's Movement in Great Britain* (1928; Virago, 1978)

Stubbs, Patricia, *Women and Fiction: Feminism and the Novel 1880-1920* (1979; Methuen, 1981)

Thompson, Donna F., *Professional Solidarity among the Teachers of England* (1927; Ams Press, New York, 1968)

Thornton, Grace, *Conversation Piece: an Introduction to the Ladies in the Dining Room* (University Women's Club, 1979)

Trades Union Congress, *Report of 111th Annual Trades Union Congress, 1979* (TUC, London [?1979])

Tropp, Asher, *The School Teachers: the Growth of the Teaching Profession*

259

in England and Wales from 1800 to the Present Day (Heinemann, 1957)

Trudgill, Eric, *Madonnas and Magdalens: the Origins and Development of Victorian Sexual Attitudes* (Heinemann, 1976)

Tuke, Margaret J., *A History of Bedford College for Women 1849-1937* (Oxford University Press, 1939)

Tylecote, Mabel, *The Education of Women at Manchester University 1883 to 1933* (Manchester University Press, Manchester, 1941)

Walkowitz, Judith, *Prostitution and Victorian Society* (Cambridge University Press, Cambridge, 1980)

Walton, Ronald G., *Women in Social Work* (Routledge & Kegan Paul, 1975)

Webb, Beatrice and Sidney, *English Poor Law History, Part II: the Last Hundred Years*, two volumes (1929; Cass, 1963)

White, Joseph L., *The Limits of Trade Union Militancy: the Lancashire Textile Workers, 1910-1914* (Greenwood Press, Westport, Connecticut, 1978)

Widdowson, Frances, *Going Up into the Next Class: Women and Elementary Teacher Training 1840-1914* (1980; Hutchinson, 1983)

Williams, Harold, *Modern English Writers* (1918; Sidgwick & Jackson, 1925)

3) ARTICLES

Alaya, Flavia, 'Victorian science and the "genius" of woman', *Journal of the History of Ideas*, 38 (1977)

Atkinson, Paul, 'Fitness, feminism and schooling', in Sara Delamont and Lorna Duffin (eds), *The Nineteenth-Century Woman* (Croom Helm, 1978)

Barrett, Michèle and McIntosh, Mary, 'The "family wage": some problems for socialists and feminists', *Capital & Class*, 11 (1980)

Bridge, Evelyn, 'Women's Employment: problems of research', *Bulletin of the Society for the Study of Labour History*, 26 (1973)

Conway, Jill, 'Stereotypes of femininity in a theory of sexual evolution', in Martha Vicinus (ed.), *Suffer and Be Still: Women in the Victorian Age* (Indiana University Press, Bloomington and London, 1972). Reprinted from *Victorian Studies*, 14 (1970)

Cunningham, Gail, 'The "new woman fiction" of the 1890's', *Victorian Studies*, 17 (1973)

Davin, Anna, 'Imperialism and motherhood', *History Workshop Journal*, 5 (1978)

Delamont, Sara, 'The domestic ideology and women's education', in Sara Delamont and Lorna Duffin (eds), *The Nineteenth-Century Woman* (Croom Helm, 1978)

Dowling, Linda, 'The decadent and the new woman in the 1890's', *Nineteenth Century Fiction*, 33 (1979)

Draper, Hal and Lipow, Anne G., 'Marxist women versus bourgeois feminism', in Ralph Miliband and John Saville (eds), *The Socialist Register 1976* (Merlin, 1976)

Duffin, Lorna, 'Prisoners of progress: women and evolution', in Sara Delamont and Lorna Duffin (eds), *The Nineteenth-Century Woman* (Croom Helm, 1978)

Dyhouse, Carol, 'Social Darwinistic ideas and the development of women's education in England, 1880-1920', *History of Education*, 5 (1976)

—— 'Working-class mothers and infant mortality in England, 1895-1914', in Charles Webster (ed.), *Biology, Medicine and Society 1840-1940* (Cambridge University Press, Cambridge, 1981). Reprinted from *Journal of Social History*, 12 (1978)

Fee, Elizabeth, 'Nineteenth-century craniology: the study of the female skull', *Bulletin of the History of Medicine*, 53 (1979)

Gray, R. Q., 'Religion, culture and social class in late nineteenth and early twentieth century Edinburgh', in Geoffrey Crossick (ed.), *The Lower Middle Class in Britain 1870-1914* (Croom Helm, 1977)

Hargreaves, Jennifer A., ' "Playing like gentlemen while behaving like ladies": contradictory features of the formative years of women's sport', *British Journal of Sports History*, 2 (1985)

Harris, Wendell V., 'John Lane's Keynotes series and the fiction of the 1890's', *PMLA*, 83 (1968)

Harrison, Brian, 'Women's health and the women's movement in Britain: 1840-1940', in Charles Webster (ed.), *Biology, Medicine and Society 1840-1940* (Cambridge University Press, Cambridge, 1981)

Holcombe, Lee, 'Victorian wives and property: reform of the married women's property law, 1857-1882', in Martha Vicinus (ed.), *A Widening Sphere: Changing Roles of Victorian Women* (1977; Methuen, 1980)

Humphries, Jane, 'The working class family, women's liberation, and class struggle: the case of nineteenth century British history', *Review of Radical Political Economics*, 9 (3) (1977)

Joske, P. E., 'Family law', in G. W. Paton (ed.), *The Commonwealth of Australia: the Development of its Laws and Constitution* (Stevens & Sons, 1952)

Lambertz, Jan, 'Sexual harassment in the nineteenth century English cotton industry', *History Workshop Journal*, 19 (1985)

Land, Hilary, 'The family wage', *Feminist Review*, 6 (1980)

McCrone, Kathleen, 'Play up! play up! and play the game! Sport at the late Victorian girls' public school', *Journal of British Studies*, 23 (1984)

McGregor, O. R., 'The social position of women in England, 1850-

1914: a bibliography', *British Journal of Sociology*, 6 (1955)

Malcolmson, Patricia, 'Laundresses and the laundry trade in Victorian England', *Victorian Studies*, 24 (1981)

Molyneux, D. D. 'Early excursions by Birmingham women into games and sports', *Physical Education*, 51 (1959)

Morris, R. J., 'The Married Women's Property Act of 1870', Social History Society *Newsletter* 5 (1) (1980)

—— 'Men, women and property: the reform of the Married Women's Property Act, 1870' (unpublished paper)

Mosedale, Susan Sleeth, 'Science corrupted: Victorian biologists consider "The Women Question"', *Journal of the History of Biology*, 11 (1978)

Oakeley, Hilda, 'King's College for women' appendix A of F.J.C. Hearnshaw, *The Centenary History of King's College London 1828-1928* (Harrap, 1929)

Olcott, Teresa, 'Dead centre: the women's trade union movement in London, 1874-1914', *London Journal*, 2 (1976)

Pedersen, Joyce Senders, 'Schoolmistresses and headmistresses: elites and education in nineteenth-century England', *Journal of British Studies*, 15 (1975)

—— 'Some Victorian headmistresses: a conservative tradition of social reform', *Victorian Studies*, 24 (1981)

Rowntree, Griselda and Carrier, Norman H., 'The resort to divorce in England and Wales, 1858-1957', *Population Studies*, 11 (1958)

Rubinstein, David, 'Cycling in the 1890s', *Victorian Studies*, 21 (1977)

—— 'Socialisation and the London School Board 1870-1904', in Phillip McCann (ed.), *Popular Education and Socialisation in the Nineteenth Century* (Methuen, 1977)

Satre, Lowell J., 'After the match girls' strike: Bryant and May in the 1890s', *Victorian Studies*, 26 (1982)

Summers, Anne, 'A home from home — women's philanthropic work in the nineteenth century', in Sandra Burman (ed.), *Fit Work for Women* (Croom Helm, 1979)

Thompson, E. P., '"Rough music": le charivari anglais', *Annales*, 27 (1972)

Turnbull, Annmarie, '"So extremely like Parliament": the work of the women members of the London School Board, 1870-1904', in London Feminist History Group, *The Sexual Dynamics of History* (Pluto Press, 1983)

Vicinus, Martha, '"One life to stand beside me": emotional conflicts in first-generation college women in England', *Feminist Studies*, 8 (1982)

4) UNPUBLISHED THESES

Brady, Norman, '*Shafts* and the Quest for a New Morality: an Examination of the "Woman Question" in the 1890s as Seen Through the Pages of a Contemporary Journal' (M.A., University of Warwick, 1978)

Cunningham, Abigail Ruth, 'The Emergence of the New Woman in English Fiction, 1870-1914' (D. Phil., University of Oxford, 1974)

Hargreaves, Jennifer A., '"Playing Like Gentlemen While Behaving Like Ladies": the Social Significance of Physical Activity for Females in Late Nineteenth and Early Twentieth Century Britain' (M.A. (Ed.), University of London, 1979)

Holton, Sandra, 'Feminism and Democracy: the Women's Suffrage Movement in Britain, with Particular Reference to the National Union of Women's Suffrage Societies 1897-1918' (Ph.D., University of Stirling, 1980)

Pedersen, Joyce Senders, 'The Reform of Women's Secondary and Higher Education in Nineteenth Century England: a Study in Elite Groups' (Ph.D., University of California, Berkeley, 1974)

Pointon, Marie C., 'The Growth of Women's Sport in Late Victorian Society as Reflected in Contemporary Literature' (M.Ed., University of Manchester, 1978)

Ross, Elizabeth M., 'Women and Poor Law Administration 1857-1909' (M.A., University of London, 1956)

Schmiechen, James A., 'Sweated Industries and Sweated Labor: a Study of Industrial Disorganisation and Workers' Attitudes in the London Clothing Trades, 1867-1909' (Ph.D., University of Illinois, Urbana-Champaign, 1975)

Acknowledgements

We are grateful to the following for permission to use illustrations:

The British Library (for plates 4, 8 and 11)
Co-operative Women's Guild (for plate 6)
Fawcett Library (for plate 5)
The Mistress and Fellows of Girton College (for plate 10)
Lady Margaret Hall (for plate 14)
Punch (for plates 9 and 12)
West Yorkshire Archive Service (for plate 3)
Longman Group Limited (for plate 16)

Index

Index

Index

Long Eaton, 150
Lough, Thomas, 154
Low, Frances, 86-7, 224
Lowndes, Marie Belloc, 85-6
Loxton, Mrs. 150
Lubbock, (Lady) Sybil, 33
Lunacy Act, 1890, 65n.38
Lush, Montague, 63n.8
Lyons, J., teashops, 36n.27
Lys, F.J., 206n.36
Lyttelton, Arthur, 159n.15
Lyttelton, Kathleen, 142, 159
n.15

MacCarthy, Mary, *see* Warre-
Cornish
MacDonald, (James) Ramsay,
100, 116, 131nn.25 & 29
MacDonald, Margaret Ethel,
112, 116, 117-18, 120, 128,
131nn.25 & 29, 132n.42
McFall, David, 15
Machine work, 95
McIlquham, Harriett, 36n.27,
140, 142, 180n.13
Mackern, Louie, 213, 214
McMillan, Margaret, 166
McWilliams-Tullberg, Rita,
189, 201
'Madge', *see* Humphry, Char-
lotte
Magill, Ann, 182n.46
Making of a Prig, The (Sharp), 31
Malcolmson, Patricia, 113
Malmesbury, Countess of (Susan
Hamilton, subsequently
Harris), 40, 43, 220
Man and Woman (Havelock
Ellis), 4-5
Manchester, 126, 148, 165, 217,
222
Manchester, University of, *see*
Owens College
Manchester Guardian, 57, 58
Manchester, Salford and Dis-
trict Trades Union Council,
120
Manchester School Board, 165
Mann, Tom, 100, 108nn.29 &
30, 223
Marcella (Ward), 32-3, 37n.47
March-Phillipps, Evelyn, 75,
93n.79, 99, 119-20, 123
Maris Stella (Balfour), 35n.8
Marland (subsequently Mar-
land-Brodie), Annie, 125-7,
128, 133-4n.61, 235
Marriage, problems of, 11n.21,
13-14, 15, 19, 20, ch.4; pros-
pects of, 12, 13-14, 71, 78, 81,
84, 91n.46, 120, 121, 132n.42,
188-9, 205n.21, 211
Married women, employment
of, 100, 101-2, 108nn.29 & 30,
109n.39, 126; enfranchise-
ment of, 143-4
Married Women's Property
Acts, 51, 137

Marshall, Alfred, 4, 74, 192-3,
202, 210nn.108 & 114
Marshall, Mary Paley, 80, 192-3
Marshall, Maud, 213
Martin, Annie, 149
Martin, Victoria Woodhull, 44,
49n.32
Martineau, Harriet, 87
Marx (also known as Marx-
Aveling), Eleanor, 87, 116,
160n.27
Marylebone, 165
Massingberd (married name
Langton), Emily, 222, 223,
225
Match girls, xiii, 95-6, 112
Matrimonial Causes Acts, 43,
52, 55
Matthews, Henry, 112, 113
Maynard, Constance, 189-90,
200, 205n.27
Mayor, Flora, 188, 198, 205n.16
Mayor, Joseph, 188
Meade, L. T., 190
Mears, Elizabeth Amy, 106n.11
Men and Women's Club, 45
Meredith, George, xii, 24
Merrington, Martha, 167
Meynell, Alice, 85, 86
Midlands, East, 102
Mill, John Stuart, 6
Mitchell, Hannah, 161-2nn.53
& 170
Mitford, Nancy, 162n.62
Modern Review, 46
Mona Maclean, Medical Student
(Travers), 30
Moncreiff, Lord (Henry James
Moncreiff, *see* Wellwood
Montefiore, Dora B. (previously
Fuller), 18, 53, 115
Montefiore, George Barrow, 53
Moore, George, xii, 24
Morant, Miss, 132n.35
Morley, Mrs., 149
Morris, William, 103
Morten, Honnor, 84, 93n.75,
169
Mossley, 125, 127
'Mrs. Grundy', xi, 20, 41, 223
Mumford, Edith Read, *see* Read
Munro-Ferguson, Valentine,
141
Murdoch, Mary, 81
Murray, (Lady) Mary, *see*
Howard

National Liberal Federation,
157, 164n.89
'National minimum', 105
National Secular Society, 45
National Union of Teachers, 78,
90n.40
National Union of Women's
Suffrage Societies, 140, 145
National Union of Working
Women, 152, 221
Necrosis, *see* 'phossy jaw'
Nelson, 133n.54

Nesbit, Edith, 30-1
Nevill, Meresia, 22n.28
Nevinson, Henry W., 36n.36
New Hospital for Women, 81
New Machiavelli, The (Wells),
37n.47
New Somerville Club, 224
'New Unionism', 100
New Weekly, 125
'New woman', xi, xiii, 15-20,
21nn.11 & 14 & 15, 137, 148,
185, 203, 207n.49, 214-15,
216, 221, 223, 233
'New woman' fiction, xii, 18,
ch.3, 97, 233
New Zealand, 54
Newman, Ernest, 7
Newnham College, Cambridge,
ch.11, *passim*; number of stu-
dents, 204n.5
Nield, Ada, 96, 97, 119, 126,
181n.30, 235
Nineteenth Century, 12-14, 84, 221
Nisbet, J.F., 5, 15
Nobody's Fault (Syrett), 28-9, 30
Nordau, Max, 5, 10n.10
Norfolk, 76
Norris, Jill, 100, 150
North American Review, 15-16
North London Collegiate
School, 185
Northern Counties Amalga-
mated Assosiation of Weavers,
100
Notting Hill, 117
Nottingham, 71, 109n.39
Nutford and Lottingland Union
(Suffolk), 175

Oakeshott, Joseph, 169
Oakley, Charles Selby, 175-6,
182n.50
Ockham, *see* Hautboy Hotel
Odd Women, The (Gissing), 90-1
n.45
Odgers, W. Blake, 63n.8
Officials, women, 171-2, 174-5
Ogilvie, Maria, 187
'Old Oriental, An', 72
Oldham, 108n.30, 122, 133n.51
'Ole', 31
Oliphant, Margaret, 39
Olympic Games, 228n.15
O'Malley, Ida, 189
On the Threshold (Ford), 27-8, 30
Orme, Eliza, 84, 151, 164n.89
Oswestry Board of Guardians,
174-5
Ouida, 15-16, 21n.14, 24, 33,
215, 229n.33
Outwork, outworkers, 121-2,
133n.47
Overtoun, Lord (John Campbell
White), 106n.10
Owens College, Manchester,
192, 195, 196
Oxford, 42, 218
Oxford, University of, xiii, 18,
77, ch.11 *passim*, 220; number

269

Index

271